ADVENTURES

in the

LOUVRE

ALSO BY ELAINE SCIOLINO

The Seine: The River That Made Paris

*The Only Street in Paris: Life
on the Rue des Martyrs*

*La Seduction: How the French
Play the Game of Life*

Persian Mirrors: The Elusive Face of Iran

*The Outlaw State: Saddam Hussein's
Quest for Power and the Gulf Crisis*

ADVENTURES

in the

LOUVRE

HOW TO FALL IN LOVE
WITH THE WORLD'S
GREATEST MUSEUM

Elaine Sciolino

W. W. NORTON & COMPANY

Independent Publishers Since 1923

For information about permission to reproduce selections from this book, write to
Permissions, W. W. Norton & Company, Inc., 500 Fifth Avenue, New York, NY 10110

For information about special discounts for bulk purchases, please contact
W. W. Norton Special Sales at specialsales@wwnorton.com or 800-233-4830

Manufacturing by Lakeside Book Company
Book design by Beth Steidle
Production manager: Lauren Abbate

ISBN: 978-1-324-02140-7

W. W. Norton & Company, Inc.
500 Fifth Avenue, New York, NY 10110
www.wwnorton.com

W. W. Norton & Company Ltd.
15 Carlisle Street, London W1D 3BS

10 9 8 7 6 5 4 3 2 1

In memory of
Jeannette Limeri Sciolino,
who saw blue in the bushes

Contents

ADVENTURES

in the

LOUVRE

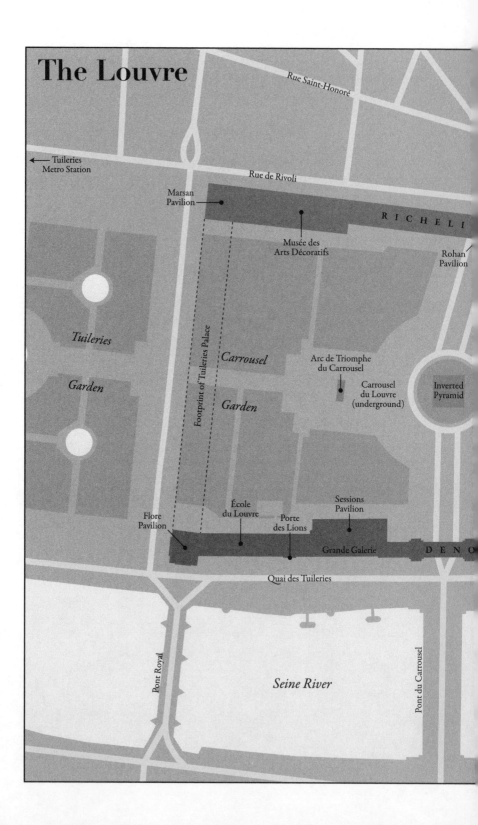

The Louvre

Rue Saint-Honoré

← Tuileries
Metro Station

Rue de Rivoli

Marsan
Pavilion

R I C H E L I

Musée des
Arts Décoratifs

Rohan
Pavilion

Tuileries

Carrousel

Arc de Triomphe
du Carrousel

Carrousel
du Louvre
(underground)

Inverted
Pyramid

Garden

Footprint of Tuileries Palace

Garden

Flore
Pavilion

École
du Louvre

Porte
des Lions

Sessions
Pavilion

Grande Galerie

D E N O

Quai des Tuileries

Pont Royal

Pont du Carrousel

Seine River

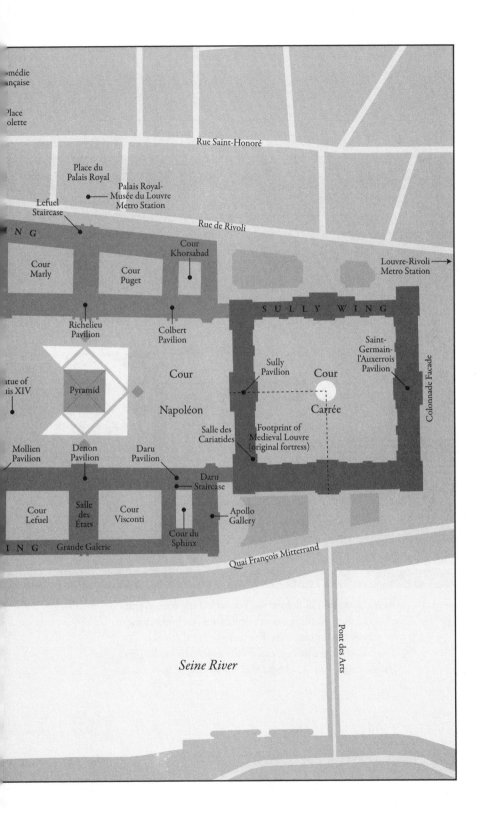

Comédie
Française

Place
Colette

Rue Saint-Honoré

Place du
Palais Royal

Palais Royal-
Musée du Louvre
Metro Station

Lefuel
Staircase

Rue de Rivoli

N G

Louvre-Rivoli
Metro Station

Cour
Marly

Cour
Puget

Cour
Khorsabad

S U L L Y W I N G

Richelieu
Pavilion

Colbert
Pavilion

Sully
Pavilion

Saint-
Germain-
l'Auxerrois
Pavilion

Colonnade Facade

Cour

Pyramid

Cour

Napoléon

Cour
Carrée

atue of
is XIV

Salle des
Cariatides

Footprint of
Medieval Louvre
(original fortress)

Mollien
Pavilion

Denon
Pavilion

Daru
Pavilion

Daru
Staircase

Cour
Lefuel

Salle
des
États

Cour
Visconti

Apollo
Gallery

I N G

Grande Galerie

Cour du
Sphinx

Quai François Mitterrand

Seine River

Pont des Arts

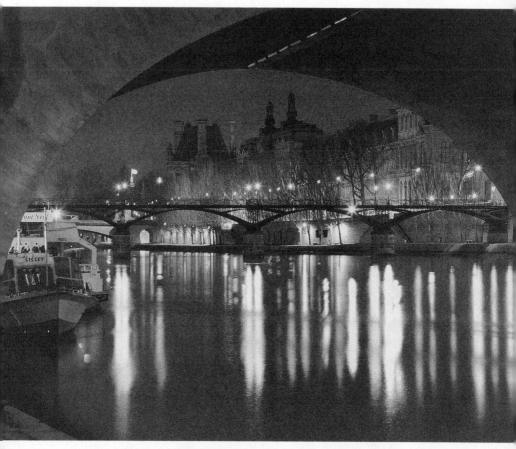

The Louvre at night behind the Pont des Arts, framed from below the Pont Neuf. It has sat, stonily, on the Right Bank of the Seine for centuries, first as a medieval military fortress, then as a palace, and finally as a museum. © *Gary Zuercher, glz.com, Marcorp Editions, marcorp-editions.com*

✦✦✦✦✦✦✦✦✦✦✦✦✦✦✦✦✦✦✦✦

Falling for the Louvre

You're the top! You're the Colosseum.
You're the top! You're the Louvr' Museum.
— **Cole Porter,** *Anything Goes*

HOW DO YOU FALL IN LOVE WITH THE LOUVRE? THE BIGGEST, GRAND-est, most visited public repository of art in the world, it demands our attention. But love? Like an evasive paramour, the Louvre may not always seem to want a relationship.

The building has sat, stonily, on the Right Bank of the Seine for centuries, starting as a medieval military fortress and then becoming a palace. Royals and rulers renovated it more than twenty times, satisfying their vanity but leaving behind a sprawling structure that lacks logic. Its galleries, facades, staircases, and ceilings are individual jewels, but together they do not form a coherent whole. It shape-shifts restlessly within the old walls.

Some New Yorkers complain that the Metropolitan Museum of Art is big, cold, and unwieldy, but at least it was built as a place to show great art. The Louvre was not, and it took a revolution to make it one. Both fortress and palace were larger-than-life settings, and even today the museum feels operatic and intimidating.

You can feel overwhelmed by the size of this place; you can also feel

underwhelmed by the experience of visiting it. It may well be the best-known and yet least understood museum in the world.

And the name! Loov-ruh. The word sits heavy on the tongue, a syllable and a half with a tricky transition from *v* to the back-of-the-throat French *r*. Even the French cannot make it musical. And the origin of the word is a mystery.

For some people, love for the Louvre is a *coup de foudre*, a bolt of lightning that strikes almost as soon as they enter its doors. For others, love is elusive, and they wander from painting to sculpture to artifact, confused by the vastness—more than four hundred rooms!—and uncertain about where to focus and how to understand. *Le Figaro* estimates that at the rate of standing fifteen seconds in front of each work, a complete tour of the Louvre requires eighteen 8-hour days, about 145 hours.

Stretching almost half a mile, the museum exhibits more than 30,000 of its 500,000 works of art in more than 780,000 square feet of exhibition space. A walk through every room would give you nine miles of exercise—about 18,000 steps. Underground are additional tunnels and passageways, storage rooms and workshops.

The museum has 2,300 employees, 900 security cameras, 25 different levels, 70 elevators, 24 escalators, about 2,500 doors, and more than 4,000 keys for locks that may or may not still be in use. Polishing its parquet floors requires about 10,000 gallons of wax per year. Some of its tens of thousands of lights are 120-volt, and the bulbs must be imported from the United States. It is so big that it is served by three Métro stations—Tuileries, Palais Royal, Louvre-Rivoli. If you include the Tuileries Garden, which belongs to the Louvre and extends its length by another half a mile or so, you can add another Métro station: Concorde.

There is almost no way to avoid getting lost once you're inside. The official maps hardly convey the flow and complexity of getting from one place to another. Signage is sparse, uneven, and confusing; you can go into room after room before you find a guard to guide you.

While many people see the Louvre as a necessary pilgrimage during a trip to Paris, others think of it as a mausoleum, a repository of dusty art objects. Its imposing galleries, obscure wings, tricky labyrinths, illogical corridors, and narrow staircases can overwhelm even the most passionate art lovers.

Some won't even try. "It's my goal to be the only person who's come to Paris and has never set foot in the Louvre," said the American humorist David Sedaris. Even native Parisians consider the museum intimidating. Only a fourth of visitors to the Louvre are French; the rest are foreign.

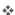

I REMEMBER NOTHING ABOUT THE first time I visited the Louvre. I wish I could say I was moved by its majesty and felt the ghostly presence of kings and queens. I wish I could recall the cool touch of marble banisters and the creaking of parquet floors.

It was the summer after my junior year in college. Perhaps I was frustrated by the scale of the place: the long, dark corridors; wings closed because of a shortage of security guards; room after room of paintings of Jesus, Mary, and their relatives, followers, enemies, and angels. I must have seen the *Mona Lisa*, but all I wrote in my journal was: "I went to the Louvre and walked outside of the Tuileries Garden along the shops."

I was more expansive about my lunch. A certain Madame Fleche from the Roquefort Cheese Company, which sold cheese to my father for his food store in upstate New York, had invited me that day. The meal was "delicious and expensive"—a small melon half filled with port wine, a grilled steak, a cheese platter, a green salad, pastries. The wine was a rosé.

I was traveling with my friend Donna. In her journal, she wrote more about the museum, although she, too, focused on food. "To the Louvre. Second floor, nineteenth-century painting is closed. We saw Egyptian, Greek, Renaissance, sixteenth-seventeenth century. Some good Renaissance, especially *Man with a Glove*, several good Leonardos besides *Mona Lisa*, a marvelous Tintoretto self-portrait. We begin to live out of a delicatessen on bread, cheese, fruit, yogurt."

So began my relationship with the Louvre.

"Art is what makes us human," Laurence des Cars, the director of the Louvre, likes to say. Des Cars comes from a noble family that dates back a thousand years. She came to the Louvre's top job in 2021 after four years as the head of the Musée d'Orsay and some years before that as scientific director of the museum that bears the Louvre's name in Abu Dhabi. But even she remembers nothing about the very first time she visited the

Louvre. "To be honest, it's a blur thing," she said to me one day. "I cannot really pin the moment, you know, so it's a very disappointing answer. I was not a great museumgoer when I was a kid."

It would take time for des Cars—and for me, too—to yield to the seductive power of the Louvre. A sensual dialogue emerges when human beings discover the wonder in works of art, and I've found that the Louvre offers more of this wonder than any other place I know.

It also triggers dreams and nightmares. At a stressful point in writing this book, I experienced a long and involved anxiety dream. I was in the Louvre and could not find my way out. Then the *Winged Victory of Samothrace*, or Nike, swooped into my subconscious.

The Nike of Samothrace, 2,200 years old, is probably the most famous ancient Greek sculpture in the world. No matter that she is both headless and armless. Standing nine feet tall, propelled by her enormous, powerful wings, she alights on the prow of a ship rendered in gray marble at the top of the Louvre's grandest staircase. One of the few artworks in the museum to occupy real estate without visual competition from any others, she presides over an imposing space under an oval skylight at the beating heart of the Denon wing. Visitors can readily encounter her on their way to or from the *Mona Lisa*.

In my own dream state, I pictured Nike carrying me off and liberating me through a magical tunnel inside the Louvre. That tunnel in reality was a gift from the great novelist and travel writer Henry James. The first time he visited the Louvre, as a boy of thirteen, he found its cavernous halls and galleries so wondrous that they "overwhelmed and bewildered" him. He was thunderstruck by the Apollo Gallery, a jewel box of a room with a vaulted ceiling and golden walls, crammed with paintings and showy stucco sculptures. He imagined that it formed a tunnel connecting him to "a general sense of *glory*." Glory meant many things at once: "not only beauty and art and supreme design, but history and fame and power, the world in fine raised to the richest and noblest expression."

James had his own dream about the Louvre, probably literature's most famous nightmare panic attack in a museum. He was sixty-seven and is believed to have been suffering from deep depression. In what he called "the most appalling yet most admirable nightmare of my life," he finds himself facing death in the Louvre. He is pursued down the length of the

Apollo Gallery by an "awful agent, creature, or presence," but then, with a surge of power, "the tables turned." James takes control and defends himself. The monster flees for its life as lightning and thunder pierce the high windows, leading James to recall the wonders he first encountered there in his childhood. From monster to magic.

It would take many lifetimes to know all of the Louvre. Even Henri Loyrette, who served as director of the museum for twelve years, stays humble before it. "No one can possibly claim to be 'a specialist of the Louvre,'" he once said. "No one has this kind of universal specialty—unless it's an incredible pretentiousness."

While there have been umpteen efforts to improve the visitor experience, the directors of the Louvre have long acknowledged the challenges it presents and its absence of cohesion and order. "Ours is a very difficult collection to comprehend—unless you know history, mythology, and the Bible," Loyrette told me. Jean-Luc Martinez, his successor, said, "The Louvre is a palace and doesn't have the logic of a museum." Des Cars calls the place "a large, jumbled encyclopedia."

To free myself from feeling overcome by its forbidding magnitude and to take personal control, the way James did, I had to learn how to visit the Louvre. I had to don the mantle of Loyrette's humility. I had to wander and get lost and forget about time. I had to come to know the works of art by making connections and starting conversations as I roamed the galleries—with experts, guards, friends, even perfect strangers.

And so, over time and long acquaintance, the Louvre has pulled me into its grasp. I no longer see it as a fortress, palace, or museum but as a living, breathing character with multiple personalities.

Somewhere along the way, I fell in love. And that is an experience worth sharing.

FRAGMENT DE PLAN DE PARIS (RÉGION DU LOUVRE).
Dressé par ordre de Michel-Etienne Turgot, prévôt des Marchands de 1734 à 1739.
Chalcographie du Louvre.
5.

A panel of the Turgot map of 1739 showing the Louvre and the neighborhood around it. Napoleon Bonaparte later extended the Louvre along the rue de Rivoli and connected it to the Tuileries Palace.

PART ONE

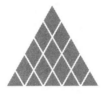

The Allure

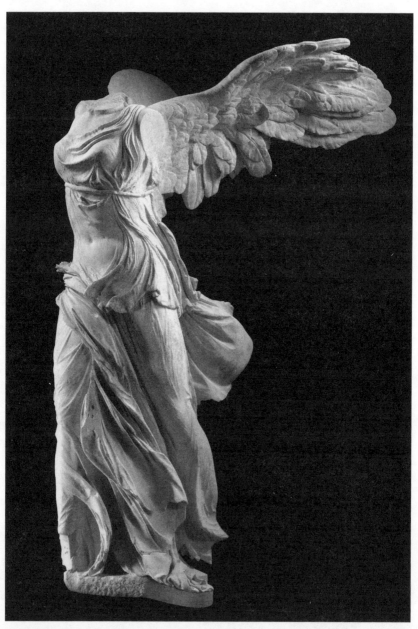

One of the Louvre's superstars is the marble statue of Nike, formally known as the *Winged Victory of Samothrace*. Nike, the flying ancient Greek goddess, personified victory—in war, athletics, art, and music. © *RMN-Grand Palais / ArtResource, NY*

CHAPTER 1

◆◆◆◆◆◆◆◆◆◆◆◆◆◆◆◆◆◆◆◆

Beauty and the Feather

The Louvre, the Louvre.
Might it be that this museum is worth
more than all of France?
Who needs France without the Louvre?

—**Alexander Sokurov,** director of
Francofonia, a 2015 Russian film
about the Louvre in World War II

SAY THE WORD "NIKE" AND WHAT SPRINGS TO MIND IS THE WORLD'S
largest supplier of running shoes. How many people think of the flying
Greek goddess who personified victory in every field—war, athletics, art,
music? Or know that the "swoosh" logo evokes the motion and speed of
one of her wings? Or that the most famous representation of Nike is an
ancient marble statue in the Louvre?

She is *Niki tis Samothrákis* in Greek, better known as the *Winged
Victory of Samothrace.* She stands high above the viewer, alone on a giant
blue-gray marble ship, under an oval skylight. She is nine feet tall, and the
ship raises her another nine feet. She fights a fierce wind and the spray of
the sea as she struggles to land on the ship's prow. Her wings are pinned
back, her great torso twisted as she tries to find her balance. The thin,
sheer fabric of her dress is soaking wet, so it clings to her flesh and reveals
her full breasts and mighty thighs. Keep looking, and you find yourself

drawn to the clenched muscles of her stomach and her large, deep navel. Get closer and you see the fissures in her marble.

Fully draped yet naked at the same time, she personifies sensuality and victory. Some consider her the most important Greek sculpture in the world. For me, she is the most powerful woman in the Louvre.

Nike is unmissable. Her perch in the Denon wing is at the most grid-locked three-way crossroads in the Louvre. As you face her, the rooms with the *Mona Lisa* and Italian and French painting masterpieces are to your right, the gilded Apollo Gallery with the French crown jewels to your left, the long, wide Daru staircase in front.

I once asked Xavier Salomon, the chief curator and deputy director of the Frick Collection in New York, if there is a work of art at the Louvre that he loves more than the *Mona Lisa*.

"The *Victory of Samothrace* is way more moving," he said. "There is an elegance in her, a monumentality. There is the fragmentary aspect, the fact that she is this headless, armless creature where she's just drapery and a pair of wings, and yet there is something almost abstract about her. She is just so beautiful on top of that staircase."

The Nike of Samothrace is not just a chunk of marble to be checked off a must-see list. With the stories she has to tell, she represents the Louvre itself: a work in progress, pieced together over time, an organic structure that has limitless potential for reinvention.

The museum, like Nike, is an amalgamation of many objects of beauty, of human achievements, of aspirations of different cultures and different eras. Like Nike, it has huge gaps and imperfections but has never lost its power to fascinate. People may think they know the statue or that they understand the Louvre, but there is always something more to uncover. And both are triumphantly ennobling, making their viewers feel they are part of something bigger than themselves.

NIKE REPRESENTED A MARITIME VICTORY celebrated at Samothrace, a lonely Greek island in the Aegean Sea. She was sculpted in the second century BC by an unknown artist. A nineteenth-century French diplo-mat and amateur archaeologist, Charles Champoiseau, dug her out of the

ground and sent her back to Paris, where she, the *Mona Lisa*, and the *Venus de Milo* became the Louvre's trio of superstars.

Like many other artworks, Nike came to the Louvre because of an excavation in a poor country. Her presence results from France's belief that it had a right to the best of the world's art.

Champoiseau was tipped off by locals that Samothrace, once the site of a collection of monuments called the Sanctuary of the Great Gods, was a treasure trove of antiquities. He sweet-talked the French government into financing excavations.

The island was steeped in myth. This was where Zeus had fathered Dardanus, the founder of the Trojan people, and where Poseidon, in the *Iliad*, settled on a mountaintop to watch the Trojan War.

In April 1863, Champoiseau saw the first fragments of marble at the end of a terrace and soon unearthed the statue along with pieces of her feathers and clothing, though she was missing her head and arms. He described Nike's drapery as "sheer marble muslin pressed by the wind against the living flesh." In May 1864, she arrived in fragments at the Louvre, where she was reassembled and displayed. Eventually, the prow on which she originally stood was retrieved, restored, and joined as her base.

LOCATION IS EVERYTHING, AND WHEN Nike was given her own space atop the Daru staircase in 1883, onlookers were mesmerized by her. The famous and the infamous—from the Beatles to the Libyan strongman Muammar Qaddafi—have posed with her. She's been copied, imitated, reinterpreted with arms and a head, and made famous around the world. On Fifth Avenue in New York, the Civil War general William Tecumseh Sherman marches behind a version of Nike in a sculpture by Augustus Saint-Gaudens. During World War I, General Ferdinand Foch kept a small replica of her on his desk. A full-sized version decorates a fountain at Caesars Palace hotel and casino in Las Vegas. Likenesses of her have appeared as Rolls-Royce hood ornaments and $175,000 Vacheron Constantin watches.

And of course, she has had countless Hollywood star turns, most famously in Stanley Donen's 1957 musical *Funny Face*. Audrey Hepburn

plays a mousy Greenwich Village bookstore clerk who agrees to become a high-fashion model so that she can get a free trip to Paris, where she hopes to meet a Left Bank philosopher whose writings she admires. She turns luminously beautiful and falls in love with Fred Astaire, who plays a fashion photographer modeled on Richard Avedon. No matter that Fred is much too old for Audrey. What girl growing up ordinary-looking and far from Paris in those days didn't fantasize about becoming Audrey Hepburn in that scene? She makes her entrance and stands like royalty in front of the statue, in a strapless Givenchy gown of crimson, a slit up the side, a train at the back, with matching crimson pumps, white opera gloves past her elbows, and a sparkly choker around her neck. Nike looms behind her as she runs down the staircase and Astaire struggles to capture her with his camera.

She extends her arms and lifts a long red chiffon scarf over her head in imitation of the statue's wingspan. The scarf catches the breeze and billows in the air. It is a triumph of whimsy and liberation. She becomes a living, breathing vision of Nike, of victory.

"Take the picture! Take the picture!" she orders Astaire, who fumbles and snaps.

NO ONE IN THE LOUVRE today cherishes Nike as ardently, as obsessively, as Ludovic Laugier, the curator of ancient Greek sculpture. Laugier arrived at the Louvre as a fresh-faced intern for a three-month stint and has stayed for more than a quarter century. He is easy to spot in the galleries, often dressed in a bow tie and velvet jacket, waving his arms above his head when he gets excited. A long, wild shock of gray hair that falls into his eyes and springs upward gives him the look of a mad scientist. He uses his cashmere scarf to wipe finger- and noseprints from glass cases in his department.

With the pure and almost carnal love he feels for Nike, Laugier doesn't fit neatly into the buttoned-up world of the Louvre. He had long admired Nike but didn't fall madly in love with her until 2013, when he oversaw her ten-month cleaning and further restoration. Weighing almost thirty tons, Nike was too big to travel very far. So a team of

expert movers separated the statue from its base and wheeled the two pieces separately into a workroom some 150 feet away. The prow of the ship—in pieces—followed.

Then Laugier had Nike all to himself, day after day.

"She became an obsession," he said. "She was what fed me from morning to night. She gave me the air I breathed. Sometimes I had dreams that I was so close to the fabric on her thigh, on her stomach, on her breast that we were almost touching; sometimes, my nose was buried in her feathers. She became my muse."

He caressed her marble flesh, studied the folds of her dress, and removed bad patching from previous restorations. He agonized over what to do with random fragments of her marble found in Samothrace that hadn't yet been placed in the reconstructed statue and remained hidden away in storage drawers deep in the Louvre's interior.

Aided by a team of restorers, he stared at those pieces every day, wondering where each should go. "This was not just a statue to be restored, but a vision to be created," he said. Academics, restorers, curators, and architects from around the world collaborated on the project.

She was back in place with the restoration long completed when Ludovic agreed to meet with me one morning to help me get to know her better. He and I explored his goddess together, from the prow of her ship all the way up to the highest feather of her left wing.

A handful of confused tourists looked on as Laugier got down on his hands and knees so close to Nike that he nearly touched her. The security guards, who knew him, didn't object. He used the flashlight on his iPhone to reveal faint markings chiseled into the marble base by the sculptor. Markings like these were keys to piecing several fragments into the statue that hadn't seemed to fit before.

He stood up to explain the statue's pose. The goddess has flown to the ship and is stepping forward and landing. Her feet have never been found, but the angle of her left leg shows that her foot has not yet touched down. Her clothing tells the story of her motion, too. Laugier imagines that the sculptor observed village women walking in the street and saw the beauty of their robes as they draped naturally and moved with the breeze. "The back of the statue's coat has come off and is floating in the wind," he said.

"It is open in front. It is held only by the speed of movement. Do you see her garment? It's loose. It opens by itself, and it flies up with the wind. Drapery can be like a work of music."

Hearing this, I recalled something the late French fashion designer Sonia Rykiel had once told me. She designed loose garments that opened and closed, that revealed and hid in perpetual movement. They were much more seductive than those that routinely showed nudity, she said.

Laugier told me to look upward to Nike's navel. "So sensual, yes, so magnificent," he said. "I have spent so much time up on a ladder, studying, looking into that navel."

I did what he said. He was right. It seemed to me that it was the most beautiful navel in the world. Ludovic told me that the only way to truly appreciate her navel was to understand navel-gazing. I always thought the term navel-gazing meant meaningless self-absorption. I learned from Ludovic that navel-gazing comes from the ancient Greek concept of *omphaloskepsis—omphalos* means "navel," while *skepsis* means "careful looking."

To the Greeks, the navel was a powerful symbol. "There's the navel of the world in Greek culture, which is sculpted in a shape like this." He formed a cone shape with his hands. "The Greeks made offerings to this navel. Then there is the navel in an anatomical sense, and all that says of the sensuality of the female form."

But that's not all. A protective glass case a few yards away, near the window, holds part of Nike's right hand. In 1950, the archaeologist Jean Charbonneaux, working in Samothrace, dug up her palm and part of her ring finger. Her thumb and another part of her ring finger had been uncovered by an Austrian team in the 1870s, stored away in a museum in Vienna, and not identified until much later. After four years of negotiations between the Louvre and the Austrians, the pieces were attached.

The hand is powerfully evocative, asking us to imagine what Nike must have once looked like. With her open hand, its palm turned upward, and her arm stretched out, Nike signals triumph.

Few viewers know that one of Nike's original wings is missing, too. The right wing is a modern invention in plaster, added in the 1880s. A question in the 2014 restoration was whether to keep it. "We said, 'But of

course. We have to keep the wing!' It is the history of this statue as she has always been known in the Louvre," Laugier said.

Yet there was one piece of the statue that haunted Laugier, a piece that kept him up at night: a marble feather.

One day, when he was high up on the scaffolding studying the arch of the left wing, he felt a small space on its edge, invisible to the naked eye but smooth to the touch. "I thought of the feathers I had in storage!" he said. "I remembered one that was smooth at the back and had the same shape." He rushed down the scaffolding to his storage drawers. He found a large feather and climbed back up the scaffolding with it. "I tried, and it fit!" he said. "I said to myself, It's like a Lego; it works!" Traces made by the sculptor confirmed the match.

The feather refused to lie down flat against the other feathers but stuck out straight as if it had a mind of its own. It changed the shape of the silhouette.

"After that, I couldn't sleep. What do I do with this feather?" Laugier agonized. "The responsibility of the most important Greek sculpture in the world was on my shoulders!"

He said that in Greek art there is always idealization, which makes its art universal and timeless, but in this case reality had been allowed to intrude. A feather flying independent of the others means movement. He compared the statue's wing with real bird wings. "The sculptor may have had a knowledge of the position of a bird's feathers when it lands, because when a bird lands it spreads its wings on the descent," he said.

In the end, Laugier pieced three fragments into the tunic of the statue, added nine fragments to the boat, and transformed the shape of the left wing with the feather.

It was the restoration of a lifetime.

"Maybe in a hundred years this icon of art will be perceived differently," Laugier said. "I will have been dead a very long time. I will be far from this story, but all the records will be there. So maybe they will say, 'He was the one with the feather.'"

Now whenever I pass Nike, I think of Ludovic Laugier and his feather and how he helped her fly.

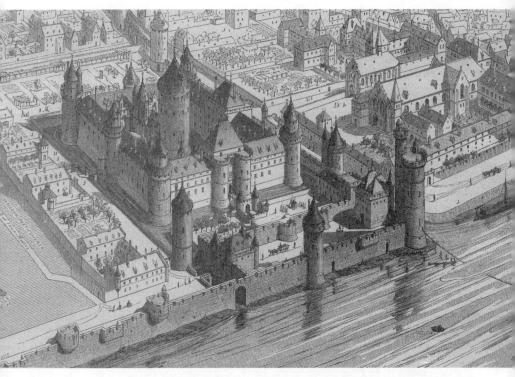

Engraving of the Louvre palace under the reign of Charles V in 1380. He transformed it into a glamorous royal residence, with ornate rooftops and windows, a grand garden, and the country's first royal library of manuscripts.

CHAPTER 2

✦✦✦✦✦✦✦✦✦✦✦✦✦✦✦✦✦✦✦✦

The People's Palace

The Louvre, the offspring of kings and son of the people, also belongs
to those who never put a foot in it and to those who never will.

—Léon-Paul Fargue,
twentieth-century poet and essayist

THE LOUVRE WAS BORN AMID THE EUPHORIA AND TERROR OF THE
French Revolution.

On August 10, 1793, the first anniversary of the end of the monar-
chy, Paris was electric with excitement. France was celebrating the new
republic with a national unity festival. Two hundred thousand Pari-
sians marched in a procession past the sites of important events in the
Revolution—the place de la Bastille, Les Invalides, the Champ de Mars,
the place de la Révolution (now the place de la Concorde), where the guil-
lotine awaited its victims.

From dawn until dusk, patriots marched to the beat of drums and
trumpets. At every destination, they were met with a revolutionary
extravaganza. On one square, the breasts of a giant statue of a woman
functioned as drinking fountains for revelers. On another, a pyramid of
crowns and scepters was set on fire, releasing three thousand birds repre-
senting the liberation of the French people. At the Champ de Mars, the
new constitution was presented as tablets of stone on an altar. Through-
out the city, actors, mime artists, a cappella singers, and musicians

performed for the people, who wore liberty caps and carried garlands and olive branches.

That same day, the new Louvre threw open its doors to the masses for the first time, inviting them in for one day to glimpse its treasures: more than 500 paintings and more than 150 assorted objects, including sculptures, porcelain ornaments, and marble tables and vases. The setting was neither grand nor elegant: the walls were painted a sickly green, the ceiling dull blue-gray; the floors creaked. But it was the realization of the goal that had been envisioned for decades: access to art.

The Louvre already had been a home for art during the *ancien régime*, but its collections were the kings' private property; their precious art was still behind closed doors, and few people saw it. The art-loving public did make inroads into the palace in the seventeenth century, when Louis XIV sponsored exhibitions by the young artists of his day. The Louvre became the center of the Salon, the annual, or sometimes biennial, exhibition of contemporary art where new artists made their reputation.

The project to create a people's museum was conceived years before the Revolution by the comte d'Angiviller (whose name was excessively difficult—Charles-Claude Flahaut de la Billarderie). Appointed the keeper of the king's estates by Louis XVI, he bought good art to round out a royal collection that would be installed in the Grande Galerie, which he renovated.

But it took the Revolution to make the Louvre a national cultural space. Some royal works of art were already stored there. Following the Revolution, more came from Versailles and other royal palaces, still more from churches, monasteries, and convents and the homes of aristocrats who had been guillotined or who had fled the country. The Louvre became the "building of the nation," and its artworks the property of the new French state.

The Revolution's Louvre project was initially overseen by the museum's de facto first director, Jean-Marie Roland de La Platière, a moderate revolutionary. Roland, like others before him, foresaw a national repository of art that would welcome all Frenchmen—and dazzle the world. His goal was to present the nationalized collections as quickly as possible. "It must attract foreigners and fix their attention," he wrote. "It must

nourish the taste for fine arts, amuse enthusiasts, and serve as a school for artists. It must be open to everyone."

The most pressing goal of the new Louvre museum was to prevent the sale or destruction of the monarchy's artworks. A loftier purpose was to spread revolutionary zeal by allowing commoners to experience and enjoy art. Only drunks and dogs were banned.

Three months after the August 1793 national unity festival at which the museum had been officially inaugurated, neither the comte d'Angiviller nor Roland was there. The count had fled France at the outbreak of the Revolution, returned briefly, and fled again, never to return.

Roland, deemed not revolutionary enough, was denounced as a traitor and condemned to death in absentia. He left Paris only months before the museum opened. His wife and political partner, Jeanne Marie, a fierce activist who had run a prominent salon, was arrested in the spring of 1793 and guillotined in the fall. Overcome by grief, Roland wrote, "I would no longer remain in a world stained with enemies." He ran his sword-cane through his heart to end his life.

The vision of d'Angiviller, Roland, and others of an open and inclusive Louvre nevertheless prevailed. That art-for-everyone attitude struck the American travel writer and radio and television personality Rick Steves, when he discovered the Louvre as an eighteen-year-old student backpacking his way through Europe. In his tours of the Louvre these days, he likes to point out a long horizontal white marble plaque with gold lettering that stretches above the entrance to the Apollo Gallery. "It says that the Louvre was established for the public by the people's revolution," he told me one day. "I love the idea that the world's biggest collection of art that belonged to the world's most powerful kings was suddenly open to the public. And, *voilà*, you've got a people's museum."

The "people's museum" came to symbolize both a new identity for the nation and the transmission of French culture around the world.

MOST VISITORS TO THE LOUVRE today come to see the art within its walls, not the walls themselves. But the monumental structure that is the

Louvre, shaped and reshaped by kings and architects and commoners, is a work of art in itself. To walk into it is to travel deep into the past.

The Louvre has led a tempestuous life, assuming and shedding roles over centuries. It was a fortress, a seat of government, an arsenal, a prison, a mint. It was a workplace where artisans wove tapestries, glassblowers shaped fragile vases, woodcarvers crafted fine furniture, and blacksmiths forged tools. The public crowded into its surrounding spaces: merchants holding trade fairs, the homeless seeking shelter, prostitutes servicing their customers, healers offering practical help and miracle cures. The Louvre has housed a telegraph station, a publishing house, a granary, an aviary, and an institute of learning.

Even today, you can trace the politics of France's kings on the museum's walls.

On facades, ceilings, and staircases over the centuries, the initials of the royals were carved in marble, forged in metal, and chiseled in wood. They are the graffiti tags of history: *H* for Henri; *F* for François; *L* and *A* for Louis XIII and his wife, Anne of Austria; *N* for Napoleon (who often left his signature symbol: the bee). Notable courtesans were not left out. The symbol of crescent moons is said to recognize Diane de Poitiers, Henri II's mistress. A superimposed *G* and *H* represented Henri IV and his pregnant mistress Gabrielle d'Estrées (to whom he promised marriage before she died suddenly).

France's kings and queens splurged on towers, wings, galleries, courtyards, ceilings, staircases, and gardens, often with no regard to architectural coherence. Some of the twenty-odd building campaigns over five centuries "were clearly more successful than others," writes the art critic James Gardner, with considerable understatement, in his full-length history of the Louvre.

One way to look at the structure's illogical architecture is through the personalities of its builders. Some were concerned with security, others were obsessed with the grandeur of France, still others sought to gratify their egos.

One of my guides to the history of the Louvre and the architectural passions of the kings is Daniel Soulié, an Egyptologist by training who over three decades at the museum has emerged as both an official storyteller and a sharer of secrets. I first met him on a tour for one of his books,

Louvre: Secret et insolite (Louvre: Secret and Unusual), which describes some of the museum's overlooked treasures.

"My job is to make anyone feel like an insider—without having to do homework," he said.

The story of the Louvre began in 1190 with Philippe Auguste, a medieval king who reigned for forty-three years and was one of the great statesmen and military strategists of his time. After he reconquered French territories from the kings of England and dramatically expanded the size of his realm, he decided to build a fortress on the banks of the Seine to protect Paris from an attack via the river. He chose a patch of ground that for centuries had been called "the Louvre."

"So how did the Louvre get to be called the Louvre?" I asked Soulié.

"Ah, that's the killer question," he said. "Everyone wants to know the origin of the name. But no one does."

He suggested I consult scholarly works by Geneviève Bresc-Bautier, who may have been the most learned historian of the Louvre. She wrote that one theory is that the word is similar to *louve*, the French word for "she-wolf"; some experts speculated that perhaps the site was inhabited by wolves, or served as a kennel where dogs were trained to hunt them. Among the other possible etymologies: A Saxon fortified castle? A leper colony? An ancient Roman signal tower? A plantation of oak trees? A patch of ground made of red clay? Bresc-Bautier dismissed these theories as "most far-fetched." The most likely explanation is that *louvre* was a word of Celtic origin that referred to a nearby river or other waterway.

In the end, however, even Bresc-Bautier admitted defeat when wrestling with the word *louvre*, saying, with the elegant equivocation of a French intellectual, "Its meaning is obscure and has challenged the ingenuity of philologists."

Louvre tour guides get asked about the name all the time. "Somebody will tell you they know what the word '*louvre*' means," said a young guide on an introductory tour one Sunday morning. "Don't believe it. It's not true."

PHILIPPE AUGUSTE'S LOUVRE TOOK MORE than two decades to complete. An architectural innovation for its time, it consisted of a square

fortress with forty-foot-high walls topped by ten defensive towers, surrounded on three sides by a moat. Inside the fortress was the cylindrical Grosse Tour—the keep—a tower almost one hundred feet tall, protected by a dry moat. Standing higher than the city walls, the keep was built to impress: a visible, deliberate assertion of Philippe Auguste's might. The fortress also contained an arsenal, the royal treasury, a prison, a cistern, a well, and a permanent garrison of soldiers. It was designed to be compact, with no chapel, farm, or extraneous buildings, and therefore easier to defend.

The vestiges of the base of Philippe Auguste's tower are restored for all to see in the basement of the Louvre. Soulié showed me another facet of the original fortress that is often overlooked: he took me into the Cour Carrée, the perfectly proportioned sixteenth- and seventeenth-century square courtyard at the east corner of the museum. Below us were the original stones of the Louvre when it was a medieval fortress.

"Ah, for me, this is *the* Louvre," he said. "It's here. The royal residence par excellence. It's the real Louvre. It's where the story of the Louvre begins."

We walked around the courtyard and stopped at a round opening covered with a grate near the edge. "Look down and you can see the base of the dungeon of the fortress of Philippe Auguste," he said.

I looked through the grate and saw darkness, but I took his word for it.

The Louvre has shape-shifted over time, but the message of Philippe Auguste's fortress endures: this is the power center of France.

CANNONS EVENTUALLY MADE FORTRESSES LIKE Philip Auguste's obsolete, and Charles V, who reigned from 1364 to 1380, transformed the Louvre into a palace comfortable enough for a king to call home. He built a glamorous royal residence with ornate rooftops and windows, a formal garden, and the country's first royal library of manuscripts.

A century and a half and several kings later, François I remodeled. An enthusiastic dancer, hunter, wrestler, and comfort seeker, he added new kitchens, servants' lodgings, and recreational space for tournaments, tennis, and jousts.

More important, François I was an insatiable seeker of knowledge, with an eye for good art and a passion for collecting it. In 1516 he invited Leonardo da Vinci to live in France and became his devoted patron until Leonardo's death three years later. He built a splendid painting collection, including works by Raphael and Titian, as well as the three paintings Leonardo brought to France, including the *Mona Lisa*. The room that best captures his Renaissance spirit is the Salle des Cariatides, in the Sully wing; it is a bright, airy, harmonious space, populated now by ancient Greek and Roman sculptures.

Catherine de Médicis, François I's daughter-in-law, queen of France from 1547 to 1559, mother to three kings, and a formidable power behind the throne, did not like the Louvre. She considered it an illogical and uncomfortable mishmash of styles. So she began work on the Tuileries Palace on an adjacent site where roofing tiles—or *tuiles*—had once been made. Her palace, so close to the Louvre that the two were later linked, stood until it was burned in the late nineteenth century. The lasting monument to her vision is the Tuileries Garden, which survived to preserve the name.

The first Bourbon king, Henri IV, ruled from 1589 to 1610. Married twice, he was an energetic lover, with four official mistresses known as "favorites," countless one-night conquests, and many children, both in and out of marriage. He smelled as bad as people said and, the story goes, promised all Frenchmen a "chicken in every pot on Sundays," as a political, not gastronomic, gesture. He was brought up Protestant but converted to Catholicism to unify France after the Wars of Religion, granted religious freedom and certain civil rights to Protestants, boosted prosperity, and made peace at home and abroad.

Henri started a visionary political project for Europe called the Grand Design, which included construction of the Grande Galerie in the Louvre. It would become the longest room in Europe, a paintings corridor running more than a quarter of a mile along the Seine and linking the Louvre with the Tuileries Palace.

Artists lived in the eastern half of the Grande Galerie and the Salle des Antiques, the first room devoted to the king's sculpture collection. For the most part the Grande Galerie survives, illuminated with soaring vaulted skylights and lined with masterpieces that inspire reverence and awe.

Soulié claims that the best way to appreciate the Louvre as a palace of the kings is to visit the Apollo Gallery, created by Louis XIV, the Sun King and Henri IV's grandson, a model for the Hall of Mirrors in Versailles. I learned from him that if visitors don't have the time and patience to tackle Versailles, they can get a feel for Louis XIV's palace there just by coming to this gilded, sculpted, painted, dizzyingly decorated royal space. In mythology, Apollo was revered as the god not only of truth, prophecy, and healing and of music, dance, and poetry but also of the sun and light. "This is a miniature world centered on the god Apollo glorifying Louis XIV as the Sun King," Soulié said. "The decor evokes the sun's journey from rising till setting. It was Louis's way of saying that Apollo is the master of time and so is he."

But Louis XIV never felt comfortable in Paris. He didn't trust the great masses of people. He had no space for hunting. He moved the royal court and all the workmen to Versailles, leaving much of the Louvre in disarray.

"Suddenly, everything stopped," said Soulié.

From then on, the Louvre served all sorts of odd functions: storage of royal art collections; headquarters for various academies; depots for government archives; a meeting place for great intellectuals; and lodging for assorted courtiers, administrators, artisans, and artists. It was a huge "caravanserai," or public inn, according to Bresc-Bautier. In other words, a mess.

But the idea that the old Louvre should be turned into a royal museum for all took hold. The fact that it provided a workspace and home to artists favored by the court created an atmosphere of exceptional creativity. Its Royal Academy of Painting and Sculpture became a laboratory for living artists to display their works, and eventually hosted the Salon expositions.

The Salons were so popular that they led to a crush of activity both inside the Louvre and outside its walls: café openings, carriage gridlock, lines of visitors waiting to enter, and a flood of printed catalogs promoting the artworks on display.

Louis-Sébastien Mercier, the first street reporter of Paris, had this to say about the Salons in *Le Tableau de Paris*, a twelve-volume collection of sketches of Parisian life in the years just before the Revolution: "Droves

of crowds, waves of people, for six whole weeks, never stop from morning till evening; some hours are suffocating. You see canvases eighteen feet long that reach the vast ceiling and miniatures the size of a thumb at eye-level. The sacred, profane, pathetic, grotesque, all subjects historical and mythical, are represented and arranged pell-mell; it is pure confusion. The crowd is as varied as the objects they contemplate . . . this crowd that has no knowledge of painting."

Still, the Louvre was a place not of luxury but of privation. "Several painters have their ateliers in this palace, and a multitude of rats in their homes," Mercier wrote.

Then came the Revolution and its transformation of the Louvre. The subsequent history of France in the nineteenth century is both incoherent and confusing: a new republic, an empire under Napoleon, a restoration of the monarchy, a second empire, two more revolutions, and, finally, the end of autocratic rule in 1870. Through it all, the Louvre remained a public museum, even as a parade of rulers left their marks.

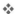

IN THE DECADES THAT FOLLOWED the Revolution, the new Louvre of the people began its transformation from a picture gallery into the world's first encyclopedic museum. At first, art was displayed with an aesthetic and decorative organization, then later—and for the first time for a museum—chronologically and geographically.

The man who made the Louvre into the world's first global museum—through imperialism and plunder—was Napoleon Bonaparte. He restored the older buildings of the palace complex and launched the construction of a new wing that would later extend the Louvre along the rue de Rivoli and connect it with the Tuileries. He renovated the Cour Carrée and the pillared Colonnade on the eastern end of the Louvre. He also used the Louvre to aggrandize himself, renaming it the Musée Napoléon and embellishing facades and pediments to reflect his imperial glory. When he built a triumphal marble arch in the courtyard that separated the Louvre and the Tuileries Palace to celebrate his great military victories, the best sculptors of the day carved it with large-scale reliefs to mark his treaties and campaigns. In 1810 his marriage to his second wife,

Marie-Louise of Austria, was performed in splendor in a religious cere-
mony at the Louvre.

Napoleon wanted to use the Louvre to display France's glory through
art treasures from around the world. "What I seek before all else is gran-
deur; what is grand is always beautiful," he said.

His lasting stamp on the Louvre was a ravenous expansion of its mis-
sion and collections. Napoleon sent cultural emissaries with great cun-
ning and good taste behind his conquering soldiers to loot art and rare
artifacts. Nothing was left to chance. There was even a bureaucracy of
piracy: a "committee of instruction" supervising the removal of works
of art from the vanquished. His agents were advised to take "only those
objects which are truly beautiful and good. Taking without taste, with-
out choice, is ignorance and near vandalism."

A reminder still on the walls today is Paolo Veronese's *The Wedding
Feast at Cana*, the largest painting in the Louvre. A wild masterpiece of
Renaissance Venice with 130 characters spread out across a canvas satu-
rated with color, it had hung for over 200 years in the refectory of the San
Giorgio Monastery of Venice, for which it had been created.

During Napoleon's conquests in Italy, more than a dozen men used
pulleys and ropes to tear the painting from the monastery wall. They
ripped the canvas along rows of nails across its length, rolled it up, and
transported it to Paris. It was so degraded upon arrival that French restor-
ers had to cut it in two and reline it.

The allied nations that defeated Napoleon at Waterloo in 1815 forced
France to return about 5,200 artworks to the countries from which he
had looted them, but many of them—including *The Wedding Feast at
Cana*—remained in France. The French argued that the canvas was so
fragile and damaged that returning it to Venice might destroy it, yet later
the French themselves rolled it up and moved it several times to protect
it during wartime.

When Louvre officials are asked these days whether the museum
should return the painting, they reply that its status was resolved by a treaty
at the end of Napoleon's reign. *The Wedding Feast at Cana* was exchanged
for a minor canvas by Charles Le Brun, Louis XIV's court painter.

After Napoleon's final defeat, his name was stripped from the
Louvre. The museum survived the years of political upheaval and the

revolutions of 1830 and 1848, building its collections and rebuilding its crumbling structure. The writer Victor Hugo proclaimed that the Louvre must become a serene "mecca of intelligence." But when Napoleon Bonaparte's nephew Napoleon III became emperor after a coup in 1851, the Louvre's mission changed. The new emperor was determined to return France to its imperial glory. The Louvre became more important as a tool of the state than as a repository of the world's art. He single-mindedly transformed the museum through an ambitious building project. He ordered the completion of the Richelieu wing and the reorganization of the Denon wing, giving the Louvre its current shape and creating the courtyard where the last piece of this architectural puzzle, the Pyramid, would be added more than a century later. His two new wings connected the Louvre to the Tuileries Palace, the imperial residence that he shared with his glamorous empress, Eugénie. The Tuileries-Louvre complex was to become "an imperial city," wrote Bresc-Bautier.

Visitors arriving at the Cour Napoléon today can see eighty-six stone figures, each about ten feet tall, that adorn the courtyard, all part of the over-the-top, more-is-better sculptural decoration Napoleon III favored.

But nothing can top the gilded opulence of the rooms he built for his personal use and for entertaining dignitaries and foreign leaders. The remnants of this era can be found in the Richelieu wing: a grand dining room and a small dining room, a salon-theater, and a "family apartment." Walk into them and enter a world of red cut-velvet upholstery, red and gold drapes, crystal chandeliers, and stucco ornamentation with cherubs, garlands, curlicues, and foliage covered in gold leaf.

It was the last hurrah of the Louvre as a place of royal privilege. After the ouster of Napoleon III in 1870, the Louvre was fully the people's palace. It still aims to fulfill the original, intended mission assigned to it in 1793 and ingrained since then—to bring art to the people.

And the artwork most people come to see the first time they visit is a small portrait, yellowed with layers of old varnish, of a Renaissance woman with a mysterious smile.

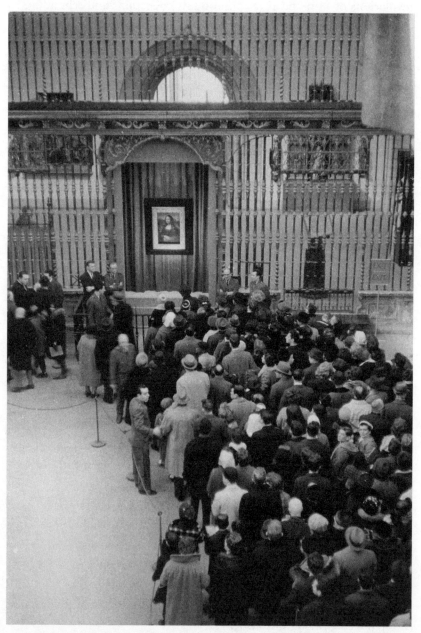

Visitors lining up to see the *Mona Lisa* when it was on loan to the Metropolitan Museum in New York in 1963, after First Lady Jacqueline Kennedy persuaded France's President Charles de Gaulle to send the painting to Washington and New York. After trips to Japan and the Soviet Union in 1974, the painting has not traveled outside of the Louvre. © *RMN-Grand Palais / ArtResource, NY*

◆◆◆◆◆◆◆◆◆◆◆◆◆◆◆◆◆◆◆◆◆

The Most Famous Face in the World

That computer is the Mona Lisa.

—**Stan Rizzo** on the power of the agency's
new mega-computer in *Mad Men*

WHO CAN EXPLAIN THE CULT OF THE *MONA LISA*? SHE'S NOT THE VIR-
gin Mary. She's not even a saint. She's a silk merchant's wife from Florence
whose five-hundred-year-old portrait hangs in the Louvre. What is her
power of seduction?

Maybe I'm trapped in a fog of familiarity. Even if I never had come
face-to-face with her, I could not have escaped her gaze. She reigns
unchallenged as the best-known artwork in the world, even though she
desperately needs a cleaning. She is the most visible female icon in France,
even though she isn't French. If hashtags are a guide, she is the most Ins-
tagrammed painting ever.

François I put her in the royal baths at Fontainebleau. Louis XIV
took her with him to Versailles. Napoleon Bonaparte hung her for four
years in his bedroom in the Tuileries.

Books, films, songs, poems, and comic strips have celebrated,
contemplated, manipulated, scorned, and parodied her. Artists have
stripped her naked, given her a mustache, dressed her up as Jackie

Kennedy and Mao Zedong. When Nat King Cole crooned about *Mona Lisa* in a sentimental ballad in 1950, it won the Academy Award for best song, hit the top of the record charts, and wiped out the singer's money woes.

The story may be apocryphal, but an artist named Luc Maspero is said to have jumped out of a Paris window in 1852 after writing in his suicide note, "For years I have grappled desperately with her smile. I prefer to die."

Amateur sleuths claim to have identified her as a harlot, a femme fatale, a vampire, a goddess, a self-portrait of Leonardo in drag. I see that slightly cross-eyed face, stripped of eyebrows and eyelashes, smiling ambiguously at me wherever I turn in Paris: on T-shirts and coffee mugs, on dish towels and refrigerator magnets. Fauchon, the fancy food emporium, put her eyes on the icing of a sinfully creamy chocolate éclair one year. During the pandemic, the Paris Boutiques de Musées site sold "Monna Pop" face masks with sixteen tiny images of her face in bright pop art colors. A Florentine website called the DaVinceFace helped users turn their faces into personal *Mona Lisa*s.

I see her in the most unexpected places. In an Air France safety video on a flight from New York to Paris. Painted on the side of a moving truck in Queens. Holding a platter of yellow corn cake arepas in a wall mural at a café in Buenos Aires. Inspiring paintings by Gérard Le Cloarec in a gallery display in my neighborhood.

At the end of the 2022 film *Glass Onion: A Knives Out Mystery*, the *Mona Lisa*, which in this story belongs to a tech billionaire named Miles Bron, is burned. Art history buffs who saw the movie quickly pointed out a glitch. In the film, fire consumes a painting on stretched cloth canvas. The real *Mona Lisa* is painted on wood.

Even her name is confusing. She should have been "Monna Lisa," short for "Madonna Lisa" or "my lady Lisa." The French call her *La Joconde*, a version of the married name of Leonardo's presumed young model Lisa Gherardini, wife of Francesco del Giocondo.

She both enslaves and empowers the Louvre. Faced with constant logistical, financial, political, and safety hurdles, knowing that it would not be the most visited museum in the world without her,

the Louvre historically has resisted calls to move her to a space of her own. It deplores the fact that about 80 percent of first-time visitors come primarily to see her, yet it shamelessly promotes her. The Louvre's officials moan about the selfie photo crush that gums up the flow of visitors, but its boutique sells dozens of items of *Mona Lisa* merch, from pencils to chaise longues. Even former director Jean-Luc Martinez carries a *Mona Lisa* tote bag. In December 2020, the museum auctioned off the exclusive right to be part of an annual inspection when she is stripped naked of her frame; the unidentified winning bidder paid nearly $100,000.

Encased in elaborate armor, the *Mona Lisa* is probably the most protected painting in the world. She is sealed into a custom-made climate control system; an identical backup system will kick in if it fails. The reverse side of the slightly convex, thin-grained plank of poplar on which she is painted is studded with sensors to detect even the tiniest change in the wood's shape. Bulletproof glass imprisons her. Although it was chosen for its transparency, the thickness of the glass seems to distort her skin color, already jaundiced from the layers of old varnish. She hangs alone, lonely perhaps, on a freestanding partition of midnight blue in the center of the most animated gallery in the Louvre: the Salle des États.

Mona Lisa confronts me every time visitors come to town. They all want to see her, so I take them. The ritual is always the same: a good fifteen minutes from the Louvre entrance to her room, another fifteen to push into a crowd of iPhone-snappers. As soon as you get to the front of the line, still several feet away from the painting, a guard tells you to move on. And after all the anticipation and waiting to see her, it's hard to believe that the painting is so small, only 30 by 20 inches.

One Saturday morning I planted myself next to the security guards near the front of the line. Sangheeta, a young agent sitting a few feet away from the *Mona Lisa*, called it her destiny to guard the most famous painting in the world. "I was born in the Leonardo da Vinci hospital in India," she said.

"What question do you get asked more than any other?" I asked.

"Is the painting a fake?" she said.

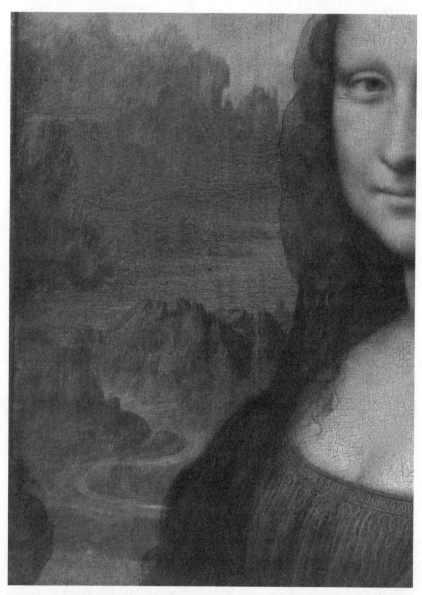

Partial view of Leonardo da Vinci's *Mona Lisa*, the best-known artwork in the world. Eighty percent of first-time visitors come primarily to see her. © *RMN-Grand Palais / ArtResource, NY*

Despite her exclusive grandeur, *Mona Lisa*, as a Florentine, is a foreigner in a room lined with sixteenth-century paintings from Venice, including Titians and Tintorettos. Sometimes my guests are so overwhelmed by the noise and the crowds in the room that they want to escape, quickly. Sometimes I have to persuade them to turn around to see *The Wedding Feast at Cana*, a masterpiece in its own right. Sometimes I struggle to show them Titian's *Man with a Glove*, which hangs on the wall to *Mona Lisa*'s left. It's not easy. The area blocked off for the *Mona Lisa* crowd dominates the gallery. The presence of too many impatient people in too small a space prevents proper contemplation of the paintings on the walls.

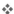

THE ABILITY OF *MONA LISA* to trigger emotions is almost as old as the painting itself. Even in Leonardo's day, viewers felt as if she were alive and communicating directly with them. "She was painted in a way that would make any great artist tremble and fear," wrote Giorgio Vasari in *Lives of the Artists* (1550). "There was a smile so pleasant that it was more divine than human to see." In the centuries that followed, artists made thousands of copies of her.

But the *Mona Lisa* became a global superstar after it was stolen in 1911. Vincenzo Peruggia, an Italian who had worked as a glazier at the Louvre, donned a white worker's smock and hid in the museum on a Monday, the day when it was closed. He took the painting off its pegs, removed its frame, hid it under his coat, and used the service stairs to slide away. He stored the *Mona Lisa* in a valise in his Paris apartment.

Recent advances in printing technology allowed good-quality newspaper reproduction at lower cost, and the *Mona Lisa* story caused a sensation. The theft was called "the most colossal crime of modern times," and newspapers kept the story alive. The painting was celebrated in postcards, games, calendars, caricatures, and puzzles. A small band of musicians roamed the streets of Paris, singing a song with the words "*La Joconde*, have you seen her?" She was embedded in the collective memory forever.

Two years after the theft, Peruggia wrote to an art dealer in Florence offering to take the painting to Italy for a reward. The art dealer contacted the director of the Uffizi Gallery, and Peruggia was arrested after he carried the painting in a box by train to Florence. The *Mona Lisa* returned to the Louvre in 1914, after being exhibited in Italy, in a gesture of goodwill between France and Italy.

Almost fifty years later, a renewed *Mona Lisa* frenzy was unleashed in the United States after First Lady Jacqueline Kennedy persuaded French president Charles de Gaulle to send the painting on tour to Washington and New York. Trips to Japan and the Soviet Union followed in 1974. The *Mona Lisa* has not traveled since, which means that anyone who wants to see her must make a pilgrimage to Paris.

She has been a target in fiction and in real life. In William Burroughs's 1959 novel *Naked Lunch*, a band of "Rock and Roll adolescent hoodlums . . . rush into the Louvre and throw acid in the *Mona Lisa*'s face." And in our own time, an environmental protester in 2022 posed as a wheel-chair-bound woman to get close, smeared what looked like a creamy cake on the painting's protective glass, and threw roses at the feet of security guards. "Think about the Earth. There are people who are destroying the Earth!" he said as he was led away.

Then, during a nationwide protest by France's farmers in 2024, two women threw soup at the painting. The crowd gasped. The women slid under the barrier in front of the work and posed on either side of the painting, hands raised in apparent salute. "Your farming system is sick," one of them shouted, as the orange-yellow liquid dripped down the thick glass protecting *Mona Lisa*'s face. Louvre staff members scrambled to block the scene with black cloth screens but not before visitors recorded and posted videos from their iPhones. The women were later arrested. The soup appeared to be pumpkin.

VINCENT DELIEUVIN, THE CURATOR in charge of sixteenth-century Italian paintings in the Louvre, is Mr. *Mona Lisa*. Many men have demanding wives; Delieuvin's is more than half a millennium old. And he loves her.

Delieuvin is in his forties, but his short-cropped hair and pale, unlined face give him the look of a doctoral student who spends too much time in the archives. It took him ten years to prepare the Louvre's 2019 mega-exhibition marking the five hundredth anniversary of Leonardo's death. He watches *Mona Lisa*'s every move.

"Every day I say to myself that I am extraordinarily lucky," he told me when I visited him one day. "I say to myself, 'How did this happen? How did I receive this historical privilege?'"

I told him I had a confession to make that had weighed on me for years. "I don't get why the *Mona Lisa* is the most famous painting in the world," I said. "I just don't get it."

Delieuvin understood my bewilderment. "The drama of this painting is that it is a victim of its own success," he said. "She has an irrational place in the world, really irrational."

He cited four problems, starting with where she hangs. "She is in the largest room of the museum, the largest in terms of size and number of visitors. It is absurd. She is made for contemplation, for dialogue. To appreciate her, you must be alone with her, to look at her face-to-face as I look at you."

Then there is the way she is presented. "We can't see her, because she is hung way too high and way too far away," he said. "Sad to say, but for reasons of security and climate control, we have to keep her that way."

There is also her coloring: she is bathed in muted tones and unrestored, and must coexist with the bright-colored restored Venetian paintings that hang nearby. "The way of the Venetians was to apply almost pure colors in paste, a dense material creating brilliant color," said Delieuvin. "The effects are very far from Leonardo's subtle mixtures. His oil painting is essentially made up of thin layers of glaze, transparency effects with imperceptible transitions."

Finally, there is the long wait. "It takes a long time to approach her," Delieuvin continued. "And then you see her, very small and in the distance, and you never really see her well. And so she may seem trivial. If Leonardo came back to earth, he would be shocked to see her! But what else can you do when you have a painting that has been attacked multiple times?"

Delieuvin has seen *Mona Lisa* naked, unframed, an experience that

transported him to a place of ecstasy. "When you take the *Mona Lisa* out of her frame, it's just the two of you," he said. "All of a sudden, I can turn her over, and put her on an easel and show her in a beautiful light. She imposes silence on the room. Why? Because in fact, you're in her presence and she vibrates. Her look, her smile seem intelligent. Her hands look alive. She is alive. You tremble.

"There is obviously something irrational for there to be such a difference between her and every other painting. It's like a singer who doesn't necessarily sing better than any other singer in the world, but there is a personality, a story, too, that make the singer more famous, more important. It's the same with the *Mona Lisa*. That's the miracle of the painting." In 2019, the scientific laboratories in the Louvre employed a new technique called "pigment mapping" to take images that isolate one paint color and pigment at a time, the layers appearing like slices of meat in a sandwich. In this way, Delieuvin was able to see how Leonardo created his masterpiece. He saw the hidden subtleties, false starts, erasures, ideas started and then painted over. "I spent two whole nights with the *Mona Lisa*, alone with her, watching a machine send her rays," he said. "I had two sleepless nights. It was surreal to be all alone with her."

Watching the images come in from the research machines, Delieuvin saw that Leonardo experimented with the neckline of her dress, eliminating a slight indentation in the middle. More surprisingly, "Leonardo adds a slightly red pigment in the strands of hair, which picks up the light," Delieuvin said. "It gives the hair, shining at the very edges, an unheard-of sensuality."

"So *Mona Lisa* could have been a redhead!" I said.

Pulling up images on a large computer screen, he showed me where Leonardo had painted over the arm of *Mona Lisa*'s chair and pointed out the spot where the painting had been damaged in 1956 when *le fou*—the madman—visiting from Bolivia hurled a stone at it, shattering its glass shield and leaving a small nick on her left elbow. Most people would never detect it, but Delieuvin winced when he saw its traces in the laboratory images.

He showed me selfies he took during those glorious days when *Mona Lisa* was alone with him. "I was like a crazy person," he said. "I

photographed myself eating my sushi dinner with the *Mona Lisa* watching me from behind." In other photos, he holds the painting, staring at the thin plank of wood in his hands.

I read aloud an excerpt from a book I had brought along that treated her as if she were real: "*Mona Lisa* smokes, she takes the train, she fights for the rights of women, she poses for a line of lingerie or cosmetics."

Delieuvin laughed. Even during the pandemic, when the museum was closed, the *Mona Lisa* was "hijacked," he said. His friends and colleagues sent him messages on his iPhone with her image: in one, she had put on more than two hundred pounds; in another, she had not washed her hair for two months; in a third, she was driving a car and smoking a cigarette. On the rue de Rivoli across the street from the Louvre, a street artist named Toolate hung a rendering of the painting's landscape but left her out, with the caption "Let me know when this is all over."

Delieuvin is more than a caretaker of the painting. When anyone contacts the Louvre about it, the correspondence goes to his office. He opened a closet filled with letters. "They all want you to know her secret," he said. Some think they have deciphered hidden symbolism. "We got a lot of that after Dan Brown's *The Da Vinci Code*."

Letters arrive from all around the world. Some come from people who are convinced that Mona Lisa is a real person; they are addressed to her at "The Louvre, Paris."

"The painting talks to people," said Delieuvin. "Some people have fallen in love and they need to talk to her, to write to her, to ask her for things. Some ask her, 'Do you have health problems?' or say, 'I read that you are in pain.' We have a whole file on *Mona Lisa*'s illnesses. Recently there have been some great studies that have been done by scientists that say she has a thyroid problem because she is all yellow. Some send the recommended dosage of thyroid medication. But in fact, it's the old varnish."

He began rummaging through papers. "I forgot to file the last ones I received," he said. "I think I still have some on my desk."

He held up an envelope addressed to Mona Lisa, quintuple-stamped to make sure it arrived from Pittsburgh. Then he pulled out a letter signed by a Frenchman named Jean-Charles, who wrote: "Dear Mona Lisa, I am

obsessed with you. You follow me everywhere—Paris, Toronto, San Francisco, Neuburg, St. Petersburg, Mexico, Finland . . ."

"Can I look through all the letters?" I asked.

"Absolutely!" he replied.

The request needed official Louvre approval. One day, I was escorted into the library of the paintings department. It holds shelves of linen-covered, acid-free cardboard boxes on the thousands of artists and paintings in the museum collection, including files with news clippings, photographs, scholarly interpretations, documents on ownership, donations, sales, and letters. The *Mona Lisa* files are the biggest, with correspondence in Italian, Russian, German, Spanish, English, and French.

"Hola Mona!" a woman named Nathalie wrote on the back of a postcard from a museum in Spain. "You are luminous. . . . Kisses from Madrid!" And in a PS: "I fell in love in Madrid. Will keep you posted."

The files included a sheaf of letters from children. One American girl, named Democracy, wrote that she had seen *Mona Lisa* in a virtual tour and was consumed by questions only the painting could answer. Her enthusiasm, reflected in her spelling, got the better of her. "Tell all your painting friends hi!" she wrote. "Also I hope to come see you when my grandma wins a lottery ticket and we can go to Paris! Do you think your smiling in your picture? How does it feel to have no eyebrows? I know how famouse and busy you are, but can you please try to squeez in some time to wright me back?"

"A.M.," from Warsaw, wrote in French, "My Dear Lisa, the women are not as beautiful as you in Eastern Europe." A girl named Crusade drew a stick figure on lined notebook paper of herself and *Mona Lisa*, the two labeled "you" and "me." "You are rilly cool," she wrote in crooked letters. "Hear is a picter I tride to drow you."

More than a third of the letters were directed to the members of the Louvre's paintings department with questions about the portrait—a German researcher wanted to know the distance between the *Mona Lisa's* pupils (the answer: five centimeters, or approximately two inches). Others offered creative theories. One man was convinced that the painting was a portrait of Leonardo's mother, while another cited Freud to argue that it was Leonardo's fantasy mother-figure. A London art teacher asked

the Louvre to confirm her research that the *Mona Lisa* was Leonardo's self-portrait. And an Austrian letter writer suggested that *Mona Lisa* was half-woman, half-male, noting that no breast was visible on the left side of her body.

I asked Delieuvin if he responds to the letters.

"I never answer," he said.

"You never answer? But why not? Isn't there an office here at the Louvre to answer all the letters?"

"At first I did respond. I'd tell them, 'Listen, what you see is this, not that. A lot of times they are overinterpreting scientific imagery. So I'd try to explain to them, but they didn't believe me. They'd say, 'I discovered the secret of the *Mona Lisa*.' And so when you tell them actually maybe not, they blame you. They think you want to steal their secret and make it your own. Some people even get aggressive when I don't agree with them. I deal with a dialogue of the deaf. So suddenly, I stopped answering."

The Louvre is supposed to be a quiet place of order and decorum, but get near the *Mona Lisa* and some kids go wild. One day, a group of about twenty French second graders on a field trip got so excited by the prospect of seeing her that they jumped up and down and shouted her name as if she were a soccer star. "La-Jo-Cond! La-Jo-Cond! La-Jo-Cond!" they chanted, giving each syllable equal importance. The students were from a school in a tough part of Paris. They were pumped, breaking the rules of staid museumgoing by having a raucous time in a former palace as they celebrated art. Instead of ordering them to pipe down, the guards looked on, bemused.

IN A LECTURE AT THE time of the Louvre's 2019 exhibition, Vincent Pomarède, one of the museum's senior officials, told the story of a retired hydrology engineer named Jean Margat, who spent decades collecting eleven thousand objects relating to the *Mona Lisa*. "The most beautiful proof of the success of an object is when it becomes part of daily life," Pomarède said.

When Margat offered to donate his collection to the Louvre, the

museum greedily scooped it up, then put it into deep storage where no one could see it.

But once in a while you get lucky, and doors at the Louvre are unlocked when you least expect it. During an interview one day with Vivien Richard, a young historian of the Louvre, he pulled out a set of keys, led me down a hallway, unlocked a metal door, and showed me Jean Margat's collection of *Mona Lisa* kitsch. This was a secret place, and I would have only a few minutes to take it all in. *Mona Lisa* umbrellas! Rows and rows of matches! Commemorative coins! A *Mona Lisa* suitcase! Dolls, ashtrays, pillows, tapestries, advertising posters, labels for bonbons and cheeses, socks, aprons, ties, and statues. A yellow bathtub toy duck with a *Mona Lisa* head. *Mona Lisa* condoms and IUDs. One shelf was filled with shot glasses. Another held coffee cups and beer steins. Still others featured plates, coasters, wine bottles, playing cards, Rubik's Cubes, board games, puzzles, cookie tins, soaps, candles, notebooks, makeup compacts, fans, medallions, fruit crates, flowerpots, lampshades, brooches, and busts (in bronze, plaster, plastic, marble, papier-mâché, and della robbia blue).

More shelves held clocks, wristwatches, nesting dolls, snow globes, DVDs, coasters, pillboxes. Richard pulled out a vertical panel from a shelf to reveal magnets, then another with key chains, then another with cigarette lighters. A section of the room was reserved for books in several languages, volumes of advertisements, newspaper clippings, letters, and documents in plastic sleeves.

"There are no words to describe this collection," Richard said. "Just soak in the atmosphere."

There is neither the will nor the money to organize an exhibit of the collection, he said. I told him that if he organized a show, people would come.

One night a few months later, I found myself in the northern city of Lens, waiting for a train back to Paris after an exhibition at the Louvre-Lens Museum about Picasso and the Louvre. One item on display was a postcard of the *Mona Lisa* that Picasso kept in his personal collection. Laurence des Cars and other Louvre curators were standing alongside me.

It is not easy to make small talk with such a group. So I said how

fascinating it was that even Picasso was seduced by *Mona Lisa*. Someone suggested that the Louvre should organize an exhibit around the cult of Leonardo's creation. Des Cars, ever the diplomat, said in a low voice, "Perhaps," and smiled. The smile was not quite so mysterious as that of *La Joconde*, but mysterious enough.

One person who did not like the idea was Sébastien Allard, the director of paintings. I had learned along the way that he had mixed feelings about *Mona Lisa*.

On a day when the museum was closed, Allard showed me around some of the galleries. We ended our tour in front of the *Mona Lisa*.

"Do you curse her?" I asked. "Do you tell her, '*Mona*, you're killing me!'"

"Absolutely!" he said with a big laugh.

I thought about what Allard's colleague Vincent Delieuvin had said, that *Mona Lisa* was made for contemplation, and that to appreciate her, you must be alone with her. I struggled to look beyond *Mona Lisa*'s small size and coats of varnish. I looked straight into her eyes, and she looked back at me. We stared at each other. I moved my gaze to her lips, and to the smile they call the most famous in the world. Trust me, believe in me, she told me. There were no crowds—there was no noise, no rush, no hype to come between us. We connected. For one fleeting moment, *Mona Lisa* came alive.

Even Allard acknowledged the mystique. "She has become an icon, like a religious relic," he said. "I have never met a person who saw her outside of her frame who did not ask, 'Can I touch her?'" But he kept his distance. "It is this constant reproduction that carves her deep into the collective memory," he said. "The question I ask myself is, In two centuries, will this still be the case? There was a time when Raphael was considered *the* genius."

I told him he should write about the question: "Will *Mona Lisa* stay in our imagination?"

"I don't have the answer," he said.

"But we can play with the idea, no?"

"Yes, we can play, or even better, we can look around. We can find a painting that we think could replace her."

And then one day we did.

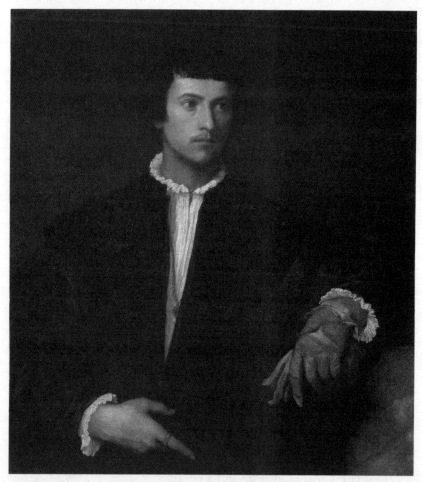

Titian's *Man with a Glove* (1520), one of the most beautiful portraits in the Louvre. Some art historians consider Titian the greatest Italian painter, even better than Leonardo, but this portrait of an ideal Renaissance man gets little attention as it hangs in the same room as the *Mona Lisa*. © *RMN-Grand Palais / ArtResource, NY*

◆◆◆◆◆◆◆◆◆◆◆◆◆◆◆◆◆◆◆◆◆◆

The Paintings Magician

What do I ask of a painting?
I ask it to astonish, disturb, seduce, convince.
—Lucian Freud

WHO IS MORE BEAUTIFUL THAN *MONA LISA*? IT'S AN IRREVERENT QUES-
tion. She is a queen whose subjects come from around the world and wait
in line to pay homage for a few seconds. The idea that she might not
deserve to reign over every other painting would destabilize the muse-
um's reputation, even its identity—as unsettling a prospect as a tornado
tearing through the galleries.

Sébastien Allard was up to the challenge.

For more than twenty-five years, he has worked as a curator in the
Louvre, and it was in 2014 that he became director of the museum's tens
of thousands of paintings. Classically trained at France's *grandes écoles*,
he is a specialist in nineteenth-century French painting, particularly
Romanticism, and has written or coauthored works on Eugène Delacroix,
Jean-Auguste-Dominique Ingres, Louvre decors, Italian painting in the
eighteenth century, portraits, the child in French painting. His ability
to bring the mystery and meaning of a painting into focus defies reason.

Allard is in his fifties, but with his round, black-rimmed glasses, his
slight build, and his closely cut suits, he looks a dozen years younger. He
is arguably the second most powerful person in the museum.

He is a perfectionist whose magical touch with paintings extends beyond the works themselves. When he decided to repaint the walls of the Salle des États, he chose the deepest midnight blue. The dark color highlighted the pinks, yellows, oranges, and greens in the sixteenth-century Venetian paintings that cover most of the room, allowing light to emanate from the works and their golden frames. Because the wall color had to be uniform, he instructed eleven painters to start and end their work at exactly the same time each day. He is obsessive about hanging art—which paintings should be neighbors and which ones should be placed higher or lower.

My challenge to him, inspired by my doubts about the *Mona Lisa*'s "most beautiful" status, was a question. Of all the painted faces in the Louvre, I asked, "Who is the fairest one of all? Who would be the finalists?" I asked him to pick five paintings that surpass *Mona Lisa* in their beauty.

Allard revealed his choices and brought them alive. He confessed his view was subjective and fluid, changing from day to day. "There is not one way to see a face in a painting," he said. "You see it differently depending on your mood, your surroundings, even world events."

We started with Vermeer and Rembrandt. In a different museum, one of them would be *the* superstar. At the Louvre, however, because of the centrality of Italian paintings (and a lesser number of French) in the Denon wing, these Dutch masters fall to the side, displayed in Richelieu, a less fashionable wing on an upper floor. The joy is that those galleries are so uncrowded that you can have an intimate conversation with the paintings, not at all like the rushed encounter with *Mona Lisa*.

The process requires time. "The most important word to know when you go to a museum is "*l'attention*," Allard said. "You have to pay attention to what a work of art offers you. You have to see. Seeing takes time."

We looked first at Vermeer's *The Lacemaker*. It is so small that even people who go looking for it have a hard time finding it. Larger works, including the Louvre's other Vermeer, *The Astronomer*, hang on either side of it. Once you spot *The Lacemaker*, it pulls you in like a powerful magnet. It was one of Vermeer's favorite works, and those who come to see it can feel him channel his intensity and emotional engagement.

Light pours in through a window as a young woman bends over her work, totally absorbed. "*The Lacemaker* attracts your gaze from afar,"

Allard said. "You approach and are mesmerized. You see a lacemaker. But what is she doing? You don't understand right away. To make her lace, she has to concentrate on the threads. And you, as a spectator, if you want to see, to understand what she is doing, you have to get closer. "

I focused on the fine threads at her fingertips, the pins and bobbins she holds tautly as she creates lace.

"You have to do what she does, to concentrate on this tiny space," he said. "All is quiet. Little by little, you see the threads one by one, just like the lacemaker does."

Next, Allard invited me to notice color. "At first you have the impression that it's a painting that's all yellow. And then, everything moves into yellow and blue." He pointed out a spot of red that Vermeer threw into the threads in the foreground. "Suddenly, once you've really leaned into that yellow and blue, you see a red splash, really a splash. Why does the painter, always so precise, add this splash of red? All of a sudden, he is telling you, 'This is paint!' And if you isolate that tiny piece of paint, it looks like Jackson Pollock.

"It is the signature of the painter, in a way. This painting forces you to concentrate and to think—all on your own. For me, it's by far the most beautiful painting by Vermeer."

Then he threw in a zinger. "By the way, if the lacemaker were a real person, she would end up losing her sight from looking at her threads so closely over time." As someone who has had to cope with extreme near-sightedness, I felt the painting's intensity in a new way.

Perhaps Salvador Dalí felt it as well. *The Lacemaker* obsessed the surrealist Spaniard for years. In 1955, he received permission to enter the Louvre with his paints and canvas to execute a copy. Dalí seemed destabilized by his subject's ferocious concentration: "Up till now, *The Lacemaker* has always been considered a very peaceful, very calm painting, but for me, it is possessed by the most violent aesthetic power," he said.

Allard and I turned next to Rembrandt's *Bathsheba at Her Bath*, which hangs a few rooms away. Announced by a heavy golden frame against aubergine walls, this much larger canvas proclaims its presence. The restoration in 2013 stripped aging yellow varnish and heightened its sensuality, with shimmers of gold bursting through thick layers of paint to reveal the glow of Bathsheba's naked flesh.

Rembrandt's model was probably his lover, Hendrickje Stoffels. He revels in his passion for the curves of her naked body. "Flesh was the reason why oil painting was invented," the abstract expressionist Willem de Kooning once said. Was he ever right.

I sat on a bench in front of *Bathsheba* and stared. I just wanted to take in the sensuality of her body: breasts that sit high and wide on her chest, a rich belly with a deep navel, and full hips and thighs. She is so young, I thought, and so vulnerable in her nakedness.

The biblical story depicted in the painting goes like this: from his terrace, King David sees Bathsheba as she is bathing. No matter that she is married to one of his soldiers, Uriah. Overtaken by her beauty, he sends messengers to summon her. She faces an excruciating choice: if she goes, she betrays her husband; if she refuses, she disobeys her king.

What makes the painting even more compelling is knowing what happens next. She succumbs to David's wishes. David will have her husband killed. The first-born child of their affair will also die.

On one level, we see only what David would have. "Bathsheba is a woman who is at the peak of her beauty, of her femininity, of her sensuality," said Allard. "We see a woman with her curves, with her body, with her nudity in an intimate bathing scene, with a servant who cuts her toenails."

But then he turned my attention to her face. "It's the most extraordinary thing—it's an expression of suspense, of melancholic hesitation. As if she knew what is going to happen when she meets with King David. At this moment she has nothing, but she's going to be at the origin of a huge story."

"I can't read her face," I said. "I can, but then I can't."

"Yes, that's it exactly—you can, but you can't," Allard said.

The beauty of the painting is justly legendary. Picasso was so taken by it that in the 1960s he did a series of paintings and drawings inspired by it. Others were haunted by the character of Bathsheba herself. The songwriter Leonard Cohen evoked the Old Testament story in his 1984 song "Hallelujah." ("You saw her bathing on the roof / Her beauty in the moonlight overthrew you.") In the Bible, King David has the power, but Cohen puts Bathsheba in charge.

On the first level of the Denon wing, in a long and narrow extension

of the Grande Galerie, a very different beauty captivated Allard. *Portrait of a Princess* by Pisanello, the fifteenth-century Italian fresco and portrait painter, hangs among dozens of gilded Italian Renaissance works. "You're in the Grande Galerie, with all the paintings of the great masters, and yet even though it is not very big, you notice this portrait from a distance," he said. "Why is your eye attracted by this young woman?"

At roughly 17 by 12 inches, it is one of the smallest works in the room, probably painted while Pisanello lived with the reigning Este family in Ferrara. This is all we know about the nameless princess: her family, identified by the vase embroidered on her garment, and her obvious youth—she appears to be fourteen or fifteen years old. She might have been Ginevra d'Este, whose first name means "juniper," a sprig of which is tucked into her sleeve. The blond hair on her neck and forehead has been shaved clean in the style of the time. She is painted against a backdrop of flowers and butterflies.

"You see her in profile, evoking an ancient coin, drawn on a blue sky," Allard said. "She's not looking at us, so there is a distance. And then there is extreme refinement, of the clothes, of the flowers. We feel that we are in a world that is a little magical, a little mysterious, almost like in a fairy tale.

"We might imagine that the painting was made at the time of an engagement or wedding, but it could also be a funeral portrait," he said. "Was she dead? Probably. You end up wondering about the butterfly and the fragility of life. And then we pay attention to the slightly pink cheeks, and the expression—a kind of smile that we can't really categorize. It's melancholic. It's diaphanous."

"Diaphanous but not seductive," I said.

"Not seductive," he agreed. "The seduction of this painting lies in its mystery."

We moved on to Jacques-Louis David's horizontal *Portrait of Juliette Récamier*, a portrait of a woman whose confident sophistication contrasts sharply with the innocence of Pisanello's princess. This painting, nearly 6 feet tall and 8 feet wide, projects power amid dozens of other neoclassical masterpieces hanging nearby. A twenty-three-year-old woman in a long white gown reclines on a Pompeian chaise longue and looks directly at the viewer. Her feet are daringly bare. She is Juliette Récamier, a

young French freethinking writer and socialite who ran a swank salon of early nineteenth-century Paris from her *hôtel particulier*. "She was considered the most beautiful woman in the world at the time, a star," Allard explained. "She was—I don't know—the Greta Garbo of her era." Madame Récamier played hostess to the political and literary stars of Paris. Aware of her importance, she commissioned the portrait herself; it was never finished. Married to a rich banker, she was irresistible to many men around her, including Napoleon Bonaparte's brother and perhaps Napoleon as well. However, Napoleon exiled her from Paris in 1811 because of her friendship with one of his political opponents. She traveled south, eventually to Rome. When she returned to Paris after the fall of Napoleon's empire in 1814, she glided back into popularity and success. An upholstered banquette for lounging was named after her—the word "recamier" is still used today.

"And here she is, presented by David in all the brilliance of her beauty with antique furniture, an antique hairstyle and dress," Allard said. "Madame Récamier is a rather distant beauty. She is not sexual. She is not sensual, but a kind of perfect beauty, with an antique purity."

I saw that she was beautiful, but she didn't draw me in. "Was Madame Récamier an interesting character?" I asked.

"She exercised a power of fascination, visibly," said Allard. "The contemporaries say, 'Yes, she was interesting, in the distance and grace she had.' That coldness is probably why she was so fascinating to the people around her, and especially men."

"She's not my type," I said, thinking of Bathsheba, whose face I could stare at forever.

Allard told me to focus on the painting's complexity: the "mystery of her incompletion" and the "the perfection of the line," he said. "Her lounging sideways on a chair positioned at a perfect right angle to the architecture of the building she inhabits was risky. But it draws so much more attention to her."

Finally, our quest led us to *Mona Lisa*'s room, but not to her. In the Salle des États, Allard's passion was for another painting. "The public, fascinated by the *Mona Lisa*, hardly notices that practically next to her is one of the most beautiful portraits—if not the most beautiful portrait—of the Louvre," he said.

It is *Man with a Glove* by Titian, the Venetian master. It depicts a young man at a three-quarter angle, set against a flat black background and wearing a long, wide black jacket over a white frilled shirt, as was fashionable among sixteenth-century aristocrats. A soft leather glove covers his left hand, which holds the other glove. On his right hand is a gold ring, around his neck a necklace with a sapphire and a pearl. His identity is unknown, but he exudes purity and elegance. He is the ideal of a beautiful Renaissance man in all his emotional and physical richness.

Some art historians consider Titian the greatest Italian painter, even better than Leonardo. His contemporaries considered him a master of *sprezzatura*, the art of making hard work look easy. "They who are compelled to paint by force, without being in the necessary mood can only produce ungainly works, because this profession requires an unruffled temper," remarked Titian, according to Carlo Ridolfi, a seventeenth-century chronicler of Venetian painting.

Allard told me to look at the relaxed pose of the young man's exposed hand, which is slightly pink, with spots of deeper color and clear blue veins, a hand so lifelike you feel it might move.

He went on: "The small medallion, the blue eyes—this young man confronts us. But we know nothing about him. That's also why this portrait is very, very seductive, which is why it is difficult to detach ourselves from it. It's up to us to imagine the reasons for his look of contemplation. Predominantly, this painting is black and gray. So Titian, who is the great painter of color, produces something different, a kind of poetry."

Allard is frustrated that *Man with a Glove* too often goes unnoticed. "I renovated the room in the spirit that we should stop to see the *Mona Lisa* and then be able to appreciate the Venetian paintings, which form the most beautiful collection in the world outside Venice," he said. "And then, one day, barriers were put up against the will of the curators. Everything I did was reduced to nothing, because normally, when you enter the room, you should be able to be in the middle and be enveloped by all these colors. But here, we are stuck."

Later, to cheer him up, I sent Allard a link to a radio interview the British actress Judi Dench gave to the BBC for its series *Desert Island Discs* in 2015. Asked what "luxury" she would take along with her to a desert island, she said she would carry *Man with a Glove*. "I've always

loved it," she said. "That wonderful young man. It's irresistible. I just like him hanging around."

I can see her on her island, gazing at her man with a glove and imagining him free and charming, moving his strong shoulders gracefully, enticing her with his unbuttoned shirt, gazing deeply into her eyes. A real *opération séduction*.

I once asked former British Museum director Neil MacGregor if there was a portrait in the Louvre that was more meaningful to him than the *Mona Lisa*, and he too mentioned *Man with a Glove*. "The great portraits," MacGregor said, "are not about observation, but conversation." Titian's young man is "somebody with whom you feel you could quickly embark on a conversation about things that matter." *Mona Lisa*, he said, refuses dialogue. "She is not remotely interested in you," he said.

If it were up to MacGregor, he'd liberate *Man with a Glove* and his neighbors by moving the *Mona Lisa* to a room of her own. The way it is now, he said, "is not fair to the *Mona Lisa*. It's not fair to the other works of art. They have rights. And we are not honoring them." He proposed a slow-moving motorized walkway like the one used every year by millions of pilgrims worshipping the image of Our Lady of Guadalupe in Mexico City.

I also asked Laurence des Cars if she ever thought about moving the *Mona Lisa* to her own space with a double ticket system—one for Leonardo only, the other for the entire Louvre. Couldn't you have a Leonardo mini-museum with *Mona Lisa* and the Louvre's four other Leonardo paintings and its twenty-two drawings? For fun, I dared to include the best of Margat's collection of *Mona Lisa* kitsch.

"Where do you put her?" des Cars asked.

"That's just a question of real estate," I said.

"Fantastic," she said. "Do you want to come with me to the minister of culture?"

Her question was a reminder that she is a government official working for an institution wholly owned by the French state, reporting first to the minister of culture and then to the president, the ultimate head of the Louvre. There had been reports of a plan of des Cars's to relieve congestion around the Pyramid by carving out a new and glitzy entrance at the Colonnade, the Louvre's easternmost facade.

Could this new entrance eventually funnel visitors directly to the *Mona Lisa*? I asked her.

"I will not reveal everything to you," she said.

Sometime afterward, des Cars announced on French radio that *Mona Lisa* deserves her own space. Noting the sheer number of visitors—over twenty thousand per day—who come to see her, she emphasized her determination to improve their experience. "Today we do not welcome visitors who want to see the *Mona Lisa*, at least not in optimal conditions," she said. That doesn't mean that visitors still won't be disappointed when they see her. "She's an icon, and by definition, when you are faced with a sort of collective fantasy, there can always be disappointment," she added.

Mona Lisa's room of her own is part of a much more ambitious building project that des Cars is campaigning for: the construction of a new entrance through the Colonnade and the redevelopment of the Cour Carrée. The entrance would accommodate between four and six million visitors per year. They could descend into two underground galleries, one for temporary exhibitions, the other for the *Mona Lisa*, and then decide whether or not to continue into the rest of the Louvre. The cost? About half a billion euros, half from the government, half from private donors.

Would there ever be the money? And if not, was des Cars doomed to forever do battle with *Mona Lisa*? When I interviewed her the day she was appointed as the first woman director of the Louvre, I joked that with her arrival, *Mona Lisa* might lose her perch as the Louvre's most famous woman.

"She already has won," she said. "She is definitely the winner forever."

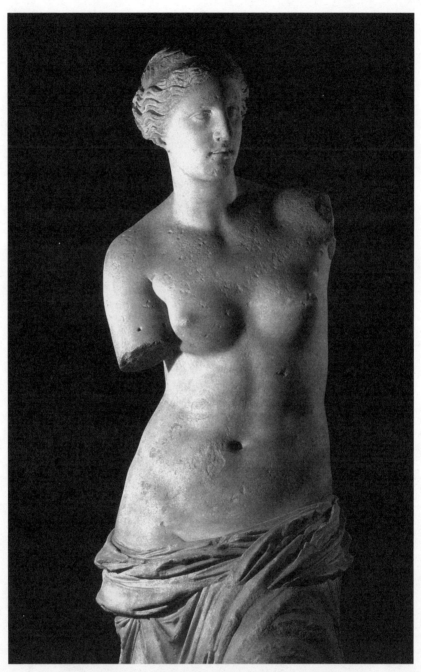

Venus de Milo, the ancient Greek statue that joins the *Mona Lisa* and the *Winged Victory of Samothrace* to complete the Louvre's trio of superstars. © *RMN-Grand Palais / ArtResource, NY*

◆◆◆◆◆◆◆◆◆◆◆◆◆◆◆◆◆◆◆◆

A Goddess with No Arms

One of the most splendid physical ideals of humanity . . .
—**Kenneth Clark,** British art historian

IF *MONA LISA* WERE NOT IN HER WAY, *VENUS DE MILO* MIGHT BE THE world's most recognizable woman in art.

Larger than life, she stands six and a half feet tall, with a curved torso and no arms, her white marble shining bright at the end of a long gallery on the Louvre's ground floor. Protected by a low metal barrier, she is not to be touched, but those who see her can feel the aura of her timeless beauty. Visitors jostle in front of her, snapping photos.

Her frame was carved in two large blocks of marble, which connect at the pleated roll of drapery falling from her hips. Her downturned mouth gives a look so impenetrable that it can be interpreted as concentration or contemplation or serenity. Her left nipple has been nicked. Her skin is scratched and pockmarked.

Her arms would have been made separately and attached to her upper body with metal dowels. They are missing, as are her left foot and her earlobes. She would have worn earrings, a headband to hold her hair in place, perhaps a bracelet above the elbow of her right arm. And, although it is difficult to imagine, her white marble would have been painted in vibrant colors, as were marble sculptures in Greek antiquity.

But what is it about *Venus* that makes her so beautiful?

Is it the deep twist of her torso? The tilt of her head? The curves of her body, robust but not too fleshy?

Is it the contrast between cold and hot? *Venus*'s face seems calm and still, while the bottom half of her body stiffens to hold up a garment that protects her from full nudity. As with the Nike of Samothrace, the Louvre's other ancient Greek beauty, a semi-clothed body can activate the imagination in a way that nakedness cannot.

Is it the centrality of her torso? The imperfection of an armless woman may have contributed to her reputation as beautiful. There are no arm movements to distract the viewer from the perfect proportions and harmony of her body. And would armlessness make her more erotic?

Is it the skill of the sculptor? The narrow crease in her spine stretches long and bends gently; the tiny muscles in her back move with her as she twists her body. "This is the most sensuous back ever carved in stone," wrote Gregory Curtis in his book *Disarmed: The Story of the Venus de Milo*.

Even the great Kenneth Clark struggled to describe her beauty in his masterful book *The Nude* (1956). He called her "one of the most complex and the most artful" of all the works of antiquity, a figure who "makes us think of an elm tree in a field of corn." What in the world does that mean? I asked the Louvre's Ludovic Laugier, and even he didn't know.

For Laugier, *Venus* is both sexy and ethereal, and therefore can do it all. "She is the celebration of the beauty of the female body," he said. "She is half-naked, wearing nothing except jewelry, her torso bare, her breasts soft, and a cloth suspended but falling. She is not maternal, but she unleashes the desire of people to have sex, and to procreate. It is through the suggestive power of her breasts, her buttocks, her genitals, that she both promises love and guarantees the perpetuation of life."

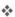

VENUS WAS DISCOVERED IN PIECES in 1820 on the Aegean island of Melos by a farmer gathering stones from an ancient ruin for a structure he was building. Created at the end of the second century BC, she is believed to be Aphrodite, or Venus to the Romans, the Greek goddess of sexual love, fertility, and beauty.

A dramatic diplomatic battle followed, pitting France against the

Venus de Milo from behind, a seductive view that reveals the upper part of her buttocks as her garment slips off her hips. © *RMN-Grand Palais / ArtResource, NY*

Ottoman Empire, which governed Greece at the time. France procured most Greek antiquities in those days through its diplomats, as was the case with *Venus*. Ultimately, France's ambassador, the Marquis de Rivière, negotiated a price, and the Ottoman Turks eventually agreed to part with her.

The statue was given royal superstar status soon after Rivière sent it to France. He offered it to King Louis XVIII, who in turn gave it to the Louvre. Her presence helped fill an embarrassing gap that had opened in the Louvre's collections after Napoleon's defeat at Waterloo, when the victorious European powers forced France to relinquish Greek art he had looted in his foreign campaigns.

Venus was so special that the Louvre portrayed her as the ideal of ageless female beauty and disseminated photographs and plaster casts of her body around Europe. The statue's head and upper body are turned slightly toward the left. Her torso is bent to the right, as she puts her weight on her straight right leg and lifts and bends her left leg as through struggling to keep her garment from sliding down her leg. Her face is not perfect. Her eyes are deep-set and uneven; her chin and mouth tilt to the right. She was minimally restored, with changes only for the tip of the nose, her lower lip, the big toe on her right foot, and some of the pleats of her dress.

"The debates about whether to give her arms were fierce," Laugier said. "The Louvre didn't really know what to do. So it discreetly completed the tip of her nose and the lower lip of her mouth. That way, she was sure to seduce."

I had more basic questions for Laugier. If she was a Greek statue, why did she get the Roman name *Venus* and not keep the name *Aphrodite*? And if she came from the island of Melos, why was she called "de Milo"? He explained that in the nineteenth century when she was discovered, it was common to give Greek statues Roman names. As for de Milo, he said it was Italian, because the Italians were so prevalent in that part of Greece that they often gave its islands Italian names. "If we discovered her today, we would call her *Aphrodite of Melos*," he said. As for her beauty, he explained that too many reproductions of the *Venus de Milo* show her facing front. That's the way many visitors view her as well. But she was made for movement. Her body flows in a spiral that invites you to encircle her, and that is the only way to truly appreciate her. I learned that during

a visit to the Louvre with the Franco-Italian photographer Ferrante Ferranti. He told me to walk around her and study the changes in her curves and twists, and in the tensions in her body. As we walked, he snapped furiously, caressing her with his camera.

The morning sun penetrating the long window turned her left side iridescent. From that angle, her shoulders and hips look even, the deep bend in her posture disappears, and she seems to be standing straight. Then he told me to keep walking and stop when I faced her back. Strands of hair have escaped from her loose chignon and fall down her neck. The pale flesh on her naked back is soft and smooth. Her loose, heavy garment hangs a bit lower on the right and reveals almost half of her buttocks.

He told me about "fragments." "Put the work into fragments," Ferranti said. "Concentrate especially on where the roughness of the fabric of her garment meets the polished skin below her spine. Her garment hangs too low. You have the impression that it is about to fall off at any second. Her nudity is not far away."

We circled some more and stopped partway on her left side. Her left breast came into view, but we could still see where her lower back met her buttocks. "What a beauty!" he said. "Erotic."

Too often, visitors who make the obligatory pilgrimage to view *Venus* ignore the score of other marble sculptures from ancient Greece that inhabit the long adjoining gallery. One of them is the torso of Venus, the *Aphrodite of Knidos*. About two thousand years old, she is naked, dramatically, unequivocally naked. *Aphrodite* has removed her clothing, revealing her breasts, belly, and genitals, and is about to descend into the ritual bath of purification. "When we look at her, we are entering a very private moment," said Laugier. "She is considered the first fully nude female statue in Western art. You absolutely must stop to look at her." Once extensively copied because of her beauty, this Aphrodite is largely overlooked today.

Another statue that gets too little attention despite its size stands at the far end of the gallery, looking straight at the *Venus de Milo* from afar. She is *Pallas of Velletri*, a helmeted ten-foot sculpture of the goddess Athena with a face resembling that of the male god Pericles, a great statesman and a founder of democracy. A first-century Roman copy of a lost Greek bronze, she has tinges of red paint on her eyes and lips. But she is a formidable, fully-clothed woman warrior, not a femme fatale.

❖

THE *VENUS DE MILO* HAS saturated our culture over time, appearing in magazines, films, cartoons, advertisements, dramatic series (*Twin Peaks*), and TV shows (*The Simpsons*). The American Society of Plastic Surgeons, also seeing perfection, once used her on its seal. A French candymaker in New York created her full-sized in chocolate for the American display at the 1889 Universal Exposition in Paris. And when she was sent into hiding on the eve of World War II, a plaster cast took her place in the Louvre. Nazi dignitaries who went to view her had no idea they were seeing a fake.

Venus has inspired artists like Cézanne, Rodin, Dalí, and Magritte. "You are not a vain and sterile statue, the image of some unreal goddess of the Empyrean," Rodin wrote in a book about her. "Ready for action, you breathe, you are a woman, and that is your glory." Dalí interpreted her as an "anthropomorphic cabinet" with pompom-decorated drawers in her forehead, bosom, abdomen, and left knee. Although there is no concrete evidence, Delacroix is said to have used her as a model for the bare-breasted *Liberty Leading the People*. Laugier was so sure of it that he once did a PowerPoint presentation to prove it.

More recently, two headless *Venus* bronzes by the American artist Jim Dine grace Sixth Avenue at West Fifty-Third Street in New York. And to celebrate the 2024 Paris Olympics, the National Assembly decorated its front steps with six rainbow-colored acrylic resin casts of two-armed *Venus de Milo*s, each ready for action in a different Olympic sport: basketball, boxing, javelin, para-archery, surfing, and tennis.

Venus has been an enduring muse for nearly every aspect of contemporary culture. British horror writer and artist Clive Barker wrapped her in rope and locked her in chains in his 1971 sculpture *Chained Venus*. Corporate giants from Mercedes-Benz to Levi's jeans to French retailer Darty used her in their ads.

Miles Davis and Prince composed music for her. Chuck Berry's 1956 rock and roll hit *Brown Eyed Handsome Man* called her "a beautiful lass [who] lost both her arms in a wrestling match."

In a poster for the 1932 film *Blonde Venus*, Marlene Dietrich curved her body like *Venus*, wearing a clingy sheer slip over a low-slung crimson drape; her long black gloves made it look as if she had no arms. In the 1948

film *One Touch of Venus*, a young window decorator kisses a statue of the *Venus de Milo*, which comes alive in the form of a young Ava Gardner. (She plays the living Venus "with the coyness and a swagger of a stripteaser," the *New York Times* film critic wrote.) And in a 2018 music video, Beyoncé bends her torso like Venus with her husband, Jay-Z, by her side; the statue, swathed in a blue tint, watches them from behind.

"There must be hundreds of products, from lead pencils to face tissues, from beauty parlors to motorcars, that use [the] image . . . in their advertisements, implying thereby a standard of ideal perfection," Clark wrote in *The Nude*.

Adrien Goetz, an art historian of the Louvre, called her "universally seductive . . . the synthesis of Greek perfection."

When France loaned her to Japan in 1964, 1.5 million people stood on a moving sidewalk to admire her beauty. Fragile, despite her larger-than-life size, she was slightly damaged in transit. The Louvre will never let her travel again.

In 2012, *Venus*'s naked beauty was used in a political protest. Members of the women's group Femen turned her into a feminist icon, posing topless in front of her in support of a twenty-seven-year-old Tunisian woman allegedly raped by two policemen. They said they chose her because, having no arms, she symbolized a woman's vulnerability.

Because *Venus* sits alone in a large alcove, tour guides speaking various languages have plenty of room to circle around her, their clients trailing behind.

One guide said her armlessness made her a brand. "The missing arms are the reason for her being the most famous statue in the world," he said. "Everyone in the nineteenth century wondered what she was doing. We don't know, because the arms weren't found, but we think maybe she was holding a shield that reflected like a mirror. Or an apple." (Or, others have speculated, a bow, a trident, or an amphora.)

A second guide had another interpretation. "When *Venus* was discovered, the Louvre was ready to make arms for her. Then people thought she was more beautiful without arms. Everyone said, 'She is perfect just the way she is.'"

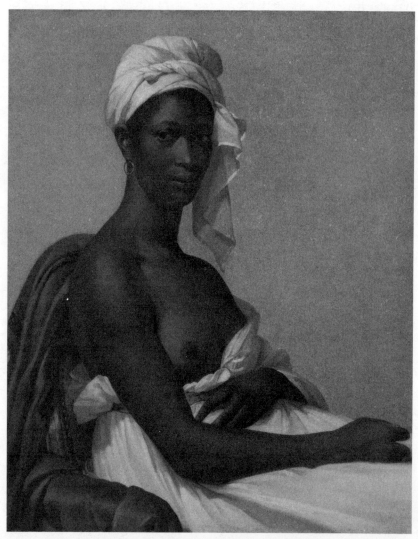

Painted in 1800, between the French Revolution's abolition of slavery in 1794 and Napoleon's restoration of it eight years later, Marie-Guillemine Benoist's *Portrait of Madeleine* is a rare example of a person of color as the subject of a portrait at that time. The portrait stars in Beyoncé's music video. © *RMN-Grand Palais / ArtResource, NY*

CHAPTER 6

✦✦✦✦✦✦✦✦✦✦✦✦✦✦✦✦✦✦✦✦

A Tour Guide Named Beyoncé

Beyoncé is worth far more than the Mona Lisa.
—**Mindy** in the Netflix series *Emily in Paris*

IF YOU WANT INSTANT LOUVRE SEDUCTION, START WITH THE SHORT music video made by the American superstar named Beyoncé.

Beyoncé is Black, female, beautiful, and rich, a singer and songwriter who has sold two hundred million records worldwide and won more Grammy Awards than any other musical performer. She is so versatile that when she ventured into country music in 2024, she became the first Black female artist to reach the top spot on the *Billboard* Hot Country Songs chart.

For two nights in the spring of 2018, she and her husband, the rapper Jay-Z, brought their artistic vision to the Louvre, taking over the galleries, staircases, corridors, and main courtyard. Joined by an army of choreographers, costume changers, musicians, dancers, producers, and videographers, Beyoncé and Jay-Z produced a music video that was an extravaganza of singing, dancing, and staging against the visual splendor that only the Louvre and its marquee artworks could provide. Their six-minute, five-second video went viral upon its release and has garnered hundreds of millions of views and 180,000 comments.

Suddenly, the Louvre shed its reputation as the world's largest repository of fusty old art and became cool.

Beyoncé dances at the top of the Daru staircase. She and Jay-Z pose in front of the *Mona Lisa*. He raps against the backdrop of the Pyramid at night. They imitate the poses of figures in famous artworks. The scenes cut back and forth: from lines of dancers to details of paintings and statuary, from Louvre architecture to Beyoncé's face. The music unifies and punctuates. Through the artistry of the camera, with its closeups and low-light caresses, the art pops out at the viewer.

Like a modern-day Nike of Samothrace, Beyoncé swooped into the Louvre and made it her own. She brought in a new audience and an egalitarian message: I am a cutting-edge artist and can look at a sea of old art and choose paintings, sculptures, and gallery objects that move me.

And anyone can do the same thing. You don't have to be a student of art history to see the Louvre and love it. You too can wander in and out of the galleries and decide what thrills you. You can even have an adventure of exciting discoveries in this place without ever going in.

"I can't believe I finally saw inside the Louvre thanks to Beyoncé and Jay Z," one fan gushed in an internet post.

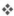

THE WORLD'S GREAT, TRADITIONAL MUSEUMS these days struggle with the same challenge: how to liberate themselves from their histories and become relevant today. The Louvre could not have found a more fitting modern-day tour guide than Beyoncé.

Beyoncé loves Paris. She and Jay-Z got engaged there. She has talked about teaching French to her daughter Blue Ivy and retiring in Paris one day. "Every time I'm in Paris, it's hard to come back to the United States," she said. "I feel at home here."

She loves the Louvre, too. Once, when she called Paris "a beautiful, sexy city," she revealed where she would most love to neck: inside the Louvre.

The French, meanwhile, like to point out that Beyoncé has French ancestry. Her mother, born Tina Beyince, is a Louisiana Creole and a descendant of the Acadian leader Joseph Broussard. Beyoncé's name is a tribute to her mother's maiden name, with a slight spelling change and a very French acute accent on the final *e*. And Jay-Z co-owns a French champagne *domaine* with luxury giant LVMH.

Beyoncé and Jay-Z (or "the Carters," as they are known) gave their music video the sanitized title *Apes**t* but sounded out the explicit word "apeshit" for the song in the video itself.

The less-than-regal name might have shocked the kings who built the Louvre, and at first the museum's leadership hesitated to approve the video project. The Louvre eagerly rents itself out to hundreds of filmmakers and videographers a year, but this one was "a bit . . . iconoclastic," said Anne-Laure Béatrix, who promoted the museum's global image at the time. But Béatrix and her team argued that Beyoncé and Jay-Z were not strangers to the Louvre. They had already visited several times before they decided to make their video there. They had rented the museum during a visit in 2014 for a photo shoot with the celebrated Ethiopian-born American artist Awol Erizku. With its costume changes and exacting choreography, *Apes**t* was a natural extension.

"They knew us, we knew them, so it wasn't a request that came out of nowhere or a celebrity whim," Béatrix said.

The Louvre assigned a large workforce to monitor the project and control how and where the cameras could shoot. Teams could enter at 8:00 p.m. and had to leave the next morning at 6:30. Light fixtures had to be small, heat-sensitive, and low-impact. "We banned things that might seem really harmless," said Leila Cherif-Hadria, deputy head of security. "Makeup, hairsprays, aerosols, blow-dryers? Zero. They could endanger the art."

One glitch came when Beyoncé and Jay-Z asked to celebrate with champagne from Jay-Z's Armand de Brignac brand, with its $300-and-up Ace of Spades packaged in opaque gold metallic bottles. The Louvre said no. Champagne could spurt onto the paintings.

The Louvre was more accommodating when it came to costumes. Beyoncé wanted the dancers to wear see-through body stockings that revealed their many shades of Black skin and made them look naked. "No problem," a museum bureaucrat said. "The Louvre has a lot of nudes."

FOR ITS MILLIONS OF VIEWERS, the message of the video has been one of inclusion, but it also flaunts its stars' success and projects their influence.

The video opens with the sounds of church bells and sirens and the image of a dreadlocked and brown-skinned man wearing angel wings and athletic shoes, crouching in the dark outside the museum. Then we are inside, in the heart of the Apollo Gallery, whose gold-framed ceiling murals light up in red, blue, and yellow.

The scene shifts to the brightly lit Salle des États, as the camera glides toward Beyoncé and Jay-Z, framing the *Mona Lisa* hanging behind and between them. The couple wear coordinated and shirtless silk power suits—his double-breasted in mint green, hers in lilac pink, open to the waist. They face the camera, trying, perhaps, to look as inscrutable as the *Mona Lisa*.

In front of the Nike of Samothrace at the top of the Daru staircase, Beyoncé wears a voluminous robe that mimics the color and structure of the statue's wings and drapery. Paying homage, female dancers in nude body stockings lie flat on the stairs and bend their torsos in synchronized motion. Beyoncé sings the refrain that punctuates the rest of the video:

I can't believe we made it . . .

The music video focuses on artistic images of majesty, terror, and death. Beyoncé and her dancers move in formation along Jacques-Louis David's 32-foot-long historical masterpiece, *The Coronation of Napoleon*; it captures the moment when Napoleon is about to crown his wife Josephine as his empress, as the pope, sidelined, looks on.

Jay-Z raps in front of Théodore Géricault's *The Raft of the Medusa*. In the enormous painting, men stranded by the wreck of a frigate sent to colonize Senegal in 1816 cling to life on a makeshift raft in a stormy sea; a Black man at the center waves a cloth toward a ship barely visible over the horizon.

The camera lingers over the most famous portrait of a Black figure in the Louvre, Marie-Guillemine Benoist's *Portrait of a Black Woman* (or *Portrait of Madeleine*). Painted in 1800, between the French Revolution's abolition of slavery in 1794 and Napoleon's restoration of it in 1802, it is a rare example of a person of color—a woman freed from slavery who worked as a servant in Paris—as the subject of a portrait in that era.

In the video's last shot, the trio of Beyoncé, Jay-Z, and *Mona Lisa* face the camera together again. The Carters turn to look at the painting.

At that moment, the couple takes over the most powerful museum in the world.

❖

FILMING THE VIDEO WAS A complex and expensive project. Beyoncé and her team required everyone connected with it, including Louvre officials, to sign nondisclosure agreements to keep the details secret. They engaged an army of advance teams and a huge security squad. "It was a big machine, bodyguards all over all the time," said Sabine de La Rochefoucauld, a Louvre protocol officer. "Their lives are completely different from ours."

Money was no obstacle. While the Louvre's base rental price of 15,000 euros a day at the time was a terrific bargain ("There are hotel rooms here that cost more than that," the *New York Times* art critic Jason Farago wrote), the museum charges on a sliding scale, depending on the add-ons.

"The cost of the museum depends on the project," said Adel Ziane, who was then the Louvre's director of external relations. "Is it day or night? How many galleries? Do you want the *Mona Lisa*? Do you want an aerial shot of the Pyramid? The prices can go quite high."

For the museum, so can the rewards. Jean-Luc Martinez, the Louvre's director at the time, credited the Carters for helping to send museum attendance soaring to a new record in 2018. The video brought a "different audience" to the Louvre and shattered the image of a museum "as a place in which there is only one way of seeing things," he said.

The video was such a powerful, living art history lesson that Louvre curators created a self-guided tour of all seventeen works of art featured in it. The couple "shook things up at the venerable Louvre palace!" the museum exclaimed in announcing the tour, which is still prominently featured on its website. The Louvre's educational outreach team used the video to open its presentations to schoolchildren.

Six years after the video was released, the Beyoncé effect endures. Asked in a radio interview in 2024 about Beyoncé, Laurence des Cars replied, "She is welcome whenever she wants."

Since *Ape**it*'s release, art historians and critics have argued over its meaning. The French media struggled to translate "apeshit" into French, trying, pitifully, *emballement furieux* (furious outburst), *gros délire* (big delirium), and *excitation sauvage* (wild excitement).

Anne Lafont, a Black French art historian, criticized the video as a

"power grab and stunt" by a wealthy and powerful Black aristocracy, perhaps "racial revenge." However, others have praised it as the couple's declaration that they not only belong in this historically white space; they would share it with their fans around the world.

Some of the Louvre's curators confessed that Beyoncé bewitched them. Vincent Rondot, the head of the department of Egyptian antiquities, was gobsmacked when he saw Beyoncé posed in front of *The Great Sphinx of Tanis*, the giant ancient Egyptian sculpture in granite that could be 4,600 years old and sits at the entrance of his department. "Beyoncé has a look, a beauty that can easily be called Egyptian," he said. "I got carried away by her. I could not have asked for more if Cleopatra herself had come to visit me."

Beyoncé's interaction with the Sphinx carried the deeper meaning that anyone can feel at home in the Louvre, he said. "By coming face-to-face with the Sphinx, she said that we are all capable of reacting to it, that it is available to everyone no matter what one's background, origins, history."

Viewers' comments posted online reinforced the importance of Beyoncé as a cheerleader for the Louvre. "*Mona Lisa* is so lucky that she got to meet Beyoncé," said one fan. Another expressed delight that Beyoncé allowed him to "finally see how pictures in Louvre look like, without pushing people around." Others assumed that the video was a crass publicity stunt organized by the Louvre. "Wow, how much did the Louvre have to pay to get Beyoncé?" one fan asked.

Béatrix recalled the viewer comment that made her laugh the hardest. "But this is magnificent. Can you visit this place?"

PART TWO

Getting to Know You

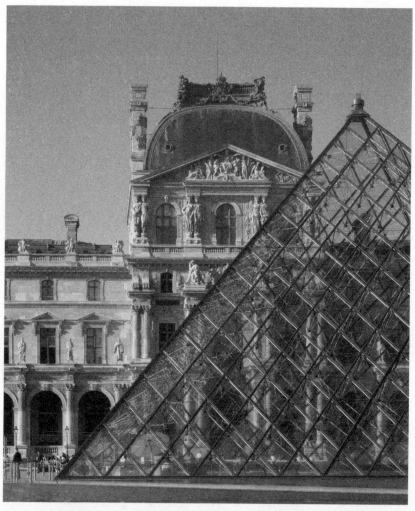

Blending history and modernity: I. M. Pei's Pyramid with the Richelieu wing behind it. This sixty-nine-foot-tall, two-hundred-ton glass-and-metal faux Egyptian structure, inaugurated in 1989, was ridiculed at the time by some critics. © *RMN-Grand Palais / ArtResource, NY*

CHAPTER 7

♦♦♦♦♦♦♦♦♦♦♦♦♦♦♦♦♦♦♦♦♦

The Center of the Universe

"Do you like our pyramid?"
— Bezu Fache
"It's magnificent. . . ."
— Robert Langdon
"A scar on the face of Paris."
— Bezu Fache

Exchange between Paris police captain
Bezu Fache and Harvard University art historian
Robert Langdon in the film The Da Vinci Code

THE LOUVRE SITS AT THE CENTER OF PARIS, WHICH IS THE POLITICAL
and cultural center of France and once upon a time was the power cen-
ter of the world. And at the center of the Louvre is a sixty-nine-foot-tall,
two-hundred-ton glass-and-metal faux Egyptian structure designed by
the Chinese American architect I. M. Pei. Reviled and ridiculed by crit-
ics as a foreign object created by a foreigner when it opened in 1989, it is
now celebrated as a vision of France's modernity.

The Pyramid adorns the Louvre like a diamond from outer space that
landed smack in the middle of the Cour Napoléon, the sweeping open
space embraced by the museum's wings. The Pyramid attracts so much
attention that visitors sometimes overlook that there is not just one pyr-
amid; there are five: three miniature versions are in the courtyard itself,
and an inverted version serves as both a skylight and a piece of sculpture

in the Carrousel du Louvre, the underground shopping mall that was another part of Pei's plan.

On days when the Louvre is open, the Pyramid is hemmed in by crowds. Soon-to-be-wed couples arrive in bridal attire, their photographers and videographers trailing behind. Instabloggers create content. *Emily in Paris* wannabes pose in their berets and outlandish colors. Add to that the touch-the-tip pose that some tourists like for photos—you stand a good distance away, stick out your arm, and pretend to touch the point of the Pyramid.

Crowds line up in the courtyard to enter the Louvre through the Pyramid, undeterred by cold winter rain or extreme summer heat. Their patience is tested. But if the wait is long, there is the Pyramid to contemplate. Calming and luminous, it gleams and reflects, changing with the sun. "The Louvre is the only museum with a work of art as an entrance," Jean-Luc Martinez liked to say. But to understand the Pyramid, it helps to know how it came to be.

As president, François Mitterrand had two obsessions: the glory of France and his own legacy. His Grand Louvre project in the 1980s modernized what had been a hopelessly disorganized and inefficient museum, adding more than 300,000 square feet of usable space, much of it underground. In a bold political move, he ejected the Ministry of Finance from the building; at last, the Louvre would be about art, nothing but art.

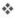

PEI HAD REALIZED THAT THE only way to open the Louvre was to create space under the Cour Napoléon, which had been used as an open-air parking lot. "We need to dig," he told Mitterrand in an early meeting in 1983.

But the digging process was complicated. Under the courtyard were vestiges of eight centuries of Louvre history. Two archaeological searches soon followed, one for the original medieval fortress, the other for a neighborhood that had endured until the 1850s. Once the research was over and the digging was done, the Louvre changed forever.

Aboveground, the most daring innovation was the creation of a single, central entrance to the museum, through which visitors would have to enter in a kind of ritual of welcome, the glass structure bringing air,

space, and light to the underground atrium. Pei agonized over the form that the centerpiece of the design should take. He conducted experiments with a cube and a hemisphere, but in the end, "the pyramid was the only shape that was acceptable," he said.

In his new underground village, Pei built temporary exhibition galleries, visitor and information centers, an auditorium, a boutique and bookstore, storage areas, restoration workshops, a lot more (but not enough) toilets, and parking spaces for cars and tour buses to replace the dingy parking lot in the Cour Napoléon.

Like the Eiffel Tower a century earlier, the Pyramid stirred up a storm of criticism as soon as it was proposed. Many critics noted acidly (with a hint of racism) that Pei was not only not French but rather an American of Chinese birth. "The Astonishing Chinese Pyramid" is how a headline in the popular newspaper *Le Parisien* described the design. Others, seeing it as an insult to French style, labeled the design "American." A *Le Monde* article likened it to Disneyland; when Pei presented his plan to a monuments commission, one of its members said, "This is not Dallas."

Thousands of opponents (including politicians, art historians, journalists, and architects) launched the "Battle of the Pyramid" campaign, branding Mitterrand a modern-day pharaoh and a left-wing megalomaniac. A pyramid in the Louvre courtyard, they said, would be an eyesore, or a gadget, or a bad joke, or a symbol of death on the Nile. But other important figures stayed quiet or supported Mitterrand's project. Crucial was Jacques Chirac, then the mayor of Paris, who defined his position as "non-hostile."

The Pyramid became Mitterrand's monument. He wanted his Grand Louvre to extend the "Grand Axis"—a straight sight line stretching for miles from the Pyramid through the Tuileries Garden, hitting the 3,300-year-old pink granite Egyptian obelisk that dominates the place de la Concorde, splitting the broad Avenue des Champs-Élysées, passing through the middle of the Arc de Triomphe, and extending all the way to the skyscraper-filled western suburb of La Défense.

But no straight line exists, because the Louvre follows the curve of the Seine. A replica of a marble statue by the Italian sculptor Gian Lorenzo Bernini of Louis XIV on horseback solved the problem. The king is dressed as a mythological Roman warrior seated on a horse rearing up on its hind legs as flames shoot up into its belly. It was an unusual choice by Pei; his Pyramid

was all about clean lines and logical beauty, while this statue was baroque excess. But there was a logic to the decision. Bernini had been chosen to redesign the Louvre in his day, but Louis XIV ultimately rejected him, sending him back to Rome. There, Bernini created the statue. The king hated it and deposited it in an obscure corner of the gardens at Versailles. Three centuries later, Pei and his associates resurrected it as a visual problem solver. It was reproduced with a stainless steel frame, cast in lead, and planted at a strategic angle in the southwest part of the courtyard to serve as the starting point for Mitterrand's extension of the Grand Axis. If you sit at the base of Louis XIV and look west, you can see the gardens and boulevards all the way to La Défense. It is one of the most glorious vistas of Paris.

THE PYRAMID HAS BEEN USED for political purposes since its origins. Three months after it opened, Mitterrand showed it off during a G7 summit in Paris. A photo for *Life* magazine by the great magazine photographer Dirck Halstead showed Pei posing with world leaders at the top of the Pyramid's circular staircase as if they were standing together at the top of the world.

Television footage showed British prime minister Margaret Thatcher, on tour inside the Louvre, gazing at a statue of Diana the huntress while President George H. W. Bush smiled nearby, his hands thrust into his pockets. As a 1959 Dom Perignon champagne flowed in the Salle des Cariatides, Bush called out, "Margaret, you're missing the tasting!" Mitterrand helped pass around champagne-filled flutes. "It's alchemy," he said with a smile, without specifying whether he meant political, personal, artistic, or alcoholic.

In 2017, Emmanuel Macron, the newly elected French president, gave his victory speech not at the place de la Bastille, as the Socialists Mitterrand and François Hollande had done, or at the place de la Concorde, like the center-right Nicolas Sarkozy, but in front of the lighted Pyramid. As Beethoven's "Ode to Joy"—the official hymn to European unity—blared from loudspeakers, Macron mounted a makeshift metal stage, grinned, waved, and blew kisses to the crowd.

When Macron ran for reelection in 2022, Marine Le Pen, his far-right

opponent, filmed a campaign video at the Pyramid as a direct response to Macron's triumphant moment there. She called the Louvre an "architectural jewel" created by French kings and denigrated Macron as the opposite of great. The Louvre protested, saying that she hadn't followed museum rules and asked for permission, and that the Louvre belonged to all French people, not one political party.

Protesters still gather at the Pyramid, sometimes with local complaints (once about inadequate working conditions at Le Café Marly, the restaurant on the edge of the courtyard) and sometimes with global causes like climate change. In 2019, the American art photographer and activist Nan Goldin led a protest demanding that the Louvre change the name of its Sackler wing because members of the American billionaire family of art philanthropists had produced and promoted the highly addictive prescription painkiller OxyContin. She waded into the fountains as other protesters shouted slogans and carried a red banner stating in English: "Take down the Sackler name." Eventually, the Louvre complied.

The Pyramid became a stage set once again in the spring of 2023 in response to President Macron's plan to raise France's retirement age to sixty-four (from sixty-two). Unions and Louvre staff waved flags and blocked the entrance to the museum, forcing it to close for a day. They shared on social media an image of *Mona Lisa* as an old woman holding a sign: "64 c'est non." (Sixty-four is a no.)

In popular culture, the Pyramid now rivals the Eiffel Tower as the city's ultimate icon. In the opening of the 2017 film *Wonder Woman*, the Pyramid is the heart of the planet. The camera starts with an image of Earth from outer space, then zooms in on Paris, swiftly passes the Eiffel Tower, and follows the Seine until it stops briefly on top of the Pyramid. It changes direction to focus on Wonder Woman in her alternate identity as the curator Diana Prince, dressed in black stiletto boots and a flowing red coat as she marches through the Cour Napoléon to her job as an antiquities expert.

Another high-octane scene—this time featuring the inverted Pyramid—comes in the first episode of the 2021 Netflix series *Lupin*. Omar Sy, playing the hero Assane Diop, poses as both a janitor and a billionaire investor to enter the Louvre and steal a priceless necklace. His accomplices attempt to flee in a red Ferrari. With two police cars in

pursuit, the Ferrari lifts off the ground and crashes into the glass top of the inverted Pyramid.

THE LOUVRE IS A MACHO museum. The Pyramid entrance reinforces that idea.

Men built it as a fortress and rebuilt it as a seat of power for kings, and men have always dominated. As you wait in line outside to get in through the Pyramid entrance, the eighty-plus granite statues of "illustrious men" of French history look down at you from the museum's facades. From the moment you descend into the main entrance at the base of the Pyramid, you must choose among the museum's three wings, named after men in French history: Sully, Richelieu, and Denon.

Maximilien de Béthune, Duke of Sully, was a Protestant and the most benign of the three. Stubborn, shrewd, and strict, he helped King Henri IV rebuild France following the religious wars of the late sixteenth century.

Cardinal Richelieu, adviser to King Louis XIII in the early seventeenth century, pretty much ran the country. Wily, brutal, and cruel, he used his position to strengthen the power and tyranny of the monarchy. A patron of the arts, he wrote serious books, which he also used as a tool to impress his mistresses.

Baron Dominique Vivant Denon, Napoleon Bonaparte's first director of the Louvre, was in a class of his own. He was nicknamed "the rapacious eagle" for looting great art for his boss—and lesser pieces for himself—from the conquered territories. He also had a reputation for being a libertine, with an insatiable appetite for women. "Conducting diplomacy and love affairs concurrently, deceiving his mistresses for his masters," is how one commentator described Denon's behavior when he was a young diplomat in Russia. He anonymously penned a short novel that detailed sexual fantasies and adventures. He created pornographic prints that he sold when he got into financial trouble: one showed tiny men and women climbing on and exploring a giant penis.

Louvre officials brush off any criticism, arguing that Sully, Richelieu, and Denon were part of French history.

❖

IN HIS DESIGN FOR THE Pyramid, I. M. Pei was bigger on vision than practicality. The fountains in the Cour Napoléon leak and often must be turned off. Escalators frequently break down. The Pyramid sits above an overcrowded circular entrance hall nicknamed the Camembert because the color is white and the structure round like a Camembert cheese. The hall is noisy and confusing to navigate. One day I spotted two black plastic pails on the floor—the Pyramid itself was leaking.

The size was another miscalculation: Pei's entrance was built to accommodate as many as 4 million visitors a year; the Louvre had 8.7 million visitors in 2024, and more than 10 million in pre-COVID 2018.

In a 1984 open letter published in *Le Monde*, Michel Guy, a former minister of culture and the founder of the Association for the Renovation of the Louvre, called the Pei Pyramid project "inhumane," predicting that it would give the museum the feel of a bad airport terminal. He wasn't completely wrong. The noise level in the Camembert can make it unbearable to think. At midday the sun can turn the space into a glass-lined oven and make the rubber handrails on the escalators too hot to touch. Enormous portable air conditioners sometimes must be wheeled in to cool the upper level, even in June.

The central pillar that juts out toward the point of the Pyramid was supposed to be the permanent setting for a museum showpiece. Occasionally a work of art is installed there temporarily, but nothing was right in this position, according to former Louvre director Michel Laclotte. He wrote in his memoirs that the Nike of Samothrace was the first choice, but she was too perfect in her perch at the top of the Daru staircase. A column capital from ancient Persia was considered too strong and "fascistic." Jean-Baptiste Pigalle's *Mercury Tying His Sandals* and Adriaen de Vries's *Mercury Abducting Psyche*? "Too small." *Diana of Anet*? "Too nineteenth-century."

President Mitterrand wanted to put Rodin's *The Thinker* under the Pyramid. "But when we installed a mock-up of the famous statue, the rather handsome effect from the entrance turned ridiculously scatological when seen from below," wrote Laclotte. *The Thinker* looked as if he were sitting on a toilet waiting for something to happen.

"Hopelessly empty" is how Laclotte's successor Pierre Rosenberg later described the pedestal.

Frankly, at forty years old, the Pyramid is showing its age. The outdoor terrace of the Café Richelieu is supposed to offer guests splendid Angelina pastries and an elevated perch overlooking the Pyramid. At a champagne reception there one evening, Laurence des Cars saw beauty, but also a crumbling structure in dire need of repair. From this high up, the dormant fountains that surround it were leaking too much to be turned on, making the Pyramid look shabby. "It's forty years old and has never been renovated," she told me. "It's old. It's falling apart." The estimated cost to restore it to its former glory: $50 million.

IMPRACTICAL THOUGH IT MAY BE, the Pyramid inspires and fascinates. In the words of one of its most passionate champions, the former *New York Times* art critic John Russell, "The glass is thin, the struts and supports look like the ankles of a gazelle, and the action of the light on and through the slanting panes of clear glass is never the same for two seconds together."

Philippe Carreau, the Louvre's chief architect, has studied the Pyramid's light for years. "In the mornings, when the sun lights up the small droplets of dew, it looks like a giant spiderweb," he said.

During the day, its glass panes might mirror puffy clouds, and one sees the color of the sky move from bright white to gunmetal. When the famous winter *grisaille* descends on Paris, the Pyramid can stay a stubborn cold metallic gray for months.

When the summer sun is determined to linger into night, the Pyramid's metal frame shines and sparkles, throwing shadows onto the stones of the pavement. Then the sun shines on the Pyramid from the west, and the facade changes color as the sun goes down. When the sunset is strong enough, it turns the metal frame a reddish color. At night, artificial lights bathe the Pyramid both inside and out.

"The Pyramid is happiest at night," Carreau said. "I started to see this phenomenon of light from the moment the Pyramid was built. I was very, very moved then, and I am still very, very moved. You rarely experience such a thing."

I call Carreau "Mr. Pyramid" because he is responsible for maintaining, cleaning, lighting, and polishing the structure. He also holds the keys to the Louvre's locks, supervises evacuations of artworks when the basements flood, oversees repairs to roofs and masonry, and monitors the plumbing and electrical systems.

The Pyramid is the most thrilling part of his job.

Carreau exudes cool in the buttoned-up Louvre. His high brush cut is flecked with gray. His eyeglass frames are bronze with brown polka dots. He wears corduroy sport coats with sober thin ties and black trousers even when he is investigating a problem with the Pyramid's lighting or climbing up scaffolding. His brown oxfords are worn and scuffed. The ringtone on his phone is the sound of violins.

From inside the Pyramid, Carreau showed me how the structure was built to maximize transparency. "If you look closely, you can see that there are very few thick supporting bars," he said. "Instead, there are many thin connecting tie-rods—as many as possible. They form an architecture very pure, very fine, very light, a bit magical, that makes you wonder how it stays put."

I. M. Pei was obsessed by lighting, Carreau said, pointing out spotlights in the walls and ceiling. Pei insisted on total transparency in the Pyramid's 118 glass triangles and 675 rhombus shapes, known as lozenges. "The presence of light during the day extends until night," Carreau told me. "The result is quite soft. It gives the Pyramid a futuristic feeling." Carreau described the Pyramid's glass as "extra white, the most transparent glass possible."

The French manufacturing company Saint-Gobain took two years to perfect the process of manufacturing what it calls "diamond glass." It built a special furnace capable of removing the iron oxides that tint and distort. On opening day, when misty clouds shut out the sun, Pei was delighted to see the clarity of his glass. "The Pyramid is even more transparent on a gray day when it takes on the moodiness of the Paris sky," he said.

Cleaning the Pyramid just might be the most difficult window-washing job in Paris. Carreau recognized the problem early on. In 1987, when he started out as a young intern at the museum, he chose "How to clean the Pyramid" as his project. On the inside are hard-to-reach

crevices. Outside, the panes must be washed at least once a month, more often in summer, when dust and sand kick up and stick like glue to the hot glass.

In the early years, the Louvre hired professional mountain climbers to help. But ropes, scaffolding, or a carriage system dropped from above didn't work. Robots saved the day, helped by human window washers who mount small remote-controlled cabins inside the Pyramid to get into the corners.

I saw the outside cleaning ritual up close one day when a nondescript white truck drove onto the Cour Napoléon and plugged into the Louvre's main water system. Didier Lacloche and Laurent Hirigoyen, technicians who work for a private company contracted by the Louvre, unrolled hoses from the inside of the truck, started the engines of machines that supplied electricity and distilled water, and pulled out the robot.

"The pressure's on, of course, and I have to stay focused," said Hirigoyen. It was his first time as the head of the cleaning brigade. "This is a very technical robot, and with one wrong move there's danger."

The 175-pound Swiss-made robot, created in 2019 and named GEKKO, is a motorized pioneer in window washing. It replaces an earlier version that was too weak to mount the 50-degree slope of the Pyramid's walls and frequently broke down. GEKKO functions with small blue suction cups arranged in two rings, one for rotation and the other for movement back and forth. The cups move like centipede legs. The robot has a long white rolling brush connected to a yellow cable and a long rubber apparatus that looks like a giant squeegee, hissing as it moves.

Lacloche moved the robot with control buttons on a large orange box strapped like an oversized fanny pack above his hips. As it climbed the steep incline up the glass Pyramid, GEKKO looked like a shiny Mars rover against the blue sky. It moved in unexpected ways: slithering like a snake, advancing rhythmically like a mechanical dancer, gliding straight ahead like a boat on a sea of glass. On their way into the museum, families with small children stopped to watch.

Lacloche and Hirigoyen agreed that their special time to visit the Louvre was in the quiet of Tuesdays, when the museum is closed. "It feels like I'm on a trip," said Hirigoyen. "Art, it's not really my field. How to put it—even if you don't really know the sculptures and the paintings,

you are carried away by the architecture itself, like you're alone in the world, traveling through these huge rooms. It's really this feeling of being very small, in an absolutely immense world."

Lacloche agreed. "It's special, when you're alone in silence," he said. "You need a lot of calm, you need silence, not many people around you. This is when you feel things. It might be a painting where you study the artist's pencil lines and paint, and the characters and their expressions. Paintings are like a book." Consciously or not, he echoed one of the most famous sayings about the Louvre, by Cézanne, who once referred to the museum as "the book from which we learn to read."

By the end of the day, the Pyramid was washed and dried, its clear panes gleaming. The two men surveyed their work.

"You feel as if there's a spirit here, the past stones of the Louvre clashing with the modern glass of the Pyramid," Hirigoyen said. "You're taken in by the ambience, the phantoms of the past."

"The Pyramid is the diamond of Paris," Lacloche added. "It's the jewel; it's modernity. And we love this diamond. We made this beautiful diamond brilliant." The day was gray, but sometimes, when the work is finished, when the Pyramid glass is sparkling clean and the sun shines bright at just the right angle, he sees rainbows.

He pulled out his iPhone and showed me close-up photos he had taken of tiny, brightly colored rainbows steaking across the glass panes.

"So very pretty," he said. "I'm so lucky to work here."

Later Lacloche sent me an email with photos attached and the words: "I am sending you the rainbows of our beautiful diamond."

The Three Graces, a trio of painted cork sculptures by Portuguese artist Pedro Cabrita Reis, installed as a temporary exhibit in the Tuileries Garden in 2022. *Juan Rodriguez*

CHAPTER 8

◆◆◆◆◆◆◆◆◆◆◆◆◆◆◆◆◆◆◆◆◆

The Open-Air Museum

"You wouldn't believe, sir, the respect everyone holds for this garden.... People come here because they are sick and need fresh air; they come to talk business, weddings, and all sorts of things that are easier to bring up in a garden than in a church."

—**Charles Perrault,** the children's fairy-tale author, on why the Tuileries should stay open to the public, *Mémoires de ma vie,* 1669

THE SUN DOESN'T SHINE IN PARIS IN FEBRUARY—A CRUEL TRICK played on those who are not forewarned. Paris is a northern city, at about the same latitude as Vancouver or Winnipeg. When winter comes, the short days combine with persistent clouds to rob the city of sun and light. By February, desperation sets in.

But on the day in mid-February when the Portuguese sculptor Pedro Cabrita Reis unveiled *The Three Graces* in the Tuileries Garden, the air was clear and the sky a pure cold blue. The sun caressed his fifteen-foot-tall works of fantasy and flight, freeing them to shine. *The Three Graces,* goddesses of beauty, are usually portrayed in human scale, intertwined and embracing each other, but Cabrita Reis's *Graces* were separate, independent, genderless beings, made of cork. To achieve the color of his *Graces* and make them communicate with the

yellow-gray stone of the Louvre and the white marble of the more traditional statues in the Tuileries, Cabrita Reis experimented with one hundred different shades in his studio in Lisbon. He landed on a near-pure whiteness softened by the slightest hint of the orange cork that lay below. "This work is a nod to the multitude of sculptures in the Tuileries—the bronzes, the marbles," he said. "It is a tender, joyful, ironic gaze that creates a chromatic relationship between the Louvre and the Tuileries."

The symbolism works. The Tuileries, a sixty-seven-acre rectangle of a park, with statues, basins, fountains, rows of trees, flower beds, and a broad central walkway, is a natural front yard for the Louvre. But it has become much more than that. Since 2005 it has been a part of the Louvre, administered by the museum. This is logical, because the Tuileries Garden includes the former site of the Tuileries Palace, which was once connected to the Louvre. A small part of the sixteenth-century facade of the Tuileries Palace, with Ionic columns and an arch, sits unnoticed along a wall near the Seine side of the garden.

The museum uses the Tuileries, one of the greatest sculpture gardens in the world, as an informal outdoor wing. At the same time, it remains a public park, a comfortable place to congregate, a pleasant stretch of greenery. Unlike the Louvre itself, which many Parisians consider too ambitious for amusement and tend to avoid, the Tuileries feels like a city garden. Every year, about fourteen million people, Parisians and tourists alike, enter the Tuileries, making it the most visited garden in France.

The Tuileries is anchored by landmarks: Napoleon's Arc de Triomphe du Carrousel in the Carrousel Garden on the east, the Jeu de Paume and Orangerie galleries on the west, the rue de Rivoli on the north, and the Seine on the south. From the place de la Concorde, with its obelisk sculpted for the Temple of Luxor, it takes twenty minutes to walk straight through the Tuileries to the other "Egyptian" monument—the Louvre Pyramid.

But seeing the Tuileries sculptures requires time to wander. There are paths to explore and quiet corners to find. I have discovered hidden masterpieces on manicured lawns and stone terraces behind the trees.

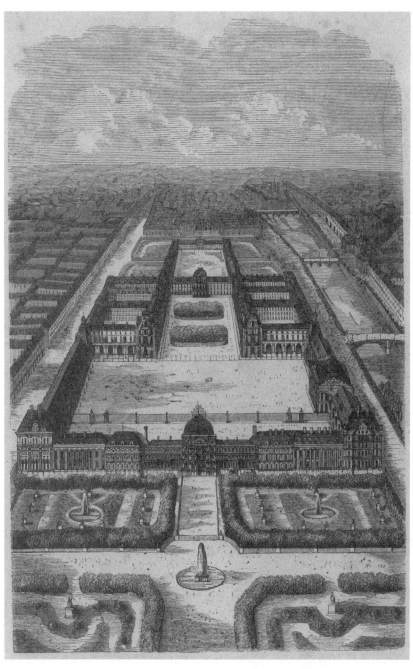

Engraving of the Louvre connected to the Tuileries Palace before it was burned
down by the Paris Commune, with the Tuileries Garden in the foreground.

The park follows a certain rhythm. At dawn, joggers and dog walk-ers pour through the metal gates minutes after they are opened. Then small green trucks with canary yellow wheels and seats, huge white panel trucks with emergency lights, and heavy tractors take over as teams of technicians, gardeners, and other workers start their day. The regulars take their seats in front of their favorite basin or sculpture. Schoolchil-dren rush to the playground. The outdoor restaurants start serving. On any given day, you might find yoga classes, tai chi sessions, author read-ings, free tours.

There is a seasonal rhythm as well. The first sign of spring comes in early March, when buds and then leaves burst from all species of trees, and the gardeners manicure the shrubs and bushes. By the end of the month, rosy-pink flowers that look like peapods cover the branches and trunks of the Judas trees; their heart-shaped leaves bloom forth in a reddish-brown hue. April brings tulips, cherry blossoms, white daffodils, and white and pink flowers on the horse chestnut trees. In summer, the garden shows off bright colors that evoke the exhibits in the museum. Then heat and drought can choke the chestnut trees and force them to shed their leaves too soon.

I once asked Isabelle Glais, one of Paris's most senior horticulturalists and the former deputy director of the Tuileries, to show me her favorite spot. She took me to an area near the Seine to see what looked like a giant dead oak tree that had fallen to the ground. Anyone could come there, she said, but a group of regulars gathered every day. She pointed out their cluster of chairs, shaded by trees and facing the tree trunk. "This spot belongs to them," she said.

The dead oak was a sculpture, a bronze cast of a 45-foot-long uprooted tree, created by the Italian sculptor Giuseppe Penone. As it oxidized, it turned the color of bark. *The Vowel Tree*, it is called. More than two decades ago Penone planted five different species of tree at the tips of each of the sculpture's five branches. They have matured into shade trees, making it several degrees cooler here than in the wide-open promenade. An unusual medley of ferns, Corsican helle-bores, and Himalayan brambles subversively transformed the bronze cast into the elegance of a contemporary wild garden. "The five live

trees are part of the work," said Glais. "As soon as there's a little wind their leaves tremble. It's life restarting from death. I feel calm here. I know that I am in the heart of Paris, but it is as if I were transported to a small forest."

There is something special about outdoor sculptures. Passersby, not gallerygoers, encounter them. The artworks invite you to get close. The Louvre is forever fretting over its Tuileries collection. People climb on artworks or paint them with graffiti. Wind, frost, snow, and bird droppings erode them. The most damaged marble statues have been removed, some replaced by molded replicas made of resin and marble powder.

Every sculpture tells its own story.

Many visitors do not realize that the landscaped area bordered by the Louvre's two long wings, Marsan and Flore, is not the Tuileries at all, but the separate Carrousel Garden, once the main courtyard of the Tuileries Palace. In the 1960s, France's culture minister, André Malraux, decided to transform the space into an outdoor exhibition space for Aristide Maillol. Declaring him to be one of the greatest sculptors of his age, Malraux approved the installation of eighteen of his powerful female nudes. The Carrousel Garden now has the world's largest outdoor collection of Maillol's works.

In the Tuileries, *The Welcoming Hands* by Louise Bourgeois tells a different story. Bourgeois created the work for Battery Park in New York, across the water from the Statue of Liberty. Bourgeois, herself an immigrant, made the hands as a symbol of welcome to new arrivals in the United States. But officials of the nearby Holocaust Museum were concerned that the hands looked like severed body parts and could evoke the tragedy of Nazi death camps. So in 2000, *The Welcoming Hands* left New York for the Tuileries. The hands spring from granite blocks and are installed in a clearing near the Jeu de Paume where several paths come together. To see them you must get up close, behind two lines of trees. The hands tempt you to touch them, which is just what visitors do.

On one of my visits, Emmanuelle Héran, the curator in charge of the garden's collection, showed me a corner that she loves: a playground with a kid-friendly monument to Charles Perrault, the author of some of

the most well-known fairy tales in the world: *Puss in Boots, Cinderella, The Sleeping Beauty.* The marble monument includes a bust of Perrault; three girls dance around him, as Puss in Boots in a feathered hat and little mouse necklace, a huge rat hanging off his belt, smiles. When Perrault served as clerk to the powerful government minister Jean-Baptiste Colbert in the days of Louis XIV, Colbert wanted to close the garden to the public. Perrault persuaded him to keep it open.

"Look at how the strong blue of the sky contrasts with the shiny white of the statue," Héran said of the monument. "I have the most beautiful office in the world."

The museum also projects itself into the Tuileries through plantings in the 60,000-plus square feet of flower beds. A team of "gardeners of art" plays with the colors of thousands of bulbs and biennials as if they were paints on a palette, harmonizing them with art inside the museum. For the blockbuster Leonardo da Vinci exhibition in 2019 and 2020, gardeners celebrated the landscape in the *Mona Lisa* through a "valley of mysteries" with orange zinnias, yellow dahlias and petunias, and green-brown touches of morning glories. For *The Virgin and Child with Saint Anne,* they planted verbena, sage, and cosmos to mimic the artist's brushstrokes and evoke the soft colors of the skin tones in the painting's figures.

The following year, for an exhibit on Italian Renaissance sculpture, the gardeners of art chose shades of red for violence, pink and mauve for calm. They rendered the broken spirit of Michelangelo's *Rebellious Slave* with hollyhocks, spiderflowers, and sage. The spirit of war in the sarcophagus of Achilles, the mythological Greek warrior, infused a pink, red, and pearl-gray flower bed using jasmine tobacco, dahlias, petunias, begonias, coleus, and cineraria. In 2022, to mark the bicentenary of Jean-François Champollion's translation of Egyptian hieroglyphics, the gardeners planted papyrus among the flowers.

"The gardeners have to be inspired by the works of art," said Franck Boyer, the longtime artistic gardener at the Tuileries. "Nothing is improvised. We have to study the color palette, the shapes, the height. We have to look at a catalog of plants and choose. Then there has to be a sequence, a repetition of patterns, like a musical composition."

❖

IN THE SEVENTEENTH CENTURY, UNDER Louis XIV, the master land-scape gardener André Le Nôtre used perspective and geometry to design the Tuileries Garden into the ordered space that it is today. He created walking paths, ponds, geometrically shaped lawns, neat patterns of flower beds, and trees lined up like soldiers standing at attention. It became Paris's first public garden, though with limits: servants, soldiers, and paupers were not allowed.

Le Nôtre also concocted a buff-colored material called *stabilisé* to pave his paths. A combination of gravel, sand, and whitewash, it was a great convenience in his time: the courtesans and their clients who frequented the garden could avoid walking in mud. Le Nôtre did not envision that trucks and tractors would one day drive along his paths kicking up dust, or that millions of people would collect whitish layers of *stabilisé* on their shoes. On windy days it blankets topiary and creeps into the Pyramid entrance. It coats the leaves of the shrubs and trees and sticks like dusty glue. You can hear the crunch of the tiny stones as you walk on it.

Stabilisé also dazzles and heats. It reflects the sun, making the paths burn hot and the light strong and the garden like a sand-choked desert. "It's so bright that it reverberates," said Louvre historian Daniel Soulié. "It's dangerous for the tree trunks. It creates tornadoes of dust. In the summer, there are times when the reverberation of the sun on the ground is so strong that I am blinded and see nothing!"

But Le Nôtre's rules still reign, and the *stabilisé* stays.

Le Nôtre also brought in horse chestnut trees—considered exotic at the time—which became predominant. But chestnuts are difficult to prune and get old and sick from diseases and parasites. Some remain, but they are no longer planted here. The original rows of trees that once lined the Grande Allée at the center of the garden are gone, too, chopped down during the French Revolution and never replaced. These days, trees are planted every year under an initiative to restore the barren walkways to leafy lushness. The Tuileries now has three thousand trees, but it will take time to fill in the many open spaces that offer no shade.

Fifty percent of the park's surface is planted, compared to 71 percent in its earliest years.

I learned about the trees from Françoise Dauphin, a gardener in her early sixties with the trim, toned body of a competitive hiker. She has worked in the Tuileries since 1995. On the day of my visit, she armed herself with a rubber-tipped hammer and a long, thin metal pole with a pointed end to test the health of tree after tree. She poked the bases of the trees to test for rot and hit the trunks with her hammer to hear whether they sounded empty. "Chestnut trees, plane trees, linden trees—they all sound different," she said.

She came across a dead chestnut tree killed by a mushroom fungus that had invaded its roots. "You hear that sound?" she asked as she pushed the pole deep into the roots. "It's not the same as the others. When it is hollow, it makes a duller sound. It's a question of training your ear, just as if you were a musician."

Animal life comes and goes in the Tuileries, too. Goats are imported in the warm months to graze on steep inclines too difficult for lawn mowers to navigate. Birds range from tough survivors like pigeons, ducks, and crows to the occasional great blue heron.

The Tuileries has housed honeybees for several years, offering six hives and a fenced-in patch of weeds and wildflowers. The honey they produce is not nearly enough to sell, so it is usually given to employees. Even pesky insects figure in Tuileries lore. Dalí spent at least one month a year at the luxury hotel Le Meurice on the rue de Rivoli, across from the garden, regularly traveling with his pet ocelot. On one occasion he asked the hotel staff to catch flies in the Tuileries for the ocelot's snacks. He paid 5 francs per fly.

I ONCE ASKED SOULIÉ IF he knew other offbeat stories about the Tuileries. He told me about the terraces looking toward the place de la Concorde. "The terraces were the places with the best view for the public executions during the Revolution," he said. It was there, apparently, that people gathered to watch the guillotine in action.

The terraces on the other side of the Tuileries not far from the

Carrousel arch became a meeting place of a different sort. "The terraces historically were a place of prostitution, and evolved into the most famous gay meeting place, perhaps in the 1930s," Soulié said. In *The Flâneur*, the American writer Edmund White described how he spent some of his "happiest moments" making love to strangers in hidden but public places in Paris, including the Tuileries. "At night the whole place rocks," he wrote, "or did, at least, when I was still motivated to jump over the fences and prowl (illegally) the moonlit pathways between ancient and modern statues or circle the mammoth round pond in which prehistoric carp doze in the ooze and surface in a feeding frenzy only when someone scatters breadcrumbs."

Today the park plays host to festivals. In summer, the Fête des Tuileries funfair takes over with a giant Ferris wheel and carnival rides. The Jardins, Jardin gardening festival attracts vendors selling wares like trees, house plants, tools, books, and planters. The French company Edmond & Fils participates with its replicas of the chairs in the Tuileries and Luxembourg Gardens, painted in their distinctive greens. Those at the Luxembourg are dark like spinach, while those at the Tuileries are the color of a spring fern.

All year long, unsanctioned entrepreneurs sprinkle themselves around the park. One day a young man from Serbia demonstrated a portable tennis training device with a base and an elastic rope attached to a racket and a ball; he sold them out of a duffel bag for 20 euros each. A vendor from Bangladesh hawked 1-euro bottles of water. A Romanian accordionist played "La vie en rose" under the Carrousel arch.

Visitors often must sidestep small bands of female pickpockets with the quickest of fingers who tend to congregate around the plaza in front of the Carrousel arch. They work in teams of two and dress inconspicuously—sneakers, parkas, hats, loose-fitting camouflage pants. They carry clipboards with phony petitions showing writing scribbled in pencil. "Excuse me, do you speak English?" one asks, and if you stop to say yes, she thrusts the clipboard in front of you while her partner slips a hand into your pocket or purse to nick your phone or wallet. If you shout "No, no!" they usually reply with vacant looks and move to their next target.

The Tuileries teams have given them the code name P, for "pick-pocket." Code T, by contrast, stands for *tour*, or "tower"—the sellers of souvenirs like miniature Eiffel Towers. Although both activities are illegal, the Ps are shooed away or arrested; the Ts are tolerated.

In my exploration of the Tuileries, I never know who I will meet along the way. One brutally hot afternoon in June, as I struggled to find a patch of shade under a meticulously pruned evergreen wall, I watched four young musicians set up their instruments: bass, saxophone, drums, a compact piano on wheels. They began playing American jazz lounge music, starting with "There Will Never Be Another You."

I wondered how long it would take before the security police ordered them to move on. Ten minutes. I caught up with the musicians as they were packing up. They were Danes in their early twenties, busking their way through Europe. They had performed—and slept—on the street the night before. They spoke English but no French, and the police spoke no English, so I explained to them the city's ban on performing in public without authorization. They thought the rules were rather unfriendly.

"We like to get out to people who don't usually listen to jazz," said Oscar Balund, the pianist. "We play in parks and restaurants and weddings."

"And funerals," said Rasmus Kirkholt, who plays saxophone. "We did a pretty nice funeral that had really good vibes."

I asked them if they had gone inside the Louvre. They had not and had no plans to do so.

"Not even to see the *Mona Lisa*?" I asked.

"Oh my God!" said Kirkholt. "The *Mona Lisa* is in there?"

"We'll do it when it rains," Balund told him. "Promise!"

Arc de triomphe de la place du Carrousel.

The Arc de Triomphe du Carrousel, in the Place du Carrousel,
at the edge of the Tuileries Garden, built between 1806 and 1808
to celebrate Napoleon Bonaparte's military victories.

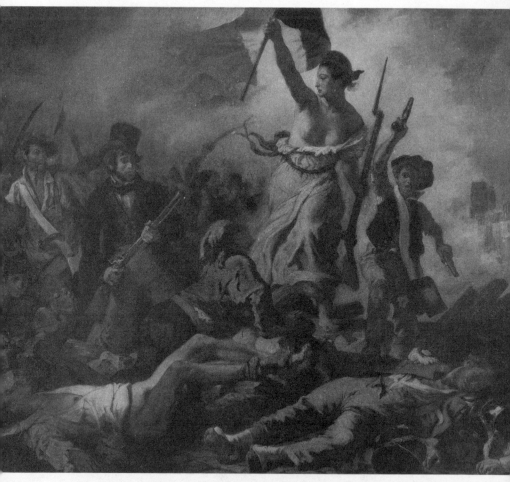

Liberty Leading the People (1830), by Eugène Delacroix, shows a bare-breasted woman wearing a Phrygian cap and carrying the tricolor flag of the French Revolution of 1789 in one hand and a bayoneted musket in the other. The painting celebrates the July Revolution of 1830 that overthrew King Charles X. © *RMN-Grand Palais / ArtResource, NY*

◆◆◆◆◆◆◆◆◆◆◆◆◆◆◆◆◆◆◆◆◆

A Strange Construction

The Louvre, by its nature, can never be completed. . . .
The uniqueness of the Louvre comes from this motion that never stops.
—Laurence des Cars

THE TEAM OF FRENCH SCIENTISTS IN A HIDDEN LABORATORY BELOW A wing of the Louvre held in their gloved hands the unframed canvas of the most expensive work of art ever sold at auction, the *Salvator Mundi*. Described at its sale as a rediscovered masterpiece by Leonardo da Vinci, the painting was purchased in late 2017 by an anonymous bidder paying more than $450 million—an obscure Saudi royal acting as a surrogate for Mohammed bin Salman, the kingdom's crown prince and de facto ruler. After the record-setting bid, the painting disappeared from public view.

Then, in mid-2018, it resurfaced, secretly, at the Louvre. The museum closeted it in a well-hidden underground wing known as C2RMF—or Center for Research and Restoration of the Museums of France—an independent institute connected to the Ministry of Culture.

The scientists used fluorescent X-rays, infrared scans, and digital cameras aimed through high-powered microscopes to match signature details of the materials and artistic techniques in the *Salvator Mundi* with the Louvre's other Leonardos.

The investigation was so secret that the scientists as well as the employees at the center of it were required to sign nondisclosure agreements and

never to mention the painting by name. Someone nicknamed it Voldemort, aka He-Who-Must-Not-Be-Named, the archenemy of Harry Potter. The name stuck.

After weeks of careful study, the scientists concluded with more authority than in any previous analysis that the *Salvator Mundi* was a genuine work from Leonardo's own hand, according to a confidential forty-six-page report on the investigation a colleague and I obtained for a front-page story in the *New York Times*.

The Saudis were delighted. Once authenticated, the painting was intended to be the star of the Louvre's 2019 Leonardo exhibition. Its image was to be the cover of the catalog. But it never happened. Power and ego got in the way.

The Saudis, unaware that the *Mona Lisa* was not to be part of the special exhibition, demanded that their newly acquired trophy hang next to her. The Louvre said no. *Mona Lisa* would remain in the secure position dedicated to her. The Saudis' painting belonged in the special exhibition on a different floor, the Louvre said, not alongside the most important painting in the world. After months of negotiations that went all the way up to Emmanuel Macron, the deal fell apart.

Although the Leonardo show went on as scheduled, the public didn't get to see *Salvator Mundi*, which remains hidden. But the episode revealed the sophisticated ability to authenticate art in the bowels of the Louvre.

THE SCIENTISTS HAD PLENTY TO work with at C2RMF.

The entrance to the three-story, high-security center is purposely discreet, near the Porte des Lions under the western part of the Grande Galerie. If you are not actively looking for it, you might never notice it. It's accessible through a double-armored door and a guarded post before one enters through a long concrete corridor.

During a private, daylong tour of the facility, I saw the full range of its activities. In the painting restoration wing, a master artisan worked in an open atelier with twenty-foot ceilings and huge windows facing the Seine. There she simultaneously wiped large swaths of a Monet canvas from the Musée d'Orsay clean of yellowed varnish and tested various varnish-removal methods in small patches on a Delacroix.

In the furniture restoration workshop, a wood and brass expert gilded strips onto the decorative legs of a Louis XV desk from the Château de Chantilly.

Below, in a high-tech archaeological restoration lab, another artisan removed encrusted oxidized copper deposits from a mask that had been worn by a Gallo-Roman horseman.

In addition to the restorers were the scientists, who worked with equipment like an electron microscope and a carbon evaporator.

I peeked into a studio where two women used infrared photography to search for Egyptian blue pigment traces on an ancient Greek dove; when they turned off the overhead lights and turned on black lights, the dove turned a Day-Glo purple-blue.

I saw one lab with rows and rows of test tubes, for a mass spectrometer that could find minuscule traces of any material; another lab with a scanning electron microscope where the researcher was delighted to show off that she had just found traces of yttrium, a rare earth element, in a funerary mask.

Farther down to the deepest and most hidden part of the center, a windowless basement fifty feet belowground was the most spectacular surprise. There I saw an apparatus in silver and blue unexpected in a museum: an 88-foot-long particle accelerator. It's called the AGLAE, short for Accélérateur Grand Louvre d'analyse élémentaire.

The only particle accelerator in the world dedicated exclusively to artistic investigations, AGLAE has worked in secret and round the clock since its installation in 1988. It has beamed noninvasive protons and alpha particles in a quest to determine the composition, authenticity, provenance, and age of works of art from museums around the world, including the J. Paul Getty Museum, the Metropolitan Museum of Art, and, of course, the Louvre.

Louvre scientists have used the accelerator to study ancient Roman votive statues; shiny, metallic, kiln-fired lusterware from ninth-century Mesopotamia; and decorative paint on 2,500-year-old ivory tusks.

The accelerator has verified that the scabbard of a saber that belonged to Napoleon Bonaparte was cast in solid gold. It has identified the minerals in the eyes of *The Seated Scribe*, a 4,500-year-old Egyptian sculpture (white magnesium veined with red lines of iron oxide for the corneas and black rock crystal for the pupils), and determined the provenance of a perfectly preserved, 6,000-year-old Neolithic necklace in a green stone

called variscite that was found in Brittany but mined far away, in the Iberian Peninsula.

Banks of monitors covered desks and hung from the walls. On the monitors were schematic diagrams of the accelerator indicating the status of each component, shifting graphs, blobby abstract-looking blue-green-yellow images from the analysis. A periodic table diagram with the names of the discoverers of the elements was pinned on a wall.

A door with a three-color signal light indicated whether the accelerator was running, with nuclear symbols warning if access was forbidden or authorized. Then came a U-shaped corridor with two-foot-thick walls leading to the accelerator itself.

There, a giant tubular steel tank lay sidewise near the start of the particle's trajectory. Just to its right, where the particle started its motion, was a bird's nest of cables and steel components. Leaving the tank, the particle passed through a long loop and then straight through a steel tube into a separate, walled-off section of the accelerator, where it crashed into whatever material was to be analyzed. At the end of the unwieldy apparatus, at least ten different sensors converged directly on that point to determine the result.

The accelerator would be one of the Louvre's most spectacular acquisitions if not for one thing. It does not belong to the Louvre. Even though it occupies Louvre real estate, it is part of the Culture Ministry's C2RMF.

For France, this arrangement is not unusual. The Louvre itself is a public institution, not an entirely independent entity. It does not control what lives in its space. In the case of the accelerator and the other labs, the Louvre gains advantage from providing room; the scientists it needs are within walking distance. But in other instances, the way it must share its space can seem quirky or even intrusive, at least to Americans used to private art institutions that determine what transpires within their walls.

The École du Louvre, a prestigious *grande école* dedicated to the study of art history, anthropology, archaeology, and museum studies for 1,600 students, is settled in the Flore wing. Across the Tuileries, the Musée des Arts Décoratifs, devoted to fashion, design, and the arts, occupies the long northern arm facing the rue de Rivoli. Neither institution is part of the Louvre.

I don't know if the Louvre is a reluctant host. But even though it is a

massive, sprawling building, the people who run it are always complaining that they don't have enough space to show art.

AND THERE IS MORE. HISTORICALLY, the Louvre's limited independence has determined its identity.

The Louvre is not and never will be the Met, its counterpart in New York. The Met's collections span the history of the entire globe, from the Paleolithic era, as early as 300,000 BC, all the way to the twenty-first century, from the Americas to China. The Louvre's mandate is to focus on Western art and the ancient civilizations—Mesopotamia, Egypt, Rome, Greece—that are at its origins. Its oldest work of art is a Neolithic statue of a human that was excavated in 1985 at Ain Ghazal near Amman, Jordan, and is about nine thousand years old. Made from gypsum plaster, the statue has eyelids and pupils of black bitumen. Its face looks like an elongated version of E.T.; its body has short, thick legs and fat feet. The contemporary artworks are also limited. With few exceptions, the collection ends in 1848. "The Louvre is absolutely not a universal, encyclopedic museum," Laurence des Cars told an audience in 2023. "It's full of gaps."

The Louvre's first mission is preservation and conservation; innovation and expansion follow. Unlike a private museum in the United States, it is forbidden to sell off its works of art to raise money, because state-owned art collections in France are "inalienable." The French president, not a board of directors, decides who will head the institution.

You cannot define the Louvre by only stating what it is. You also have to understand what it once was and what it is not.

By one measure, the museum became a victim of its own success. For a time it was the greatest repository of art in the world. But in the middle of the nineteenth century, the Louvre was overloaded.

Archaeologists had begun sending home treasures from around the world, adding more as French imperial and colonial expansion in the Middle East, North Africa, Mexico, and Southeast Asia brought them new territories to explore. Mini-museums grew up in the Louvre, which later motivated it to shed some of its holdings and send them elsewhere.

The process continued for almost a century, transforming the Louvre and narrowing its focus again and again.

You won't find prehistoric art in the Louvre. When the scientific community became interested in prehistoric times in the second half of the nineteenth century, Napoleon III dedicated a new museum to its study by imperial decree. Located in Saint-Germain-en-Laye, it lives on to this day as the National Archaeology Museum.

In the first half of the twentieth century, the Louvre shed many of its smaller, more eclectic collections. Among them were the museum's non-European ethnographic works and the popular Musée de la Marine, which showcased scale models of ships and the wealth and technical know-how of the French navy. For some time, the Louvre also had a large department devoted to Central Asian, Indian, and East Asian works of art. When, in 1945, art historian Georges Salles was named the director of the Musées de France, an institution created after World War II to manage the national collections of fine arts, he moved away from the idea of the Louvre as a universal museum and outsourced more chunks of its collections. That same year, the Asian collections were transferred to the Musée Guimet on the place d'Iéna in the Sixteenth Arrondissement, where they are today. The Louvre's eastern borders now stop at Iran.

Added to this dispersal of parts was the tragedy of the loss of the Spanish collection. King Louis-Philippe, who took the throne after a revolution in 1830 as the "citizen king," launched a personal campaign to bring together the Louvre's first comprehensive collection of Spanish art. Inaugurated in 1838, the Spanish Gallery contained 454 paintings, including nineteen masterpieces by Diego Velázquez. After still another revolution in 1848 overthrew the monarchy, Louis-Philippe fled to England in disguise and took the Spanish collection with him, arguing that he had bought it with his own money. After his death, his heirs auctioned off his collection at Christie's in London in 1853. The anti-monarchical French Republic made no effort to buy it back.

"The gaps in the Louvre collections are cruel," wrote former director Pierre Rosenberg. "The saddest is without a doubt Velázquez."

But by far the most dramatic loss for the Louvre came after World War II, when its impressionist and post-impressionist paintings moved out. In 1947 they were installed in the Jeu de Paume, then an annex of the

Louvre close by in the Tuileries Garden, and finally relocated in 1986 to a defunct train station on the other side of the Seine that was remodeled into the Musée d'Orsay.

Both Leonardo and Manet had once hung in the Louvre. But the French government decided that the Louvre's collection should end in 1848, a defining year of political upheaval in Europe and a logical dividing line for a new era in art.

There were tense negotiations about what other works might also be removed from the Louvre. President Valéry Giscard d'Estaing once asked Louvre director Michel Laclotte where in the Orsay he would put Delacroix's *Liberty Leading the People*, painted in 1830. "I am not putting it," Laclotte replied. The Delacroix belonged in the Louvre, and that's where it stayed.

The losses were painful. "The Louvre progressively lost a part of its ambition at universality," declares the official three-volume history of the Louvre. Former director Henri Loyrette, an expert in nineteenth-century painting, was more dramatic. "It's like when your arm gets cut off, but you still feel it," he told me.

Perhaps because the Louvre is so big, many visitors overlook or are ignorant of those gaps, but museum professionals are deeply aware of them. Former British Museum director Neil MacGregor called the decision to stop the collection in 1848 "extraordinary."

"Extraordinary bad or extraordinary good?" I asked.

"Well, it's impoverishing," he said. "If you want to look at a history of European painting or drawing, or whatever, you want to see the long continuities of cultural creation. Here, you are cutting off the culture of the past from the last two hundred years."

To see in Paris the same broad representation of art across time and place that is on display in New York's Metropolitan Museum of art or the British Museum, you have to visit not just the Louvre but several museums. The millions of visitors who line up every year to get inside the Louvre are not complaining about what is missing.

The Louvre has gaps; but walk around and be dazzled by its art. There can be only one conclusion. The museum still fulfills the original, intended mission assigned to it in 1793 and ingrained over decades and centuries: to bring art to the people.

What remains is more than enough.

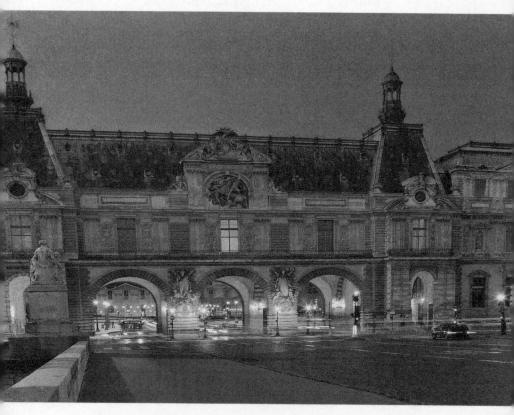

The Louvre facade as seen from the Pont du Carrousel. An area normally buzzing with people during the day is serenely quiet after dark. © *Gary Zuercher, glz.com, Marcorp Editions, marcorp-editions.com*

CHAPTER 10

◆◆◆◆◆◆◆◆◆◆◆◆◆◆◆◆◆◆◆

Le Louvre *La Nuit*

The night disquiets and surprises us with its otherness. It releases forces within us which by day are dominated by reason.
—**Brassaï,** twentieth-century photographer of Paris

THE LOUVRE'S PERSONALITY CHANGES AT NIGHT. BY DAY, ITS GALLER-ies are clogged; visitors hurry through its corridors. The atrium under its Pyramid is a cacophony of chaos. The place is nervous, confused, and frazzled.

At night the crowds leave. The doors shut. The pace slows. Only watchmen, repairmen, and firefighters remain. In the dark and solemn silence, the museum is serene. But the Louvre does not sleep. It has the irresistible, irrational power to trigger the imagination.

The Louvre is a perfect place for ghosts.

I confess, I believe in ghosts. So I wanted to know: Do ghosts wander the halls of the Louvre at night? The night watchman who was intro-duced to me as Monsieur C swears they do. He said he has felt their pres-ence and heard their sounds.

I met Monsieur C late one evening when I was at the Louvre to watch the cleaning of the Pyramid. The cleaners told me they had never been inside the museum or seen the *Mona Lisa*. I wondered aloud if a midnight tour might be possible.

Monsieur C laughed, leaving it to his younger partner to respond.

"At this hour, *Mona Lisa* is sleeping," the younger man said. "She's a lady of a certain age, you know. Tomorrow she will have plenty of visitors to welcome. She will have to smile for them. She needs her rest."

Eager to keep the conversation going, I asked the question that was really on my mind.

"Are there still ghosts in the Louvre?"

"Always!" Monsieur C replied, looking me straight in the eye. He was not laughing. "We hear them from time to time."

"Really?"

"Yes, yes. Really. I'm not kidding."

"I am of one hundred percent Sicilian origin," I told him. "We are very superstitious people."

He picked up on this. "You know, I've been working nights for almost twenty-five years," he began. "When you are a young night agent, the older guys tell stories to get you scared. But for years there have been weird phenomena, yes, happening at night. I'll give you an example. You are in a certain spot, and you know that no one is on the floor above you. It's the attic, and it's empty. The alarm system is on, and every movement is monitored by alarms. And then you hear furniture moving. I tell you, you hear chairs being pulled out and tables being pushed around when there's nobody! It's empty! It's the attic! And there are alarms, but they don't go off! And there's no logical explanation!"

He paused and lowered his voice. "It is one of the mysteries of the nights in the Louvre."

"Of course, it's true there are supernatural events in life that cannot be explained," I said.

"Exactly," said the young colleague. "Older guards who have left also lived through inexplicable phenomena. One was doing his rounds and felt someone trying to pull his Maglite flashlight out of his pocket. He felt it spinning. But there was no one there. He was sure. When he told us the story, he was sweating."

"Yes, that's a true story," said Monsieur C.

A Louvre official accompanying us said that she had her own story to tell. "It sounds crazy," she said. "It was two a.m. and we were rehearsing a shoot for a television show. It was going badly. The journalist was

hungry and there was nothing to eat, and the director tells me, 'Please, do something,' so I say, 'Hey, let's go see the *Mona Lisa*. This never happens, but let's do it.' So, I take her to see the *Mona Lisa*, and she stays in front of it for a long while. After we leave, she tells me, 'I saw her move.' She said she had seen *Mona Lisa* move! The problem was that I had seen her move, too."

Monsieur C recalled an incident when he was responsible for the door into the Grande Galerie. "It is a monumental, heavy wooden door that was a bit warped, very difficult to open and close. So we left it partially open when we did our rounds and closed it when we were finished. One night when I was making the rounds with another guard, we suddenly heard the door slam. BAM! With enormous force. There are plenty of stories like that that feed the mythology of the Louvre at night. It's a place so deep into history that you can't just say to yourself, 'No.' Believing makes perfect sense."

By this time he was overcome with excitement, and he told an even wilder story about a levitation. "One night a guard on the team felt his body was moving through space, but he wasn't walking. His body was moving in air all on its own. It was in . . . it was in the colonnades."

"The colonnades?" I asked.

"Yes, we were in the ancient Egypt galleries. There is a real mummy there, and it is a place where there are often supernatural phenomena, doors slamming, things like that."

TELLING GHOST STORIES IS A way for night guards to pass the time. "Being alone with a flashlight and just one person in the Louvre was magical, but at the same time, terrifying," the artist Jean-Michel Othoniel, who was once a Louvre guard, told me. But it wasn't just ghosts—there was real crime. "Maybe five or six years before I came, a big crime happened in the Apollo Gallery. Someone broke the windows and came into the gallery, took a sword, and when the guard came, he used the sword on him."

I looked up the story and indeed, in December 1976 three masked burglars broke into the Louvre at dawn. They climbed a cleaning crew's

scaffolding, smashed unbarred windows, clubbed two guards, broke a glass showcase, and grabbed the diamond-studded sword of King Charles X, leaving behind his stirrups and saddle. The sword has never been recovered. It is listed on the Louvre website as "not on display."

For centuries word had it that two Médici queens—Catherine and her distant relation Marie—contributed to the invasion of the ghosts.

In the 1500s the "phantom of the Tuileries" haunted Catherine's new palace and predicted her untimely death. According to legend, he was said to be Jean l'Écorcheur, or Jack the Skinner, a French Sweeney Todd who had worked in a slaughterhouse near the palace. Catherine had made him one of her preferred henchmen. The story goes that she suspected he knew too many royal secrets and ordered his execution. He told his executioner he would return from the dead, and he did, a ghost bathed in blood, earning the nickname "the little red man of the Tuileries." He taunted the queen until her death.

Later the phantom appeared to Marie Antoinette shortly before the fall of the monarchy and to Napoleon Bonaparte before the Battle of Waterloo. In May 1871, as the Tuileries Palace burned, the phantom's silhouette was seen by several witnesses before he disappeared forever in the flames.

The Louvre's Galerie Médicis, which displays the colossal canvases by Rubens on the life of Marie de Médicis, is also said to be haunted. Even during the day.

"One day, ten or fifteen years ago, one of the guards sees a guy dressed like he was in the seventeenth century," Monsieur C said. "We always have weirdos who come to the Louvre dressed in historical costumes, and it's always funny. The guard asks another guard, 'Did you see that guy go by?' and he says, 'No, I haven't seen anyone at all.' Then later a third guard, who had nothing to do with the first, sees the same guy dressed the same way.

"They did some research. It looks like he was a marquis, and he came often. One night there a colleague said to me, 'That's where the marquis was!' And he began to yell, 'Monsieur le Marquis!' I had to tell him, 'Stop!'"

It was cold that night underneath the Pyramid, where he was telling this story, and he had me spooked. "I am a former war correspondent, and I know how to deal with the enemy, but not with ghosts," I said.

"No need to worry," said Monsieur C. "At the moment, we don't have any bad ghosts."

I was having a lot of fun, more fun than I usually have at the Louvre, which is normally a deadly serious place.

"Do you know Belphégor?" I asked him.

"Yes, I do!" Monsieur C said.

But the evocation of the name Belphégor was too much for the Louvre official accompanying me, who told me it was midnight and we had to go.

"Hope to see you another time, Monsieur C!" I called out as she led me away.

"With pleasure, madame," he replied.

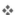

BELPHÉGOR. THE WORD ITSELF IS disturbing. In the Old Testament, Baal-peor was a demon from Hell who could deceive mortals by changing his shape. During the Exodus, Moses ordered the death of Israelites who worshipped and made sacrifices to him. John Milton's *Paradise Lost* and Victor Hugo's *Toilers of the Sea* conjure up his name.

In France just about everyone of a certain age knows the name Belphégor. In 1965, a television miniseries, *Belphégor ou le Fantôme du Louvre*, mesmerized—and terrified—the nation. Produced by Claude Barma, a television pioneer inspired by Alfred Hitchcock, it ran in seventy-minute episodes four consecutive Saturday evenings.

It was loosely based on a 1927 detective novel by Arthur Bernède about a ghost haunting the Louvre. Most of the series was shot in a studio, but the reconstruction of the Louvre's corridors, pillars, and sculptures enveloped in nighttime shadow looked so real that viewers believed it.

People stayed home, glued to their television sets. From the first episode, fans pleaded in vain with producers, actors, even technical assistants, to reveal the real identity of the phantom; they replied that they were bound to secrecy. One journalist spent a night locked in the Louvre hoping to catch a glimpse. Visitors asked museum guards where they could find the famous ghost. President Charles de Gaulle mentioned the series in a press conference.

"We talked only about Belphégor, everywhere," *Le Figaro* wrote

two decades later. "The streets, shops, theatres were empty on Saturday evening."

"It was a phenomenon, a phenomenon," Catherine Belanger, a retired Louvre official who had worked on the series, told me shortly before her death. "People were like, 'Did you see the episode last night?' I remember one night taking a taxi to the Louvre for a shoot and the taxi driver asked, in all seriousness, 'Are you going to meet Belphégor? Truly?' It was also quite terrifying because there really were places in the Louvre, corners in the basements, where we were sure we heard footsteps at night."

Commentators railed about the destructive effect the masked phantom had on children, and the series generated one of the first cases of mass hysteria in the history of television. There were reports of French children having nightmares, and even cases of serious psychosis. "Some parents forbade their children to watch *Belphégor*," Claude Barma recalled later. "Teachers protested, believing that the terrifying figure of the ghost traumatized their students and disturbed their sleep."

Juliette Gréco, who starred in the series and was famous in France as a singer, actress, writer, and onetime muse of Jean-Paul Sartre, said at the time, "This thing—it's like a bomb!"

The plot was convoluted and hard to follow. The terror came from the sight of Belphégor, tall and sinister, wearing an elongated black mask with a large, chiseled nose, evil eyes, and a full mouth, and covered by a black veil, headdress, and robe.

The tension is created from the opening scenes. A night watchman named Gautrais claims to have seen the ghost, but nobody believes him. The next day the museum's head guard is assassinated. André Bellegarde, a university student in physics, becomes obsessed by the mystery and stays overnight in the Louvre, where Belphégor almost kills him. From then on, the audience is hooked. Deaths, assaults, attempted assassinations, and disappearances follow.

Gautrais discovers a secret passage to an underground space where Boris Williams, the mad villain, and a team of doctors bring an Egyptian mummy to life. The mummy, draped in black, is possessed by the spirit of Belphégor.

Ultimately, Williams is revealed to be seeking the treasure of the

kings of France hidden in the Louvre. He has created the costume worn by Belphégor, who is not a ghost but a hypnotized medium played by Greco. In the last scene, she dies tragically by throwing herself from a beam at a building site.

A 2001 film version starring Sophie Marceau and Michel Serrault, with Julie Christie as an Egyptologist, was a flop. But the 1965 version, restored and subtitled, is still fun to watch.

It is not forgotten. On the desk of one Louvre official I met sits a statue of Belphégor made at the time of the series; on a wall of another office hangs an original publicity poster. Veteran Louvre guards still laugh about the first episode, when a security guard tries to shoot the phantom. Security guards at the Louvre do not carry guns.

In a three-hour livestream interactive tour of the Louvre in 2022, Samuel Etienne, the host, read a viewer's question for Sébastien Allard, the head of the paintings department: Have you ever met Belphégor?

"In my childhood, I think we were not even allowed to watch because it scared children," said Allard. "And so maybe that's what made me become a curator at the Louvre. It was to overcome this fear of Belphégor!"

Etienne asked him about the darker hours, in the evening or early morning. "Do you see things? Do you sense things that are a little strange?"

"I do not know how to answer, because in fact—it's things that are very fleeting." He spoke of the strangeness of crossing the Grande Galerie when it is dark, and the strange sounds. "You can hear the frames cracking, the floors cracking. And so, in fact, you feel that it's moving. It lives with the lights of the city."

The opening scene of the 2006 blockbuster film *The Da Vinci Code* captures the terror that can flood the Grande Galerie at night. Famous paintings like Leonardo's *The Virgin of the Rocks* and Jacques-Louis David's *The Oath of the Horatii* are shrouded in shadows and then flash on the screen. The footsteps of a museum curator as he runs reverberate on the parquet floor. The curator leaves clues written in his own blood before the assailant, a fanatical monk, shoots him dead. He is found naked, a bloody pentagram traced on his stomach, lying in the pose of Leonardo's *Vitruvian Man*. The Grande Galerie at night may never feel safe again.

Yannick Lintz, the former director of the Islamic art department, said that she had an eerie feeling whenever she left the museum at night. "The Roman sculptures of Caesar, Hadrian, Nero—I thought they were all looking at me," she said. "I was always afraid. I was always very anxious. When you heard a noise and there was almost no light. And of course, everyone has heard about Belphégor." Her voice trailed off. Now, as director of the Musée Guimet, she feels calm at night. "When Buddha looks at me, I feel better," she said.

One day while wandering through the Sully wing, I came upon a four-thousand-year-old black stone sculpture of an Egyptian pharaoh. His headdress was not as imposing as Belphégor's, but his eyes and mouth were just as fierce as he stared out imperiously over all who passed by.

As for the mummy, I encountered it alongside Vincent Rondot, the director of Egyptian antiquities. It is the remains of the body of a wealthy man, identity unknown, preserved under thick strips of linen. The mummy is kept in its own alcove, away from the caskets and sarcophagi. It lies straight, with arms crossed. Its original necklace, boots, leg coverings, and chest cover decorated with images of gods are intact. The mummy must be kept in a separate space out of respect for its spirit.

"Why is this mummy here?" I asked.

There was a practical answer. "The public wants to see the mummies," Rondot said. "The public does not conceive of a department of Egyptian antiques without mummies."

Indeed, this gruesome artifact is one that both thrills and terrifies children who feel compelled to come face-to-face with a mummy.

Then Rondot showed me a glass case holding animal mummies: fish, cat, dog, falcon, and crocodile. "The Egyptians mummified animals, and these animal mummies were offerings to the gods," he said. "The very fact of putting to death this animal and sending it to the beyond allowed a link between man and his god." We looked at a cat mummy together, and he said, "Cats were twisted to death by the neck."

Cats tortured to death?

He assured me the deaths were carried out by priests in a "painless, industrial way."

"Vincent, one night when I was here," I said, "one of the guards told me about ghosts—that this place with the mummy is known—"

The Louvre facade at night toward the Cour Carrée entrance as seen from the Pont des Arts over the Seine. © *Gary Zuercher, glz.com, Marcorp Editions, marcorp-editions.com*

"It's known. Yes, it's known. There are numerous places, where there are ... forces."

"Is it true? Is it the truth or is it superstition?" I asked.

"It is said so," he replied. "Of course, I don't know officially."

And with that, he ended the conversation.

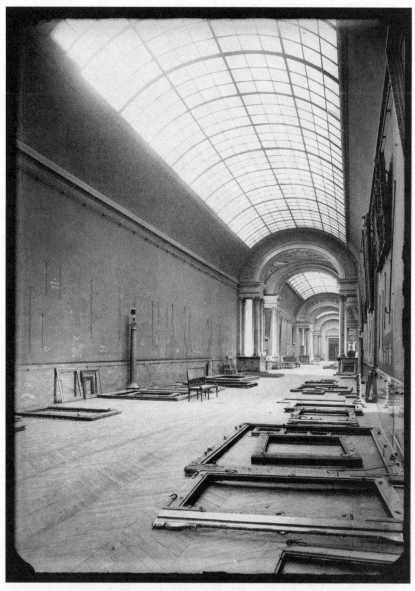

The Grande Galerie after most of its art was removed and hidden in 1939 in anticipation of the occupation during World War II. © *RMN-Grand Palais / ArtResource, NY*

CHAPTER 11

✦✦✦✦✦✦✦✦✦✦✦✦✦✦✦✦✦✦✦✦

Is the Louvre Burning?

The Mona Lisa *is smiling.*
—**BBC radio,** a coded message in 1944
confirming that the Allies knew where
Louvre masterpieces were hidden

THERE ARE TWO MOMENTS IN HISTORY WHEN THE LOUVRE WAS IN danger of destruction: the first in 1871, when it came close to being enveloped in fire, and the second in World War II, when Hitler planned to destroy central Paris.

The first story starts with the mistakes of Emperor Napoleon III, an autocrat who kept trying—and failing—to match the exploits of his uncle, Napoleon I. He sent military forces to Mexico. He joined in Italy's wars. But he badly misjudged the power of the Prussians. In 1870, they defeated him in battle and imprisoned him. Then they attacked Paris and forced its surrender. Napoleon's empire collapsed, and a conservative provisional republic was proclaimed.

But utopian rebels backed by the working classes opposed it, and they rose up in Paris to form their own short-lived government called the Commune. The republic's forces first fled to Versailles and then, in May 1871, invaded Paris. During the subsequent fighting, about thirty rebels led by a typesetter named Jules Bergeret drenched the walls and floors of the Tuileries Palace in turpentine and petrol and covered them

in tar. The building ignited; the skies of Paris turned red. The palace was consumed by a fire so fierce that it threatened the Louvre, which was attached to it at the end of two wings. On the northern side, fire surged into a part of the Louvre that is now inhabited by a separate museum, the Musée des Arts Décoratifs. On the southern side, it reached the Flore wing, where the Louvre's engravings and drawings collection now sits. Another fire was set in the imperial library in the Richelieu wing, where Rubens's paintings of Marie de Médicis hang today.

Some of the Louvre's greatest works—including the *Mona Lisa* and *The Wedding Feast at Cana*—had been evacuated when the Prussians arrived in Paris months before. But the Grande Galerie was at risk.

Joseph-Henry Barbet de Jouy, an archaeologist and Louvre curator, was determined to save the museum. He and some of his staff had stayed in the Louvre to protect it throughout the Prussian shelling of Paris. They sprang into action. Martian de Bernardy de Sigoyer, an officer in the French army, was equally motivated. Disobeying orders to stand back, he attacked the Commune invaders. His soldiers waged a two-pronged offensive: against the rebels and against the fire.

The soldiers grabbed the tools they could find—axes, pickaxes, and hammers—to break down closed doors. Some soldiers stood guard at the windows; others climbed onto the roof. They formed a human chain to pass buckets of water to quench the fire and pierced a hole in the roof so that the flames could escape. The fire destroyed more than eighty thousand volumes of the Louvre imperial library, but the museum was saved. Two days later, Bernardy de Sigoyer's body, riddled with bullets, stripped of his weapons and boots, was found more than two miles away.

It is hard to find the two marble plaques honoring the memory of the brave Louvre curator and the military commander. They hang in semidarkness near the gallery that leads to the staircase up to the Nike of Samothrace.

The plaque to Bernardy de Sigoyer says that "his energetic initiative saved the palace and the national collections of the Louvre from fire." The plaque to Barbet de Jouy and his two colleagues praises "their courage and their decision that insured security inside the Louvre and allowed France to preserve its national collections."

❖

THE SECOND STORY STARTS WITH Germany's occupation of Paris during World War II.

Adolf Hitler loved the architecture of Paris. One Sunday in June 1940, shortly after the French surrender, he came for a predawn tour of the city.

In his 2015 film *Francofonia* on the Louvre in World War II, the Russian director Alexander Sokurov inserts black-and-white archival footage of Hitler's tour. Seated next to his chauffeur in the front of a six-wheeled Mercedes convertible, Hitler is accompanied by Albert Speer and Hermann Giesler, his two favorite architects, and Arno Breker, his favorite sculptor. The film shows Hitler as he drives past the main sites of Paris and poses for photos like any other tourist. At the place de la Concorde, he stands up and looks toward the Tuileries and along the rue de Rivoli. "Where is the Louvre?" he asks in the film. "Ah! There's the Louvre! How good that it's there. It always fascinated me it's where it belongs."

There is no record that Hitler said these words, and no agreement among those in his entourage on his reaction when he first saw the Louvre. According to Speer's memoirs, Hitler showed "no special interest" in the museum. But Breker, in his memoirs, quoted Hitler as saying of the Louvre that day, "I do not hesitate to consider this grandiose construction as one of the most brilliant ideas of architecture."

In a voice-over, Sokurov uses this moment to celebrate the Louvre as the symbol of France. "The Louvre. The Louvre," he said. "Might it be that this museum is worth more than all of France? Who needs France without the Louvre?"

Hitler didn't go inside, but if he had, he would have found little to see. The Louvre had closed during part of World War I, and when war broke out anew in 1939, its curators knew its art collection was once again vulnerable. Nine months before the Nazis seized Paris, Jacques Jaujard, the director of French national museums, organized the evacuation of the Louvre art collection. In August 1939, the Louvre closed for three days. The official reason: repairs; the real reason: a massive secret project to empty the museum of its artworks and hide them in inconspicuous places throughout France.

Curators and staff were called back from their summer vacations. Packers from a nearby department store helped wrap the major works of art. Wooden crates were marked with yellow, green, and red circles depending on the importance of the art they contained (The *Mona Lisa* merited three red circles; she left the Louvre, cushioned in lush velvet, in an ambulance.)

To move the largest canvases, the Comédie-Française lent trucks that usually transported sets and scenery. Private cars, delivery vans, ambulances, and taxis were requisitioned. Engineers devised a system of planks and ropes to transport the *Winged Victory of Samothrace*, the last artwork to leave. By the time the Germans seized Paris, the Louvre had dispersed 3,600 paintings and thousands of sculptures and art objects throughout France. During the war, the artworks moved secretly from place to place (the *Mona Lisa* would move six times.)

The only art the German occupiers found when they arrived at the Louvre were works either considered of little artistic value or too heavy to be transported easily. Like many German aristocrats, Count Franz Wolff-Metternich, a trained art historian and Hitler's curator of art assigned to the Louvre, was not a Nazi Party member. Metternich knew that Jaujard had hidden the most valuable pieces but stayed quiet, believing that to confiscate them would violate international law. The two men worked together to both protect the Louvre's collections in their hiding places and keep the near-empty museum open during the occupation.

As the war neared its end, Hitler declared that if the Allies took back Paris, he would leave them a city in ruins. He ordered the destruction of its bridges and monuments, including the Opéra, the Eiffel Tower, and the Louvre; he hoped to leave tens of thousands of people dead. The British intercepted and decrypted Hitler's communiqué of August 23 addressed to General Dietrich von Choltitz, the German commander of Greater Paris, which gave the order: "Never, or at any rate only as a heap of rubble, must Paris fall into the hands of the enemy."

In his 1951 memoirs, Choltitz told his version of the story. On the day Paris was liberated, he surrendered—without following Hitler's orders to destroy the city. He wrote that he saved Paris because of his love of the city and his conviction that Hitler had gone mad. Over the years, some of Choltitz's claims have been questioned, but Hitler's plan to destroy Paris makes for great reading.

It has been the stuff of literature, film, and myth. Larry Collins and Dominique Lapierre spun the story with *Is Paris Burning?*, their blockbuster 1965 bestseller. Then came the film of the same name directed by René Clément and with a screenplay by Gore Vidal and Francis Ford Coppola. Some critics called it messy in its structure, flat in its storytelling, and thin in its veracity. As far as we know, Hitler was not, as the film relates in the last scene, on the other end of a telephone line to Choltitz screaming over and over, "Brennt Paris?"—"Is Paris burning?"

I loved the movie. Shot almost entirely in black-and-white, it seamlessly wove in documentary footage that injected reality into the story. And the cast read like a who's who of the greats of French and American cinema: Alain Delon, Leslie Caron, Charles Boyer, Simone Signoret, Yves Montand, Jean-Louis Trintignant, and Michel Lonsdale on the French side; Anthony Perkins, Orson Welles, Glenn Ford, Kirk Douglas, Robert Stack, and E. G. Marshall on the American.

When Germany surrendered in May 1945, the artworks returned to the Louvre.

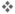

THE PROSPECT OF FIRE OR invading enemies will always inspire vigilance. It was already on people's minds in 1796, when Hubert Robert painted his *Imaginary View of the Grande Galerie of the Louvre in Ruins*. The painting captures the symbolism of the inevitable passing of time and of civilizations, but it is also a concrete reminder that museums are vulnerable.

These days the museum's main enemy is water, not fire or an invading enemy. Fire in a structure like the Louvre, which is largely made of stone, does not pose the same threat as it did at Notre-Dame Cathedral, whose attic frame of five hundred tons of medieval oak tree trunks turned it into a blazing inferno in 2019.

The Louvre sits on low ground along the banks of the Seine. In June 2016, the river overflowed, and floods threatened the museum. The Louvre closed for five days. Louvre employees mounted a round-the-clock emergency evacuation of the basement. Within forty-eight hours, they wrapped and crated thirty-five thousand art objects stored underground

and hauled them higher. It was the museum's most ambitious evacuation since World War II.

The art was saved, but future flooding threatened. The Louvre responded by building an ultramodern storage site 120 miles away in the northern town of Liévin, near its satellite museum in Lens. It could house more than a quarter of a million artworks. "The reality is that our museum is in a flood zone," Jean-Luc Martinez said on a tour of the storage center after its opening in 2021, when he was the museum director. "There was a danger that the sewers would back up, and that dirty, smelly wastewater would damage the art. We had to find a solution. Urgently."

That solution doesn't help much when roofs crumble and rusty pipes leak. In a period of relentless rain in July 2017, water dripped on several seventeenth-century paintings, including those of Nicolas Poussin and Jean-François de Troy. In late 2023, a hidden, hard-to-access water pipe burst and sent water flowing into the Sully wing. The Louvre had to remove all the exhibits there, including a score of works borrowed from the Capodimonte Museum in Naples. It also canceled a long-awaited retrospective of the works of the designer and satirist Claude Gillot shortly after it opened, a heartbreak for the American organizers who had worked on the exhibition for years.

THE LOUVRE IS AN AGING, organic structure, ever-changing, adapting, expanding, deteriorating. There is always a facade to clean, a parquet to replace, an escalator to repair, a molding to dust, a roof to patch, a picture frame to fill with gold leaf, a loose stone to anchor with cement.

"The Louvre needs constant attention," said Philippe Carreau, the chief architect. "Something is always falling apart."

One day, he and I donned hard hats to examine restoration work on the museum's facade, passing through a series of security barriers and riding a noisy, jittery elevator up six flights of scaffolding to come eye to eye with the roof, where workers had been laying new gray slate. Carreau pointed out how cracks between the stone blocks had opened and expanded. Erosion had also blurred the details of statues and stone carvings. He showed me intricate masonry that remained: exotic fruit garlands hanging from lions' mouths, a relief of Diana leaning against a deer. Carvers chiseled

away at replacement pieces whose shapes just barely started to pop out of the stone. The farther down we went, the louder and dustier the construction site became. Stonecutting machines kicked up clouds of tiny particles and coated the walkways and the workers in a thick, creamy white patina.

Another day, I toured unlit public galleries of tapestries with Anne de Wallens, the chief of preventive conservation, as she waged war against persistent invaders. First there were moths, which attacked tapestries, carpets, drapes, and upholstered furniture. Wallens's team had hidden dozens of sticky pheromone moth traps along the baseboards and in the corners. The glue in the traps is impregnated with the smell of female moths; mature male moths fly in, searching for a mate, and die. I was stunned—the Louvre uses the same store-bought moth traps that I do.

Once she found infestations of moths dining in a horsehair-stuffed armchair. "It was a delicious cake for them," she said.

The Louvre once conducted an insect survey and found "a bit of everything," Wallens said, including scarabs, mosquitoes, spiders, and swarms of ants. She called the small common woodworm "a charming little animal that can settle in the woods and reappear after five years to crunch." And then come the beetles, which attack parquet floors, picture frames, furniture, and woodwork. Most ominous is the great capricorn, "a bigger, bigger beetle that makes bigger, bigger holes—a horror," she said. "You have to spend almost every day in the rooms on all fours to look if, by chance, there are critters," she said. She then walked over to a corner of the tapestry room, bent down, and picked up what looked like a brownish piece of dirt. "I know this is not dust," she said. "It's a dead moth! I don't know why the good God created moths!"

Dust is an enemy, too, she said, worse than bug infestations. When dusters clean an elaborately carved ceiling, they use both dry and water-moistened microfiber cloths, not solvents. She explained that if a ceiling isn't dusted for years, a thick gray film of dust accumulates, muting tones and dulling the gilding.

ONE WAY TO LEARN ABOUT the complexity of the Louvre's physical structure is to make friends with the firefighters, fifty-two members of

the Brigade de sapeurs-pompiers de Paris who are permanently based there. This is the museum's first line of defense not only against fire but also against violent crime, terrorist attacks, threats to works of art, collapsing roofs, and flooded basements. The sapeurs-pompiers belong to the French army and bring military rigor to the mission.

Captain Fabien Hequet, who headed the brigade for four years, is both an expert on the building and passionate about the art inside. He is one of those exceptional military men who carries responsibility on his shoulders and joy in his heart. His brush cut, lean body, and ramrod-straight posture give the impression that he is significantly younger than his actual age. When he retired from the service in his midfifties in 2023, it stunned some of his colleagues. For me, he has been a font of practical knowledge about the Louvre.

Before his retirement, we met in his office, which was lined with windows that gave out onto the Tuileries Garden. He sat at a carved, gilt-trimmed, eighteenth-century desk made not for a tough fireman but for a courtier of Louis XV. A red-handled hatchet hung on one wall; a long, color-saturated photograph of the Seine, showing the Louvre, on another. A plaster mold of the male head of an ancient Greek sculpture rested on a cabinet.

The firefighter-soldiers in the Louvre run a round-the-clock operation. Members stay overnight in simple dormitories furnished with bunk beds, tables, and chairs. The brigade monitors screens linked to the museum's galleries, staircases, corridors, doors, elevators, and escalators, supported by eight thousand smoke detectors that are so annoyingly sensitive that the ones in the museum's cloakrooms are easily triggered by dust.

Some tasks border on the frivolous. When pigeons zoom in through open windows, the firefighters must shoo them out. Other tasks are dead serious: the brigade is the first point of contact and care in all health emergencies.

One of Hequet's hobbies was to give VIP tours to firefighters visiting from around the world, not of the major works of art but of what he calls "the hidden faces of the Louvre." "There are very special places where the public is forbidden to go," he told me the first time we met. "Only privileged people like firefighters can go there."

"Would you take me there one day?"

"With pleasure!"

The day of my tour was in the early spring. The wind was soft and the sun had turned the sky eggshell blue. I had been sent written instructions to wear "comfortable shoes with good grips, and warm clothing that is not too baggy so that the wind does not rush in."

We started in a public place at the beginning of the Louvre's history: the foundations of Philippe Auguste's fortified castle that was discovered and restored when I. M. Pei's Pyramid was built. We walked together on what was once a moat. "Stop!" he said. "We are in Philippe Auguste's world!" He told me to look, really look, at scratches on some of the pale, smooth stones of the wall. The scratches showed that the medieval stonemasons left their mark by carving designs into the stone—a heart in one, a square in another. "It was the stonecutter's way of saying, 'I made a stone at such a location,' " he said. "It was a way to sign their work, like an artist signs a painting. This is thrilling, beautiful, no?"

Then it was down into the Louvre's underground network of tunnels and corridors. It stretches two miles to connect the wings and rooms of the foundation and dozens of staircases in metal, stone, marble, wood, and concrete. Some spaces are brightly lit, others so dark you can see only a few feet in front of you. Hequet unlocked doors, marched me up and down secure staircases, and guided me through hallways stuffed with equipment. The casual visitor may find the Louvre confusing and hard to navigate, but the firefighters face a far more complicated maze. "The first task of any newcomer is to learn the entire site," Hequet said. "The public spaces are pretty easy. It's the corridors, the roofs, the storage areas never seen by the public that make it hard. It takes a year to get to know the place."

There are high-ceilinged storage rooms the size of small warehouses; workshops where artisans repair damaged wood, iron, fabric, and gold; holding areas for heavy-duty plastic garbage dumpsters; and a concrete room with a stationary bike, two exercise machines, and a few weights that serves as the firefighters' gym. At one point Hequet led me into a two-room fluorescent-lit area with stone walls, stone tile floors, and ventilators attached to the ceilings, probably no more than 300 square feet. It is an air-raid shelter built before World War II to protect personnel in case the Louvre was bombed.

We followed one hidden tunnel that was partially blocked by a large cluster of misshapen stones, twelve feet high and held together by cement—a fragment of Philippe Auguste's wall that has never been restored. It has to be the oldest and most glorious hidden architectural remnant of the museum. "This is a very special place that will never be seen by the public, although it is the original Louvre," Hequet said.

Some hidden sites are within public spaces. Hequet wanted to take me onto the balcony at the top of the Salle des Cariatides, which visitors can see only from below. To get there, we passed through a marble-pillared room displaying ancient Greek art and arrived at a stairway. Halfway up, Hequet lifted a section of the wooden banister and put a master key into the lock of a small door that blended invisibly into the wall. The lock didn't budge. He looked into the keyhole with a flashlight. Nothing seemed blocked. His lieutenant picked up the section of the banister and whacked the lock with it. The sound echoed loudly on the stone staircase.

It still didn't move. The two military men had no choice but to surrender.

We walked back to the Salle des Cariatides and looked at the balcony from below. France's greatest playwright, Molière, staged some of his plays here. "It was on that very balcony in the seventeenth century that *Les précieuses ridicules* was performed for King Louis XIV," Hequet said. "That gives me so much pleasure!"

The sight of a man in uniform playing tour guide attracted attention. Two lost Brazilian tourists, Louvre maps in hand, interrupted him to ask in English where in the museum they were. "Whenever the sapeurs-pompiers are in the public spaces, we have to keep moving," he told me. "When people see our uniforms, in two minutes we'll have, 'Where is the *Venus de Milo*? Where are the toilets?'"

We moved to the Richelieu wing, through more corridors and metal doors and then up the majestic Lefuel staircase—named for the architect Hector Lefuel—until we reached the rooms of Napoleon III. One room features the gilded throne of his uncle, Napoleon Bonaparte, upholstered in midnight blue with gold embroidery. Next door, a portrait shows the very same throne peeking out from behind the emperor's mink cape. Some of the rooms, such as the dining room and the Grand Salon, are easy to identify, while others are arranged

with furniture and objects from elsewhere, including the long-gone Tuileries Palace.

Far and away the largest room is the Grand Salon. Its secret is hidden in plain sight: it can be transformed into a theater with a 250-person capacity. One of the red-velvet curtained entrances to the room originally served as the stage. Above that, nearly concealed in decoration of golden brocade, cherubs, and painted flowers, is a small balcony, a musicians' platform. Hequet was determined to get me there. Opening two doors in succession, he took me into a room deep in the shadows, where the visitors below could not see us. This was a room for musicians, but it had such bad acoustics that holes were drilled in the walls to let the sound seep through. The original stage curtain, along the top of the balcony, was rolled up. Hequet turned the crank, and the curtain began to fall. "It still works!" he said.

Here was a new perspective. From below, I had imagined Napoleon III's party guests, but from this view, I was immersed in the history of the Louvre. On the salon's ceiling was a series of frescoes. The central and largest was an allegory with Napoleon III and his wife Eugénie, surrounded by pink cherubs. Others showed François I and his plans for the Louvre, Henri IV and his Grande Galerie wing along the banks of the Seine, and Catherine de Médicis receiving the plans for the Tuileries Palace.

I've seen a lot of gaudy chandeliers in my day, but none to top the one in front of us, with 180 lights. And how in the world to clean all the crystal pieces, I wondered. The answer: it is connected to a contraption that lowers it to the floor.

We left behind the glitz and headed back into the hidden spaces the public doesn't see. We climbed up and up a narrow wooden curved staircase that didn't seem to end until we were in the unlit Turgot dome, a dark gray pyramid shape with the top cut off, filled with classical-style figures carved in limestone, but forgotten in time. What potential, I thought. It could be a perfect place for a wedding. Then up another winding staircase that also seemed to circle forever—I stopped counting at fifty steps.

Then to a door that opened to the outdoors. We stood on a ledge and climbed—vertically—up a metal ladder attached to the wall. When we got to the top, Hequet jumped from one ledge to another and held out his hand so I could follow his lead without falling.

We were on the roof of the Louvre! The sculpted chimneys; the statues; the small, rounded windows in their carved stone frames; the tiles of the roof that seemed close enough to touch. To our right, the French flag was flying from the building's highest point. Below us, the Pyramid, flanked by its fountains, shone bright in the sunlight.

"Isn't this the most beautiful view ever of the Pyramid?" Hequet said. "And there is all of Paris to the west before us."

With shyness in his voice, he asked whether we could take a photo together. "It will create a memory of this day," he said.

"You bet!" I said.

We smiled and he snapped.

"There are people who have worked for thirty years in the Louvre and they have never had the chance to come up to the rooftop," he said.

AS WE MADE OUR WAY down, I asked Hequet to show me his favorite work of art in the museum. Earlier, he had confessed that sometimes he likes to pop into a gallery he doesn't know well. "There is something for everyone here, something to find and appreciate, even if you know very little about art," he said.

We walked through a long tunnel with stone walls lined with pipes. More tunnels followed. Along the way he opened a series of metal doors with his passkey. We arrived at the Cour Marly sculpture courtyard, headed up the stairs, and turned left into the French sculpture halls. There we found the *Tomb of Philippe Pot*.

The *Tomb of Philippe Pot* is a large fifteenth-century sculpture in painted limestone, created for a tomb. Eight life-sized mourners, wearing voluminous black cloaks and hoods, are carrying on a slab the body of Philippe Pot, a military commander, diplomat, and scholar who served the Burgundy dukes. He later switched his allegiance to the French king, Louis XI, who appointed him as his steward. Philippe Pot is dressed in knight's armor and a knight's helmet, his hands clasped in prayer, his eyes wide open. Each of the mourners carries a shield with a coat of arms representing Philippe's eight noble titles. Inscriptions carved into the tomb describe his achievements. A sword sits at his side. An animal sitting like

a dog but looking more like a lion stands guard at his feet. Curiously, Philippe Pot commissioned the tomb himself years before his death.

The mourners have faces, but downturned and hidden under their hoods so that you can only see them if you bend down and look at them from below. It is a strange apparition—creepy and sad at the same time. It is considered one of the greatest tombs of its time, because the mourners show their deep anguish as they struggle to move forward.

Hequet stood at attention and looked at the work for several seconds before he spoke. "It is my favorite," he said softly, as if he were in a church and needed to keep his voice low. "I find it beautiful, magnificent. *Mona Lisa*, *Venus de Milo*, the *Victory of Samothrace*, okay, they are superb, but for me, magic is in this corner. There are places in the museum that are so crowded it's oppressive. There's no pleasure. Then you have places that are super-soothing, super-pleasurable, like this one where hardly anyone comes. This work speaks to me. In the beginning, I understood nothing. Now I bring my family and my colleagues here. I tell them who Philippe Pot was and that he played many, many roles in the era of the knights that is deep in our history. I tell them to look at the faces. You see they have expressions as if they are real."

There was also a more contemporary military significance, which touched Hequet. "It inspired the tomb of Marshal Foch," he said. He was referring to the bronze tomb of Ferdinand Foch, the chief of staff of the French army in World War I, in the Invalides. The monument shows Foch's uniformed body on a stretcher carried by eight soldiers, their heads bowed. "There is a bond between a special era of chivalry at the time of the knights, and then the military of the twentieth century," Hequet said.

"The work also evokes death," I said. "The sapeurs-pompiers face death every day, right? They saved Notre-Dame."

"The sapeurs-pompiers face so many life-and-death emergencies every day," he replied. "And yes, this work of art is a symbol of death. But it is so much more—a beautiful celebration of courage and chivalry. So I prefer to focus on its beauty."

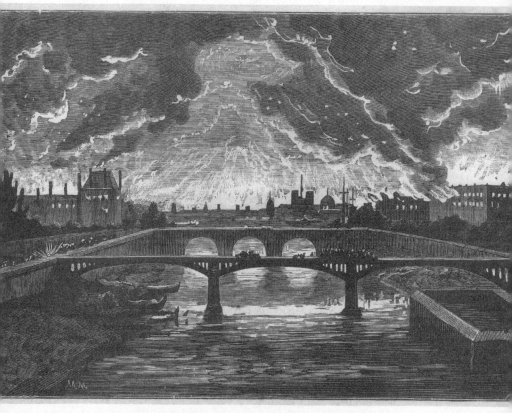

Rebels in Paris during an uprising in 1871 set the Tuileries Palace
on fire; the palace was destroyed, but the Louvre was saved.

PART THREE

Revelations

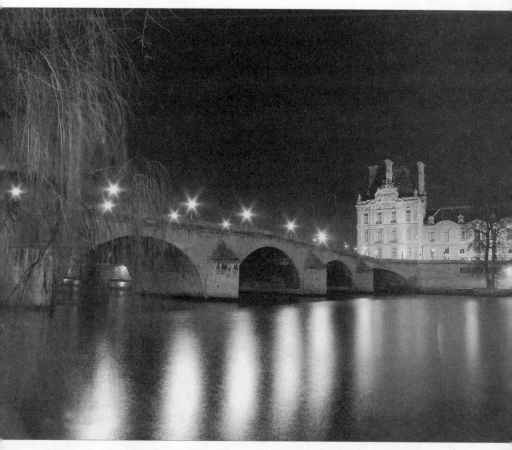

The Flore Pavilion lit up at night as seen from the Pont Royal. © *Gary Zuercher, glz.com, Marcorp Editions, marcorp-editions.com*

CHAPTER 12

♦♦♦♦♦♦♦♦♦♦♦♦♦♦♦♦♦♦♦♦♦

Up Close

You can see the originals. You can hold the originals in your hands.
— **Xavier Salmon,** head of the Louvre's
prints and drawings department

WOULDN'T IT BE EXCITING TO HOLD IN YOUR HANDS AN ORIGINAL work by one of the world's most famous artists? To look at it out of its frame, up close, for as long as you want, making a connection with the person who created it?

You can do it in a little-known room at the Louvre. The Consultation Room for Prints and Drawings dominates the wing connected to the Pavillon de Flore at the far end of the Louvre facing the Tuileries Garden. It looks more like a formal library in a château than an arm of the museum. Few visitors go there.

Flora is a Roman goddess of spring, flowers, and fertility. The pavilion with her name was built by Henri IV in the seventeenth century. During the Reign of Terror, Maximilien Robespierre used it as the headquarters for the Committee of Public Safety, which sent more than eighteen thousand people to the guillotine. In the 1860s the pavilion was demolished, rebuilt, and expanded, and a series of government services took over the space: the Prefecture of the Seine, the Ministry of Colonies, the National Lottery.

In 1961, the Flore Pavilion was transferred to the Louvre, and its wing now houses a collection of almost a quarter of a million drawings, pastels, miniatures, prints, engraved plates, rare books, autographs, woodcuts, lithographic stones, and manuscripts, most of which never see daylight. Too fragile to be exposed to light and air, they are taken out mainly for temporary exhibitions under strict rules: exposure for no more than four months, low light, controlled heat and humidity, a "period of rest" for five years afterward. But they can also be viewed, one at a time, by anyone who wants to visit.

Although the works are displayed in a digital database, the Louvre does not advertise how visitors can venture into the Consultation Room to view them up close. So I will tell you how to do it.

The Consultation Room is open Monday through Friday afternoons. You used to have to submit a written request for an appointment naming the works you wanted to see and then wait for formal acceptance. Now, in principle, you can just show up, though the Louvre's website (on a page that only exists in French) says you still must send an email. Once you do that, the automatic email response—also in French—will tell you that you should have just come unannounced. Staff members prefer that you notify them of your impending arrival and of the inventory numbers of your chosen artworks in advance. This information can be found on another website, which catalogs the prints and drawings collection, by searching for each piece.

There are other rules as well:

"Consultation of the works is strictly individual. Two people who wish to study the same work will be placed at two separate worktables and will not be able to communicate within the consultation room."

"The number of portfolios of drawings that can be consulted per day is limited to ten," or about eighty drawings per day.

Pens, pastels, colored pencils, and erasers are forbidden. To consult the reverse side of a drawing, you must request a large sheet of blank paper and flip the page "with the utmost delicacy." Page-turning in books or albums must be done by touching only their corners.

Drawings by the great masters, including Ingres, Poussin, Watteau, Leonardo, Michelangelo, and Raphael, are classified as "red

cards"—fragile, highly sought-after—and available officially and with few exceptions only once to any one person.

Photos are allowed, but a detailed document explains what is banned. You must never take a photo from directly above a drawing if it is lying flat on the table in case the phone falls, but instead from a distance at an angle.

"It's a nightmare if you need to do serious work," said one occasional visitor, Xavier Salomon of the Frick Collection in New York. "It's only open in the afternoons, and you need natural light, which disappears early in winter, so you have to work fast." The last time he visited, the staff required him to buy a cord so that he could hang his iPhone around his neck before he was allowed to take photos.

Despite the rules, a visit to the Consultation Room is one of my favorite outings at the Louvre: tranquil, uplifting, exciting, a world away from the crowds. To get there, you head toward the end of the long arm of the Louvre along the Seine. Look for the Porte des Lions entrance, where two huge bronze-green lions sit. If you are coming through the Carrousel Garden that abuts the Tuileries, you may pass Aristide Maillol's sculpture *Nuit*, of a woman resting her head on her knees. You are almost there.

A large door at the entrance is marked *Entrée des Lions*. Ignore the notice that says *Accès réservé* (reserved access). Press the buzzer in front of an automatic sliding door with a sign taped to it that says Do Not Enter in English.

You have now entered a small, low-ceilinged security vestibule. A Louvre official takes your ID (a passport or French residency card), processes the information, and prints a temporary badge that allows you through a turnstile and up one floor in an elevator. There you find yourself in a hallway with no instructions about where to go. You walk until you come upon a door at the end of the hall labeled *Département des arts graphiques, cabinet des dessins—salle de consultation*.

You ring the buzzer—still unsure if this is the right place, as no one is around to ask. After a short wait, someone will open the door to greet you. It might be Helena Mendes, the department's receptionist, whose blend of reserve and warmth at first startles, then reassures. Or it might

be Guillaume Bedot, a manager of the site, who is thrilled when he can show off the collection. Or no one comes, and eventually you turn the handle of the door and—*voilà!*—it opens.

You enter a long room with cabinets and lockers, sign a guest book, and fill out a name card. You can bring in objects like a notebook, laptop, camera, or iPhone and a small handbag or briefcase. Anything else must go into a locker. You will be offered a sharpened, eraser-less pencil. If you have come to examine albums or miniatures on wood, you will be given blue latex gloves. Down another long hallway, a small door opens to a hall of discovery.

As noted before, the Louvre historically has been a masculine museum, and even this space can be seen in that way: organized and austere, anchored by pillars of gray and white marble topped by gilded bronze. But I prefer to focus on its celebration of womanhood, the triumph of Flora, the ancient Roman goddess of flowers, gardens, and fertility. Four large arched bas-reliefs, sculpted into the walls, tell her story. Look upward to see an oval ceiling painting by Alexandre Cabanel celebrating Flora's triumphal festival of spring. She sits on a gold chariot and is led by women in sheer robes through the clouds to the east. Zephyr, the god of the west wind, lifts her hair and robes. A long procession of young men and women trail behind, offering flowers, playing music, entangled among themselves.

Artworks are stored in oversized black file boxes kept in locked glass-and-wood cases that line the room. A fifty-foot oriental runner stretches along the central aisle of the parquet floor. Light pours in through ten-foot-high arched stained glass windows facing the Seine. The constant whir of an air-conditioning and filtering system pierces the calm.

You sit at a square, leather-covered wood consultation table lit by a table lamp with a green glass shade. A Louvre official brings out a black file box, opens it to reveal unframed drawings matted on heavy cardboard, removes the one you have chosen, and props it on a stand set before you on the table.

"This is a place for serious people, but not necessarily art history researchers, or professors," said Bedot. "All you need is to be an art lover. We welcome all the world!"

"And students!" said Marie-Pierre Salé, the department's curator, who specializes in nineteenth-century French works. "I find it marvelous that they often find scholarships to come and study. It's awesome. Americans who have been here as students sometimes come back again and again."

"I love this room," I said. "It's a space of sanity and rest."

Xavier Salmon, head of the department (and unrelated to his near-namesake at the Frick), is a cheerleader for the collection. "You can come face-to-face with Le Brun and Leonardo," he said. Then he sighed. "But we have only eight hundred visitors a year."

Salmon started coming to this space when he was a student at the École du Louvre and assigned as a Louvre intern. Its story began, he said, with Louis XIV's purchase of 5,542 works from a private collector in 1671.

The collection expanded over time, most notably with the seizure of more than 5,600 works from noble families during the French Revolution. In 1935, the children of Edmond de Rothschild, a prominent philanthropist and heir to the Rothschild banking fortune, donated his collection: 43,000 prints, drawings, manuscripts, and rare books, including a hundred works by Rembrandt. A special climate-controlled, two-story area for his gift was built nearby.

"We function like a library, so people come like you, and say, 'I'd like to see this, this, this,'" Salmon said. "We have students, we have artists, we have lovers of art, we have collectors. We are starting to receive our first Chinese visitors who write to us from China saying, 'We will be in Paris from such and such a date. Can we come and see?'"

Too many people want to see the same "big names," he said. "We are regularly asked to see the *Portrait of Isabella d'Este* by Leonardo da Vinci. We are asked about very famous Rembrandts, but these were done with a very particular ink that attacked the paper. I tell them 'No, you won't be able to see these works, because they would be out every day. But you can see 249,000 others. So choose!'"

One day I asked to see some works by Delacroix. I picked out ten drawings and sketches in watercolor and pen-and-ink.

Bedot presented me with an oversized black file folder containing several works and removed Delacroix's *A Courtyard in Tangier*, showing a staircase and a tent. I could see Delacroix's obsession with color. "Oh my

gosh," I said. "Look at how he used green, and it's exceptional because of the red here, and the staircase in rusty brown."

Other Delacroix works followed, including a study for *Justinian Drafting His Laws* and an early sketch for *Faust and Wagner*.

"What I love is the variety he covered: landscapes, horses, the wind, objects," Bedot said.

He showed me how to look at the back of the artworks. "You never know when you'll find something interesting. We're not sure. We have to look every time."

He brought out what he called a "neutral" piece of cardboard, flipped one of the Delacroix works onto it, and turned it over. "Nothing there, just the inventory number," he said. "Most of the time there is nothing. But sometimes there is a surprise—with illustrations on the back."

Another Delacroix image, of six muscular nude women, featured their backs and profiles in varying poses. Brown and yellow spots caused long ago by mold spores marked the paper. "Unfortunately, the paper has suffered," Bedot said.

"But for me, it gives a bit of life. Because it is a paper that has changed over time," I said.

I CAME BACK ANOTHER DAY to meet Salmon again. He was deciding where to put a trove of engravings that turned up in a routine inventory of a storeroom. "Suddenly, we discovered prints that everybody had forgotten about, that nobody had seen for decades," he said. He unrolled on the floor a print the size of a Persian carpet: it was a seventeenth-century chronology of a few hundred or so of the royals of Spain with each of their portraits. He picked up another long roll. "Let me show you another one! This one is for you."

It was a grand engraving of the detailed Turgot map of Paris from the eighteenth century. Salmon tried to find the rue des Martyrs, a street I had written a book about. I pointed out that the Turgot map was flawed and that some of the streets were in the wrong place. "The Turgot map's not logical," I said.

"Yes, but the map is luminous, isn't it?"

He was right. "Well, thank you for the little research on my street!" I said.

Salmon also told me how fragile engravings are. If you want to care for them, he said, you can expose them to light only for short periods of time.

Uh-oh, I thought. "Can you leave the engravings permanently on exhibit—the engravings you have by Dürer, for example?" I asked.

"Oh, no. Dürer used only ink—it's ink on paper."

I told him I had a confession to make. I own an engraving by Dürer—a Madonna and child with a pear—that I bought when I was young, single, and carefree, and had loose money from months on the road as a foreign correspondent. I told him it hung not far from a window and over a radiator.

He was incredulous. "And you have exhibited it in your living room?"

"It's in the hallway. There's no direct light, but it's been exposed for years."

He gave me that how-could-you-be-such-an-idiot look.

"It's lost its full value?" I asked.

"It hasn't lost its full value, but it has . . . lost . . . it must be faded."

"Really?"

"Oh yes. Sunlight is a terrible light. And moonlight is even worse."

"Moonlight?"

"Moon*light*." He used the English word and stressed the second syllable to make sure I understood what I had done. "Terrible. It's a light that bleaches things considerably. We used to bleach laundry by moonlight. You have to protect your graphic works from this light. Really absolutely protect them. That's why when people tell me it's protected from the light, it's never protected from the light."

Moonlight. Who knew? The damage had already been done, probably years ago. So I might as well live with my faded *Virgin and Pear* and enjoy her.

OVER TIME, I MADE THE Flore my own special place at the Louvre.

The room is usually tomb-quiet, but one day it was hopping. A small clutch of art historians from Naples was sitting at the next table, breaking the rules by talking to one another.

Bedot told me that Marie-Pierre Salé had a surprise for me. I had asked her about the history of the room, and she had told me about Cabanel's preparatory study for the ceiling, a "very, very pretty preparatory study in watercolor and brown ink." She had looked up the inventory number for it. Bedot asked if I would like to see it.

Would I ever!

The work was about 10 by 18 inches, a miniature copy of the oval ceiling in all its intricate detail, as Flora is lifted into a heavenly chariot. But it was much more than that. Cabanel had used the space at the lower right-hand corner to try out his colors—splotches of red and peach and cerulean blue and shades of brown and gray and gray-green. The corner looked like a modern abstract painting.

"You can see how this is really the work in progress—how the result is very, very finished, but he struggled to find just the right tints," said Bedot.

Indeed, I felt that I was with Cabanel in 1870 as he was imagining his masterpiece. The spirit of the artist was with me. At first I just stared and said nothing.

Then I needed to share this experience. I broke with protocol and went to the Italian professors' table to urge them to come quietly and quickly to look at the watercolor. They were deep into their research, but one of them was curious and ventured over. "I have only one word for what I see," she said. "*Stupendo!*"

Les lions de Barye, à la porte des Tuileries.

Engraving of the lion sculptures that guard the entrance to the Flore Pavilion.

Illustration for a journal article about the 1887 auction of the crown jewels. Jewelers and gem dealers from around the world descended on Paris for the event.

◆ ◆

Whatever Happened to the Crown Jewels?

The life of a historic jewel can sometimes take an unusual twist.
—Christie's, press release after the Louvre spent
millions to buy back a royal brooch in 2008

ON A MAY AFTERNOON IN 1887, HUNDREDS OF WELL-DRESSED PEOPLE
gathered in the Louvre for the opening of one of the most momentous
sales in the history of France: a grand public auction of its crown jewels.
The story is so bizarre and out of character given France's obsession with
preserving its *patrimoine*—its cultural heritage—that it deserves a prom-
inent place in the lore of the Louvre.

Jewelers and gem dealers from around the world, including the
United States, Britain, Spain, Italy, Russia, Turkey, Tunisia, and Egypt,
descended on Paris. To gin up enthusiasm, a catalog with fine photo-
graphs had been distributed in advance.

A hundred policemen surveilled the crowd for the eleven days
of the sale. Newspapers in France and abroad reported on each day's
events. Seats in the front rows were reserved for representatives of the
most prestigious names in jewelry, from Tiffany to Boucheron. Most
buyers came to cement their place in the world of jewelry at the expense

of French history. But a few, like the Bapst family, sons and grandsons of jewelers who had worked for the kings of France and were among the first historians of the crown jewels, bid heavily in a frantic attempt to preserve at least some of the jewels in their original mountings in France.

Over the centuries, from François I to Marie Antoinette, Napoleon Bonaparte, and Empress Eugénie, French royals amassed a mountain of gems, many of them exquisite and rare. They wore them in crowns, rings, brooches, bracelets, earrings, and necklaces, placed them on swords, or closeted them away. Through wars and royal rivalries and revolutions, tens of thousands of these jewels remained with the French state. Now all but a few were to be sold.

Never before had a royal collection of this importance been put up for sale, and never would one be again. Jewels were removed from their settings and organized in lots; historic ornaments were disassembled. In the end, the buyers snapped up more than seventy-seven thousand stones. The most aggressive buyer was Charles Lewis Tiffany, the founder of New York City's Tiffany & Co., who scooped up almost a third of the inventory. The sheer volume of diamonds put on the market, coming around the same time as the flourishing of diamond mining in South Africa, sent diamond prices plummeting in the world market.

"Artistically, historically, it was a tragedy," said Léonard Pouy, professor of the history of jewelry at L'École des Arts Joailliers, a Paris-based school of jewelry arts. "The French Republic dismantled what probably was the oldest and most beautiful collection of jewels in the world. To put it bluntly, it was like a second beheading"—a reference to the fate of Louis XVI in the French Revolution.

There is a consolation. The Louvre's remaining crown jewels are showcased in the most beautiful jewelry box in the world, the Apollo Gallery.

A daring architectural statement of royal power, the room is a worthy receptacle for them. The king wanted grandeur and pizzazz injected into the cold, somber walls of the Louvre. Sunlight pours in from high arched windows. The vaulted ceiling is adorned with paintings of Apollo driving his chariot across the sky; symbols and images that pertain to the sun's light and heat—hours, days, months, seasons, continents, zodiac signs—fill the room. Many of the gallery's paintings and tapestries depict

The crown of Louis XV, the sole surviving crown from the *ancien régime*, on display in the Apollo Gallery with other crown jewels. © *RMN-Grand Palais / ArtResource, NY*

allegories and scenes from mythology, while others feature the kings of France and other historical figures.

There is no other room in the Louvre like it. It is a favorite place to take children bored by too many marble statues and dark paintings. But the gallery does not tell the whole story of the crown jewels and why there are so few of them. The museum's website hints at "a tumultuous history involving theft, dispersal, and sale." A 300-page coffee-table book about the crown jewels published by the Louvre in late 2023 devotes only a few pages to their fate under the Third Republic, the parliamentary

government created in 1870 from the ashes of Napoleon III's empire; it does not admit that the auction was a mistake. Louvre officials say that some of the labels and texts in the gallery address the 1887 auction, but I never stumbled on an official version of the details. Perhaps it is all too embarrassing a story to tell.

Each jewel has a history of its own. The collection that visitors see is an incomplete hodgepodge of the few jewels that were never sold and others that have been located around the world and have somehow returned.

One treasure that never left France is Louis XV's crown, the sole surviving crown from the *ancien régime*. Jewelers created it for his coronation in 1722, using 282 diamonds, 237 pearls, and 64 colored stones— rubies, emeralds, and yellow and blue sapphires. At the coronation, his crown was placed on the altar next to the crown of Charlemagne, following tradition. Its diamonds are said to have sparkled so brightly that they lit up the church. But tradition also required that the real gems be reused, so they later were replaced by imitations. The crown is the object that gets the most attention from visitors. Many don't seem to know or care that it is made of gilded silver, not gold, and is mounted with bits of glass, not jewels.

The real jewel that was its original centerpiece sits beside it in the same display case: the 140-carat Regent diamond, the most valuable gem in the collection. Stolen during the Revolution, it is believed to have changed hands several times before it was found at a private home in a Paris suburb. During his reign, Napoleon Bonaparte liked it so much that he used it to decorate a scabbard and then a sword.

Nearby is the 55-carat Sancy diamond, which passed into the hands of several prosperous European families. It was eventually bought by the Astor family and sold back to the Louvre in 1976 for the equivalent of $2.3 million today. The Apollo Gallery also contains the sixteenth-century Côte de Bretagne spinel, carved in the shape of a dragon; the 21-carat five-sided pink Hortensia diamond; and a golden reliquary brooch decorated with two brown diamonds cut in the shape of hearts and mounted as butterfly wings.

Louis XIV had a mania for ridiculously exuberant containers and mounts set in gold and carved from minerals or mineral aggregates like

lapis lazuli, agate, amethyst, jade, and rock crystal. Given the paucity of the jewels owned by the Louvre, a small part of his "hardstone vessel collection" fills the empty glass cases in the gallery.

FOR LÉONARD POUY, THE STORY of the French crown jewels can be told in three crucial dates.

First comes 1530, when François I declared in a written edict that the king's jewels were to be measured, weighed, and inventoried as they passed on to successors. After that, no French king or emperor dared to sell them. The aim was to guarantee the prosperity of the king's lineage. With this "inalienable" wealth, the French crown could pawn its jewels as collateral to have enough money to wage war all over Europe.

The next important date is 1792, amid the chaos and violence of the Revolution, which was still unfolding. There are many versions of this story, but the most plausible is that for several nights, drunken thieves raided the Garde-Meuble—the royal storehouse—in central Paris and stole most of the crown jewels. While most were recovered, one that never came back was the French Blue, a flawless, rare steel-blue diamond mined in India and sold to Louis XIV. After the theft it was recut to a smaller size, 45.5 carats, and resold more than once. Eventually the jeweler Harry Winston bought the gem and donated it to the Smithsonian Institution in Washington. It is displayed there today as the Hope Diamond, the single most viewed object in the world after the *Mona Lisa* and one of the largest blue diamonds in the world.

Other random French jewels ended up in the Smithsonian as well: a tiara and a diamond necklace that belonged to Napoleon's empress Marie-Louise and a pair of Marie Antoinette's diamond earrings.

The final date is 1887, the year of the Louvre auction. Following the founding of the Third Republic in 1870, an anti-monarchical republican fervor swept the country. Some diehard republicans branded the crown jewels "stones waiting for the monarchy's restoration." Agitation by right-wing royalists on the other side fanned the flames. Seizing the

opportunity to weaken the monarchists and reaffirm the values of the Third Republic, the republicans proposed legislation to force "the regalia collected by the former tyrants of France" to be sold and the proceeds deposited in the national treasury. They prevailed; the crown jewels would be auctioned off to cleanse the country of its royal remnants. "The Third Republic did not like kings; it did not like emperors," said the Louvre historian Daniel Soulié.

Some French luminaries, including the country's finest jewelers, were infuriated. The government agreed to keep a small number of jewels of geologic or historic importance, but the rest were sold and dispersed around the world. Only some of their stories have been told in France.

While the French were shedding the symbols of royalty, rich Gilded Age Americans were eager to appropriate and wear them.

Early in the nineteenth century, Tiffany's was known for its luxury goods and fine stationery but gradually built an identity as a seller of jewelry. But it was Charles Lewis Tiffany's sweeping success at the 1887 auction that cemented his reputation as America's "diamond king."

He created for each jewel he purchased a custom-made, satin-lined leather box embossed in 24-karat gold with the royal coat of arms and the words "Diamants de la Couronne" (diamonds of the crown).

One of Tiffany's customers was the husband of New York socialite Cornelia Bradley-Martin. In 1887, he bought her a ruby diadem and a pair of ruby bracelets that had once belonged to Marie Antoinette's daughter, the Duchess of Angoulême. Mrs. Bradley-Martin hosted a costume ball in 1897 so extreme in its excess that it was estimated to have cost about $10 million in today's money. The old Waldorf Hotel, where it was held, was turned into a replica of Versailles. The six hundred guests dressed up as kings and queens, Ms. Bradley-Martin as Mary Queen of Scots, her husband as Louis XV. To complete her royal ensemble, she joined the ruby bracelets together and wore them to the party as a necklace.

The proceeds of the 1887 sale, more than $30 million in today's money, were pathetic. They did not reflect the historical, aesthetic, and monetary worth of the jewels of the kings. And ever since, the value of the gems from the auction has soared. When a pink 19-carat Grand Mazarin surfaced at a Christie's auction Geneva in 2017, an anonymous buyer snatched it up for more than $14 million.

For decades the Louvre has struggled to buy back, piece by piece, any jewel from the collection that came up for sale. One condition must be met: the gems and the adornments must be in their original settings. Alas, most were broken up and reset over the years.

Nevertheless, one of its most spectacular recoveries was a nine-inch-long diamond brooch in the shape of a tasseled bow that had been created for the Empress Eugénie. It had been owned by the Astor family for decades. In 2008, with money from the Paris-based Société des Amis du Louvre, created in 1897 to help build both the collections and a loyal following, the French state paid a reported $10.5 million for it. "The crown jewels are important among the nation's treasures," said Henri Loyrette at the time, "and we are thrilled." The brooch is now on view in the Apollo Gallery.

Another sumptuous piece from the 1887 auction that returned to the Louvre was a silver diadem embellished with 212 pearls and nearly 2,000 diamonds that also had belonged to Eugénie. A German prince, Albert von Thurn und Taxis, had bought it in 1890 as a wedding present for his wife, Margarethe. In 1992, the Société des Amis du Louvre bought the diadem at an auction for over $1 million and donated it to the museum. A small number of the auctioned jewels of the Duchess of Angoulême also have returned, including a large diadem with more than 1,000 diamonds and 40 emeralds, purchased by the Louvre in 2002, and the pair of ruby bracelets once owned by Cornelia Bradley-Martin, which were gifted to the museum in 1973. The duchess's ruby diadem never came back.

MY EXPERIENCE WITH CROWN JEWELS comes mostly from visiting the collection of the shahs of Iran, during the time when I reported from that country for the *New York Times*. They are considered the largest royal collection in the world and so valuable that they became a reserve fund to back the Iranian national currency.

After the Islamic Revolution swept away Iran's monarchy in 1979, the jewels were removed from view and kept locked in the basement vault of the Iranian central bank in Tehran. Whenever I asked officials

where they were, I was met either by a blank stare or the response, "What crown jewels?"

Over time they reemerged as an acceptable source of national pride, the ultimate symbols of Persia's imperial past. Iran's leaders put them on public display again.

Among the jewels are the egret-plumed crown of 3,755 jewels that Mohammad Reza Pahlavi placed on his head when he crowned himself shah in 1967; the gem-encrusted Peacock Throne that he ascended afterward; a solid gold globe and stand, three and a half feet tall, that shows the world in more than 51,000 stones; the flawless 180-carat pink Sea of Light diamond; drapery tassels made of thousands of miniature seed pearls; watch fobs of diamonds the size of lima beans; and trays and bowls piled high with loose emeralds and rubies. There are also jeweled fruit knives, flyswatters, opera glasses, opium pipes, horse bridles, and kebab warmers. The French have nothing like it.

But then, to access Iran's collection, you enter the central bank building, descend a Persian-carpeted staircase past security checks and a pair of electronically controlled steel doors, and arrive at a cool, dimly lit, marble-floored vault protected by armed guards in the basement. This is not the Louvre's Apollo Gallery. The Iranians have nothing like that.

TIFFANY'S IS PROUD TO HAVE taken the lead in buying so many of France's crown jewels. In a dossier in its archives, the jeweler boasts that it was the "most significant buyer" at the 1887 auction in Paris and the only American jeweler to attend. "Tiffany promptly sold the historic stones and settings from the French Crown Jewels to their wealthiest American clients, who were eager to establish themselves as the aristocracy of the New World," the dossier says.

Little known is that Tiffany's keeps its own remnants of the crown jewels locked in a vault in a nondescript building in Parsippany, New Jersey. The first is a brooch with 125 diamonds set in gold and silver that Empress Eugénie ordered from Bapst Frères, the court jeweler, in 1855. Three diamond leaves curve around the top of the brooch; a cascade of diamonds hangs from a cluster at its center. The brooch was part of a set

that were exhibited at the 1855 Universal Exposition in Paris. Tiffany's initially sold it to J. P. Morgan, the American industrialist, who offered it to his partner's wife as a Christmas present.

Matching the brooch is a pair of large and very modern-looking diamond clip earrings shaped like leaves that were also shown at the Universal Exposition.

More intriguing is a brooch with a large central emerald, pearl pendants, and twenty-six diamonds of varying sizes set in a circular gold and silver frame, made in 1864. It was part of an oversized jewelry belt that Eugénie asked Bapst Frères to make for her. She wore the piece, even though it was uncomfortably heavy.

Finally, there is a 65-carat diamond necklace that was fabricated with stones ripped from Eugénie's comb. Shortly after the Paris auction, Junius Spencer Morgan, an American banker and financier and the father of J. P. Morgan, bought the stones from Tiffany in trust for his granddaughter Mary Ethel Burns. The necklace was sold and resold at auctions over the years; Tiffany's bought it back in 2015 for $1.5 million.

Perhaps the story is not over. In 2021, LVMH, the world's leading luxury conglomerate, bought Tiffany's. Bernard Arnault, the CEO of LVMH and the richest person in France, is a major donor to the Louvre. Will Tiffany's small crown jewel collection stay hidden away on Fifth Avenue? Or could it one day adorn the Apollo Gallery in the Louvre?

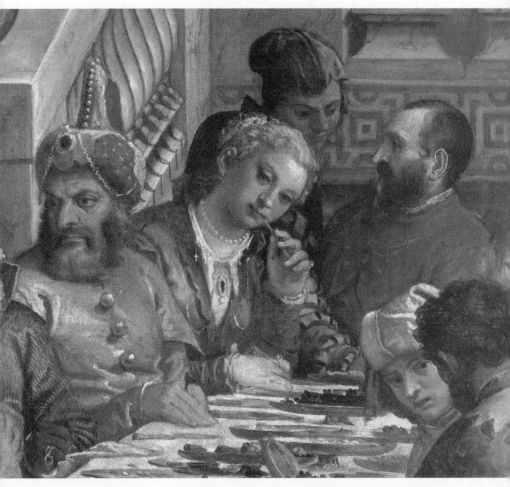

Detail of a woman picking her teeth at the dinner table in *The Wedding Feast at Cana* (1562), by Paolo Veronese, a masterpiece of Renaissance Venice and the largest painting in the Louvre. © *RMN-Grand Palais / ArtResource, NY*

CHAPTER 14

◆◆◆◆◆◆◆◆◆◆◆◆◆◆◆◆◆◆◆◆◆◆◆

"La brioche est brûlée!"

Chardin has taught us that a pear is as much alive as a woman, an ordinary jug as beautiful as a precious stone.

—Marcel Proust

I WAS WANDERING ONE DAY IN THE GALLERY THAT HOUSES THE ancient legal text known as the *Code of Hammurabi*, and I was hungry. In one of the glass cases I spotted a shallow round dish decorated with four concentric circles and made of biscuit-colored white clay. In the center were indentations in the shape of animals—four with large ears that could have been donkeys and six with raised tails that could have been dogs. "Kitchen mold," the label read. There was nothing unusual about this simple object, but its date jumped out at me. It was about 3,800 years old.

The plate was found in 1936 in the vestiges of one of the kitchens of the Royal Palace of Mari in what is now eastern Syria. Molds—with designs of animals and of pregnant women—were customarily used to make savory tarts and sweet cakes for the king.

Food, I thought. What if you could look at the universe of food through the works of art in the Louvre? How would you do it?

Ancient Mesopotamia is a good place to start. It turns out that Hammurabi was more than just a lawgiver; he was also an epicure.

I sought out Ariane Thomas, the head of the department of Near Eastern antiquities, to learn more. When discussing Hammurabi, Thomas is usually faced with predictable questions about the King's Code, the Babylonian system of 282 laws governing trade, slavery, theft, interest rates, the presumption of innocence, and the principle of "an eye for an eye, a tooth for a tooth." The most complete collection of laws from antiquity, its precepts are carved in cuneiform script into a seven-foot-tall black stone slab in the shape of an index finger that dates from about 1750 BC.

The Iranians seized the stele from the Babylonians as war booty and brought it to Susa in the mid-twelfth century BC. French archaeologists dug it up in 1902 and shipped it to France the following year.

Unlike much of the Louvre, the Near Eastern antiquities galleries are gloriously free of crowds. The *Code of Hammurabi*, however, is part of the French elementary school curriculum, and on any given day students may be sitting cross-legged at the base of the stele listening to museum curators tell its story.

They don't bother to look at Hammurabi's pots and pans.

In *Mesopotamia at the Louvre*, Thomas wrote that in the region between the Tigris and Euphrates Rivers (which includes present-day Iraq and parts of Syria and Turkey), the cuisine was rich and refined. Food was mainly based on barley or emmer wheat (including porridges, breads, cakes, crepes, and semolina pasta) and grilled or pureed vegetables such as cucumbers, lettuce, leeks, and turnips. The Mesopotamians sometimes added meats (beef, mutton, lamb, dove, quail, duck, and goose) and fresh or smoked fish; they also produced dairy products from the milk of sheep, cows, and goats. They were known for their wines, which they mostly exported, and were the first known makers of beer.

"They had *lots* of recipes for beers!" said Thomas.

The food gradually became more complex. For flavor and variety the Mesopotamians used onion, leek, cypress berries, cress, sesame and olive oil, vinegar, salt, and spices like mustard, cardamom, cumin, coriander, mint, thyme, turmeric, and sumac. Sweeter foods included honey, dates, figs, apples, pears, pomegranates, raisins, walnuts, and pistachios. In "palatial" settings, people ate ice cream and drank cold drinks. "There

was a chef who made Hammurabi's favorite dish," Thomas said. "It was a sort of quail tart. It was, let's say, strong but tasty!"

"Quail tart?" I asked. "Is there a recipe?"

"*Bien sûr!*" she said. "There are many recipes from ancient Mesopotamia, and the Louvre has some of the oldest cooking molds and recipes in the world. Tarts, cakes, even inventories recording the world's first ice creams." The recipes are short, with no measurements and incomplete instructions, and require many ingredients and lengthy preparation.

"Let's do a cookbook!" I joked.

YOU CAN LOOK AT JUST about any gallery, any collection, at the Louvre through food and drink. You never know where you might encounter eating and drinking: Egyptian water jars dating from the great dynasties before Christ; eighteenth-century saltcellars with bases in the form of a turtle or an oyster; a 2,500-year-old clay drinking vase from Italy adorned with the head of a donkey; a seventeenth-century stoneware pitcher with the coat of arms of the city of Paris.

Spend enough time contemplating cooking and eating habits, and you'll realize that the ancient Egyptians were buried with food to eat in the hereafter, ancient Romans reclined when they ate too much, ancient Greeks considered hunting a servile activity, and people in many lands have consumed a modern "Mediterranean diet" of wheat bread, wine, olive oil, and cheese for centuries.

In the ancient Egyptian department sits a painted limestone frieze from the tomb of Princess Nefertiabet, showing her seated on a throne before a meal. She is wearing a long, form-fitting leopard-skin dress that leaves her right shoulder and arm bare. The pantry behind her is stocked with drinks, bread, beef, gazelle, venison, liver, goose, duck, fish, turtle-doves, poultry, fruit, and cereals.

Move to the department of ancient Rome to find preparations for a banquet in the fragment of a second-century BC colored floor mosaic. One servant holds a basket of ripe figs. Another carries a straw tray of round breads in his uplifted arm. A third, with a pole over his left shoulder, balances a roast on a spit. A fourth brings a carafe of wine.

Visitors to the Apollo Gallery tend to focus on the crown jewels and the golden decorations of the room itself. But also on display are royal collections of dishes, plates, and silverware. You get a feel here for the *grand couvert*, a ridiculously artificial and formal ritual in which the king and queen ate their dinner governed by fussy rules of etiquette in front of the public. Louis XIV dined *au grand couvert* at Versailles almost every evening, but Louis XV preferred to eat in private.

The excess of the ruling classes cuts across centuries. The museum holds more than a hundred pieces of heavy silver tableware—some embellished with gold—from the ancient site of Boscoreale, outside of Pompeii. The utensils' main function was to impress guests with their owners' wealth.

I once came across a sixteenth-century spoon and fork set from Ceylon (now Sri Lanka), carved from rock crystal and decorated with rubies. When the Portuguese opened new maritime routes to India in the late fifteenth century, they also established trading posts, and jeweled cutlery like this set arrived in Europe as a "Portuguese curiosity."

The Galerie Marie-Antoinette contains ninety-four objects, from coffee and tea pots to crystal receptacles and silver cutlery, including the queen's 110-pound wooden travel kit from 1788, engraved with "MA" in gilded copper.

And an entire room of the Richelieu wing is filled with the tableware collection of Adolphe Thiers, France's first prime minister under the Third Republic, and his wife, Élise. Most of the collection comes from the elite porcelain makers of Sèvres and Vincennes and shows the *art de la table*—teapots, milk bottles, jam jars, gravy boats, cheese plates.

If you end up in the Islamic wing and feel confused or underinformed, just think of food and you'll feel right at home. Among the nearly three thousand objects on display are ceramic plates and jade bowls, glass bottles and metal pitchers and basins. A Persian inscription on a sixteenth-century platter reads: "That this platter always be full, always surrounded by friends, that they are lacking for nothing and that they enjoy everything well." A pitcher from Susa is inscribed: "Drink heartily."

❖

THERE ARE SIMILARITIES BETWEEN THE chef and the artist. Both use tools: the chef's utensils are not unlike the painter's brushes or the sculptor's chisels. Both use their hands to mold creations—from a *pâté en croûte* to a painted ceramic bowl. Both are attentive to proper proportions—how heavily to season a soup, how rich a red to paint a roof. Both transform raw materials into an original work. Think of the importance of oil for both. It greases the pan for one, gives life to colors for the other.

Art has borrowed from the language of eating. A painting may start *maigre* (thin), with the artist applying a background to the canvas. Then the painter tends to go toward the *gras* (fat), thickening the layers. And the colors? Tones and shades evoke the vocabulary of the kitchen. Colors are cold or hot, acidic, sweet, sour, strong, *suave* (mellow). Once a painting is finished, it can seem *tendre* (tender), *mousseuse* (frothy), or *sèche* (dry).

My favorite is the word *"croûte."* The word has multiple meanings: it's the crust of a baguette, the scab of a wound, the hard rind of a cheese. But it can also mean a worthless painting that has aged poorly, its surface hardened and damaged. To call a painting a *croûte* means it's pretty bad.

In ancient Greece and Rome, an artist who could make physical objects like a carrot and a crock come to life was considered a great talent. But Christian Europe looked down on object art. For centuries, critics ranked still life painting below landscapes, daily life, portraits, and history paintings. But if you are interested in food, you have to love the Louvre's still lifes.

Some artists reveled in painting fruits and flowers. "With an apple, I shall astonish Paris," said Cézanne. His paintings hang in the Musée d'Orsay, because he painted too late to be included in the Louvre. But visit the prints and drawings department in the Flore wing, and you will find some of his work there.

Most of the Louvre's still lifes are relegated to an upper floor of the Richelieu and Sully wings, whose rooms are the least trafficked part of the museum's painting collection. Even so, the curators consider their collection the richest when it comes to food.

The Louvre coveted a small painting by Jean-Baptiste-Siméon

Chardin, the eighteenth-century master of still life, when it surfaced at a Paris auction house in 2022. It already had forty-one Chardins in its collection—the largest museum collection of his work in the world. *Basket of Strawberries*, a 1761 canvas measuring only 15 by 17 inches, had long been kept hidden in a private collection. But it was so important that it had appeared decades earlier on the cover of a catalog of a comprehensive exhibition on Chardin in France and the United States. Deceptively simple, it shows a pyramid of strawberries at the center, with a transparent glass of water on the left, a peach and some cherries on the right, and two carnations in the foreground.

A New York art dealer who turned out to represent the Kimbell Art Museum in Fort Worth, Texas, scooped up the masterpiece for nearly $27 million, an auction record for Chardin and well beyond its $16.5 million estimate. The French government immediately declared the work a "national treasure" and blocked its export. That move gave the state two and a half years to raise the money to buy it on behalf of the Louvre.

LVMH, the French fashion conglomerate led by Bernard Arnault, the world's richest Frenchman, kicked in $16 million. More money came from the Louvre's modest acquisitions budget. Other donations poured in. The Louvre launched a grassroots campaign to raise the rest.

Laurence des Cars gushed in interviews that the painting was a "sensual, delicate, extremely elegant" masterpiece of "striking seduction." If France was to prevent the painting from falling into American hands, the fundraising was a "race against time," she warned. No donation would be too small. In the end, the Louvre raised 1.6 million euros from nearly ten thousand individual donors to seal the deal and send the painting on tour in France.

I FOUND FOOD WHEREVER I went in the Louvre, although not always the most appetizing. Heading up the Lefuel staircase one day, I turned to see a copy of a painting from the studio of Flemish painter Frans Snyders of the ugliest fish imaginable. Two fishmongers are unloading the daily arrival—carp, tuna, ray, eels, turtles, crustaceans, and other bloody fish. A cat grabs a chunk of red tuna with its claws.

A painting about dining also is the museum's largest: Veronese's *The Wedding Feast at Cana.* Using contemporary Italian imagery, it tells the New Testament tale of Jesus performing his first miracle by turning water into wine at a wedding after the hosts' wine has run out. Delicate glass goblets, gold and silver plates, and serving vessels convey luxury. The individual napkins and table settings highlight the advanced state of Venetian culinary practices compared to those of northern Europe. The guests have finished the main courses and sit before dishes of the final course: quince, grapes, dates, and sweetmeats. It would be crude to show them eating; even a woman using a toothpick to free a morsel of food from a tooth keeps her mouth closed.

I WANTED A CHEF TO analyze the relationship between food and art, so I contacted Guy Savoy, whose restaurant on the Seine is located in the building that houses the oldest institution in France: the Paris Mint. Savoy is considered by some food critics to be the number one chef in the world. An art lover, he has covered the walls of his restaurant with paintings borrowed from the private collection of the French billionaire François Pinault.

Instead of bringing Savoy to the Louvre, I brought the Louvre to him. Sébastien Allard and Jean-Claude Ribaut, the retired food columnist for *Le Monde,* joined Savoy and me at a table tucked in a corner of the kitchen and reserved for the chef's special friends. He served a different wine with each of the dishes. One was a tuna tartare with tomato coulis and a garnish of green salicornia, a purple nasturtium, and a sunny zucchini flower. "The oranges of the zucchini flower—they remind me of the Delacroix painting *Women of Algiers in Their Apartment,*" said Allard. "We are restoring it at the moment. And we are finding colors exactly like this."

Ribaut, who trained as an architect before he became an expert in food, turned philosophical. "The chef creates a work that may be appreciated for its artistry but is consumed in a few minutes," he said. "A painting is forever."

Another offering was Savoy's signature dish: thick artichoke soup

with slices of black truffles and parmesan shavings, served with a toasted mushroom brioche that you slather with truffle butter before dipping it in. Ribaut knew a lot about artichokes. He noted that the artichoke developed mainly in Sicily and was brought to France by the Italian-born queen Catherine de Médicis; that her husband, Henry II, loved artichoke hearts, which were considered an aphrodisiac; and that Louis XIV's gardeners grew five different artichoke varieties for him at Versailles.

As we were eating, I pulled out a book on art and gastronomy and turned to Chardin's *The Brioche*. The painting's focus is a large circular loaf whose lopsided, dark top makes it look as if the cook might have left it in the oven too long. A sprig of orange blossoms, the standard decoration for weddings, pierces the top of the brioche.

There is no sexual subtlety here. On the left is a flowery, plump, hand-painted porcelain sugar pot symbolizing the bride as an open vessel; on the right, a thin phallic bottle containing a dark liquid. In front of the brioche are two ripe peaches, two cookies, a small biscuit, and three cherries.

Savoy looked at the copy of the painting in horror. "But the brioche is burnt!" he exclaimed. "The chef burned the brioche!"

Ribaut laughed, but Allard was shaken. He saw the painting as he had never seen it before. "It certainly looks as if that brioche isn't very good," he said. "But why did Chardin use a burnt brioche in his painting?"

Savoy tried to make light of the dilemma. "Well, the cooks sure had a problem with their oven thermostat!" he said. "They could have protected the brioche with tinfoil, if only it existed back then." He then observed that what was in the bottle on the right looked like liqueur—either a very old sweet dessert wine, perhaps a Château d'Yquem, or a port. "Ah, to serve a port with a flaky brioche made with warm chocolate or perhaps with sour cherries," said Savoy.

But Allard looked as if he had been struck stiff by a bolt of lightning. A chef had forced him to look at a disciplined master of still life as out of control. "Chardin is almost the father of perfection, and to see his brioche as burnt is a brand-new interpretation of his art," he said. "It's revolutionary! I used to focus on the fixed, still life nature of the painting, but come to think of it, the state of the burnt brioche adds the idea of time. It gives me the impression that time flies."

We were speaking in French, and Allard used the French expression for still life—*nature morte*—literally, "dead nature."

"The brioche died twice then!" Savoy said, laughing out loud and pleased with his joke.

Allard stayed serious. "I'd say that the *nature morte* is actually a *nature vivante*"—a living nature, he said. "With this cold, overcooked, uneven brioche, Chardin captured the passing of time and the fragility of life."

The observation reminded Savoy of his personal history. Brioche, it turned out, was the first pastry Savoy learned to make as a young teenager, when he was apprenticing to a master pastry chef outside of Lyon. "It's actually my first memory from those apprentice days," he said. "A brioche with candied fruit was pure *gourmandise*. And the idea of the brioche stayed with me. I wanted to prepare a brioche for a soup, a savory version of the sweet. So I blended the modest artichoke and the luxury truffle with the child's brioche. It took me three years to perfect the recipe. And I did it! And it was seventh heaven for me!"

He then flipped through my book and said that still life brings him into the "concrete" of food. "The paintings show you how to skin a rabbit, bone a chicken, gut a fish—what is still done in a traditional kitchen," he said.

Savoy's time was precious, but passion overtook his tight schedule. "I have an exceptional work of real art to show you!" he said. He went to a remote corner of his kitchen and returned with a big plate of the most beautiful black truffles I had ever seen. Thousands of dollars of perfumed truffles for future bowls of artichoke soup. They were piled high like a pyramid in a painting by Chardin, if Chardin had ever painted truffles.

Our meal meandered, through giant langoustines swimming in broth, sautéed mussels with *mousseron* mushrooms, Wagyu beef with a potato truffle salad, a raspberry tomato gazpacho with a basil coulis, and then cheeses, sorbets, and pastries. By the time we finished, Allard and Savoy were exchanging stories. "For me going to the museum is like hearing an opera, or eating a meal," Allard said. "There is the unfolding of the event. The likelihood that something unexpected may happen."

"It's like going in a rush to see the *Mona Lisa*, that's your goal," Savoy

responded. "But then, suddenly, you get lost. You come across a work that speaks to you of an atmosphere or a place. Like looking at a still life and dreaming about what to put on the table next."

Allard offered to take Savoy on a tour through the food paintings of the Louvre one day. This is the joy of *partage*, the elusive concept that means "sharing." It is one of my favorite words in the French language.

One morning, Allard led Savoy and me into the bowels of the Louvre, through back doors, staff elevators, and basement corridors until we arrived in a gallery where we beheld Delacroix's *Still Life with Lobster*. Allard explained that Delacroix had spent time in England and that this painting mixes the genres of still life and landscape. It has the feel of a hunting scene, complete with a hunting rifle and a large Scottish beret, but with an enormous red lobster in the foreground beside a large, gray-haired dead hare.

"This is crazy, how can I put it?" said Savoy. "The lobster!"

"The lobster's red," I said. "It's already cooked."

"Obviously," said Allard.

"But the lobster is very lively at the same time," said Savoy. "Yes, the lobster took years to reach this size. The magic of cooking is that we give products a second life. This second life is much shorter, but it is much more pleasant for us! We know we're going to enjoy it!"

In a nearby room is one of Chardin's most powerful but unsettling still lifes: *The Ray*. There's nothing still about it. A cat with an arched back and a wild grin is about to pounce on a plate of oysters. In the center is a tragic figure—a triangular white eviscerated ray—or skate—suspended from a meat hook. Its gills look like a face with beady eyes and a mouth that smiles; the bloody insides drip out and give the fish an eerie anthropomorphic look.

"What a mess!" said Savoy. "The ray looks like it's hanging, but for how long? A ray must be served very fresh. It's not like a turbot, which can last a week. Ray smells and tastes like ammonia very quickly, very quickly. Pretty terrible. And the cat is on the attack! We are waiting for something to happen."

One of Savoy's signature dishes is a filleted skate wing poached in court bouillon and shaped into a rectangular block, layered with

chopped oysters and topped with black caviar. He promised to make it for us one day.

Finally, Allard took us to see the Chardin painting with the brioche. Just as in the photo in the coffee-table book, the brioche in the painting is unmistakably burnt.

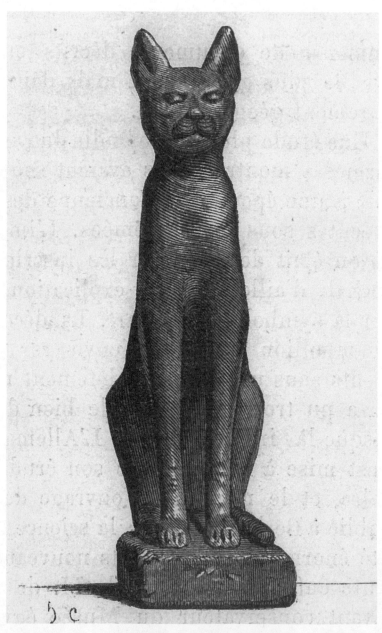
Engraving of a sacred Egyptian cat sculpture from the fifth century BC.

CHAPTER 15

✦✦✦✦✦✦✦✦✦✦✦✦✦✦✦✦✦✦✦✦

The Artist's Menagerie

The Louvre is one big child of our longing to live.
—**Léon-Paul Fargue,** twentieth-century poet and essayist

STANDING IN FRONT OF *THE WEDDING FEAST AT CANA* ONE SATUR-day morning, a French father was educating his son about art. "Look right at the center," the father said. "What is the most important figure of the painting? What jumps out at you?"

The boy, who was about six, said nothing for several seconds. Then, he exclaimed, "Dogs! I see two dogs!"

Indeed, smack in the center were two lean white dogs, leashed together by a long blue ribbon. One lay on the stone floor, gnawing on a bone; the other seemed fixated on a cat that was clawing the spout of a jug of wine to the right.

The father laughed out loud; he had expected another answer. Straight up from the dogs was a haloed Jesus Christ, staring out from the center of the dining table, serenely oblivious to the revelry around him, the Virgin Mary by his side.

Instead of an early lesson in the New Testament in art, the conversation between father and son turned to animals. How many other animals were hidden in the painting? the father asked. Ah, the boy found a greyhound poking its nose through a gap in the balcony balustrade high up in

the left corner. Nearby were two spaniels, one large, one tiny, not far from a parrot held by a court jester. Another small dog pranced on the table on the right.

Veronese certainly was having fun injecting all these animals into a crucial story of Christian lore. But his habit of leavening Scripture with animals helped get him into trouble—the Inquisition called him in to reprimand him for his irreverence.

The father-son conversation triggered a eureka moment for me. No longer did children have to suffer—tired, hot, hungry, and bored—through overcrowded rooms of ancient naked marbles and old portraits. They could go on safari! The Louvre is a rich hunting ground for animal lovers.

The menagerie here once had real bark and bite. When Charles V transformed the Louvre fortress into a glamorous palace in the fourteenth century, he added a private zoo and a falcon house. As a child, Louis XIII once rode his pet camel through the Grande Galerie. Today the Louvre's animals are in artworks, but every department of the museum, from every era, has its share of domesticated, wild, magical, or imaginary creatures.

In the ancient collections, animals often take center stage: gigantic stone bulls from Mesopotamia; elegant Persian gazelles; fantastic statues of Egypt's animal-headed gods. The Egyptians believed gods could change their form and become animals, so every small figurine of a fish, frog, bird, hippo, or crocodile represents a particular deity.

In the decorative arts department, three-dimensional ceramic snakes and lizards cling to platters and vases crafted by Bernard Palissy, the French Renaissance scientist and potter. Other objects of whimsy include a pair of nineteenth-century vases from the pottery center of Sèvres outside of Paris. Made of porcelain but painted to imitate golden bronze and lapis lazuli, draped with flowers and fruits, they resemble high-heeled shoes with boars' heads at their toes.

Paintings are the Louvre's richest hunting ground. Some painted animals, including the lions of Théodore Géricault and the battling horses of Delacroix, leap out of their frames. Many are symbolic. Pastoral cows and flying ducks suggest nature's bounty. From Greek antiquity through the Renaissance, hares and rabbits appear as symbols of sexuality in art,

and Titian put a white rabbit in his painting *The Madonna of the Rabbit,* symbolizing the purity of the Virgin Mary.

The Louvre's animal kingdom is so overwhelming that I decided to limit my search to cats and dogs. I started with two slim picture books—one on cats, the other on dogs—published by the Louvre in English and French and available in its bookstore or online. There are dozens, maybe hundreds, of cats and dogs in the museum. Sometimes I have told parents with sulky children in tow to reward them with an unspecified amount of money for every cat or dog they find. The tactic has been so successful that even though I have never owned a cat or a dog, I sometimes think in my next life I'll come back as a guide and give tours to children about the dogs and cats of the Louvre.

The dogs of the Louvre span the canine world. Sentimental dogs, royal dogs, aristocratic dogs, toy dogs, lapdogs. Bichons, Chihuahuas, Maltese, bloodhounds. Well-bred toy spaniels accessorize portraits of elegant women. Greyhounds accompany kings on hunts.

Among my favorite dogs are the two in Jan Massys's painting *David and Bathsheba.* The Old Testament story of King David lusting after and summoning Bathsheba for sexual pleasure is well known. But this version also includes a face-off between a greyhound, the regal companion worthy of a king like David, and a small red and white spaniel, the preferred lapdog for a lady. Implicit is the inevitable triumph of the bigger and stronger dog.

Assorted dogs populate the works that Rubens painted about the life of Marie de Médicis. The small spaniel that was a gift to Marie appears in three of them. In the painting of her coronation, two royal hunting dogs, front and center, steal the show. Oblivious to the momentous occasion, a bloodhound looks bored next to a black-and-white hound that busily scratches himself.

In *The Dead Adonis Mourned by His Dog,* a painting by Laurent de La Hyre, the young, handsome hunter of Ovid's *Metamorphoses* lies dead, killed during a chase with a wild boar. An enormous dog that must have accompanied his master on the chase mourns him.

More challenging to find are the dogs that appear in objects and sculptures. From ancient Iran, and often unnoticed in its glass case, is a 5,000-year-old dog pendant of solid gold, no more than half an

CHIEN BRAQUE, PAR FRANÇOIS-GRÉGOIRE GIRAUD.
(Marbre du Musée du Louvre.)

Engraving of a marble sculpture of a dog by François-Grégoire Giraud.
Every department of the museum, from every era, has its share of artworks
showing domesticated, wild, magical, or imaginary animals.

inch long and high. This dog is rather porky, but cute, with a rolled-up
tail and ears cocked at attention. "This was one of the first portray-
als of a domesticated dog, a kind of shepherd dog used to protect cat-
tle," said François Bridey, a curator of ancient Iranian art. "The piece
is also a technical feat—the first evidence of the use of soldering to
make a pendant." Indeed, the dog hangs from a loop that deserves to be
hung on a silk ribbon and reproduced and sold at the Louvre gift shop.
(I would wear it.)

Dogs can appear when you least expect them. One day, while I was
visiting the restoration of the Lefuel horseshoe-shaped ramp in a long-
forgotten outdoor courtyard, Philippe Carreau, the museum's chief archi-
tect, removed white plastic tarps to reveal a bronze statue that would soon
be restored to its place atop one of the staircase's four columns. It was a
dog nursing her pups.

AS PLENTIFUL AS DOGS ARE, I would bet that cats would win in a num-
bers contest.

There are quiet cats. One is in the right-hand corner of Charles Le Brun's *Infant Jesus Sleeping*. The baby Jesus is asleep, between his mother and a servant, protected by the warmth of a stove. The cat's eyes are shut, too.

There are angry cats, like the one in an odd menagerie in Paul de Vos's *Earthly Paradise*. The cat is small but, with its arched back and bulging eyes, looks as if it is about to attack. There are comfort cats, as in Louis Léopold Boilly's *Portrait of Gabrielle Arnault as a Child*, which shows a seated young girl holding a fluffy Angora cat. Then there are disturbing felines, like Géricault's *The Dead Cat*. Stiff in death, the cat lies at the edge of a bench or table, its front paws falling limply over the edge and its face contorted in pain.

On a tour of the Islamic wing one day, I was shown a Persian bronze perfume burner in the form of a stylized animal, and Sylvie Cuni, a private tour guide, identified it as a predatory cat known as a caracal. The head of the cat rises so that a block of incense can be put inside, and the body, neck, and head are pierced with holes to allow the scented smoke to pass through.

Cats enjoyed a high position in ancient Egypt. Under the protection of the pharaoh, they were deified and venerated. *The Cat Goddess Bastet*, an eleven-inch bronze from the seventh century BC, depicts her in her roles as protectress of the home, women, and children; a wild lioness; and the goddess of sun, joy, pleasure, and fertility. As the small gift shop book *Cats in the Louvre* by Frédéric Vitoux and Elisabeth Foucart-Walter describes her: "Our elegant puss with large erect ears sits most dignified." Her front feet are "strictly parallel" with "her tail neatly placed along her body," and her eyes, inlaid with blue-colored glass, give her "a strangely un-feline character."

More memorable are the cat mummies that have been found in the tombs of ancient Egyptian high dignitaries. Often the cats were only a few months old. One from the seventh century BC sits in a glass case in the Louvre along with other animal mummies. "The Egyptians did not worship animals—not at all," one tour guide explained. "Animals were less expensive than offerings made of metal, so when the Egyptians had something to ask of the gods, well, they sacrificed an animal and sent it to the beyond as an intermediary. So here they are—the vehicle of their prayers."

The Japanese manga artist Taiyo Matsumoto wrote and illustrated a book called *Cats of the Louvre*, which tells the tale of a group of felines that have lived secretly for years in the Louvre's attic. The aging security guard Marcel feeds them every night. One of them, a small white cat named Snowbébé, frequently escapes reality by succumbing to the seductive power of art and entering the Louvre's paintings. The story follows the cats' adventures but ends badly when unfeeling museum officials discover their presence and toss them into the unforgiving streets of Paris.

Visitors can design other Louvre safaris. The gift shop volumes on cats and dogs are part of a series that also includes books on flowers, food, jewels, and love. Pick an object, any object, and you will probably find it in the art of the Louvre.

One of my favorites is shoes. A tour of the Louvre's paintings turns up leather thongs, embroidered oriental mules, heeled boots with spurs, and the black, pointed strappy sandals of Saint Francis. Women of ill repute show off fancy ankle boots tied with ribbons, and courtiers wear boots of kidskin, velvet, suede, silk, patent leather, and brocade decorated with ribbons, rosettes, pom-poms, buckles, and flounces. The Louvre has so many shoes in its paintings that it published a luscious coffee-table book on footwear some years ago.

Yet animals, especially the ones people keep as pets, will probably always be the favorite subject for Louvre versions of "I Spy." And as the artworks show, over the centuries they have always been humans' companions.

So what about real ones? Not surprisingly, the Louvre bans animals, except for guide or assistance dogs. That did not stop the actress Demi Moore from sneaking in her small brown and white Chihuahua, Pilaf, under her large shirt, so that she could take a picture of them together in front of the *Mona Lisa*. She posted a photo of the two of them gazing at the painting. "Pilaf takes the Louvre," the caption read.

Despite the publicity, the Louvre was not pleased.

Engraving of a sixth-century BC Corinthian krater featuring
various animals. In the ancient collections, animals often take
center stage: gigantic stone bulls from Mesopotamia, elegant Persian
gazelles, fantastic statues of Egypt's animal-headed gods.

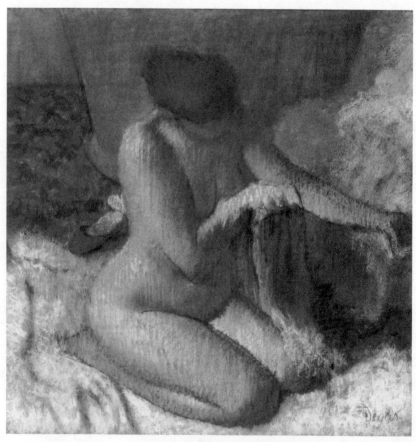

Leaving the Bath (1880), by Edgar Degas, is one of the few works of impressionism in the Louvre, as almost all works of that movement were moved to the Musée d'Orsay. © *RMN-Grand Palais / ArtResource, NY*

◆◆◆◆◆◆◆◆◆◆◆◆◆◆◆◆◆◆◆◆◆

Hidden Corners

Move me, surprise me, rend my heart.
—**Denis Diderot,** eighteenth-century
philosophy, in an appeal to artists

MY SEARCH FOR ODD OBJECTS IN THE LOUVRE IS A REMINDER THAT IT
is so large, its collections so capacious, that just when you think you know
your way around, you encounter eye-popping surprises. Certain collec-
tions are shown separately for assorted reasons. The terms of a bequest
may come with strings attached, requiring works to be kept intact as a
tribute to a donor or a family. Or the museum may decide to analyze some
of its possessions from an unusual angle, creating something special in
the process. Or plain old power politics can determine what goes where.

There are so many obscure collections that live in quiet spaces where
crowds rarely gather. Each has its own story. Here are three of them.

THE UNEXPECTED IMPRESSIONISTS

Impressionists in the Louvre? The museum has not featured impression-
ist art for decades, those paintings having moved first to the Jeu de Paume
and then to the Musée d'Orsay. But one day I happened on a lovely Degas
nude—the pastel *Leaving the Bath*. It belongs to a collection of sixty-seven

paintings and three pastels donated to the museum in 1961 by Victor Lyon in honor of his wife, Hélène Loeb. The collection spans Venetian, French, Dutch, and Spanish works from the fifteenth to the early twentieth century, by painters including Poussin, Canaletto, Van Dyck, and Tiepolo. It was donated under the condition that it would never be broken up. Given its chronological breadth, the Louvre was judged to be its best home. The impressionist works couldn't leave; they sit with the rest of the Lyon/Loeb collection on an upper floor of the Sully wing.

Victor Lyon was a French banker and businessman. A secretive man with a cold personality, he ran business schemes in the period between the two world wars that earned him the nickname *La Pieuvre*—the Octopus—at the Paris stock market. He owned a successful racehorse stable and financed a building at the Cité Internationale Universitaire de Paris that is still called the Fondation Victor Lyon. He also was known for his artistic flair, and before his death in his eighties, he decorated the walls of his home in Geneva, where he lived a great deal of his life, with a private art collection. It was considered one of the best in Europe.

Various stories are told about the donation of the collection, although the predominant one is that the couple's son Jean left no direct heir when he died, in 1957. The Lyon collection went to the French state.

Jean, who went by the name Jean Lion, was an interesting character in his own right. A sugar industrialist and an aviator, he was most famous for his fourteen-month marriage to the American actress and singer Josephine Baker from 1937 to 1939. The marriage gave her French citizenship, and she was poised to leave her exotic lifestyle for domestic bliss. But Lion was a cheat who spent her money, and she divorced him.

I like the Hélène and Victor Lyon collection, in part because hardly anyone ever comes to see it. The quiet allows for a close look at the art itself. Also, two large wooden benches planted in the middle of the gallery offer the chance to rest. The oldest work is *The Beheading of Saint Catherine of Alexandria*, painted by an unknown artist late in the fifteenth century. The two twentieth-century works are *Still Life*, by Alfred Lindon, a Polish Jewish jeweler and painter who died in 1948, and a portrait of Victor Lyon, the smallest work in the collection. He is painted as an older man, distinguished and successful, mustached, and balding, with a red rosette pinned to the left lapel of his dark suit, identifying him as an officer of the Legion of Honor.

One wall with the impressionists stands out from the rest. Dominating the space are three large Monet landscapes of Honfleur, where the Seine meets the sea in Normandy, covered in silvery snow. Joining them are two Sisleys, a Cézanne, a Pissarro, a Toulouse-Lautrec, a Renoir, and my favorite: Degas's *Leaving the Bath*.

THE WIDER WORLD

A mask of multicolored wood and swan feathers, from Alaska. The head of a Hawaiian god with an open mouth made of dog teeth. A wooden carving of a couple having sex from the Solomon Islands. A multiheaded terra-cotta sculpture at least 1,500 years old from Nigeria.

A giant, fierce-looking stone head of a statue from Easter Island. It must have stood about sixteen feet tall; perhaps it is a god.

Four flights of stairs down from the galleries of Italian and Spanish paintings of the seventeenth and eighteenth centuries is a collection with such a distinct identity that it doesn't belong to one of the Louvre's official departments. About 120 tribal and folk artworks from Africa, Asia, Oceania, and the Americas are gathered here.

The collection owes its existence to Jacques Chirac, who, as president, decreed in 1995 that indigenous, ethnographic art from around the world should have a permanent place in the Louvre.

The museum's hierarchy pushed back, protesting that the Louvre was not encyclopedic but a repository for Western art through 1848, along with ancient art from the civilizations that are at its origins. Art critics railed that the sculptures and objects were not really works of art but representations of beliefs and rituals. Some proposed sending the collection to more specialized institutions, like the Musée Guimet for Asian art, or to a natural history museum.

"For many curators of the 'largest museum in the world,' it is an earthquake," *Le Monde* wrote in response to the criticism of the initiative. "These fundamentalists still refuse to consider these objects on the same level as Western artistic production." In 2000, Chirac opened four new galleries in the Louvre celebrating the art of early non-European civilizations. His goal was outrageously ambitious: to treat non-Western art with

the same respect that is devoted to the Western canon. In a short film on the history of the collection, Chirac is shown touring the space when it opened, elated that art that had been called "primitive" had "finally and forever entered the hallowed space of our greatest museum." When the Quai Branly Museum, dedicated to the art of Africa, Asia, Oceania, and the Americas, opened with much fanfare in 2006, the Louvre administration was ready to see its sampling in the Pavillon des Sessions go. Former museum director Pierre Rosenberg tried to make it seem as if the collection was too precious to stay in the Louvre. He argued that having a permanent branch of what used to be called "primitive" art there would deprive the Quai Branly of "masterpieces." Keeping such a small number of objects in the Louvre, he said, would "isolate them from their historical and artistic context."

But the Louvre's small collection stayed. As of this writing, it remains in the Sessions Pavilion, a cross-cultural cache of surprises, all of superb quality. The works are supposed to function as a "permanent embassy" of the Quai Branly Museum within the "temple of Western art" that is the Louvre. The Quai Branly administers the collection and pays hundreds of thousands of euros per year for its upkeep. Neither the Louvre nor the Quai Branly actively promotes this collection to visitors. I had been to the Louvre more times than I could count before I learned of its existence.

The Sessions Pavilion is an inviting, clutter-free space. Natural light gently penetrates silver-plated bronze mesh screens that cover high arched windows. The message is minimalist—cream-colored walls, floors, and ceiling; four geographical spaces that flow easily into one another; the generous placement of most of the objects in individual glass cases; the discreet descriptive signage on the walls.

There are two ways of looking at its art. On one level, the spectacular selection makes it a manageable "best-of" look at non-European artworks. Some of them could create a dialogue with artworks in other parts of the Louvre, like African stone sculptures that could easily fit in the galleries of the ancient Egyptian collection. On another level the pavilion can be seen as an anachronism. It avoids present-day concerns about colonialism, slavery, and misappropriation of indigenous art objects. Many of the objects are not identified by date, location, or historical significance. The first time

I visited, a giant elephant tusk from fifteenth- to sixteenth-century Sierra Leone stood in the entrance room. As a work of art, the tusk is a brilliantly carved treasure of its time. Given contemporary prohibitions on elephant hunting and ivory trading, the prominent display was jarring.

To modernize the collection and celebrate its twenty-fifth anniversary in 2025, Laurence des Cars decided to better integrate the Sessions Pavilion with the rest of the Louvre. About fifty works from the rest of the museum were chosen to join objects in Sessions to "show how much the history of the world has always been about links between societies and civilizations," the Louvre said.

Even with the changes, there are few visitors and always places to sit, which makes the pavilion one of the most desirable places in the museum to contemplate the passage of time and the big questions of life.

ART OF THE FRAME

Many people walking through three rooms in the Sully wing with empty picture frames hanging on the walls assume that they are part of an exhibition in process. Not so. The frames are meant to be seen as works of art in themselves. The Louvre owns one of the world's largest collections of frames; about six thousand of them hold and enhance paintings, while another three thousand are stored away. The museum rediscovered its loose frames in the 1980s, when they were gathered and properly stored in the basement. After 2016, when the Seine rose and threatened to flood the museum's lower levels, the empty frames were vulnerable. The time had come to do an inventory and move the collection to safety, eventually in the new Liévin conservation center.

"This collection was completely unknown," said Charlotte Chastel-Rousseau, a senior paintings curator. "Suddenly we were asking questions like 'What are these objects? Why do we have them here? How do we protect these empty frames from water and from insects that love to eat wood?'"

Some were bought, some were donated, some were made from scratch, and some date from the collections of French kings. They may be carved, gilded, or emblazoned with the name of the artist. Or they are adorned

with flowers, ribbons, leaves, beads, branches, heads, vines, crests, swirls, shells, and fleurs-de-lis. There are frames with carved gold curlicues and frames with mother-of-pearl inlaid with stained wood.

Until a few decades ago, the Louvre cut up old frames to fit them onto paintings that needed framing. Now the goal is to preserve frames in their original state and match a work of art to fit.

The frames are so glorious that Chastel-Rousseau organized an exhibition, *Looking at Frames*, whose purpose was to show off their complexity as simultaneously utilitarian objects and works of art. The exhibition was such a success that the Louvre created a permanent display. Those who stop to look closely find themselves fascinated, drawn in by the rich detail.

The most ornate frame is made of gilded wood that was hand-carved in sixteenth-century Italy. It hangs on a wall among other Italian gilded frames. From its corners, male heads poke out of round medallions like curious characters ready for action. Linking them are scrolls, leaves, flowers, fluting, beading, and a spiral of a ribbon. "It's a masterpiece; it's like a sculpture," said Chastel-Rousseau.

While Italy tended toward making gilded frames, Holland favored exotic woods brought back from its colonies. The smooth ebony lines of a Dutch frame dating to 1650 catch the light and give off a slight silvery hue. Two smaller Dutch frames from the same era show off a tortoiseshell veneer.

Frames can be overlooked by visitors who are understandably more interested in the paintings they enclose. The best way to appreciate the beauty of a frame is to see it on its own first, without the distraction of a work of art inside. As someone who buys old frames at yard sales and sometimes hangs them empty because they are so interesting, I can relate.

Ingres understood the intimate connection between his paintings and how they were framed; he designed elaborate frames that still grace some of his portraits. Vincent van Gogh hired a carpenter to make frames for him in black. Degas used green, white, and brown frames; Mary Cassatt favored red and green. For Chastel-Rousseau, a frame has an intimate, seductive role—it should interact with its painting, add to its intensity and power, and create a rapport between the painting and the viewer. "You want a happy marriage between a picture and its frame," she said.

Sometimes, as with people, opposites attract. Rembrandt's *Bathsheba at Her Bath* was reframed in an ornate gilded Louis XIV frame rather than a sober ebony Dutch model.

Frames can be delicate, and most paintings at the museum have lived through an average of three each. One of the Louvre's most visited paintings, Vermeer's *The Lacemaker*, is enclosed in a frame of three dark wood panels holding dark honey wood with floral marquetry; the frame once held a mirror. "A Vermeer is extremely precious, so we put a precious frame around it to magnify its importance," Chastel-Rousseau said.

Two floors below the display of frames is a high-ceilinged three-room workshop that is harder to find, where the public cannot go. This is where master artisans carve, patch, and gild old picture frames and create new ones. It is one of thirteen workshops hidden away in museum corners where artisans work; their other crafts include marble chiseling, cabinet-making, metalworking, locksmithing, and upholstery repairing.

On a wall in the framing workroom hangs an array of tools—curved implements to shape plaster, sculpting instruments, scissors, chisels, saws. Tables and shelves are crammed with brushes, sponges, rolls of protective paper, stacks of wine corks, bottles of bleach and ammonia, rabbit skin glue in a tomato sauce jar. Empty frames hang on walls and spill onto the floor.

Regilding is done stingily. Once upon a time, gilding was slapped on with a heavy hand. Now the original gilding of a frame, even if it is worn or slightly damaged, is valued. "We always ask ourselves how far we can live with a slightly damaged appearance," said Elisabeth Grosjean, the gilder in charge. "It's a delicate balance."

Another artisan held up a string of gold leaf color chips ranging from yellow to red. She was touching up a nineteenth-century frame with a sheet of sheer 23-carat gold leaf. She placed a leaf on a cushion covered with calfskin, blew on it gently to flatten it, and cut it with a gilder's knife. She applied the pieces to the frame with a comb made of marten hair, then coated them using a tiny paintbrush dipped in rabbit skin glue. When the gold leaf dried, there would be more tools, more refining.

Though unfinished, the frame spoke to us.

"It's poetry," said Grosjean. "No?"

Head of a Lioness, by Théodore Géricault (1819). It is a part of a collection of "orphans," most of which were looted or bought by the Nazis during World War II. © *RMN-Grand Palais / ArtResource, NY*

CHAPTER 17

◆◆◆◆◆◆◆◆◆◆◆◆◆◆◆◆◆◆◆◆◆◆◆

The Orphans of World War II

This is not about money. I have a responsibility to honor the memory of my five family members who perished at Auschwitz.
—**Francine Kahn,** who has fought the French state to recover her family's works of art held in the Louvre

ON AN UPPER FLOOR OF THE RICHELIEU WING, SECURITY GUARDS mainly watch over works by Rubens and Bruegel the Elder. They respond with *ennui* and *incompréhension* when you ask how the museum came to acquire the thirty-one paintings that are crammed nearby into two small rooms of the National Museums Recovery collection. No chronological order, technique, or theme unites the works: German portraits and Dutch landscapes, idealized ruins of a medieval abbey and of ancient Rome, the crowning of Jesus with thorns, a fortune teller reading palms, a trio of nude women representing the Three Graces.

The paintings hang helter-skelter, some "salon style"—stacked two or three high—on pale gray walls. Not one on its own is particularly important, though some stand out: a portrait of a girl by Élisabeth Louise Vigée Le Brun, and a scene by Delacroix depicting a farrier fitting horseshoes.

Most of these artworks, it is believed, belonged to Jews persecuted during the Holocaust. Most were looted or bought by the German

occupiers of France during World War II, then recovered and gathered in France when the war was over.

During the war the Louvre earned a reputation as a fierce protector of its art. In 1939, before the Germans invaded and occupied France, the museum sent thousands of its artworks to the provinces. Louvre officials went to great lengths and put themselves at personal risk to keep art from falling into the hands of the Nazis. And so it seemed only natural, after the war, that the Louvre should become a national guardian for works of art that had been ripped from their owners. Eight decades have passed since the end of World War II. Although many artworks have been reclaimed by their owners or their descendants, others still exist in an awkward limbo. The Louvre is not their owner, only their custodian, holding on to them for safekeeping, hoping their rightful owners can be identified. The Louvre doesn't like to call them "orphans," but the name fits. Like many things in France, they fall under the authority of the national bureaucracy. The Ministry of Culture oversees conservation, preservation, historical research, and legal decisions about restitution.

These works of art bear witness to a traumatic and unfinished chapter in France's history; they also represent a historically meaningful collection.

The Louvre's more than 1,600 orphans are scattered across the museum's departments, but only about 10 percent of them are on display: about 100 paintings, about 30 sculptures, one piece of furniture, more than a dozen textiles, and more than 30 other objects. Three additional orphans have been sent to the Musée National Eugène Delacroix, a small jewel on the other side of the Seine in the Sixth Arrondissement; the museum falls under the Louvre's jurisdiction. The rest sit in storage or have been lent to regional museums across France, which use them to strengthen their own collections.

But what does it mean to safeguard these works today, after all the easy-to-identify ones have been returned and only the hard-to-attribute ones remain? Fading memory and the possibility that some of these works will never find their rightful owners raise uncomfortable questions. And restitution activists argue that despite the Louvre's acts of heroism during and after World War II, its treatment of the orphans of war reflects inertia, bureaucratic paralysis, and lack of funding.

About 100,000 artworks in France were looted by the Nazis or sold by their owners under duress. A large number of them were sent to Germany; some were sold at auction to the collaborationist Vichy government or its agents during World War II. Most had belonged to Jewish families whose homes were raided during the occupation, or who were forced in life-threatening circumstances to sell their possessions. Most owners did not survive to make restitution claims after the war, leaving children or relatives to piece together memories of their prewar lives.

From 1945 to 1949, about 60,000 stolen paintings, sculptures, and other artworks were sent back to France, and the postwar government swiftly turned over 45,000 of them to survivors and heirs. The government sold thousands of unclaimed works—and kept the money. Others were later sent to French museums. Since 1951, fewer than 200 such artworks have been returned to owners or their descendants.

The Louvre's departments have analyzed their collections to identify works that came to the museum during the period when forced sales might have occurred. Although acquisitions are usually subject to an inquiry into their provenance, sometimes there are gaps, either in research or in judgment.

"The most complicated cases," said the Louvre's Ludovic Laugier, "that takes time. It's *un jeu de patience.*" A waiting game. "The more time passes, obviously, the more memory fades."

The two rooms of paintings in the Richelieu wing are cold, frozen in time. "MNR," for Musées Nationaux Récupération, is discreetly displayed on the plaques identifying them, as well as on other orphans scattered throughout the Louvre. It was Sébastien Allard who championed the idea of grouping the paintings here for their symbolism. "Our goal is restitution—if it's possible," Allard said. But if it's not, he continued, "we must make clear that these works don't belong to us." He wanted to do much more. He proposed a separate space in every wing dedicated to MNR paintings. The idea went nowhere.

Allard also lobbied for a visible identification system of all the orphans hanging in the museum. "I proposed that all MNR paintings have a label in a different color, or with a logo, plus QR codes to allow visitors to immediately identify them," he said. "But up to now, it hasn't been done."

Why not? I asked. He shrugged.

❖

THE FIRST TIME I ENTERED the orphan rooms, I felt uneasy, realizing that these works once hung in the salons and dining rooms and perhaps even the bedrooms of private homes that had been violated during the war.

I understood the context in which the paintings had come to the Louvre. But there was nothing to identify this space at the entrance, nothing to mark it as a memorial, other than just two rooms and some explanatory text in one of them. Some of the paintings had been hung so high that they were hard to see. Others, with their heavy varnish, caught the light unevenly, and I had to find just the right spot to make out the details.

One of the hardest paintings to see is *Man Reading*, by the seventeenth-century Dutch artist Barent Fabritius. It shows a man with a long, untrimmed beard wearing a dark coat and dark hat. He is backlit in yellow; light falls on his right hand and the book he is reading. His face is shrouded in shadow; like the person who once owned the painting, his name is not known to us.

The paintings span the seventeenth century to the twentieth. Fourteen are Dutch, nine French, six German, and two Italian. The smallest, at about 10 by 9 inches, is *The Fortune Teller*, by the seventeenth-century painter Jacob van Velsen; the largest, at more than 4 feet by 5 feet, is the biblical scene *Feast of Balthasar*, by the school of the Italian Nicola Bertuzzi in the late eighteenth century.

Chilling discoveries include the fact that a nineteenth-century portrait of two sisters by Jacques-Augustin Pajou had been taken to Germany for the Nazi regime's foreign minister, Joachim von Ribbentrop, and that a seventeenth-century oil painting by the Dutch artist Nicolas Knupfer depicting the apparition of the virgin-martyr Saint Cecilia had been transferred to Hildebrand Gurlitt, one of Hitler's art dealers, in 1944.

Unlike the Louvre's collections, which are the property of the French state, these MNR artworks have a separate status. They may have rightful owners, somewhere. "There should be readily available information in the galleries about everything that is known about the original owners, how the works were stolen, and the provenance research already done," said Corinne Hershkovitch, a Paris-based lawyer specializing in art law and restitution. Hershkovitch has worked with so much passion and

determination to return works of art seized by the Nazis during World War II to their legitimate owners that she has earned the nickname Madame Restitution.

She explained that France's stated commitment to research the history of these works and find the heirs goes back years. In 2013, the Ministry of Culture formally committed itself to the goal. This led, in 2019, to the creation of a Mission for the Search and Restitution of Spoliated Cultural Property. But the initiative came with a limited amount of money and personnel. "There is no real research methodology, criteria, and training," said Hershkovitch. "Making things worse, historically all of this was entrusted to the curators, and over the years we sometimes faced their closed attitude. After all, the French word for curator is *conservateur*, and *conservateurs* are there, by definition, to keep and preserve and not to return."

As part of the Louvre's efforts to turn its image around, it published an official catalog of the MNR inventory in 2004. In March 2021, when it put a catalog of its entire museum-wide collection online, it created a separate category for the MNR group. But there is no order to the listing, and no map or interactive guide for locating the artworks.

I DISCOVERED BY CHANCE THAT some orphan paintings are considered too important to be confined with the others; the Louvre displays them in more prestigious galleries. I saw the tiny letters "MNR" when I was examining the label of a Géricault painting of the head of a lioness among other Géricaults on the upper floor of the Sully wing. It is such a striking work that it graces the landing page of the guide to the collection on the Louvre website, but on the label identifying the painting itself the MNR designation is small and not explained.

Close by is another MNR painting by François Boucher in which two small Roman legionnaire-style figures rest near a stream in a lush forest. In the next room, an MNR painting by Chardin with a copper pot, a jug, and a slice of salmon hangs alongside other Chardin masterpieces.

A second MNR painting by Boucher, *Woman and Children*, a pastoral scene of a woman in a red dress with flowers in her hair, lovingly

embracing two children against the romantic background of classical ruins, is on the upper floor of the Richelieu wing. So are two tall MNR paintings of the evangelists Saint Peter and Saint Paul by the German Renaissance painter Cranach the Elder.

During a tour of paintings by women, I happened on *The Bad News*, painted in 1804 by Marguerite Gérard. Gérard trained as the unofficial apprentice to her brother-in-law the painter Jean-Honoré Fragonard, when she lived in Paris in the home he shared with her sister. Unencumbered by the responsibilities that came with marriage and children, Gérard sold her paintings to collectors and became financially comfortable. This painting depicts a woman in blue still holding a letter whose contents have made her faint. The tour guide did not know—or did not notice—that the painting was an MNR orphan.

It is haunting to see a painting stolen from someone's dining room hanging in the Louvre, but even more disturbing are the "decorative arts" pieces. They did not just hang on walls but were handled, touched, perhaps every day, by human beings who became victims of the Holocaust. Were these ivory boxes used to store jewelry or cuff links? Did a mother prepare hot chocolate for her children in the eighteenth-century black wood-handled silver *chocolatière*, or was it an object to be admired?

THE LEGAL CASES FOR RESTITUTION of artworks looted by the Nazis or sold under duress can be complicated, contentious, and messy. One tells the story well.

In June 1942 a frenzied four-day auction took place in the grand hall of the Savoy Hotel in Nice. Buyers bid on paintings, sculptures, and drawings from "the cabinet of a Parisian art lover." Among the 444 items for sale were works by Bonnard, Vuillard, Renoir, Degas, Delacroix, and Rodin. The Vichy regime had appointed an administrator to monitor the sale; he worked alongside René Huyghe, a paintings curator at the Louvre. Both men knew the real identity of the "Parisian art lover" who had owned these works: Armand Isaac Dorville, a successful lawyer. They also knew that he had been Jewish.

After Hitler's armies invaded France and occupied Paris in 1940, the Vichy government began to actively persecute Jews, even those who, like Dorville, had fought for France in World War I. Just after war was declared in 1939, Dorville fled south, to his estate in the part of France administered by Vichy. He died there of natural causes in 1941, a year before the works he owned were auctioned. "Aryanization" laws allowed the government to take over personal property owned by Jews, so Dorville's lawyer and executor, also Jewish, decided to avoid the confiscation of his artworks by putting them up for auction.

But on the first day of the sale, the French state appointed an administrator to Aryanize Dorville's collections and seized the proceeds of the sale. Huyghe used state funds to buy twelve lots on behalf of France's national museums. Two years later, Dorville's sister Valentine, her two daughters, and two granddaughters were arrested, deported, and murdered in Auschwitz.

Eight decades after the auction, the consequences of this sale continue to haunt France, pitting the government against Dorville's heirs and reviving the ugly history of the Louvre's involvement. The issues are thorny. Was the sale of artworks owned by a Jew during the occupation done freely, or under duress, and therefore an illegal act of "looting"? Was the executor of Dorville's will, a Jewish lawyer who had spent more than a year in a German prisoner of war camp, pressured to turn over the artworks for sale when Dorville's will specified that most of his possessions would go to family members?

Dorville's heirs contend that the sale of his artworks was forced, but the French government arrived at a different conclusion. In 2021 it accepted the findings of a commission that declared the Dorville auction was carried out "without coercion or violence." Because of the Louvre's direct involvement, however, it decided that the twelve works purchased by the museum should be returned to the Dorville heirs. These include five drawings owned by the Louvre, six owned by the Musée d'Orsay but kept in the Louvre, and a wax sculpture at the Château de Compiègne. But other French museums that hold works from the auction were allowed to keep them.

The convoluted ruling enraged French art historians and critics. "If you were a Jew, you didn't need a revolver to your head to be forced to

sell," said Philippe Dagen, an art historian and art critic for *Le Monde* whose expertise is looted art. "Dorville was dead. Jewish families needed money—to survive, to flee. Of course it was a forced sale, and it involved the Vichy government of France. The government is playing with ambiguity to avoid taking responsibility. The decision was sordid, absolutely sordid."

Claire Bommelaer, a senior culture correspondent for *Le Figaro*, wrote, "What is a sale under duress, if not a sale organized by Vichy, when all the beneficiaries are hunted down, banned from auction rooms, and subject to anti-Jewish laws?"

France's interpretation contrasts with a ruling by one of Germany's culture ministries, which concluded in 2020 that the Dorville auction was a forced sale.

France later returned the dozen artworks bought by the Louvre to the Dorville heirs. The family is demanding the restitution of nine more works, including a work on paper attributed to Delacroix, and an official acknowledgment by the French state that the initial sale was indeed forced.

FRANCE HAS FACED CRITICISM FROM art critics, foreign museums, claimants, and their lawyers that it lags behind Germany and the United States in identifying and returning artworks looted during the Nazi era. There also have been suggestions that if the Louvre had the money and the will, perhaps it would create a permanent exhibition space dedicated to the orphans. Or perhaps, to make the orphans more noticeable, the Louvre could publish and sell an official orphans' guide and frame all labels of orphans on display in one distinctive color (with explanations about what they are), as Allard has proposed.

I asked Laurence des Cars whether the Louvre could create a comprehensive presentation of the MNR works in the Louvre, but she said no: "Because of the numbers, the perfect display is just physically impossible." More important, she said, is that the museum has gathered together all the "orphans" on its website and will continue researching their history.

More visitors might seek out the rooms in the Richelieu wing if the Louvre added another MNR work it keeps in storage—a shockingly good

copy of the *Mona Lisa*. It is one of the strangest MNR paintings in the museum's care.

This *Mona Lisa* copy is thought to have been painted in the seventeenth or eighteenth century. The painter and the owners are unknown. In 2019, the copy was taken out of storage for the exhibit *La Joconde nue*—The Naked Mona Lisa—at the Musée Condé in the Château de Chantilly, where other Renaissance masterpieces were on view. In Paris, though, the Louvre prefers to keep the painting in storage. To put it on display would invite "desecration and disrespect" and send the wrong signal, said Allard. "It would attract visitors who would come not to remember the horror of the Holocaust but only to take selfies with what looks like the most famous painting in the world. We'd be criticized—for using the collection for sheer amusement."

Maybe. Maybe not.

THE LOUVRE IS PROUD OF a restitution success story that followed the Dorville case. In 2024, the Ministry of Culture announced the return of two still lifes from the Louvre's MNR collection to their rightful owners: the descendants of Mathilde Javal, whose family was persecuted during World War II.

The Javals, a prominent Jewish family from the Alsace region of France, had four paintings seized from their home in the Seventh Arrondissement of Paris by German occupiers. Over the course of the war, five members of the family were deported; they perished in Auschwitz.

Mathilde Javal managed to reclaim one of the four artworks before her death in 1947. Two of the remaining works, Floris van Schooten's *Still Life with Ham* and Peter Binoit's *Dish, Fruits and Glass on a Table*, were entrusted to the Louvre's MNR collection. After years of investigation and negotiation, the French government returned the works to the family.

There was another happy consequence: the restitution brought nearly fifty of the family's descendants together for the first time. "In

the eyes of the entire family, these paintings are a way to better understand the tragedy of the deportation," one member of the Javal family told *Le Point.*

The family officially donated the two paintings to the Louvre, where they will be displayed together, alongside documents about the history of the Javal family and the horrors that befell them.

SO WHY NOT PUT THE entire MNR collection in the spotlight? Would it not honor the memory of those who lost so much during that tragic chapter of history? Wouldn't it contribute to the public's understanding of what really happened? And who would object?

Engraving of the Richelieu Pavilion in the Cour Napoléon. The Richelieu wing is the least-visited of the museum's three wings, but houses many of its most important paintings. The rooms containing the "orphans" of World War II are located there.

Panathenaic frieze. A five-foot-long, 2,500-year-old marble fragment
from the eastern frieze of the Parthenon in Athens.

CHAPTER 18

◆◆◆◆◆◆◆◆◆◆◆◆◆◆◆◆◆◆◆◆◆

You Belong to Me

The role of a museum is to give a conscience to society.
—**Michelangelo Pistoletto,** painter and representative
of the Arte Povera movement, in a lecture at the Louvre in 2023

ONE MORNING I WAS STROLLING AMONG THE LOUVRE'S GREEK ANTIQ-
uities when I found myself in the Salle de Diane, one of the clusters of
rooms you might pass through without really looking. This time I stopped.

In the center of the room is one of the Louvre's most extraordinary
ancient Greek vases with scenes from the epic battle between the giants
of Greek myth and the gods Zeus, Athena, and Nike. Athena, fierce and
courageous, drew me in. Her face is determined. She grabs the hair of her
naked male victim with one hand while she gets ready to stab him with
the long knife she holds in the other.

Then I paused to look closely around the room. The floor is a geomet-
ric puzzle of colored marbles. A ceiling painting from the nineteenth cen-
tury shows Diana, the goddess of the hunt, imploring Jupiter, her father,
not to subject her to marriage.

Along one wall is a five-foot-long, 2,500-year-old piece of a frieze in
marble. Exposure to the open air has given it a brown, orange, and honey-
colored patina. The frieze was once part of the Parthenon in Athens. It
shows six young noblewomen, who are weavers, as they walk in procession

to present a ritual offering to Athena, patron goddess of Athens. They are greeted by two priests along the way. Two more weavers walk behind them.

Three other artifacts on display in the room were also once part of the Parthenon. The most dramatic is a fragment of a powerful centaur—half horse, half human—abducting a woman. The centaur's right leg slips under her robe and presses against her groin. Her left breast and her left leg are exposed; she pulls at her robe to cover herself as she struggles to flee.

The other two fragments are small heads, both damaged, one a young, beardless male said to be a cavalier, the other female, thought to be the goddess Iris. On one side of the room are maquettes of what the Parthenon and the Acropolis on which it sits originally looked like. Hundreds, maybe thousands, of visitors walk through the Salle de Diane in the Sully wing every day, on their way from the *Mona Lisa* to the *Venus de Milo*. Few people stop. When they do, they are sometimes with a tour guide who may give the room short shrift. I overheard one say: "This was all part of the competition between England and France to bring art to their nations. Everyone knows about the Parthenon, but if you were to ask the president and the prime minister of France whether we should send these pieces back to Greece, they'd say, 'No, it's so cool to have them.' All right, let's now go see the *Venus de Milo*."

Who knew that the Louvre had fragments of the Parthenon in its collection? The British Museum famously has the Parthenon Marbles, once named after Lord Elgin, the British ambassador to the Ottoman Empire, of which Greece was then a part. Around 1800, the Ottoman Turks gave Elgin permission to strip the marble pieces off the ruins of the Parthenon. He took them back to Britain, sold them to the British Museum, and since 1816 they have been on public display there. These marble architectural ornaments, which have since become a centerpiece of the British Museum's collection, are among "the most moving and uplifting sculptures ever made," wrote Neil Macgregor, the museum's former director.

The decades-long battle between Britain and Greece over who owns the Parthenon Marbles is the most famous museum dispute in the world. The British Museum has resisted Greek demands for their return—even on loan. The Greek actress Melina Mercouri made their return her most passionate international cause when she was her country's culture minister in the 1980s. For her, repatriating these pieces of Greece's heritage was

a matter of national and spiritual pride. "This is our history, this is our soul," she said in an appeal to Britain in 1983. "You must understand us. You must love us. We have fought with you in the second world war. Give them back and we will be proud of you."

It turns out that vestiges of the Parthenon Marbles are held in museums across Europe, in Munich, Copenhagen, Vienna, and Paris. The museums argue that their antiquities collections were built legally, following practices and customs established in an era when explorers and archaeologists were free to excavate and export the treasures of ancient civilizations. In 2002, directors of major European and American museums signed a declaration that condemned what is now seen to be the illegal traffic in archaeological, artistic, and tribal objects. These days, ancient artifacts stay in their countries of origin; illegal excavations and smuggling are prosecuted. But the 2002 declaration was also an affirmation of the right to keep antiquities acquired long ago, despite claims by countries like Greece and Egypt that the artworks should be sent back.

"Objects acquired in earlier times must be viewed in the light of different sensitivities and values, reflective of that earlier era," the declaration said. Those objects "have become part of the museums that have cared for them, and by extension part of the heritage of the nations which house them."

But practices governing art objects legally obtained long ago are breaking down. In January 2022, after ten years of negotiations, the Antonino Salinas regional archaeological museum in Sicily returned to Greece a fragment from the Parthenon that had been in its possession for more than two hundred years. In March 2023, Pope Francis, as a personal gesture of ecumenical rapprochement, decided to give the Orthodox Christian Archbishop of Athens three Parthenon fragments—the head of a horse, the head of a boy, and a bearded man—that had been in the Vatican Museums for more than two centuries. The Louvre doesn't flaunt its Parthenon Marbles. They are mentioned in guidebooks but are not featured in the giant posters that hang as guides for visitors at the escalators for each of the three wings below the Pyramid.

As the world's museums struggle with the complex issue of restitution, and what pieces in their collections should be returned to their countries of origin, a thorny question arises: Do the bits and pieces of the Parthenon on display in the Louvre belong there?

❖

SO HOW DID THE LOUVRE acquire them? The processional frieze and the centaur abduction were literally picked up from the foot of the Parthenon in 1788 and 1789 by the French painter, diplomat, and archaeologist Louis-François-Sébastien Fauvel. Fauvel worked for the comte de Choiseul-Gouffier, the French ambassador in Constantinople, and the Ottoman Turks had given the ambassador's representatives permission to carry off any part of the Parthenon that had fallen off the structure and was lying on the ground.

Ten years later, revolutionaries seized the frieze from Choiseul-Gouffier, a royalist, and turned it over to the Louvre. The Louvre bought the centaur abduction at a public sale in 1818, and later acquired the two heads on display from private collections. If history had turned out differently, the Louvre might have had Britain's Parthenon Marbles as well. When Napoleon learned that Elgin was selling his collection to the British Museum, he offered to pay more; Elgin, perhaps out of patriotic fervor, refused.

Curiously and happily, the Salle de Diane also has on display a plaster cast that Fauvel made from a mold of a fragment of the Parthenon's processional frieze. It shows two war heroes, one bent over and holding a walking stick, the other looking up and pointing a finger in the air. The original of this fragment has disappeared, but it is preserved forever for all to see—in this copy.

Greece has not formally demanded restitution of its Parthenon pieces in the Louvre, a move that would certainly be opposed in many cultural quarters in France. Among the prominent defenders of keeping the marbles would be Adrien Goetz, art historian, editorial director of the Louvre's *Grande Galerie* magazine, and a sword-bearing member of the Académie des Beaux-Arts. "I am ready to use my academician sword so that the fragments remain in the Louvre, where they have their rightful place," he told *Le Figaro* in 2023.

The Louvre, meanwhile, is not looking for trouble. I once asked Laurence des Cars about the Parthenon Marbles; she responded like a seasoned diplomat. "There's no official request from Greece," she said. "It's a different story from the British Museum, and I will leave it at that."

In her long career, des Cars has prided herself on working hard to return

artworks to their rightful owners. Since she became Louvre director, she has been involved in a restitution request from Italy, which wants the return of seven archaeological art objects that the Louvre purchased between 1982 and 1998, a time when the provenance of artworks was a less prominent issue.

One object is a fifth-century BC black and ocher amphora, attributed to a master of Greek pottery known only as the "Berlin painter." On one side, a laurel-crowned figure extends his arm; on the other, a musician plays the zither. Another work is a fourth-century BC yellow, red, and brown krater, a wine-mixing vessel, painted with a scene of the slaughter of the suitors, the climactic event in the *Odyssey*.

Des Cars has called the case "important." As of this writing, however, the Ministry of Culture is still studying the Italian demand.

There are other cases as well. Xavier Salomon of the Frick once told me that if you look hard enough in the Greek antiquities collection in the Louvre, you'll find sculptures and fragments that once were part of other important sites. During the Greek war for independence in 1829, he explained, French explorers transported several marble pieces from the Temple of Zeus at Olympia to the Louvre. And in 1864, a French paleologist removed four of five sculpted pillars known as *Las Incantadas* from a portico that once adorned the forum of Thessaloniki. He sent them off to the Louvre. Greece has tried and failed to get them back.

"So much focus has been on the restitution of the Parthenon sculptures," Salomon said. "But we forget that the Louvre and other museums also have other great works of art that were violently separated from their place of origin in Greece. They are difficult cases, but equally important."

But objects from national museums are the property of the French state, and the wheels of artistic justice can turn slowly when they involve the French bureaucracy. Much of the Louvre's collection was acquired with the ethics and traditions of different times. "You cannot rewrite history" has been one of its mantras.

The champions of restitution around the world struggle to do just that; more than ever, countries seek to define and fortify their identity through objects from their past.

So what will happen to the bits of the Parthenon Marbles on display behind glass in the Louvre? For the moment that is a story with no ending.

An engraving of a fragment of a sculpted marble piece
from the Temple of Zeus at Olympia.

PART FOUR

Discoveries

The Bolt (1777) by Jean-Honoré Fragonard: Is it a scene of seduction or rape? © *RMN-Grand Palais / ArtResource, NY*

CHAPTER 19

♦♦♦♦♦♦♦♦♦♦♦♦♦♦♦♦♦♦♦♦

Where Are the Women?

Do women have to be naked to get into the Met. Museum?
—**Guerrilla Girls,** an activist art group, in a 1980s billboard
depicting Ingres's nude *Grande Odalisque* with a gorilla head

LOOK AROUND THE LOUVRE AND YOU WILL DISCOVER THAT MEN HAVE
portrayed women as victims and heroines, virgins and whores, tempt-
resses and murderesses, queens and goddesses, sexual objects and moth-
ers. There is the ingenue, the innocent, the nursemaid, the diligent worker,
the pregnant Madonna, the idealized vision of perfection in the form of
the fleshy Venus. Women in the art of the Louvre have been adored, dei-
fied, airbrushed, rescued, raped, and killed.

Overwhelmingly, women in works of art are the subjects of male
artists. The male gaze dominates and penetrates; with few notable
exceptions, women do not do the looking. Yes, the Louvre is filled with
beautiful nude male bodies in sculpture and painting, in the ancient
Roman and Greek sculpture galleries, for example, but they too seem to
be seen through the male, not the female, gaze.

Before 1848, the cutoff year for most of the Louvre's collection, artists
were almost always male. Although elite women patronized the arts, most
purchasers of art were men, too. Together, they lived out their fantasies

and expectations about women through art—male artists working for male patrons.

There are a lot of naked women in Louvre paintings—reclining on beds, frolicking in gardens, bathing in ponds, paying homage to kings and queens. Elisabeth Ladenson, a professor of French and comparative literature at Columbia University, points out that in France "nudes" in art most often means nude women. "When the French hold exhibitions of the nude, it's almost always all female nudes, seldom nude male bodies," she said. "The exceptions are ancient statues and images of Saint Sebastian," the Christian martyr who has emerged as a queer icon. "Why is it that straight men and women alike never tire of looking at female flesh, whereas gay men line up for Saint Sebastian?"

Not that some women over time haven't been disconcerted by both nude women and men. The writer Charles Baudelaire, a libertine in his personal life, passionate about art, once took Louise Villedieu, whom he called a "two-bit whore," for her first visit to the Louvre. "She . . . began to blush and cover her face," he wrote in a notebook. "Each time pulling my sleeve, she asked me before the immortal statues and paintings how such indecency could be publicly displayed."

If women today are taken aback by a work of art in the Louvre, it is likely to be for different reasons. For me, one of the most unsettling French paintings in the Louvre is Fragonard's *Le Verrou—The Bolt*. Fragonard may be the best-known libertine genre painter of the eighteenth century, showing sexual gratification and erotic love through art. Often his sexual imagery is merely implied; here it is explicit.

The painting is small, 29 by 37 inches, and the Louvre bought it in 1974 for a record 5 million francs, more than $1 million at the time. It shows a small, closed chamber dominated by a large bed with its linen turned back in disarray. A young man restrains a woman; he is apparently determined to have sex, despite what looks like her resistance. He is slamming shut the bolt on the door. Her expression is frozen; she pushes his face away with her right arm and pulls her face away from his.

On a guided tour of eighteenth-century painting I joined one Saturday morning, we stopped in front of the painting.

"And so here, we have a masterpiece: *Le Verrou*," the guide said. "A painting that is very easy to understand because it is so clear and precise. The light directs our gaze automatically toward the door on the right, where you see this hand pushing the lock, the hand of a somewhat scruffy young man. His intention is very clear."

She pointed out the large red curtain, which she says suggests "warmth," an apple on a table that is the "forbidden fruit that will be bitten into at any moment," the sheet on the bed that "can evoke the leg or thigh of a young woman.... Even though the subject is quite daring, it does not fall into vulgarity."

Daring but not vulgar? Really? No one said anything. I broke the silence.

"Is it really a seduction?" I asked, trying to raise a sticky issue in polite French. "Could this represent rape?"

"Ahhhh!" said the guide. She paused. Some members of our tour group snickered. "Today, this is the question that arises," she said, stumbling over her words. "I'm not hiding that.... I don't know if this kind of scene would really be.... The lady doesn't really seem to agree. That said, it was another era."

"Indeed, the question arises, is this consent—or rape?" another woman asked.

The guide said nothing. She smiled sweetly, as if to say, "Okay, folks, you got it." And with that, it was time to move on.

The painting is so celebrated by the museum that it is featured on the cover of former Louvre director Pierre Rosenberg's *Dictionnaire amoureux du Louvre*, an authoritative volume that organizes the history and artworks of the museum alphabetically in nearly a thousand pages. Rosenberg declares that the encounter is consensual. "*Le Verrou* is at the crossroads of a thrilling reality and a voluptuous dream," he writes. There is "audacity" in portraying a "complicit couple who refuse each other, agree, and surrender."

The painting also serves as the cover of a book in English published by the Louvre entitled *Love in the Louvre*. Love? Really?

I once asked former director Henri Loyrette about the painting. There was no ambiguity in his voice. "It's rape," he said. "I don't know how you could say it's consensual."

❖

THE BOLT IS AMONG THE countless works showing women seduced by trickery, abducted, raped. Many of these scenes are inspired by the sexual violence of Greek and Roman myth. The word "rape" is used in some of the titles.

For example, in François Boucher's version of *The Rape of Europa* (a subject also painted by Titian, Rembrandt, and Veronese), a beautiful young Phoenician princess arouses the god Zeus, who disguises himself as a bull. According to the myth, she is charmed by his playful antics and jumps on his back; he carries her off into the waves and to the island of Crete, where he rapes and impregnates her. Like Fragonard, Boucher was a painter in the eighteenth-century libertine tradition. The official painter of King Louis XV, Boucher is best known for boudoir art—the portrayal of female flesh in erotic poses. In his version, Europa, barebreasted, seated on Zeus-as-bull, a demi-smile on her face, is unaware of impending violence.

You can find a depiction of rape outdoors, in a public place like the Tuileries Garden. When I was there one day with the curator Emmanuelle Héran, she pointed out *The Centaur Nessus Abducting Deianira*, a nineteenth-century marble statue. It shows the evil Nessus carrying off the naked, terrified wife of Hercules as she struggles to break free. The story gets darker after that.

"It's crazy but, in reality, it's a story of rape," Héran said matter-of-factly.

"If this were Central Park, there would be protesters out here attacking it with hammers," I said.

But this is a garden in Paris, where the public portrayal of sex in art—willing or forced—does not follow the same codes as in a garden in New York.

The Louvre's dilemma—like that of all traditional museums today—is whether and how to take account of changing perspectives. At a symposium at the Louvre in 2023, Claire Bessède, the director of the small Musée Delacroix, which belongs to the Louvre, acknowledged that the way she looks at Delacroix's portrayal of women has evolved over time. "When I arrived at the museum, because of the #MeToo movement and many other issues, I realized that I did not at all see his works in the

same way that I did when I was studying Delacroix," she said. "I saw that his paintings depicted women being invaded or raped, or wearing bodices that are completely open without any connection to the subject of the painting. I had been blind to this interpretation before. So it's interesting to listen to the perspective of young feminists who write about women's roles, and the representation of women's bodies in art, because it allows us to understand the artworks differently. We are in a world that is changing."

I asked Ladenson whether great art from the distant past can escape the moral judgment of the present. "Obviously, it cannot," she said. "But what should happen once the past has been judged and found wanting by the standards of the present? Do we take it down? Watch out—if this policy were followed to its logical conclusions there would be no Louvre left. It's like some cultural version of the Terror, and sooner or later everyone will have guillotined everyone else."

ONE WOMAN WHO HAD THE power to control her image in the Louvre was Marie de Médicis. An entire gallery is devoted to the Rubens paintings of her life story—as she wanted it told.

Born in Florence, Marie was the second and much younger wife of the beloved Henri IV. After Henri was assassinated, in 1610, she was named regent for her son Louis XIII. When Louis came of age, she refused to step aside. He sent her into exile, but she escaped, waged war against him, and lost. Louis allowed her to return to Paris, where she sought to legitimize her influence by using art as a weapon. In 1615, she began building the Luxembourg Palace (today the Senate) as a new residence for herself, modeled on the Palazzo Pitti in Florence. She hired Rubens, the greatest painter of the day, and he paid homage to her life in twenty-four extravagant canvases. Overdecorated, dramatic, and saturated with color, they are the Instagram posts of Marie's life gone wild.

History tells us that Marie was austere, manipulative, mediocre, and jealous, but from looking at the paintings, you might think she was beautiful, learned, brave, and wise.

Sylvie Cuni, who has been bringing tour groups through the Louvre since the 1990s, explained to a group one day that to make Marie a heroic authority figure, Rubens had to change the traditional storyline. He could not show manly physical strength, so he idealized Marie in other ways. In one painting, Henri IV falls in love the moment he looks at her portrait. In another, Minerva, the Roman goddess of justice, wisdom, the arts, and strategic warfare, and Mercury, the messenger of the gods, descend from heaven to educate her. She assumes other identities as well. In the painting of her arrival in Lyon, her right breast is exposed. A painting of the birth of Louis XIII shows a cornucopia filled with the tiny heads of children who have yet to be born to her.

Even so, Rubens played with the idea of Marie as warrior. In one of the paintings, *The Capture of Juliers*, he put her in the equestrian pose of a commander. She holds a military baton and wears the helmet of Athena, the goddess of war, and the Greek version of Minerva.

If you know nothing about baroque art, you will get more than you bargained for in Marie's gallery—curves of peachy, pearly naked flesh of goddesses. "Thinness wasn't in style in those days," Cuni said.

Later we stopped at a very different portrayal of a seventeenth-century woman, *The Bohemian Girl*, by Frans Hals. "There was no problem showing Marie de Médicis's bared breast because it was allegorical," Cuni said. "But there is nothing idealized here." The woman's red bodice reveals full, pushed-up breasts. Her face is blotchy, her hair messy, her features coarse. She has the look of a sly cat. "All this means she was a prostitute," said Cuni.

In our era, more graphic and contemporary female nudity has found its way into the Louvre in photo shoots and photo art.

For a 2009 issue of the French magazine *Paradis*, Juergen Teller photographed the actress Charlotte Rampling and the model Raquel Zimmerman wandering around the Louvre—nude. Teller said he originally considered the idea as a joke, telling Rampling, "I think it's time to take your clothes off. We've got the Louvre to ourselves, and you're going to be naked in front of the *Mona Lisa*." The result was a series of full-frontal nude color photos of Rampling and Zimmerman—on a banquette in the Grande Galerie, with ancient marble sculptures, and, yes, in front of the *Mona Lisa*.

Rampling and Zimmerman are empowered women with respected careers, making choices in the real world. But in much of the imagery in the Louvre, women's value begins and ends with their physical beauty as perceived by men.

Much has been written about the Louvre's most beautiful *fesses*—the curves best perceived from behind. The word *fesses*, which doesn't translate easily into English, is more refined than "ass" or even "butt" but less formal than "buttocks" or "backside." "Derriere" can work, but *derrière* is a French word, too.

One of the Louvre's most famous paintings of *fesses* is Boucher's *The Brunette Odalisque.* At its center is the big, plump, fleshy naked backside of a woman lying on her stomach on a soft surface lush with flowing drapery. The top part of her body is wrapped in a sea of white, but her legs are parted, and her *fesses* are on display. The left cheek shines in bright light.

One slow-news summer, when the left-leaning newspaper *Libération* published a seven-part series—seven parts!—on *culs cultes* (cultish backsides) of the Louvre, *The Brunette Odalisque* was one of them. The author (male) wrote, "It's watching us, right? I would even say it is smiling at us. I'm not talking about the character, this young woman lying on cushions who turns around as we approach. I'm talking about her ass. This painting . . . is an invitation offered directly by the crease of an ass . . . which says, 'Are you coming?' "

Les plus belles fesses du Louvre, a slim, amusing 2013 book, recommended looking at *Venus de Milo* from behind to see her *raie des fesses*—a relatively polite term that translates somewhere between the colloquial "ass crack" and the technical "intergluteal cleft." Because of her garment, Venus's *raie des fesses* extends below what is visible. "The eroticism is not in the artwork, but in the eye of the beholder," the author writes. The effect? "Hypnotic."

In *Le grand incident* (*The Big Incident*), a graphic novel published in 2023, the feminist artist Zelba used the Louvre to critique the portrayal of women in art. "Under the cover of mythology and biblical scenes, women are kidnapped, subjected to nonconsensual touching, rape," said Zelba on French radio. "It is very different for male nudes, which are portrayed showing strength, virile power."

In her book, the naked women in paintings and sculptures decree that men can enter the Louvre only if they shed their clothing. Soon, the director of the Louvre decides that she will be attending work naked and encourages all women to do the same for the sake of a more egalitarian environment. By the end of the novel, everyone is naked.

As part of a series of performances in the museum galleries in 2023, the Louvre took a step toward treating the nude male and female equally. In one performance, *Non-Human Dance*, six stark naked dancers, male and female, young and old, got on all fours and pretended that they were lions.

Most of the audience—even Laurence des Cars—applauded, although some of her Louvre colleagues groused among themselves about the nudity. Noting the choreographer's "zest for perversity or provocation," *Le Figaro* asked, "How did we end up with lions being let loose ass-naked in the Red Rooms," with their nineteenth-century French masterpieces? *Le Monde* noted that the naked "hairy men and women" aroused "a stimulating visual shock" but praised the capacity of the human body "to slip into other skins" through dance.

HISTORICALLY, MEN DECIDED HOW TO both depict the female figure in art and define women's roles as working artists. Women artists were forbidden to attend life classes and draw from the nude, limiting them to a narrower range of formats and techniques. Often women who had painted freely in their fathers' studios were discouraged from continuing after they got married; or they gave up because of their husbands' work, writes historian Paris Spies-Gans in *A Revolution on Canvas* (2022).

Take Marie-Guillemine Benoist, for example. An award-winning painter and one of the few female artists whose work hangs in the Louvre, she was the daughter of a civil servant who encouraged her artistic skills and arranged for her to work under Élisabeth Vigée Le Brun, the most famous woman painter of the *ancien régime*. Benoist anchored her standing in society by marrying a banker, but in 1814, she was forced to abandon her career when her husband was given a senior position under Louis XVIII.

"Don't be angry with me if at first my heart bled at the course I was forced to take—and ultimately, to satisfy a prejudice of society to which one must, after all, submit," she wrote to her husband.

But the Louvre also served as a subversive, accidental refuge for ambitious women artists in the decades before and after the French Revolution. If a male artist had a lodging and studio space in the Louvre, his female relatives could also create art there, quietly. Men could secretly train young women artists not related to them; female family members of male artists could serve as chaperones.

"Women were able to dare the most revolutionary artistic ambitions while behaving like conventionally feminine mothers, wives, daughters, or young ladies," writes Anne Higonnet, professor of art history at Barnard College.

Spies-Gans argues that women had unprecedented artistic freedom in that window of time. In 1791, the National Assembly issued a radical decree, allowing all artists, regardless of nationality and gender, to submit their art to the Salon. The decree transformed the participation of women in artistic circles. That did not mean, however, that women's works ended up on the walls of the Louvre.

In fact, Spies-Gans ends her book with an unfinished tale of a self-portrait: In 1825, Hortense Haudebourt-Lescot, a recognized painter of Italian daily life, painted herself, not in fancy dress but in a sober smock over a white blouse. She put a man's artist beret atop her dark curls. In doing so, she proclaimed her identity "as both a woman and a mind, one and the same and together at work," writes Spies-Gans. "At the time of writing, the painting sits in storage at the Louvre." It remains in storage today.

It is challenging to find works of art in the Louvre that were created by women. In one of her first speeches as director, delivered in English, Laurence des Cars noted the paucity of works by women. "In the Louvre's department of paintings, only 25 women are referenced out of some 3,600 artists. How can museums claim universalism when entire sections of society are not represented in their collections or publics?"

A few women did become professional painters in the years represented in the Louvre, and the museum does feature works by some women painters who were celebrated during their lifetimes. Anne

Vallayer-Coster, Adélaïde Labille-Guiard, and Élisabeth Vigée Le Brun, all French and born in the mid-eighteenth century, were labeled "the Three Graces" by their contemporaries, in recognition of their skills. Vigée Le Brun painted for and was protected by Marie Antoinette and even managed to survive the Reign of Terror. The Louvre displays more of her works than those of any other woman painter.

But I am more fascinated by Vallayer-Coster, the mistress of still life. Vallayer-Coster found success young. Although she was not married, she was chosen to be the only woman to be given lodging in the Louvre—thanks to Marie Antoinette's intervention. She slipped into France's Royal Academy of Painting and Sculpture in 1770 at the age of twenty-six. That entitled her to participate in its Salon. A year later, she exhibited eleven paintings, including an early masterpiece, *Still-Life with Tuft of Marine Plants, Shells and Corals*, which features two dozen animal and plant species tightly arranged in an array of colors and textures. Coral branches sway against an inky background. But it is the conch shell, with its open, fleshy, shiny pink lips, that catches my eye. It is placed at the center of the painting, highlighted in white so the viewer won't miss it. I see an early Georgia O'Keeffe at work, subversively making the painting sexually explicit.

Art by women may also be quietly present in the museum. Women painters endured snide suggestions in the past that their portraits and historical scenes were really painted by men, but scholars have determined that the reverse was sometimes true. Art dealers often replaced the signature of a woman artist with that of a man to increase a work's value.

That's what happened to Judith Leyster, a seventeenth-century Dutch painter who was rediscovered at the end of the nineteenth century. A court case revealed that the 1630 painting *Carousing Couple*, attributed to Frans Hals (likely her teacher) and praised as one of his finest works, was in fact signed with her initials. Today the painting, now attributed to her, hangs in the Louvre alongside Hals's paintings.

If you keep looking, you will find the work of women artists in unexpected places. Hector Lefuel supervised construction of the staircase in the Richelieu wing that bears his name. He gets the credit. But it was a woman, his lover Claude Vignon (born Marie-Noémi Cadiot), who

Engraving of a woman warrior on an ancient Greek vase. In Greek mythology the
Amazons were brave, beautiful, and as skilled and aggressive in war as men.

carved three bas-reliefs—of children reading, writing, and studying the
world—that helped decorate it.

I found another example of women's work on the facades of the
Pavillon de Marsan at the far end of the Louvre where the Tuileries meets
the rue de Rivoli. There, nineteenth-century artist Hélène Bertaux cre-
ated the massive reliefs called *The Navigation* and *The Legislation*, as well
as the smaller *Moses* and *Charlemagne*.

I also discovered—with some difficulty—the work of two female
sculptors on display in the Louvre's large collection of French sculp-
tures: a clay bust of a slightly pudgy, well-coiffed middle-aged man
by Marie-Anne Collot and a three-foot-tall sculpture of Reparata,
the Italian saint who protected her admirers from cholera, by Félicie
de Fauveau.

After several years as director, Laurence des Cars defends the muse-
um's attitude toward women artists as a product of its time. "You cannot
change your past," she said, when I asked her about the lack of works by
women artists. "I mean, you can buy a few works by women. But you can't
change the fact that the Louvre is a very incomplete museum."

Still, she is searching for ways to use the Louvre's collections to deliver

messages that will resonate with new audiences. To that end, Louvre curators began to prepare an exhibition on the Amazons, from ancient mythology to pop culture.

In Greek mythology the Amazons were brave and beautiful, and as skilled and aggressive in war as men. The curators in the ancient Roman and Greek departments pulled together recent archaeological studies suggesting that ancient warrior women really did exist.

"It's one way of addressing how to be faithful to what you are, but pushing it, twisting it a little to connect to questions facing society of today," des Cars said. "And to use archaeological excavations to confirm the myth. Fascinating."

Search the Louvre and you will find Amazons: on a Greek amphora in which Hercules fights them, on an ancient Roman mosaic in which a horseman grabs the cap of a mounted Amazon warrior armed with a double-sided axe, in four seventeenth-century mythical paintings by French artist Claude Deruet, who glorified the female warrior in his work.

I have my own favorite power woman in the Louvre. I found her in the Mesopotamia collections: a nine-and-a-half-inch alabaster statuette of a naked woman who may be Ishtar, the great goddess from ancient Sumer, and the most important female deity of the time. Heavy gold earrings hang down to her shoulders. A thick choker rings her neck. A horned headdress characteristic of a Mesopotamian deity sits on her head. Her ruby eyes, shining and ringed in black, pierce my imagination.

She was a goddess of contradictions: order and chaos, sex and death, beauty, power, justice. She represented both sexual love and fertility, but she was also a goddess of war, terrifying on the battlefield and unafraid of vengeance, an ancient Wonder Woman who prefigured the Amazons. Perhaps because she was both sexual and threatening, she was believed to have the power to change gender. Some of the male priests who worshipped her at times dressed like women and adopted female names. In one ancient text, she says, "I am a woman; I am a man." Sex, power, and identity all in one statuette. Ishtar is the sculpture in the Louvre I would take with me in a bag on my shoulder if I could choose just one.

37. — DIANE CHASSERESSE.
(Musée du Louvre.)

Engraving of an ancient statue of the hunting goddess Diana alongside
a young stag. She holds a quiver of arrows on her shoulder.

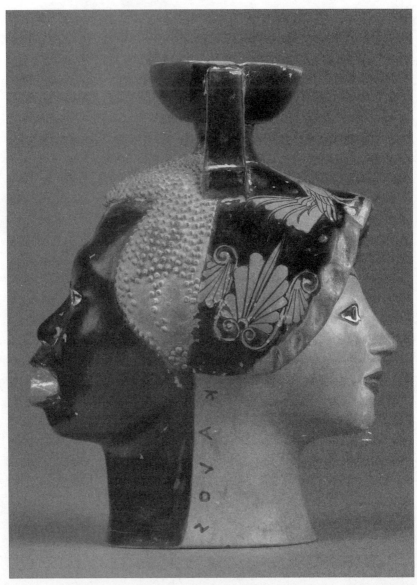

An ancient Greek vessel showing the head of a white woman and of a
Black man, 520–510 BC. © *RMN-Grand Palais / ArtResource, NY*

✦✦✦✦✦✦✦✦✦✦✦✦✦✦✦✦✦✦✦✦✦✦✦

Pharaohs, Kings, Slaves, Servants

Colour is not something one has, colour is bestowed on one by others.
—**Arthur Japin,** *The Two Hearts of Kwasi Boachi*

*We do not have a will to change our collections. They are
what they are, and they reflect the past . . . extraordinary
things, terrible things too. But, you know, that's our past.*
—**Laurence des Cars,** presentation at
the Villa Albertine in New York, 2023

THE LOUVRE'S EGYPTIAN COLLECTION IS FILLED WITH MASTERPIECES:
the twelve-ton rose granite *Great Sphinx of Tanis* (a lion with a human
head) that guards sacred places; *The Seated Scribe*, whose rock crystal eyes
follow you; a row of gilded, painted sarcophagi standing at attention; a
reclining mummy with human remains inside.

But you can find a world far from the familiar remnants of Egyptian civilization not far from Egypt: the world of the Black pharaohs of
northern Sudan.

I had no idea Sudan had an ancient civilization that mirrored, fought,
and commingled with its neighbor to the north until I saw a map at the

Louvre of the Nile also traversing all of present-day Sudan. The ancient region called Nubia, including parts of Egypt and Sudan, was centered on the Nile.

Ancient and modern geopolitics have defined Egypt as part of the Mediterranean Near East and Sudan as part of East Africa. But as archaeologists have trained the spotlight on Sudan, distinctions blur. Sudan, for example, had more pyramids than Egypt, although they were much smaller. Sudanese pharaohs Taharqa, Shabaka, and others governed the Kingdom of Kush in Nubia in what is now the northern part of Sudan.

Around 720 BC, the Kushites conquered Egypt, ruling the Nile Valley all the way to the Mediterranean Sea. Taharqa, who defended Jerusalem from the Assyrians, was the most important of the Kushite pharaohs, so important that he is mentioned in the Old Testament.

Theirs is an epic, an African epic, involving heroes and wars, victories and defeats, conquered and lost kingdoms. They sealed their success by incorporating Egyptian traditions and beliefs into daily life, including worship of the same gods. "They adopted the ways of the north so thoroughly that they became more pharaonic than the pharaohs," said Vincent Rondot, the head of the ancient Egyptian department. He has excavated for years in the ruins of the temples, palaces, and small, steep pyramids of Sudan.

The Kushite pharaohs were ousted from Egypt in under sixty years. But they continued to maintain their own rule for nearly a millennium, their civilization neither an unsophisticated backwater nor a pale imitation of ancient Egypt. In 2022 the Louvre mounted an ambitious exhibition on Napata, the Kushite capital, featuring colossal dark granite statues, terra-cotta vases, gold jewelry, parade weapons, and amulets. Enlargements of photos of archaeological sites lined the walls. Sudanese cultural officials came for the opening. The exhibition's poster showed the black-bronze statuette of a kneeling Taharqa, his arms outstretched toward the much larger gilded falcon god Hemen, atop a silver brick inscribed with hieroglyphics.

The Louvre did not put the word "Black" in the exhibition's title or call the pharaohs "Black." Rondot explained that to define the pharaohs in terms of skin color was deceptive and even dishonest, because skin color meant little in ancient Egypt, where people were classified according

to nation, ethnicity, and class, not race. The issue of skin color may have contributed to perceived differences, along with language, culture, and rituals, but there is limited information about what those perceived differences were, he said, adding that the concept of race as we know it today developed only centuries later and was permanently defined by the trans-Atlantic slave trade.

"From the beginning I found myself having to say we cannot talk about 'Black pharaohs,'" said Rondot, who curated the exhibition. "These pharaohs were not concerned with their Blackness, which is a contemporary construct, but rather with asserting their assimilation."

The tradition of considering ancient Egypt as Middle Eastern and not African has complicated how history, contemporary geopolitics, and the history of art are studied. "How is it that Egypt is not considered African?" said Anne Lafont, who studies eighteenth- and nineteenth-century art through the prism of race. "We are no longer in a continental categorization; we are in a fantasized geography."

I saw the Napata exhibition through a multicultural American lens. It was the celebration of a Black royal culture in a traditionally white museum in France, a country that is so color-blind by law that it doesn't count race (or ethnicity or religion) on its census. On opening day I asked a security guard—young, female, French, and Black—what she thought of the exhibition.

"I'm very proud," she said. "Very proud."

THERE IS AND HAS LONG been a Black presence in the Louvre. Africans and people of African descent are found in marble statues, decorative arts, paintings, and drawings. But the Black presence is rarely acknowledged. You will not find a museum-sponsored tour or a comprehensive Black Louvre guidebook. "I don't think it's our job to be experts on Blackness," said one senior Louvre administrator. "Our job is to show works and protect them and make sure that the contemporary audience, coming from so many different backgrounds, finds itself there. We just can't focus on Black people the way American museums do." The subject is so sensitive he did not want to be named.

To round out the argument, Rondot said that an exhibition like the one focused on the Kushite pharaohs demonstrates that Blackness has been deeply researched, not ignored. "There's a kind of paranoia, especially in the Black community that says, 'We are not studied; we are left out, because we are not interesting,'" he said. "On the contrary, look, we have been studying this for a long time. The proof is that here's an exhibition."

The ancient art from Sudan is the best starting point for discovering Blackness in art in the Louvre. Just walk through the halls of the ancient Egyptian collection. The statue of Sudanese pharaoh Taharqa is kept one floor above the famous Egyptian sarcophagi. It is small, only 10 inches long and 7 inches high—hard to find, but well worth it. In a nearby room a small statuette carved in soapstone and glazed in deep green depicts the dark-skinned Queen Tiye, Tutankhamun's grandmother, who was worshipped as a goddess in Nubia. Here she wears a feather dress, a necklace, bracelets, and a hawk-winged cap over her elaborately styled hair.

"The museum audience has expectations and continues to evolve," said Darren Walker, the president of the Ford Foundation and a board member of several cultural institutions, who is Black. "When people go into cultural institutions, they want to see people who look like them and experiences that they can relate to. What about the Black lady in the museum? Maybe, if we're lucky, she is visiting the museum and not just working there in the cafeteria. What does she see? What? To be excellent means you have to engage your audience."

Laurence des Cars likes to say that the Louvre must be "an echo chamber of society." So who is the Louvre for? How have ethnic groups like people of color been excluded, and what steps are being taken to include them? How can the museum be a place of empathy, of emotional connections? The Louvre argues that it is blocked chronologically (its collections mostly ending, as noted, in 1848) and geographically (as mainly a collection of European art and art from ancient civilizations); the challenge is to find creative approaches to its limitations. "We cannot jump on every subject because it's the subject of the moment," des Cars said. "We have to bring something new to the conversation, to try to be as creative, as open, as possible." As a step in this direction, in 2023 the Louvre announced a three-year partnership with France's Foundation for the Remembrance

of Slavery to "raise awareness of the place that colonial slavery and the struggles for its abolition occupy in the history of France and the world."

Still, anyone who seeks to summarize, analyze, and categorize the subject of representation in the Louvre gets caught in a tangle of contradictions, historical nuances, and accusations. One way to look at art that depicts Blackness in the museum is piecemeal, depending on the genre, origin, and era of the works, without making sweeping generalizations. And to ask questions. In the Louvre you can pick just about any subject and hunt for it there. So what would you find if you went looking for Black imagery?

The Greek antiquities collection, for example, documents the presence and celebration of Blackness. The rise of ancient Greece and Rome coincided more or less with the rise of Nubian rule, and people moved and traded widely across sea and land. A sixth-century BC Greek jar used for transporting perfumed oils known as an aryballos portrays the face of a Black man on one side and a white woman on the other. An image of an Ethiopian warrior with a spear in one hand and a shield in the other decorates a fifth-century BC Greek alabaster vase.

I once toured the Louvre with a French guide who took Black American students to look at art through the prism of race. She refused to include the Louvre's decorative objects. "You've got Blacks carrying sugarcane, represented only as slaves," she said. "It's not pleasant. So it's difficult for me." I found an example of what the guide meant in eighteenth-century objects in the decorative arts department. A pair of matching containers for pouring granulated sugar take the form of enslaved people carrying heavy bundles of cane on their backs. They wear feathered clothing and headdresses inspired by costumes of natives of the Americas described by travelers.

Indeed, most of the Louvre's representations of Blackness are found in paintings by white European artists (not unlike the fact that most works depicting women were created by men). You have to be attentive to them. They fall into several categories:

THE BLACK KING. A recurring theme in early European painting is the Adoration of the Magi, with one of the three kings revering the baby Jesus portrayed as Black. Christianity was widespread in Ethiopia as early

as the fifth century; Balthazar, the Black king who brought the gift of myrrh, symbolized its reach.

Early on, European artists were often forced to rely on prints, paintings, and sculptures to envision dark-skinned people. By the seventeenth century, Rubens painted the Black king as if from life. He may have encountered Black people in Antwerp, the port city where he lived, and may even have had Black models. He became the leading artist of his day to draw attention to the beauty of Black skin color.

THE HANDMAIDEN, SERVANT, AND SLAVE. The Louvre has late seventeenth- and eighteenth-century European paintings with a young Black page or female servant alongside a white aristocratic woman or man. Black people brought to Europe as slaves were symbols of the affluence and ostentation of their masters.

Wander the halls of the Louvre and you will find paintings showing a Black assistant helping Saint Paul set dangerous magical books on fire and a Black servant pouring wine for aristocrats. It was also fashionable to include a small African boy in portraits of high-ranking white women to set off their pale skin to greater advantage.

Sometimes the Black servant stands center stage. In Louis Jean-François Lagrenée's *Death of the Wife of Darius*, the servant grieves openly, his body facing the viewer as he pulls back a curtain to reveal the body of the dead woman.

Black servants—and also Black guests—appear among the more than one hundred human figures in Veronese's *The Wedding Feast at Cana*. An African man wearing an exotic headdress gazes at the splendid banquet. Seated not far from the bride and groom is another honored guest: a bearded Black African man wearing an Ottoman-style turban.

ORDINARY MEN. Black people were part of everyday life in European port cities long before the Americas were discovered. The early sixteenth-century painting *The Sermon of Saint Stephen* by the Venetian Vittore Carpaccio shows a Black man standing among the listeners.

Throughout the seventeenth century, the increasing exchanges between Europe and Africa found their way into paintings. When in 1644 landscape artist Claude Lorrain painted *Ulysses Returning Chryseis to Her*

Father, he placed the Homeric story in a setting of his own time. "See the Black man talking with the two white men in the foreground—we can imagine they're talking business," a Louvre guide told me one day. "It says something about the new relationships among traders."

THE SENSUOUS "OTHER" FROM AFAR. Ingres's *The Turkish Bath* was painted in 1862, making it one of the few exceptions to the museum's 1848 cutoff date. (It is there because it logically fits with his pre-1848 works.) Ingres shows several Turkish women, white, naked, posing with sensuous abandon in a steam bath. In the background are two Black women who suggest the cosmopolitan diversity of North Africa and the East.

Then there is Delacroix, who, perhaps more than any other painter in the Louvre, was fascinated by the real and imagined customs, culture, and colors of North Africa. *Women of Algiers in Their Apartment* was inspired by sketches he made of women during a diplomatic mission to North Africa in 1832. Delacroix's inside access to their apartment was exceptional; France's colonial domination of Algeria authorized him to enter their private space in a way a painter could not elsewhere. In the painting, three Algerian Muslim women, dressed in sumptuous, colorful garments and gold jewelry, are seated; the fourth figure is a Black servant who stands at their side.

The complex colors and intricate details of the canvas sprang to life following a recent restoration. The Black servant's face and coloring touched Bénédicte Trémolières, the painting's chief restorer, who removed layer upon layer of varnish over seven months. I was invited to watch her one day as she experimented with various solvents. "There's something so just and delicate in the movement, in the face, because of little blue paint strokes delicately overlaid on the dark skin," she said. Trémolières pointed out Delacroix's subtle yet profound use of color, even in the deepest darkness. "All the deep shadows are explored, and there's always a small note of pure color that animates these darker parts. He neglects nothing."

THE SMALL BOY AS THE "OTHER." In some paintings, the presence of a Black boy brings a touch of the exotic. In Antoine Caron's *Sibylle of Tibur*, a late sixteenth-century painting, you have to wonder, Who is the small Black figure painted at Sibylle's feet? He is almost naked, and in

his right hand he holds a monkey on a leash. Is he some sort of protector? Is he the personification of the other, of travelers from Africa that most Europeans had never seen?

In *La Tabagie*, a seventeenth-century painting by the brothers Le Nain, a Black boy stands beside a group of soldiers gathered around a table smoking their pipes. The boy looks directly at the viewer as if to say, "I belong."

THE MYSTERIOUS. I asked Anne Lafont where she would start if she were to explore Blackness in the Louvre. She chose two works that capture the mystery—and the dignity—of Black figures. Her first choice was Benoist's *Portrait of Madeleine*. It is both the subject of a small book she wrote and a featured attraction in Beyoncé's *Apes**t* video.

Madeleine was a real person. Enslaved by Benoist's brother-in-law in colonial Guadeloupe, she came to France and became his domestic servant after slavery was briefly abolished. The painting is exceptional in its portrayal of a Black figure; it presents Madeleine as neither a servant nor a minor figure. She is the star. She looks straight at her viewers, perhaps to challenge them. Benoist contrasted Madeleine's dark skin with the whiteness of her turban and the cloth that partially covers her but leaves her right breast exposed. "So much can be said about this painting—history, revolutions, the place of women, of the female artist, of slavery," said Lafont. "We are in front of a young Black woman who looks at us. And if she looks at us, it is because she looked attentively at the person who painted her." So the painting tells two stories: one of Madeleine and her presence in France, the other of a relationship that developed between two very different women. "An intimacy is created between these two women, even if one is a servant and the other is an artist who belongs to the *petite bourgeoisie*," Lafont continued. "This closed-door relationship is what is interesting."

The Louvre still struggles with the mysteriousness of Madeleine, at least as of this writing. The original title of the painting was *Portrait of a Negress*. Then the title was changed to *Portrait of a Black Woman*. When the Musée d'Orsay, then under Laurence des Cars's leadership, opened a major exhibit in 2019 on "Black Models" in French painting, it restored her dignity by calling her by her first name. The painting was renamed

Portrait of Madeleine. Alas, the Louvre website and the label next to the portrait still identify her as *Portrait of a Black Woman*.

Lafont would then go to Géricault's *The Raft of the Medusa*. The 1816 wreck that inspired the painting occurred when the *Medusa* ran aground off the Senegalese coast. The captain and senior officers saved themselves in lifeboats but left 147 soldiers and crew to face the ocean. For thirteen days, the abandoned men were plagued by hunger, terror, madness, murder, suicide, disease, and cannibalism. Only fifteen were rescued and survived.

Géricault, who was in his twenties at the time, captures the moment when the men see salvation. Some on the raft are dead or dying; before painting them, Géricault studied corpses in the morgue and the agony of dying in a Paris hospital. The cloth that is waved at the ship in the distance is held by a Black man, seen from behind at the top of a pyramid of other survivors. The figure was inspired by a Black immigrant from Saint-Domingue named Joseph. A tightrope walker before he arrived in Paris, Joseph became an artist's model. Géricault did preparatory studies of him before painting this work. He chose to add two other Black men to the painting, one of whom, it can be seen, is dead.

Never before had a French artist dared to paint a horrific current event like a shipwreck on such a large scale and with meticulous attention to detail. This scale was reserved for heroes of history and myth, for kings, not for survivors on a raft. The painting was also a political statement, "overt criticism of the mismanagement of the navy," Lafont said, and it showed a Black man in a heroic role. "It's the figure of the slave who saves the world," she said. "The Black man at the top of the pyramid gives hope to the survivors."

In 2006, Henri Loyrette invited the American novelist Toni Morrison to the Louvre to lead a six-week "conversation" around a theme of her choice. She chose "The Foreigner's Home," combining art, poetry, music, dance, lectures, and debates to capture and articulate the suffering and at times the healing of displaced people.

It dealt with the "other," the outsider. "Who better than Toni Morrison, the first person of African American culture to receive the Nobel Prize, to bring a new, shifting vision to our museum?" asked Loyrette.

At first Morrison hesitated. "I don't know the Louvre," she told him.

Loyrette persisted.

The starting point for Morrison's series of conversations was *The Raft of the Medusa*. For her, the painting represented the long and difficult journeys of millions of refugees searching for a new home. She selected the painting as a backdrop for a poetry slam performed by young rappers.

Long before, in a lecture in 1988, Morrison had called on Black artists to tell their own stories. "Now that Afro-American artistic presence has been 'discovered' actually to exist . . . ," she said, "it is no longer acceptable merely to imagine us and imagine for us. . . . We are the subjects of our own narrative, witnesses to and participants in our own experience."

A QUESTION TO ASK IS whether the Louvre owns any artworks by Black artists—not ancient and anonymous but known people of later centuries. I found only one painter in the Louvre defined as having Black roots: Guillaume Lethière, a famous figure in the Paris art establishment in the late eighteenth and early nineteenth centuries.

Born in Guadeloupe, most likely into slavery, Lethière was the son of the king's royal prosecutor and of a mixed-race enslaved woman whom he emancipated. Encouraged by his father, he started painting as a boy, and at fourteen was sent to France to develop his talent.

There he worked with live models, and the precision and spirit of his work with historic scenes and landscapes made him an artistic rival to the much better-known Jacques-Louis David. Lethière painted on large canvases and infused his work with the republican and democratic spirit of his day. Two of his best-known works, which depict stories of parents who turn against their children for the greater good, hang little-noticed in the room with the gift shop just outside the gallery with the *Mona Lisa*. One is *The Death of Virginie*. (After failing to seduce Virginie, a Roman magistrate abducts her and rigs a trial that makes her his slave. To save her honor and ensure her freedom, Virginie's father, Virginius, stabs her to death at her request.) The other is *Brutus Condemning His Sons to Death* (Brutus, the founder of the Roman Republic, stoically watches as his sons are beheaded for having rebelled against the state).

Though most of Lethière's work makes no reference to a Black identity, an exception hangs in Haiti: *The Oath of the Ancestors*, painted in 1822. In the midst of the abolitionist movement in France and then riots in French colonies, Lethière showed his solidarity with the new Black republic. He painted a white God bearing witness to the alliance of two of Haiti's revolutionary leaders, Jean-Jacques Dessalines, the Black leader of the slave revolt, and Alexandre Pétion, a mixed-race French officer who turned against his army to join the independence movement. Broken chains lie under the feet of the two men.

Despite great success during his lifetime, Lethière was largely forgotten after his death. Finally, in 2024, the Clark Art Institute in Massachusetts cast him as the star of his own exhibition for the first time, a project that took years to develop. The show then moved to the Louvre. It took the initiative of an American museum to make him famous in France once again.

In other small ways, the Louvre is recognizing Black artists. The Franco-Cameroonian artist Barthélémy Toguo was commissioned in 2022 to create a monumental installation under the Pyramid in conjunction with an exhibition called *Les choses* (Things). He used fabrics in riotous colors and patterns from Cameroon to make dozens of sacks between five and ten feet in diameter, arranging them in a tall pillar that reached the pinnacle of the Pyramid.

The sacks represented the baggage that migrants who disappeared and died took with them on their journeys. They contained "the desperate objects of all these migrants who move en masse around the world," Toguo said. "I tried from this installation to mourn all these migrants, these human beings who have disappeared."

The installation fit perfectly in the empty space. It was only temporary. Toguo's sacks were dismantled and carried away. Would they be remembered?

Princely Head, a twelfth/thirteenth-century sculpted decoration, considered the *Mona Lisa* of the Islamic department. © *RMN-Grand Palais / ArtResource, NY*

✦✦✦✦✦✦✦✦✦✦✦✦✦✦✦✦✦✦✦✦✦✦

An Islam of Enlightenment

Don't walk by. Sit. Rest. Forget your daily life.
Dream. That's the message.
— **Yannick Lintz,** former director
of the Islamic art department

There sure is a lot of old pottery here.
— **American tourist,** speaking to his
young son in the Louvre's Islamic collection

THERE IS A QUIET PLACE IN THE LOUVRE THAT SEEMS TO EXIST ON ITS
own, far from the chaos, noise, and kinetic energy of the overcrowded gal-
leries that absorb most visitors' attention. As you enter the Denon wing,
instead of turning right and up the stairs to the *Mona Lisa*, turn left into
the world of Islam.

The main gallery welcomes you with a large video screen zooming in
on architectural jewels like the Alhambra in Spain and the Great Mosque
of Isfahan in Iran. To see the interplay of the tile work, the fullness of
the domes, and the intricacies of the wood carvings is to be ushered into
a new universe. The message is clear: Islam is art and culture, as well as
a religion.

The Islamic department was a bold, $125 million initiative born out of President Jacques Chirac's desire to reach out to France's growing, restive Muslim community. The argument was that the Louvre holds one of the richest collections of Islamic art in the world and could use these treasures to bring Muslims and the rest of France closer together.

"The only problem was where to put it," said Henri Loyrette, who promoted the idea as soon as he became director of the museum in 2001. "The wealth of the collection could have justified a stand-alone museum elsewhere in Paris. But it had to be in the Louvre itself."

In 2002, Didier Selles, then the Louvre's chief administrator, drafted a formal proposal for the creation of the new department. Under the plan, the Musée des Arts Décoratifs, the private museum that occupies choice real estate in the Louvre's Marsan and Rohan wings along the rue de Rivoli, would move to the Monnaie de Paris—the Paris Mint, just across the river.

Loyrette presented the plan. Chirac loved it.

But then Chirac's wife, Bernadette, weighed in. Her close friend Hélène David-Weill, the head of France's decorative arts entities, was opposed to the idea of displacing the decorative arts museum—so opposed that she and Bernadette vowed to launch a public campaign in protest. Chirac, defeated by his formidable wife, gave in.

Inevitably, there was other criticism. The art historian Rémi Labrusse denounced the Louvre for accepting huge sums of money from what he called "certified tyrannies" and for ignoring the dark reality that many of the objects had been acquired by force. He predicted that the department would promote "a pseudo-world of dreams yoked to the past . . . and a caricatured present, arousing repulsion and rejection."

But the project survived. The bulk of the money came from corporations like the oil giant Total and governments and entities of Saudi Arabia, Oman, Morocco, Kuwait, and Azerbaijan. The largest onetime financial gift ever given to the museum, $20 million, came from billionaire Saudi prince Alwaleed bin Talal. At the opening ceremony in 2012, President François Hollande called the Islamic wing a "political gesture in the service of respect for peace. . . . What more beautiful message than that demonstrated here by these works?"

❖

THE DEPARTMENT HAS THE LOOK of a spaceship docked in the neoclassical Visconti courtyard. The roof, weighing 135 tons, consists first of an inner web of almost 9,000 steel tubes that sit below a layer of 2,350 glass triangles. On top of that is an undulating, filigreed surface that looks as if it were made of spun gold and silver. When its design was first revealed, the two architects—one French, one Italian—said it resembled "a scarf floating within the space."

The best place to see the top of the roof is through one of the windows in the Daru Gallery of marble sarcophagi en route to the Nike of Samothrace. When the sun is shining, I think of a gossamer wing of a giant dragonfly or an exotic spineless ocean fish or a sand dune shaped by the wind. In the ground-floor gallery, the roof dips so low at points that you can reach up and touch it.

Unlike most of the Louvre's other collections, which had to adapt to the existing architecture from centuries past, the Islamic art department has the advantage of 30,000 square feet of open gallery space constructed on two floors from scratch. Ceramics, metalwork, stone sculptures, books, manuscripts, textiles, carpets, and glass are organized chronologically, spanning 1,200 years of history, from the dawn of Islam in the seventh century to the mid-nineteenth. Touch stations for the blind include made-to-scale models of sculptures, wood carvings, and fine objects; samples of the materials; and descriptions in Braille.

Islamic art first arrived at the Louvre through the looting of royal palaces and churches in France in the wake of the Revolution. Kings and clergymen had collected beautiful objects crafted in the Islamic world. Some were purchases from Egypt or Syria or even beyond, from Iran and India; others were gifts from important visitors. In the Middle Ages, French rulers were fascinated by Mamluk Egypt; later, Louis XIV loved Indian miniatures of the Mughal dynasty and jade bowls from the Ottoman Empire.

A search of the Louvre's storage facilities also turned up forgotten objects. Three thousand colored ceramic Ottoman tiles had been hidden

away since 1970, many of them uncatalogued and never before photographed. It took curators and artisans almost six years to classify them into families of similar tiles. Then came the task of assembling them into a 39-foot wall in the wing's underground level. "It's even more beautiful than what I'd imagined," said Sophie Makariou, then the director of Islamic art, when she saw the finished artwork.

Another spectacular work in the Islamic collection is the fifteenth-century Mamluk Porch, once a decorative passageway in an Egyptian mansion in Cairo. The porch, made of three hundred pieces carved from golden yellow and white limestone, was disassembled, crated, and shipped to France. It was intended for the Universal Exposition of 1889, at which the Eiffel Tower was a main attraction, but it was never shown. The stones languished in storage in southern France until they were discovered in 2000. The Mamluk Porch was reassembled using stainless steel pegs and installed in an alcove off the lower gallery of the Islamic wing. Standing more than thirteen feet high and weighing five tons, with its hexagons, eight-point stars, and stylized floral motifs, it bears witness to the bygone architectural grandeur of Cairo. Alas, it often goes unnoticed.

THE COLLECTION IS BOTH GEOGRAPHICALLY and chronologically incomplete. A descriptive panel at the entrance to the Islamic wing acknowledges—without explanation—that the collection is distorted by what it is not: "Certain regions with significant Muslim populations today—such as sub-Saharan Africa and Southeast Asia—are not represented here." Most of the Louvre's works of Islamic art from Asia were sent after World War II to the Musée Guimet, as previously noted. Works from Africa are now in the Quai Branly Museum. And like the rest of the Louvre's collection, the Islamic art department ends in the mid-nineteenth century.

Acknowledging these gaps, Yannick Lintz devised a strategy to focus on the "best of the best." "I put myself in the shoes of a tourist who doesn't want to be intimidated, just to have a good look at the masterpieces," she

said. "What are the ten or fifteen works to see? And what are the different stories they tell? I can take you on a journey in one of the most beautiful artistic collections in the world, over twelve centuries, from Spain to India!"

And so, one day, we traveled together.

She showed me her favorite work of art in the Louvre: *Princely Head,* a nine-hundred-year-old life-sized stucco head of an Iranian prince from the ancient city of Ray, now part of greater Tehran. Traces of paint indicate that he was created in full color. He wears a triangular headdress trimmed in fur. His eyes are slanted, his face round and full, evoking the ideal beauty praised by the poetry of the time. But it is his smile, as serene and magnetic and mysterious as *Mona Lisa*'s, that draws you in. "He is a beauty of figurative art," Lintz said. "He proves that the art of Islam can be both secular and religious."

We stopped next at a glass case holding a tenth-century cylindrical carved ivory box from Córdoba, Spain. Its detailed carvings on a section of a single elephant tusk recount the story of an assassination that took place five hundred years before: a princely heir to the throne of Córdoba was killed so that an eleven-year-old child could take his place. The scenes are complicated and confusing, but what is known is that this act of violence sparked the eventual fall of one of the great centers of Islamic power. There are delightful scenes of everyday life—people picking clusters of dates from a tree and gathering eggs from a falcon's nest; there are also acts of violence: a bull fighting a lion, dogs biting a donkey. "It's kind of a comic book of the tenth century!" Lintz said. "I don't know one person who hasn't been fascinated by it."

Then we proceeded to an eleventh-century Egyptian pitcher carved from a single piece of rock crystal. It had belonged to the French kings. "The Egyptians imported rock crystal from Madagascar but were not interested in it," Lintz observed, "so the real collectors of these objects were the Europeans, not just royals and aristocrats. Clerics, too. In the Middle Ages in France, the best art of the Islamic world was seen in cathedrals and chapels. In fact, you could call the clergy the first creators of museums of Islamic art in their churches."

My calm place in the Islamic arts department—and one of my

favorite places in the museum—is the windowless underground level, which is darkly lit to protect the fragile carpets and miniatures on display there. Accessible via a staircase at the back of the main floor, it is easy to miss. A simple oak bench along one side invites you to savor the complex designs that surround you and the precious objects sitting in splendor in glass cases.

If I listen hard, a deep male voice beckons. It is a recording of some of the most famous verses of poetry in Persian, from the *Shahnameh*, the *Book of Kings*, written in the tenth century by Abolghasem Ferdowsi, Iran's greatest epic poet. The subject is not art or religion or politics but wine. A nearby plaque translates.

> *Now is the time to drink fine wine,*
> *As the perfume of musk wafts from the heights,*
> *The air is full of cries and the earth trembles,*
> *Happy is he made joyful by drinking . . .*

Happy is he or she made joyful in a museum. That can happen here.

In 2021, the French state, together with the Louvre, launched a nationwide exhibition of the country's Islamic treasures to help disseminate a positive message of Islam. The initiative was an official response triggered by the beheading in October 2020 of the schoolteacher Samuel Paty for showing caricatures of the Prophet Mohammad during a class on freedom of speech.

Eighteen destinations outside of Paris—from the rough Paris suburb of Seine-Saint-Denis to the French island of Réunion in the Indian Ocean—were chosen; each received ten works from the Louvre and other cultural spaces. The emphasis was on the joy, luxury, sensual pleasure, and cultural reconciliation of art in Islam.

In the exhibition brochure, the Louvre dared to include a reproduction of a fifteenth-century manuscript depicting the Prophet Mohammad, bearded and haloed. The pictorial representation of the Prophet is seen as sacrilegious by almost all authorities in the majority Sunni Islam sect. But the Koran does not explicitly ban pictorial depictions of Mohammad, and Mohammad's image has been shown many times over the centuries in Iran, which largely adheres to Shiism.

I signed up for a tour one Sunday afternoon at the local museum of Mantes-la-Jolie, a working-class, multi-ethnic town near Paris. Among the works we saw were a centuries-old ceramic bowl from Iran showing a couple in a stylized embrace, a Syrian candlestick with the coat of arms of a Florentine family during the Crusades, and a portrait of an eccentric sixteenth-century court poet playing with his dog.

Ours was an older crowd; the Muslim youth of the town didn't seem interested in the exhibit, the guide said. No matter. "We're bringing the Louvre here, and these tours are free for everyone," she said. "Maybe it's a start in changing the dialogue."

THERE IS ONE OBJECT IN the collection that perhaps more than any other illustrates the complexity of France's relationship with Islam: a large basin created in either Syria or Egypt in the fourteenth century. Made of hammered brass and inlaid inside and out with bronze, gold, and silver figurative decoration, it was an object of luxury used for a practical, secular purpose: handwashing. Perhaps it was commissioned by a wealthy Mamluk patron; perhaps his guests used it at fancy receptions. On the outside are four medallions with a formally dressed cavalier on horseback. Costumed characters hold the symbols of their roles at court, among them a mace-bearer, an axe-bearer, and a bow-bearer. One servant holds a piece of crockery with words of whimsy: "I am a container for carrying food." On the inside are battles and hunting scenes whose stories are animated by a menagerie: from prey such as gazelles, hares, wild boars, lions, bears, wolves, and cheetahs to imaginary creatures such as griffins, sphinxes, unicorns, and dragons. It is signed several times by a master artisan named Muhammad ibn al-Zayn.

The basin was listed as having been part of the French royal collections since the fifteenth century, and royal coats of arms were hammered onto its curved lip sometime after it arrived in France. It served as a baptismal font for the royal children of France. Sometime in the eighteenth century, though, it mysteriously got the name by which it became known: *Baptistery of Saint Louis.*

Saint Louis was King Louis IX, who led two failed Christian crusades against the Muslim rulers of the Middle East and North Africa. He was captured and ransomed in the first one and died of dysentery during the second. Known for legal reforms and good works for the poor, he was considered the ideal Christian monarch and was made a saint. (He also expanded the Inquisition in France, turning against the Jews and punishing blasphemy with mutilation of the tongue and lip.) The Île Saint-Louis in Paris and the city of St. Louis in Missouri are named after him. He is among historical lawgivers represented on a frieze at the U.S. Supreme Court.

But Muhammad ibn al-Zayn made his basin fifty years after Saint Louis died, so he couldn't have been baptized in it.

In late 2021, Neil MacGregor, the former director of the British Museum, gave a series of lectures at the Louvre on the future of museums. In one, he showed an image of the basin, praised it as a masterpiece of Islamic art, and asked a tough question: "What must a Muslim visitor to the Louvre feel when he sees this profane object transformed in this secular museum into a religious object, all the more so for a religion that is not his own?"

The standing-room-only audience was silent as he spoke.

He followed with another tough question: "What do we think when we know that the object is linked to Saint Louis, knowing his role in the Crusades?" He suggested that changing the name of the basin could be the starting point for a dialogue of reconciliation.

In a book based on his lectures, MacGregor went further with an unusual attack on the Louvre. "For many visitors, the current name must seem as insulting as it is absurd," he said. "The name '*Baptistery of Saint Louis*' symbolizes centuries of alleged European Christian supremacy—political, cultural and military—over the Arab world."

Yannick Lintz, who also knew that the name of the basin was false, was eager to tell the real story to just about anyone who would listen. "The fantasy story is that Louis IX brought it back from the Crusades," she told me. "Of course, it isn't true. Stories about the Crusades are always romanticized."

So is it time to rename this object? The obvious answer is yes, but

life moves slowly at the Louvre. The name has not been changed so far. A misnomer, as well as a missed opportunity for reconciliation. After all, the French fleur-de-lis—a three-petaled lily—would not have been offensive to the basin's original owner. The flower was not only a symbol of the French royal family but also a popular, stylized emblem of the Mamluk dynasty.

An Armenian gold-and-silver vase handle in the shape of a winged ibex,
dated between the fourth and sixth centuries BC, so delicate and lifelike
that it seems to be flying. © *RMN-Grand Palais / ArtResource, NY*

CHAPTER 22

◆◆◆◆◆◆◆◆◆◆◆◆◆◆◆◆◆◆◆◆◆

Persia Comes to Paris

And I saw in a vision; and it came to pass,
when I saw, that I was in Susa in the palace . . .
— Daniel 8:2

IN 2014, SHORTLY AFTER FRANÇOIS BRIDEY JOINED THE LOUVRE AS A
curator of ancient Iran, his first assignment was to do an inventory of the
collection. He camped out, alone, in a large second-floor storage facility
crammed with thousands of objects. One day he came upon something
unexpected: two enormous wooden crates shoved out of the way in a cor-
ner of the space.

The crates were from excavations of the ancient city of Susa in south-
west Iran, conducted between 1906 and 1908 by Jacques de Morgan, a
French archaeologist and expert on mining, engineering, and geology.
Those digs unearthed objects from thousands of tombs. The crates had
never been opened.

Bridey peeked inside and saw dozens of packages individually num-
bered, carefully preserved, and wrapped in yellowed French-language
newspapers. Each package contained pottery dating roughly from 4000
BC. They were in fragments, encrusted with dirt and sediment from the
excavation site.

"It was like receiving a special Christmas gift," Bridey said.

This was a specific style of ceramic pottery, with black decorations on buff-colored clay, from burial sites during the earliest days of the city. The work had stylized abstract geometric motifs and depictions of animals—birds, ibexes, and dogs. By chance, this type of Iranian pottery had been the subject of Bridey's doctoral dissertation at the École du Louvre. Over the next several months, he and a team of experts began the time-consuming process of studying the shards and piecing them back together.

"It's something that happens to you once in a lifetime," he said.

Discoveries can come when you least expect them, and Bridey struck gold a second time during his inventory. He happened on a random chunk of sandstone with no identification. He turned it over in his hands and had a hunch. A fragment of what looked like women's hair and a decorative pattern reminded him of something. He didn't tell the other curators, because, he said, "I was thinking, It's crazy. It can't be." One Tuesday, when the museum was closed, he took the piece of stone with him into one of the galleries. There, the four-thousand-year-old statue of Narundi, one of the most important goddesses of Susa, was on display. She is seated on a lion throne, holding a cup and the branch of a palm tree in her hand. Her body and disconnected head had been discovered in the early part of the twentieth century and joined together much later.

But part of her forearm just below her left shoulder was still missing. Bridey discreetly lifted the stone piece and placed it in the empty space. It was a perfect fit. He ran to find the curator who had worked on the statue for decades and had been his mentor. "It was a very emotional moment!" he said. "My heart beat faster! I cried a little bit."

The piece was added; the goddess became more complete. For Bridey, the discoveries mean something more. "They allow the works of art to bear witness to history," he said. "They are a form of respect that we carry for our collections."

"Do you know the word *qismat*?" I asked him. *Qismat*, used in Arabic and Farsi, means kismet, or destiny, those random moments of fate that make up our lives.

"Yes, exactly, *qismat*," he replied, laughter filling his voice.

❖

WHENEVER I TAKE VISITORS TO the Louvre, I like to take them to the Richelieu wing to see the decorative friezes of glazed bricks that once graced Susa.

It took more than two decades of traveling to Iran before I discovered ancient Persia. I went to Iran as a journalist—for a revolution, a war, an embassy seizure. It was only when I was writing a book about Iran that I allowed myself the luxury of discovering the world of Darius the Great.

When Darius became the ruler of the Persian Empire in the sixth century BC, he made Susa his permanent capital, complete with a 250-acre palace complex. One of the oldest cities in the world, it became a commercial, bureaucratic, and political hub that was as important as Persepolis, a largely ceremonial site about the same size, which Darius also built. In the Old Testament, Susa is best known as the place where Esther outwitted Haman to save the Jews from annihilation.

Susa is located in a remote part of southwest Iran in the Zagros Mountains, on what is now the border with Iraq. Foreigners are rarely allowed in, either to the ancient site or to the nearby modern town of about forty thousand people. I visited Susa in early 1982, during the Iran-Iraq war. The Iraqis had attacked a huge swath of Khuzestan Province, where Susa is located, and the Iranians wanted to show the destruction to the outside world.

Even before the Iraqi attacks, however, there was little to see of ancient Susa. Over the centuries, invaders captured, plundered, and destroyed the palace complex. Starting in 1884, French archaeologists carried out wide-ranging excavations there. An agreement required France to split its discoveries equally with the Persian authorities, but the French archaeologists ignored this provision and shipped whatever they found back to Paris. Most of the artifacts—tens of thousands in all—ended up in the Louvre. Naser ad-Din Shah was not pleased, and in 1886 he revoked the French excavation permit. The French responded by inviting him to Paris, where he saw the Persian galleries at the Louvre. Seduced, he agreed to a new arrangement under which all discoveries became the property of France.

"France made a very clever diplomatic agreement and had a monopoly," said Julien Cuny, the Louvre's curator of the ancient Iranian collection. "For decades only the French could dig, and everything they dug up in Susa was allowed to come to France." This cooperation continued until the Iranian Revolution in 1979.

One of the most unusual objects in the Louvre collection is a silver-and-gold handle of a vase in the shape of a winged ibex, more than 2,300 years old. It is so delicate and lifelike that it seems to be flying. There are also clay accounting tokens and pottery, carved cylindrical seals, gold jewelry with semiprecious stones, terra-cotta figurines, and sculptures rendered in metal, clay, and ivory. Fragments of black-and-white floor tiles from an unknown composite material show that they had been made to look like marble. "You ask me why I am interested in Iran? Well, it's because it was the center of the world," Cuny said. "The Persian Empire— the center of the world in that era. You enter these rooms, and you have arrived in Persia."

The centerpiece of the palace rooms from Susa in the Louvre is the upper part of what was a nearly seventy-foot-tall limestone column decorated at the top with two kneeling bulls. Thirty-six of these columns once supported the roof of a 128,000-square-foot audience hall, or *apadana*. The column was pieced together from several fragments.

Susa was a center for artistic brickmaking. Large decorative friezes of polychrome glazed bricks, some of them molded into bas-reliefs, line the walls, pieced together from thousands of fragments, like giant puzzles. One frieze shows bearded, richly clad archers in profile carrying bows, quivers, and spears as they march. Others depict muscular lions, baring their teeth; griffins with lions' heads, bodies, and forelegs, the hind legs of an eagle, and the horns of a ram; and winged bulls. The friezes use dazzling glazes of turquoise, green, brown, white, and yellow.

The first friezes from Susa came to Paris because of an unusual French couple: the Dieulafoys. Jane Dieulafoy, an anthropologist, was also an explorer, field manager, photographer, sociologist, novelist, feminist, and journalist. The convent-educated daughter of a monied merchant family, she married Marcel-Auguste Dieulafoy at the age of nineteen and followed him to the front of the Franco-Prussian war in 1870, wearing the uniform of a French soldier. When Marcel was offered an unpaid

assignment in Persia, Jane accompanied him there as well. They traveled 3,700 miles across mountains, deserts, and swamps by horseback, joining caravans along the way. Jane kept her hair short and dressed like a man, in pants and sturdy boots, armed with a rifle and a whip. When her hair became infested with lice, she shaved her head. Felled by fever, the couple returned to France, empty-handed except for Jane's sweeping photographic inventory of Iran's heritage. As a result of this trove, the French government and the Louvre financially supported their project to explore and excavate Susa for France. Jane managed the extraction and classification of the enameled bricks they found, which were eventually reconstructed as the friezes of lions and archers in the Louvre today. In her obituary, the *New York Times* called her "the most remarkable woman in France and perhaps in all Europe."

Dieulafoy did not hide her brutal excavation tactics. In her memoirs of the excavations of Susa, she wrote, "Yesterday, I was watching with regret the large stone bull that was recently discovered. It weighs about twelve thousand kilograms! It is impossible to move such a massive object. Finally, I couldn't control my anger, I took a hammer and started hitting the stone bull. As a result of my violent blows, the column split like a ripe fruit."

During a phase of warming relations between the United States and Iran between 2014 and 2017, I took several trips to the country with groups of American tourists. Every time we went to Persepolis, our guide, Cyrus, would tell us that if we really wanted to experience the beauty of ancient Persia we should head to Paris. "Go to the Louvre," he said. "The works there are more spectacular."

The gift shop at Persepolis even sells postcards of the colored brick walls of Susa, the ones displayed in the Louvre.

Small statuette of a hermaphrodite from ancient Mesopotamia, one of the Louvre's figurines with intersex bodies that are among the museum's most intriguing surprises. © *RMN-Grand Palais / ArtResource, NY*

✦ ✦ ✦ ✦ ✦ ✦ ✦ ✦ ✦ ✦ ✦ ✦ ✦ ✦ ✦ ✦ ✦ ✦ ✦

The Queer Universe

There lies within a great museum's hall,
Upon a snowy bed of carven stone,
A statue ever strange and mystical,
With some fair fascination all its own.
And is it youth or is it maiden sweet,
A goddess or a god . . . ?

—**Théophile Gautier** on the Louvre
sculpture *Sleeping Hermaphrodite*

HIDDEN BEHIND THE FRIEZES OF GLAZED COLORED BRICKS FROM ancient Iran is a room of about 150 objects from two thousand or more years ago that don't seem to belong anywhere else. They come from empires, dynasties, and peoples long forgotten, among them the Parthians, Sasanians, Seleucids, and Neo-Elamites. You need patience and energy to examine the objects after visiting the galleries of friezes and artifacts from the palace of Emperor Darius in Susa. They include a two-pronged metal fork, a stone sarcophagus, an incense burner, a sword, mosaic tiles, handles of mirrors and vases, oil lamps, and dozens of tiny figurines carved from animal bone.

Two of the figurines show intersex bodies. They are among the Louvre's most jolting surprises.

The figurines are stuffed into glass cases with other random objects.

Their labels reveal little. The first figurine is geometrical and evenly balanced, about three and a half inches high. Described as a "hermaphrodite," it was found in a child's tomb. You start by looking at the hairstyle, fashioned with deeply carved lines blackened over time, then move down to huge eyes that bulge like headlights, then past the neck to small breasts above a tiny waist lined with stomach rolls. Between full, strong thighs is a penis. It is all stylized but unmistakable, a penis.

The second figurine, from Sumer, is also tiny, with small, high breasts and full hips. Its penis is more pronounced, sitting below a deep V-shaped slash where a vulva might be. The origin is obscure, but one form of worship during this era involved the Sumerian myth of Ishtar, who was said to have had powers over gender.

The Louvre often seems to avoid the issue of sexual identity in its collections. It offers no queer-themed tour on its website, as do the British Museum, the Metropolitan Museum of Art, and the Rijksmuseum. But the presence of these sexually fluid figurines opens onto a universe of queerness within the Louvre's walls. The museum possesses one of the greatest queer art collections in the world, ready for anyone to discover.

The ancient Greek and Roman collections are a good place to begin. Classical literature and mythology are stocked with gender-fluid Greek gods whose stories are retold in ancient art. The most famous example is *Sleeping Hermaphrodite*, an ancient Roman marble sculpture in the Salle des Cariatides, whose body lies on a tufted marble mattress carved in 1620 by Bernini. From behind, it looks like the beautiful, life-sized body of a woman sleeping. Circle around, and on the front side are rich breasts and a healthy penis. Hermaphroditus was the beautiful young son of Hermes, the messenger god, and Aphrodite, the goddess of love. The infatuated water nymph of the fountain of Salmacis aggressively pursued Hermes, but he rejected her advances. Disappointed, she begged the gods to join their bodies into one. They granted her wish, and Hermaphroditus became half-man, half-woman.

Some visitors to the Louvre see the statue as an artistic oddity, a freak of nature. In his book *Dictionnaire amoureux du Louvre*, Pierre Rosenberg called it the museum's "most notorious attraction, especially to teenagers." The Louvre had to construct distance barriers around it to prevent

inquisitive visitors from getting too close to the sculpture's "attributes," he wrote. But perhaps it also embodies an ideal beauty characterized by completeness. And the statue is indeed beautiful.

Gay relationships were another familiar theme for the Greeks and Romans. A fifth-century BC Athenian vase depicts a scene of *paiderastia*, the love of boys. A tall older man cradles a small young man; the young man raises his head so that their lips can meet. The scene is typical. Greek vases often showed what was considered an initiation practice between a bearded adult with a boy of around twelve. The practice ended with the appearance of the boy's own facial hair, although adult male couples are also featured in ancient Greek art and literature.

A real-life story from Roman history documents a different kind of gay relationship. The emperor Hadrian was so smitten with his young and beautiful Greek lover, Antinous, that when Antinous died at the age of nineteen, Hadrian made him a god. The Louvre has a statue and three busts of Antinous. Another close relationship is captured in the mythical story of Achilles and Patroclus, warriors in the Trojan War. An eighteenth-century painting by Giuseppe Cades portrays their relationship as a profound passion. The two men lounge in their tent. Achilles plays the lyre with his leg intimately placed between the legs of Patroclus, who leans comfortably toward him.

Roam the Louvre's other ancient departments and you may find yourself overwhelmed by sexual fluidity. An ancient Egyptian relief of *The God Amon and Ramses II Kissing*, discovered in the East Temple of Karnak, shows the two men in profile, their faces almost touching. Was the kiss one of religion, ritual, or passion?

And how to interpret the relationship between a young male page and Shah Abbas in a seventeenth-century Persian painting? The shah grips the wrist of his young servant. The page looks at the shah; the shah averts his eyes. They are so close that their headdresses are touching. There is always a question of whether to judge centuries-old art by current standards, but the scene seems clearly sexual.

The Louvre's rich collection of art from Renaissance Italy also sparks passionate debate. At the time, homosexuality "was so common in Florence that the word *Florenzer* became slang in Germany for 'gay,' " according to Walter Isaacson, biographer of Leonardo da Vinci. Donatello and

Benvenuto Cellini were thought to be queer, as was Michelangelo. Verrocchio and Botticelli (who was at one time charged with sodomy) never married. All of them have works in the Louvre.

Then, of course, there was Leonardo himself—beautiful, brilliant, and attracted to men. Female nudes are nearly absent from his oeuvre. When he turned twenty-four, he was twice accused of sodomy with a male prostitute; both claims were dismissed. His John the Baptist, in one of the Louvre's most famous paintings, seems to have been modeled on Gian Giacomo Caprotti (better known by Leonardo's nickname for him, Salaì, or "little devil"), a young assistant with a soft face and luscious curls with whom Leonardo was in love. The sexual ambiguity of the painting was noted as early as the end of the seventeenth century. Isaacson calls this Saint John a seducer as much as a saint, with an androgynous appearance and an erotic frisson. In *The Virgin of the Rocks*, another Louvre treasure, the angel, whose stare is as alluring as that of Saint John, is supposed to be either Gabriel or Uriel, both male. But its appearance is so feminine that even some art critics have referred to it as female.

Michelangelo produced two homoerotic works that are Louvre superstars, the *Rebellious Slave* and the *Dying Slave*. Larger-than-life marble sculptures, they were conceived as part of a group of twelve slaves for the tomb of Pope Julius II, but left unfinished. They show two extremes of sensuality—power and abandonment. The *Rebellious Slave* is heavy, rough, and tormented. The *Dying Slave* is beautiful and dramatic, a young male nude with his eyes closed. Despite his muscular body, he seems unwilling to free himself from the strips of fabric that enclose his chest, or incapable of doing so. He abandons himself. He surrenders.

"No one can tell me that Michelangelo's slaves are not about a man's desire for another man," said the Frick's Xavier Salomon. "Those two statues are unbelievably sexy. They're clearly done by a man who loves a male body—and a naked male body. At the same time, making Michelangelo or Leonardo into gay icons is not the point, because they would have never identified as such. And that was a word that didn't even exist at the time. But clearly it's part of their life story and it's part of their output in terms of their work."

❖

FOR ANOTHER, VERY PERSONAL PERSPECTIVE on the queer Louvre, I turned again to photographer Ferrante Ferranti, who was born in Algeria to parents of Sicilian and Sardinian origin. He and I bonded over Sicily, where my grandparents were born. He gives lectures on Renaissance and baroque art, takes friends on cultural tours of Italy and Turkey, and has long photographed art through the prism of queerness.

We met in the morning at Pierre Puget's 1682 baroque marble sculpture *Milon of Crotone*, in the Cour Puget sculpture gallery. Milon was a wrestler of huge stature and strength in ancient Greece. According to legend, his hubris convinced him he could pull out an oak tree by its roots; instead, his hand became stuck in the tree's trunk, trapping him. In the sculpture, a lion is sinking its claws and teeth into his leg. Milon twists his muscular, nearly naked body in a hopeless struggle to escape.

Ferranti reminded me of "the fragment," the idea of looking at part of a work of art to capture its ambiguity. He pointed out the fragment he meant to emphasize. "If you cut off the lion that devours Milon, you don't see suffering. If you look closely, it's not a cry of pain." Instead, Ferranti sees emotional complexity. "He is being devoured by a lion, but he's there, with a kind of pleasure. It touches the dimension of sadomasochism."

Nearby was Edmé Bouchardon's sculpture *Sleeping Faun*. The figure's eyes are closed, his head resting on his raised right arm. His legs are spread wide, drawing your eye straight to his exposed genitals. "It's a most erotic work for me, really homoerotic," Ferranti said. "Sex offered like that, it made everyone fantasize—the whole aesthetic of intoxication, of desire expressed, of total abandonment."

Then it was on to Saint Sebastian, whose death was ordered by the Roman emperor Diocletian. In real life Sebastian was a pious captain of mature age in the Praetorian Guard. In paintings, he is usually a young, slim, curly-haired beauty with arrows in his chest. "Saint Sebastian is the most homoerotic saint, of course," said Ferranti. "He's become a gay icon, because of his abandonment, and the sensuality of his gaze. His performance is almost a provocation. It says, 'Look how beautiful I am, I don't care about suffering.'"

Of the Louvre, he exclaimed, "Saint Sebastian is all over this place!"

Ferranti found Mantegna's *Saint Sebastian* austere and sexless, "the perfect incarnation of the anti-queer." Perugino's Sebastian, in contrast, looks up to heaven, nearly nude. "We're completely over the edge," Ferranti said. "You can see the sex behind the veil. We have a captivating approach. The blond curls are here. His loin covering is about to fall off. There's only one thing we want."

In another gallery, he pointed out *The Sleep of Endymion*, by Anne-Louis Girodet de Roucy-Trioson. In Greek mythology, Endymion is a beautiful youth who spent much of his life in everlasting sleep. This version features a naked Endymion sleeping on a leopard skin with a naked teenager named Zephir hanging from the branches of a tree, his genitals exposed. The painting was a rousing success when it was presented during the Terror in the Salon of 1793, the year the Louvre opened.

We looked at Jacques-Louis David's canvas *Leonidas at Thermopylae*, in which Spartans ready themselves courageously for battle. Their leader, Leonidas, is naked except for a helmet on his head. (The Spartans held naked war games, which led to inaccurate legends that they fought naked as well.) Decode the painting, Ferranti said, "and you see it is completely gay."

When we passed Michelangelo's slaves, Ferranti told me how he photographed them, following the curves of their marble flesh with the play of light. "Michelangelo was probably the most crypto-gay artist in history," he said. "He was very tortured by his homosexuality. He put a very strong erotic charge in all his works. You know the acorn theory, too?"

"I have no idea what the acorn theory is," I replied.

"There was a whole controversy about that," he said. "People wondered why there were chains and tassels on works of art of the time. And some people saw it as an allusion to male sex organs."

As for the famous *Sleeping Hermaphrodite,* Ferranti sees the figure not as sleeping but in the throes of sexual pleasure. "Look at how the feet are actively pulling the fabric that is wound around the lower legs," he said. "And the sex organ! I forgot—it is erect!" I saw the penis as present but not erect, but who was I to question Ferranti's interpretation?

Ferranti was mostly interested in male nudes, but there is an anonymous late sixteenth-century painting of two naked women together in the bath that can startle and destabilize viewers. The work is presumed to

show Gabrielle d'Estrées, King Henri IV's beautiful, young, and famous mistress, who is pregnant with his child, and the Duchess of Villars, her sister. The duchess is pinching—hard—the erect nipple of her sister's right breast with the fingers of her left hand. Her index finger and thumb form a C. Both women look fearlessly at the viewer.

The standard interpretation is that the nipple-pinching is a symbolic announcement of Gabrielle's pregnancy, not a display of incestuous lesbian foreplay. The Louvre website describes the nipple-pinching as "oddly affectionate." The gesture is complicated and intimate, an erotic fantasy that could appeal to viewers of various sexual orientations.

Does anyone really know what it means?

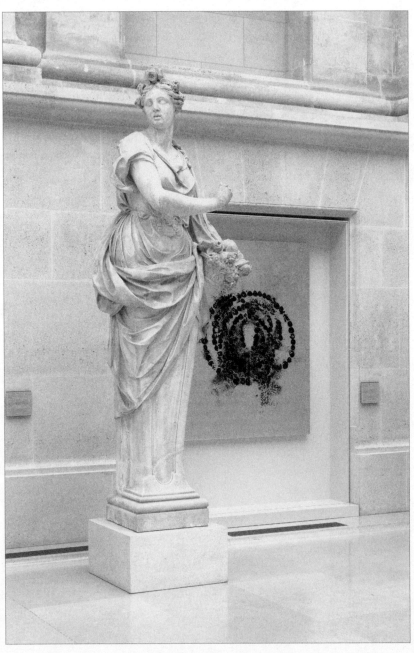

When contemporary meets antiquity: Jean-Michel Othoniel's *La Rose du Louvre*, in the Cour Marly. *Jean-Michel Othoniel / ADAGP, Paris, 2023*

◆◆◆◆◆◆◆◆◆◆◆◆◆◆◆◆◆◆◆◆◆

Celebrating the Contemporary

*In my low periods, I wondered what was the point of creating
art. For whom? Are we animating God? Are we talking to
ourselves? And what was the ultimate goal? To have one's work
caged in art's great zoos—the Modern, the Met, the Louvre?*
—**Patti Smith,** *Just Kids*

*I was amazed to be invited to work in the Louvre. I
thought it was just for artists who were dead.*
—**JR,** French artist

WHEN JEAN-MICHEL OTHONIEL WAS AN ART STUDENT IN PARIS IN THE
1980s, he supported himself by working as a security guard at the Louvre.
By day, he rotated through different galleries, exploring the canvases of
Rubens and the Greek and Egyptian art objects piled high in glass cases.
By night, he made the rounds with a large flashlight and slept alongside
other guards on retractable beds hidden in the paneling of the galleries.
On Tuesdays, when the museum was closed, he and his fellow guards
mopped and swept the parquet floors and staircases.

Othoniel was a daydreamer. "Maybe I was a very bad guard in those
days because I was just looking at the paintings and the sculptures and

not the people," he told me one day as we toured the museum. "But it was fantastic for me, maybe the most beautiful lesson I ever had about art, looking at it every day. It was like being in a living book."

As a teenager growing up in the coal mining town of Saint-Étienne, he had written notes on the history of plants and photographed flowers and weeds. Now he began to focus on flowers in Louvre paintings. Every morning he would cross the Palais-Royal gardens en route to work, for coffee at Le Nemours café and restaurant on the place Colette. An old woman sold violets; in the evenings he would buy her wilted leftovers to bring back to his attic room. Years later, he gained fame by transforming the entrance of the Palais Royal Métro station on the place into a double canopy of colored glass beads—at the spot where the old woman's flower stall had stood.

Contemporary art, and the artists like Othoniel who create it, play only a minor role at the Louvre. Because the museum's mandate is to focus on art made before 1848, there is little in its permanent collection from any later era. But increasingly, the Louvre finds ways to incorporate art of the moment, through temporary exhibitions, lectures, concerts, and performances.

In 2019 the museum invited Othoniel to create a work based on his love of flowers, as part of the thirtieth anniversary celebration of the Grand Louvre and the Pyramid. The Louvre gave him a badge that allowed him entry every Tuesday, when the museum was closed to the public. He came faithfully, week after week, for more than a year, photographing flowers in paintings, sculptures, furniture, art objects. "I was chasing the flowers. I was like the Hercule Poirot of the Louvre," he said, evoking Agatha Christie's sleuth.

He had to choose one flower to represent the Louvre, and for him, that flower was a rose. "In French culture, the rose is important for eroticism and femininity but also for power," he said. And so he created *The Rose of the Louvre*, a series of six views of a single rose, rendered in a swirl of beaded forms in black ink on gleaming gold leaf paper. A rose from one of Rubens's tremendous paintings of the life of Marie de Médicis inspired him. It is the marriage scene, in which the Florentine princess marries King Henri IV in a proxy wedding. (Her uncle plays the stand-in.) On the steps of the red-upholstered altar, Rubens painted a blood red rose, open

and illuminated in white, which seems to have fallen from the wedding wreath. In *The Secret Language of Flowers*, Othoniel's small companion book about the flowers he discovered during his research, he wrote of the Rubens rose, "Like a bloodied eye, it looks at us.... Symbol of passion and power, of erudition and sensuality, this rose is the rose of mystery, the flower of the Louvre."

Othoniel donated the ink paintings to the museum, and they are on permanent display in niches of the Cour Puget sculpture garden, among marble masterpieces of the seventeenth and eighteenth centuries.

THROUGHOUT ITS HISTORY, THE LOUVRE has been criticized for its celebration of the past and its uneven relationship with living artists. At times "Burn the Louvre" became a rhetorical conceit for wanting to tear down the old to make space for the new.

"If I'd had matches, I would have set this catacomb on fire without regret, with the intimate conviction that I was serving the cause of art to come," the art critic Louis Edmond Duranty wrote in the 1850s.

Some artists carried on a love-hate relationship with the Louvre. Cézanne wanted to destroy it but later changed his mind. "Life! Life! I only talked of this one thing," he is said to have exclaimed. "I wanted to burn down the Louvre, poor fool!"

In 1909, the futurist Filippo Tommaso Marinetti launched an anti-Louvre movement in a manifesto on *Le Figaro*'s front page. It called for young artists to destroy, or at least reject, the art of the past. "Turn aside the canals to flood the museums!..." it said. "Oh, the joy of seeing the glorious old canvases bobbing adrift on those waters, discolored and shredded!"

During the student rebellion in Paris in May 1968, Michel Laclotte, then the museum director, was so concerned about violent protesters that he shut down the museum, moved in with some of his aides, and hid away precious works like the *Mona Lisa*. "We were worried enough to sleep on-site for several nights, fearing a fire or some incident would get out of hand," he wrote in his memoirs.

The rebels of May '68 believed that real art was in the streets, not

in museums. "Grand paintings, all the pictures of the Louvre—we were ready to burn them," the French artist Annette Messager once said of the radicalism of her youth. " . . . I wanted to work on the everyday, the ordinary, things from the street, from magazines. That was my '68." The irony was that in 2021, Messager was one of two contemporary artists whose works on paper were chosen by the Louvre to be put in its permanent collection. She was honored. "When you're young, you want to destroy everything," she told me. "You have the idea that you have to break with the past to create something new. But you cannot break with the past. So it's always a constant battle."

Over the centuries, the Louvre has often served as a home for living painters and sculptors. It's worth recalling that Henri IV gave artists and artisans their own workshops in the Louvre, sometimes with free apartments. His son Louis XIII continued the practice. Then Louis XIV created the Royal Academy, whose mission was to educate a new generation of artists. He also gave the country's best artists and artisans free lodging and encouraged them to take on apprentices. Charles Le Brun, who headed the academy, was responsible for paintings for the Apollo Gallery. (As noted, the gallery would be completed nearly two hundred years later by Delacroix, who painted the central ceiling.) In the eighteenth century the academy included ambitious painters like Jacques-Louis David, Élisabeth Vigée Le Brun, and François Boucher.

But the arrival of the Impressionists on the artistic scene in the last quarter of the nineteenth century ushered in an aversion to showcasing living artists in the Louvre that survives to this day. When the Louvre invited Georges Braque to paint two amorphous giant black birds on three panels on the ceiling of Henri II's former antechamber in 1953, some experts considered his work mediocre. "Nothing monumental here," wrote one art critic.

Even Pablo Picasso had an uneven relationship with the Louvre. Obsessed by the museum, he longed for his paintings to be shown there. In 1947 ten of his paintings were hung very briefly on the walls of the Galerie Mollien alongside masterpieces of Spanish art from previous centuries. Next to the work of Zurbarán, El Greco, Murillo, and Ribera, Picasso boasted: "See, it's the same thing." Then, to celebrate his ninetieth birthday in 1971, the Louvre put eight of his paintings

on display in the Grande Galerie for ten days, a rare achievement for a living artist.

Bringing contemporary works into the museum permanently has had mixed success. In 2010, the Louvre unveiled a 3,750-square-foot ceiling painting by the American artist Cy Twombly in the Salle des Bronzes, which holds Etruscan, Greek, and Roman antiquities. In the painting, spheres float on a background of rich blue hues evoking the Aegean Sea, and names in Greek letters pay homage to ancient sculptors. A few years later, after Twombly's death, the Louvre renovated the gallery to restore the Second Empire style of its creator, Napoleon III. Its neutral cream-colored walls were repainted in bright terra-cotta; parquet replaced the marble floor.

The orange hue of the terra-cotta walls and Aegean Sea blue of the ceiling mural clashed. The Cy Twombly Foundation sued, claiming that the Louvre was failing to protect the artwork's integrity. The Louvre backed down, settled out of court, and restored the gallery walls to cream.

In 2007, the Louvre installed, with much celebration, a triptych by the German artist Anselm Kiefer, including a painting more than 30 feet high and nearly 15 feet wide. Placed at the top of the northern staircase above the Cour Carrée, on a landing built by Napoleon Bonaparte that linked galleries that display the antiquities of Egypt and Mesopotamia, the work was particularly meaningful for Kiefer because of his passion for the Louvre.

When he was seventeen, he hitchhiked in a truck to Paris to study writing. He made a pilgrimage to the museum the night of his arrival, even though it was closed. "I remember a huge black wall. It must have been at night. After that I walked through the Louvre for days. The Louvre had become like my home." When the Louvre installed his work, he said, "I can say that I am coming home."

Yet the triptych sits lost in semidarkness on its landing, amid Corinthian capitals and bas-reliefs.

The Louvre has showcased contemporary art in its short-term exhibitions. In 2007, the British-Indian sculptor Anish Kapoor's C-shaped mirror of stainless steel was placed in the Cour Khorsabad, which holds ruins from an eighth-century BC city in what is now Iraq. The monumental stone slabs depict the glory of the court and life of Assyrian king

Sargon II, who ordered their creation. The visual distortion between Kapoor's mirror and the stones of Khorsabad created a dialogue between them.

And in 2023, the Louvre shed its fusty past when it gave twenty young artists, designers, musicians, writers, videographers, and photographers 5,000 euros each to create videos of approximately three and a half minutes about their "unfettered vision of the Louvre." In one of the most creative—and disturbing—presentations, the New York–based Canadian Black performance artist and sculptor Miles Greenberg transformed his body into a living sculpture of the martyred, arrow-riddled Saint Sebastian. "I'm never quite sure whether Saint Sebastian experienced pain or pleasure," Greenberg told me.

To prepare for his performance, Greenberg donned tiny black briefs and full black body paint, then had a professional piercer puncture his shoulder, pec, hip, and ribs with silver-plated aluminum arrows custom-made by a jeweler. "Getting stabbed is a very frightening kind of pain," he wrote later. "I wouldn't recommend it."

In the video, he moves his body like a Saint Sebastian in timeless suspension, his Blackness standing out against the whiteness of classical sculptures in the Cour Marly. "Flesh and blood are a medium of sculpture," he said, "just as much as carved marble."

CONTEMPORARY ART BRINGS LIFE TO the Louvre, but the Louvre also gives back, linking today's artists to its long tradition. For Jean-Michel Othoniel, part of the privilege was looking at centuries' worth of art close up, without interruption, as he prepared his floral project.

One day Othoniel took me on a floral tour of the Louvre, in which he explained his focus on detail, seeing "from the small end of the spyglass."

"I'm obsessed by the hidden meanings of flowers," he said. "It's a way to read works of art, of course, but also a way to discover the world, its marvels, its wonders."

To see the painting that had inspired his choice of the rose as the flower of the Louvre, we went to the Galerie Médicis. "Rubens was a

young, flamboyant contemporary artist at the time, not terribly respect-
ful because he painted the queen in a very sensual way," Othoniel said.
"He was very controversial because he was Flemish, not French. A bit like
the Basquiat of his day."

A few rooms away was a self-portrait by Albrecht Dürer in which
the artist holds a thistle. "When you look at this painting, you say, 'Why
does this guy hold this flower? It can't be by chance,'" said Othoniel. "It's
a direct message. It's the idea of fidelity, of spirituality. The thistle also
looks like a small crown of thorns symbolizing repentance and the sorrow
of Christ and of the Virgin. It also could represent virtue, like the chest-
nut that is protected by its prickles."

We then moved to Jacob Claesz's *Portrait of a Young Woman from
Lübeck Holding a Carnation*. According to one Christian legend, when
Mary saw her son Jesus on the cross, her tears fell to the ground and
turned into carnations. "It's a symbol of Christ," Othoniel said, "and it is
the shape of a nail in her hand."

We saw a dandelion in the fifteenth-century *Pastoral Instruction*;
the dandelion has been associated since ancient times with the sun and
with vision. In *The Rest During the Flight into Egypt*, the centerpiece
of a triptych by Hans Memling, Othoniel pointed out a poppy, a symbol
of Christ's blood and its redemptive power.

Time was short. I would have to return another day to focus on the
white irises in Leonardo da Vinci's *The Virgin of the Rocks*, the laurel
sculpted in marble on the forehead of Antinous, the peony in the open
blouse of the young woman in Greuze's *The Broken Pitcher*.

The most memorable moment came in the Cour Puget, where Otho-
niel's own rose paintings hang. A couple and their two children were
looking at his series of flowers. The daughter was taking photos of the
paintings, even their labels.

"I have to do something very American," I said. I went up to the fam-
ily and asked them about themselves. They were tourists from Brazil, they
said. I told them the artist was here. "Can we meet him? Can we take his
photo?" the father asked.

A bit shy, Othoniel seemed embarrassed by all the attention.
"Please—it is a great honor for us," said the father. They shook hands and

took photos. Othoniel told them he was traveling for a show in Brazil the next week and invited them to come. "Thank you again—for the great honor," the father said again, as the family said goodbye.

Othoniel likes to say that "paintings are always different, because you are always different." In other words, your mood determines the way you look at a work of art and respond to it. The family from Brazil left the Cour Puget happy that day. The encounter made Othoniel happy as well. He allowed himself to be carried away by the joy of the moment.

"Imagine that for someone like me, who was a security guard more than thirty years ago, to come back to do a work of art. To be in the Louvre. To be shown permanently. Permanently. To touch people. A crazy dream. Except it came true."

PART FIVE

Romance

Fenêtres, an engraving by Marius Tessier, a printmaker and
artist who makes engravings for the Louvre at an atelier
outside of Paris called La Chalcographie du Louvre.

CHAPTER 25

❖❖❖❖❖❖❖❖❖❖❖❖❖❖❖❖❖❖❖

Exit Through the Gift Shop

The museum gift shop . . . is quite simply the most important tool for diffusion and understanding of art in the modern world . . . the most important place in the museum.

—Alain de Botton and
John Armstrong, *Art as Therapy*

WHENEVER I GO TO A MUSEUM ANYWHERE IN THE WORLD, I LIKE TO start and end with the gift shop. I mean the old-fashioned serendipitous kind—not the IKEA-like version that requires you to follow a predetermined route. Wandering through a good museum gift shop can offer a mini-tour of the works of art you don't want to miss. The Louvre is no exception.

On the way in, guidebooks offer a quick way to cram in what I don't know, and what I don't know I don't know. On the way out, I can leave with a memento of something I've seen. Even Picasso bought postcards to take home from the Louvre—lots of them.

If you need a *Mona Lisa* fix, you will find a mini-boutique as you exit the gallery where Leonardo's much-too-famous portrait hangs, devoted almost exclusively to *Mona Lisa* paraphernalia. On sale are playing cards, coffee mugs, tote bags, key chains, eyeglass cases, fans, trays, water bottles, T-shirts, erasers, Rubik's Cubes, iPhone cases, kaleidoscopes, and notebooks.

It is a most unusual museum boutique. Look up and you will see one of the most overdecorated ceilings in the Louvre. With a skylight surrounded by stucco figurines, the room is also a connector for the two main halls showing some of the Louvre's most important French paintings, so it's always crammed with people who are likely to be tired, disoriented, and confused. More than a dozen paintings hang on the walls, including a nineteenth-century rendering of a strange, young, haloed, female martyr lying dead in a shallow pool of water. And out the window is a straight-on view of the Pyramid.

"This must be a great place to work," I said one day to the cashier. "Just look at that ceiling! And you see the Pyramid. What a view!"

"It's awful working here," she replied. "Everyone has to come out this way from the *Mona Lisa*. The noise. The heat. The smell. I hate it."

FOR LESS FRENZY AND MORE serious shopping, there are the Louvre's two main boutiques, on either side of a corridor below the Pyramid. Perhaps I am a museum boutique snob, but the scarves, dishtowels, Pyramid paperweights, and iPhone covers are nothing exceptional. The jewelry is tasteful and of good value but sometimes not made to last. The crystal, porcelain, and assorted trinkets can be overpriced. (The shop once sold Italian ceramic fruits and vegetables; the tomato cost 70 euros. I bought the same tomato in the Umbrian pottery town of Deruta for 20.) Uniqlo got off to a slow start when it launched its Louvre clothing collection in 2021, but improved when it offered Louvre-inspired T-shirts designed by nine young artists for a competition in 2024.

One irresistible buy for me, though, is the museum's collection of four loose teas in cylindrical tins, each a different color. Labeled Garden Tea (green), Courtyard Tea (purple), Garden of Venus (ivory), and Egyptian Night (turquoise), they are said to evoke, respectively, the Tuileries, the Louvre's architecture, a Mediterranean garden, and the mystery and opulence of Middle Eastern nights.

A bit over the top, perhaps, but I have all four.

Yet it is the bookshop, one floor up, that draws me in when I need an

oasis of calm. Near the children's section are a coffee table and comfortable chairs that beckon the weary museumgoer. You can sit however long you want and flip through the most glorious art books and magazines.

Sometimes I wander through the children's books and games section for an amusing tour of art history. I might start with an English-language children's book with embedded sound chips called *My Little Musical Louvre*, a sight-and-sound journey through the collections. Verdi's *Aida* accompanies *The Crouching Scribe*; the Renaissance composer Josquin Desprez plays for the *Mona Lisa*; Vivaldi's "Autumn" is set to Arcimboldo's *Autumn*.

Hidden near the children's section is a long corridor that at first glance looks like an administrative office. There is no sign to indicate that you are entering one of the most original spaces in the museum: a repository of more than six hundred prints (or, as the museum refers to them, engravings) made from fourteen thousand copper plates in the Louvre's permanent collection. These are rendered on museum-quality paper and guaranteed to last a hundred years. The space also displays small casts of famous sculptures, including miniature jewel-colored copies of the *Venus de Milo* and the Nike of Samothrace. The engravings and casts are on sale here, or online.

For me the prints are the draw—glorious old maps of Paris, images of the gardens and galleries of Versailles, engravings of Napoleon's military campaign in Egypt, decorative art and botanical prints. On sale as well are museum-quality prints by contemporary artists. In 1989, as part of the Grand Louvre renovation, the museum commissioned engraved copper plates from living artists, a practice that continues to this day. Every year, contemporary artists are chosen to create a printed work for the museum; these have included Pierre Alechinsky, Louise Bourgeois, JR, Giuseppe Penone, and Jenny Holzer. If the boutique does not have the image in stock, it will order and custom print it.

You don't have to make an appointment to see the prints. Many of them are framed and hung as if this were an art gallery. Others are filed in dozens of folios, each wrapped in heavy plastic that gives off the smell of an old print shop. No one tells you this, but you can get into the boutique—and this annex—without paying the price of museum admission.

I drag even my weariest museumgoing visitors to this destination.

But more often, I am alone with the people who work there, except when a visitor—either curious or lost—wanders in.

"Why is this terrific place hidden at the back of the boutique?" I asked a woman working there.

"Don't talk about this—it might make people here upset—but it's because we don't bring in as much money as mugs and postcards," she replied. "So they put us in the back. Sometimes they tell us that our prints are so beautiful, and they're going to redo the boutique to put our prints up front. I'm waiting."

The engravings are inked, and the small sculptures molded, in an industrial site that the public can visit once a month on Fridays, in the ethnically and racially diverse working-class suburb of La Plaine Saint-Denis. At one atelier there, called La Chalcographie du Louvre, print-makers use traditional techniques to produce prints that look exactly the way they did centuries earlier from the same copper plates. The Louvre created La Chalcographie inside the museum in 1797, four years after the museum opened, and after moving many times, it settled here in 2007. At the Louvre's Sculpture Casting Atelier, a separate team of artisans create *moulages*—molds—that replicate marble statues in plaster or resin.

The Louvre doesn't widely advertise the two ateliers, which are administered by an arm of the Ministry of Culture. The ateliers are not on the everyday tourist route; I've rarely found a Parisian who knows of their existence. But they are as exciting as they are offbeat, worthy of discovery. And some day, perhaps the Louvre will organize shuttle buses to make it easy to get there.

The first time I made the trip, I took the No. 12 Métro line to the Front Populaire stop, then walked about fifteen minutes to a large factory with windows framed in red. The waiting room is a showroom of sculpture. Backlit replicas of busts struggle for space on wooden shelves that reach the ceiling; larger, faithful replicas, including a wingless Nike of Samothrace, fill much of the empty floor space.

I was there to meet Sophie Prieto, the manager of both workshops. She had studied art history in Paris and used to live in Brooklyn. Unlike the more formally dressed female curators and administrators at the Louvre, she favors a uniform of jeans, a black T-shirt, and sneakers.

We started with the Casting Atelier. It produces perfect replicas not

only for the Louvre but also for Versailles, other museums in France, and art schools, museums, and private clients around the world. Copies of some of the most fragile statues in the Tuileries are molded in this atelier, while the delicate originals have been moved inside the Louvre or tucked away in storage. I followed Prieto through darkened storage rooms, passing hundreds, maybe thousands, of sculptural casts, including Sphinxes and aristocrats, a Statue of Liberty, a Michelangelo Moses, and more than a dozen Venus de Milos.

Then she opened the door to the patina workshop. Hanging on one wall are about 150 small sculpted wings in the colors and finishes that can be ordered from the moulages studio—from semi-translucent stone to a velvety royal blue. Each work can be made to look like marble, wood, terra-cotta, gilded wood, bronze, or stone—or even rendered in frivolous pop colors.

One artisan brushed layers of paint and varnishes on an oversized mold of a Barbie doll. Near her sat a row of busts of Brigitte Bardot depicted as Marianne, the imaginary figure who is France's embodiment of freedom. The Bardot-Mariannes, designed with V-necked see-through garments that reveal full breasts and nipples, were waiting for a blue, white, and red patina. They are among the atelier's best-sellers.

Prieto explained the art of statuary casting. The artisan works from a physical imprint or a computer scan of the original piece to produce a "negative imprint," or mold. This is used to make perfect copies, many of them in resin, which is more durable than plaster, especially in outdoor installations.

I wanted to stay and watch the molders as they massaged wet plaster in large mixing bowls, but Prieto promised that the best was yet to come—the Chalcographie du Louvre.

The word "chalcography" is of Greek origin—from *khalkos*, copper, and *graphein*, to write. Much of France's collection of plates, engraved from the sixteenth century to the present, are stored here, including thousands of copper plates commissioned by Louis XIV about subjects including royal marriages, châteaux, artworks, military victories, and portraits. When Louis sent Jesuit missionaries to Beijing in the 1680s, they brought with them, as gifts for China's emperor, engravings made from copper plates. "It was French royal propaganda for the world," Prieto said.

She led me through a series of corridors and two sets of doors up the stairs into a locked room lined with metal shelves holding original copper plates. A sophisticated ventilation system keeps the temperature and humidity constant. She found a château mural in the style of Louis XIV. "Look! I hold in my hands a seventeenth-century piece of art!" she said.

Then she pulled out plates at random. "Here is a portrait of King Louis-Philippe, I think, from the nineteenth century," she said. "Here is a family's coat of arms! Architectural plans, battle scenes! Even I don't know them all. It is a huge collection. Alas, we cannot print from the oldest plates anymore. But now, on to the atelier!"

She opened the door to a printing studio with a wall of windows flooded with light, and called on Marius Tessier, a young printmaker, to demonstrate his craft. He wore a dark blue work apron over his jeans and T-shirt and sported oversized gold-rimmed glasses, a mustache, and a bun. His hands were stained with black ink. His worktable was piled high with rags, jars, ink bottles, cleaning products, and tools: spatulas, rollers, needles, paintbrushes. One end of the table was pushed up against a sink with soap and brushes so that he and his colleagues could scrub their hands clean at the end of the day.

Framed contemporary prints produced over the years cover the walls. Three iron presses built more than a century ago dominate the center of the room. The presses were once manually operated, requiring two workers to turn their wheels. Their giant gears have been preserved, but the presses are now electrically powered. Printmaking requires several operations. Tessier inks a copper plate, removing the excess with a piece of muslin. He uses the palm of his hand to remove the last traces of excess ink before placing the inked plate on the press plate. Then a pristine artisanal sheet of moistened paper passes under a roller while ink is transferred from each of the holes in the plate to the paper: ink touching paper is described as being "in love with the paper." Tessier removes the wet proof to reveal the print: a line drawing of a bull on its side.

"Even when the system is all set up it takes several hours to get a print right," he said. "You want to put your hands into the ink and work with, play with the materials. The paper has to capture every detail of the perfectly measured ink, so it has to be precise. But the paper must be wet, so as to be more flexible, more loving."

And that's when magic happens.

"A spirit exists in this studio," he said. "You don't really see the final print as it's being made. And then it appears, and you have something concrete in your hands. It's manual work, all about flexibility, precision, balance. But it's artistry, too."

"To put your hands in the ink, how exquisite," I said. "Do you want to be an artist yourself?"

Tessier said that he had just finished his studies at the only engraving school in Paris. "I do some work on the side, yes. Do you want me to show you?" he asked. He looked at Prieto for approval; she encouraged him to go on. He explained that he uses a combination of steel tools, drypoint needles, and sandpaper to engrave on copper plates; he then turns the work into prints. He pulled out his phone. "Here are the engravings for my diploma! It is really different from what I do here."

Angular, modern, some looked like construction sites. Others were so detailed they could have been photographs.

"Congratulations, Marius!" I said.

It was time to move on. I didn't think much about Marius Tessier after that. But a few months later, a small artists' association in my neighborhood organized an exhibition and sale of works by more than a dozen engravers and printmakers. Prieto invited me to go with her to the opening. There was Tessier, who finally could show me his own work. I fell in love with *Fenêtres*, an engraving of two stark, darkened windows, one on top of the other. How could I not support a young artist? It now hangs on a wall in my apartment.

Cast of *Dying Slave* by Michelangelo at Louvre-Rivoli Métro station. In 1968 André Malraux, then the culture minister, decided to make the station a sort of antechamber of the Louvre by installing copies of some of the museum's most important sculptures. *Gabriela Sciolino Plump*

CHAPTER 26

◆◆◆◆◆◆◆◆◆◆◆◆◆◆◆◆◆◆◆◆◆

Tuesdays at the Louvre

Who said you can't educate yourself in the Métro?
—**Le Parisien** newspaper article about the Louvre
sculptures in the Louvre-Rivoli Métro station

EVERY TUESDAY, THE RITUAL IS THE SAME. MUSEUMGOERS, MANY OF
them foreign tourists, all of them clueless, arrive at the Louvre and learn
that it is closed. The guards at the metal barricades who turn them away
in an array of languages are trained to be polite, although some reveal
smirks that say, How could you be so stupid?

So, what do you do? I'm here to tell you that you can still visit the
art of the Louvre on a Tuesday—and get enough of a taste for it that you
can fool your friends without ever stepping inside. You won't see all the
wonders you have heard about, but you will get a sampling of the mas-
terworks and a sense of the historical significance of the Louvre itself,
with views from angles not everyone will see. This advice is also good on
other days, for would-be visitors with no timed tickets or patience when
they find hundreds of people waiting in line ahead of them. Or when it
is raining.

My "No Louvre" tour takes a trip around the periphery of the
museum. I start at the Louvre-Rivoli Métro station. In 1968 André Mal-
raux decided to make it a sort of antechamber of the museum. Louvre-
Rivoli, which sits at the far northeast corner of the museum, is one of the

least trafficked stops in central Paris. Métro travelers are "astonished and delighted" by the resulting welcome, writes Loràant Deutsch in *Metronome*, a best seller about the train system.

The inside of Louvre-Rivoli does not look like any other Métro station. Its dimly lit walls, free of advertisements, are covered in pale yellow-white limestone blocks decorated with burgundy-black sandstone niches that house faithful reproductions of some of the most interesting works of art in the Louvre.

Copies of statues line the platforms for trains running in both directions. On the way east to Château de Vincennes are a bust of a bearded Socrates from about the first century, and one of a delicate Marie Antoinette from the eighteenth, along with a statue of the southern Mesopotamian prince Gudea of Lagash, his hands joined in prayer. On the opposite platform, for trains moving toward La Défense, are a full-sized white plaster copy of Michelangelo's *Dying Slave*, a virtually full-sized resin replica of the *Venus de Milo*, and a black plaster replica of the *Code of Hammurabi*. Among the other works are molds of statues of the Pharaoh Tutankhamun, the Virgin of the Annunciation, the god Apollo, and the goddess Diana. Most of the works have no labels, which means that if you want to know what you are seeing, you have to take photos with your smartphone and look them up.

On each platform are two four-foot-wide screens showing a video tour of the museum. The video starts with the Sphinxes and mummies of ancient Egypt, enters Emperor Napoleon III's chandeliered and elaborately painted apartments, and moves on to Islamic art, the *Mona Lisa*, sculptures in the Puget courtyard, Iranian and Assyrian antiquities, and other famous works, from *The Coronation of Napoleon* to Michelangelo's *Slaves*.

Black molded plastic seats line the walls, but none, alas, sits in front of the screens. And you have to endure the regular screeching of the Métro trains and the recorded voice warning you in several languages to beware of pickpockets. But you can see the highlights of the Louvre for free in thirteen minutes.

At the top of the staircase en route to the exit is a glass case holding a full-sized replica of one of the Louvre's most prized possessions,

the painted limestone statue of the ancient Egyptian *Seated Scribe*, cross-legged as he writes. Lalique, the French glass and crystal maker, created a faithful version of his magnesite and rock crystal eyes. Framed in thick black eyeliner, the eyes are so piercing that they give Métro commuters the sense that he is watching them as they move past, just like the real thing.

As you emerge from the Métro station at the corner of rue de Rivoli and rue de l'Amiral de Coligny, you see the eastern side of the Louvre, the Colonnade. Before he even fantasized about building a dream palace at Versailles, Louis XIV wanted to do a total makeover of the Louvre so that it would rank as one of the most beautiful buildings in Europe. He ordered the construction of a bold structure, with a sweeping, horizontal, geometrically pure facade with a central arch and eighteen giant Corinthian double columns. For three centuries afterward, the Colonnade served as the Louvre's front door, its triumphal face to the city.

The Colonnade is considered an ideal example of French architectural classicism, and inspired many other great buildings, including the Metropolitan Museum of Art and Grand Central Terminal in New York. "Grand without being grandiose . . . , it ravishes us through the perfection of its proportions and details," writes art historian James Gardner. Snag a seat outdoors across the street at Le Fumoir and savor the sight over coffee.

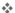

THE CHURCH OF SAINT-GERMAIN-L'AUXERROIS, ALSO across the street from the Colonnade, is another place to find the Louvre outside the Louvre. The resting place for many of France's poets, architects, painters, and sculptors, the church holds a history and art that speak directly to the museum. When you walk through its fifteenth-century porch entrance, you notice tall, narrow stained glass windows. The Louvre, in its Richelieu wing, displays stained glass windows from the thirteenth to seventeenth centuries. At Saint-Germain-l'Auxerrois, you see them as they were meant to be seen, in a church. Depending on the time of day, the windows create rainbows on the ceiling.

The side chapels were sponsored by prosperous patrons who hoped to

garner spiritual favor with God. Stuffed with paintings, altars, and more stained glass, they function as mini-museums. A map to the right as you enter the church points out the highlights.

Some of the church's art would sit comfortably next to the Louvre's own masterpieces. One Flemish altarpiece, carved from dark oak in the fifteenth or sixteenth century, shows the Passion of Christ in gruesome detail; a sixteenth-century carving captures the life of the Virgin Mary, including a tender image of Luke the evangelist combing her hair. The Chapel of the Virgin is decorated with nineteenth-century paintings imitating the early Italian Renaissance style of Fra Angelico, whose work is shown in the Louvre's Denon wing.

From here, head to the museum's Colonnade, where you will find a small side entrance that leads into the courtyard beyond, the Cour Carrée. Under the courtyard lies the foundation of the original Louvre, the twelfth-century fortress of Philippe Auguste.

Walk straight through to the Cour Napoléon and the glass Pyramid. Even on a Tuesday when the museum is closed, there will be crowds, but stop to look and admire.

Then keep walking. Across the busy two-way thoroughfare that hugs the place du Carrousel and its garden is the Tuileries Garden. Take in the sculptures along its central alley and dodge the vendors selling water, miniature Eiffel Towers, selfie sticks, love locks, and smartphone chargers until you get to the place de la Concorde. Once there, examine the ancient Egyptian 75-foot-tall Luxor Obelisk. The Louvre has Egyptian artifacts with hieroglyphics, and here you can see hieroglyphics clearly on the obelisk, especially when the sun shines bright on its pink granite surface.

Now it's a short walk to the rue de Rivoli, where shops line a long arcade. Most of them are narrow and small, filled with thousands of souvenirs. At first it seems as if they all sell the same merchandise. But shortly before one Christmas, while looking for a notebook, I saw something I had never noticed before—the perfect stocking stuffer: *Mona Lisa* socks! There were two different versions: *Mona Lisa* on either a pink or a blue background. And only 5 euros, when the ones sold in the Louvre boutique cost 12. I took one of each. I also found a notebook: small, with *Mona Lisa*'s image on both the front and back.

The shop has no name but goes by its address: 180, rue de Rivoli. Next door are offices of the Louvre.

"What other *Mona Lisa* items do you have?" I asked Mohammed, an Indian-born resident of France and the shop's co-manager, who stood behind the counter.

Mohammed showed me playing cards, shot glasses, plates, mugs, key chains, thimbles, clocks, wallets, tote bags, aprons, cigarette lighters—all with *Mona Lisa*'s face. I was tempted by the *Mona Lisa* condom; her face is on the tip. But I resisted, even though it cost only 3 euros and its label assured the buyer that one size would fit all. Instead, I scooped up three small compact mirrors with *Mona Lisa*'s face sprinkled with rhinestones.

Mohammed and his Bengali partner, Mahabub, told me that the pleasure of their job is meeting people from all over the world. It's not always easy, however. Some clients can be intolerably rude.

"They don't know they are supposed to say bonjour to be polite when they come in," said Mohammed.

"They break things, and we have to pay," said Mahabub.

The shop is filled with just about every sort of Paris souvenir you could want, but one image is missing: the Pyramid. It is protected by strict copyright, and only official vendors, like the museum boutique, can sell it.

Opposite the arcade and across the rue de Rivoli is the Passage Richelieu, which leads back to the Louvre's courtyard. The passage is lined with plateglass walls that offer a peek into two French sculpture terraces inside the museum: the Cour Marly, on the right side of the passageway, and the Cour Puget, on the left. In the summertime, the sun sets at just the right angle, filling the Cour Marly with a light that glows orange.

Farther along the rue de Rivoli, at No. 99, is one of several entrances to the Carrousel shopping mall in the subterranean Louvre, which I. M. Pei designed along with his Pyramid. The Carrousel has a food court, familiar chain stores like Lacoste and Swatch, and upscale food emporia including La Maison du Chocolat, with the best chocolate champagne truffles in Paris, and Ladurée, with overpriced colorful macarons that are now industrially made and not as good as they used to be.

Down the long corridor of shops, you find the subterranean inverted version of the famous right-side-up Pyramid. Its tip almost touches a

smaller pyramid on the floor, making the space between them just big enough for visitors to pose for photos with their heads between the two points. Just beyond are six sculptures salvaged from the pediments of the central pavilion of the Tuileries Palace and restored. The stone figures, personifying Counsel, Valor, Prudence, Religion, Justice, and Sincerity and carved between 1666 and 1668, add a bit of gravitas to the commercial mall.

For a memorable view of the overwhelming length of the Louvre edifice, walk across the Seine to the Left Bank, turn around, and look across the river. When the sun is just right, the museum and the river combine to project a beauty so profound it can lift the darkest thoughts.

In 1900, the sculptor Augustus Saint-Gaudens was racked with stomach pain. A cancerous tumor was discovered in his lower intestine, and he fell into a deep depression. One day, he fled his Paris studio to kill himself. "I had definitely made up my mind to jump into the Seine," he told James Earle Fraser, his student and apprentice.

> *I practically ran down the rue de Rennes toward the Seine, and when I looked up at the buildings they all seemed to have written across the top a huge word in black letters – "Death—Death—Death."....*
>
> *I reached the river and went up on the bridge and as I looked over the water, I saw the Louvre in the bright sunlight and suddenly everything was beautiful to me....*
>
> *Whether the running and the hurrying had changed my mental attitude, I can't say—possibly it might have been the beauty of the Louvre's architecture or the sparkling water of the Seine— whatever it was, suddenly the weight and blackness lifted from my mind and I was happy and found myself whistling.*

SOMETIMES WHEN I SEE A group struggling to take photos in front of the Pyramid, I offer to do it. One Tuesday in June, I took a photo of a Spanish couple and their two teenage children. They hadn't known the

Louvre was closed. The parents seemed to be suffering from the tourist fatigue and quiet desperation that hits many who are trying to cram in all of Paris for their kids. I knew where to send them: the Bibliothèque Nationale de France Richelieu (or the Richelieu branch of the National Library of France) a short walk through the Palais-Royal garden. "It's a mini-Louvre," I said. "It's open on Tuesdays, has a good café and a great garden." The mother kissed me.

France has had a public national library since Charles V created a royal collection in the Louvre in the fourteenth century. Part of the Bibliothèque Nationale de France Richelieu dates from the seventeenth. When the library expanded in 1996 with the opening of the ultramodern François-Mitterrand site on the other side of the Seine, Richelieu was reserved for specialized departments: manuscripts, prints and photographs, antiquities, performing arts, music, maps, medals, and 600,000 coins. In 2022, it reopened after twelve years and more than $250 million in renovations.

It is a museum to see in its own right. Here you can find the seventh-century king Dagobert's bronze throne, Charlemagne's ivory chess pieces, and a sixteenth-century globe that was the first to use the word "America." Ancient sculptures sit in glass cases so that you can view them from every angle, and they are mixed in with backlit translucent medals and plates, jewelry, sculptures, photographs, books, and prints. You can't get into the Louvre to see the *Hammurabi* stele, but the library has its own example of cuneiform that was one of the keys to the decryption of that script: the ancient black Michaux stone from Babylon, the first object inscribed entirely in cuneiform to arrive in Europe. The Louvre may have Charles V's gold scepter, carried by many of the French kings on the day of their coronation, but here you can see antique Roman silver objects and the royal collections of precious stones.

The library echoes the Louvre's collections. In 1863 the Duke of Luynes donated what was called a "princely gift." It included almost seven thousand coins of Phoenician, Gallic, Greek, Roman, and Spanish origin; ancient Greek, Roman, and Etruscan gold jewelry; armor and arms; and sculptures including a white marble torso of Venus. But

the stars of the show are the ancient Greek vases. Thanks to the duke's gift, the library has the second-largest collection of Greek ceramics, after the Louvre's.

You cannot see the frescoes by Giovanni Francesco Romanelli on the walls and ceilings of the summer apartment of Anne of Austria in the Louvre on Tuesdays, but so what. The seventeenth-century arched ceiling of the long Mazarin Gallery, the most striking space in the library's museum, is covered in Romanelli's frescoes, inspired by Ovid's *Metamorphoses*.

No paintings hang on the library's walls, but there are manuscripts to wow you. Manuscripts must be protected from exposure to light, so they can only be exhibited for a few months before they are rotated out and replaced by others. You never know what might be on display. Perhaps some of the handwritten pages of the steamy memoirs of Giacomo Girolamo Casanova, the eighteenth-century gambler, swindler, diplomat, lawyer, soldier, pleasure-seeker, and serial seducer. Or a page from Marcel Proust's seven-volume opus, *In Search of Lost Time*, whose words—scratched out and written over—bear witness to his hesitations, uncertainty, and pursuit of excellence. Scores by Stravinsky, original prints from Rembrandt to Picasso, drawings by Sonia Delaunay, photographs by Robert Capa, an engraving by Matisse, one of the library's two Gutenberg Bibles, a map of Paris published just before the Revolution—any of them might be exhibited.

The Louvre is home to the world's largest collection of sculptures by Jean-Antoine Houdon, the greatest European portrait sculptor of the late eighteenth century, including busts of George Washington and Benjamin Franklin, along with Enlightenment intellectuals like Diderot, Rousseau, and Voltaire. But the library has a singular Houdon statue of Voltaire. It stands in the Salon d'Honneur inside the rue de Richelieu entrance. The statue is also a reliquary. Voltaire's official tomb is in the Panthéon, but it is in the base of this statue that the French state decided to put the heart of the Frenchman who wrote an estimated fifteen million words.

The ground floor remains what it always was: a library. The Salle Ovale, an architectural jewel inaugurated in 1936, is a public reading room accessible without a reservation. It offers table seating for 160, a child-friendly area, and access to interactive screens and 20,000 open-access

works (including 9,000 graphic novels). Its scale, with a nearly sixty-foot-high glass roof, sixteen round decorative windows, mosaics, and miles of bookshelves, makes it one of the most beautiful rooms for reflection in Paris.

It's a marvelous place to spend a Tuesday.

Art Deco mosaic on the wall of the Louvre-Lens train station, honoring the history of the small city of Lens, in the northernmost part of France, once a booming coal-mining center. *Charlotte Force*

CHAPTER 27

♦♦♦♦♦♦♦♦♦♦♦♦♦♦♦♦♦♦♦♦♦♦♦

The Museum with a Conscience

Miracles don't happen, yet the Louvre-Lens
happened. Lens deserved this miracle.
—**Daniel Percheron,** former president
of the Nord-Pas-de-Calais region

WHEN MY AMERICAN FRIENDS AND FAMILY VISIT PARIS, THEY OFTEN bring a to-do list of day trips outside the city. It usually starts with Monet's house at Giverny and the D-Day beaches of Normandy. Then come Fontainebleau and Chartres.

"Why not go to Lens?" I ask. The replies come in various forms, mostly negative, but always with the same message: "Lens? Never heard of it."

I have to sell them on the place. Lens, near Belgium, is dreary, dark, and cold much of the year. World War I battlefields scar the land, and huge *terrils*, cone-shaped hills of coal slag, tower over the city. There are no water lilies growing here. But take the trip to Lens, only an hour and ten minutes north of Paris by high-speed rail, and you will find some of the best art in the world.

In the shadow of the *terrils*, an improbable structure stretches low, light, and fluid over the green carpet of a park: a revolutionary glass-and-steel art museum, the Louvre-Lens. Inside are more than two hundred masterpieces from the Louvre's permanent collection, with a few more

on loan from other museums at any given time, in displays that defy conventional classifications. There is abundant space for special exhibitions that have explored topics from the dining tables of power in France to Picasso's fascination with the Louvre. Local people come and go, free of charge, savoring this museum of dreams in a city that has endured too many nightmares.

The Louvre-Lens is a laboratory for what art museums might become.

Lens was a booming industrial center after coal was discovered there in 1849. Mining redrew the landscape, digging deep into the ground and throwing up towering heaps of slag, the stony waste generated when ore is separated from rock. Then World War I rolled over the city, leaving some of the worst destruction on the French front. German invaders flooded the mines and threw coal wagons down the shafts. Artillery barrages flattened most of the city; half its population died or fled.

The town rebuilt after the war. Some new structures were finished with appealing, if quirky, Art Deco facades that remain today. Then came World War II. During the Allied bombings of 1944, hundreds of people died, and a thousand buildings were destroyed.

Prosperity returned, but it was fleeting. Coal lost its value as a source of fuel, and the mines closed in 1986, leaving a legacy of unemployment. Battered and demoralized, Lens seemed an unlikely place for the Louvre's first regional branch to open. But in 2012, open it did.

The Louvre-Lens was born from the friendship of an odd couple: Henri Loyrette and Daniel Percheron, then the Socialist president of the Nord-Pas-de-Calais region. Percheron grew up in Lens, and when he learned in 2003 that Loyrette had an idea to create a regional museum far from Paris, he finagled an introduction and made an audacious move. "I asked him a simple question," he said. " 'If Lens applies to become the new Louvre branch, would I look ridiculous?' "

"No, not at all," Loyrette replied. "On the contrary, on the contrary."

"His words became my guiding light. It was extraordinary encouragement!" Percheron said. The two men liked each other immediately. As Loyrette recalled, "Everything was born of this meeting."

Loyrette didn't know Lens, except for the outlines of its dark history.

He arrived one day at the train station, a tiny jewel of Art Deco architecture, and discovered the story of the mines through mosaic murals on the station's walls. "Absolutely magnificent," he said to himself.

Six cities applied to host the regional Louvre museum. Lens offered a site with nearly fifty acres. It was close to the high-speed train line from Paris and to highways favored by tourists from Britain, Belgium, the Netherlands, and Luxembourg. It was halfway between the French working-class cities of Lille and Arras. It was also the only subprefecture in France that didn't have a museum.

The city marshaled its citizens for the fight. A local campaign committee was created. After residents were invited to add their views in a book of support at the city hall, eight thousand wrote in.

"Our once black land now lights up. . . . Trust us, trust us," wrote one family.

"I like statues in books, on TV, but I would love to see statues for real," wrote three ten-year-old schoolgirls. "We count on you." But what would it mean to the Louvre's identity to throw in its lot with an economically depressed northern city like Lens? Would a branch in Lens tarnish the Louvre's gilded traditions? In Loyrette's vision, the opposite was true. The Louvre would share the power of its identity with a wider, more inclusive France, and it would build a museum encompassing the range of human experience.

"Lens was a poor city devastated by so many crises and wars," he told me. "This new Louvre had to grow in a place without a museum. A Louvre in a cultural and tourist mecca like Aix-en-Provence would not have had the same meaning. Here, the history strikes me every time I visit— the mines, the destruction of war. We were bringing another history— the long journey of humanity." Lens won the competition, and the result was transformational.

From the start, this new museum was not to be a provincial Louvre, not a miniature Louvre, not a Louvre for rejected works of art in storage. It would be an original creation, showcasing some of the Paris museum's most glorious treasures, in a way that invited visitors to experience them freed from time and place. It would be Le Louvre Autrement—The Louvre Differently.

Instead of commissioning a well-known architectural firm to design the museum, the Louvre hired the up-and-coming Japanese firm SANAA, which would later win prizes and become famous. "It was a fragile site," Percheron said. "In the middle of sickly nature you couldn't have something arrogant or thunderous."

For the opening, Percheron wanted a big splash. He asked Loyrette to send the *Mona Lisa* on loan. Loyrette had to reject him—the world's most famous painting was too fragile ever to leave the Louvre again. Percheron asked again and again—the request for the *Mona Lisa* became a running joke between the two men. Instead, Louvre-Lens got Leonardo's *The Virgin and Child with Saint Anne* on opening day.

THE LOUVRE-LENS ANNOUNCES ITS PRESENCE at the railway station, where underground passages are lined with the names of the artists whose works have been exhibited at the museum—Fragonard, Pisanello, Botticelli. Signs in French, English, and Dutch direct you to the museum, a twenty-minute walk across a fifty-acre landscaped park. It is a visual delight, with sweeping fields of wildflowers, clusters of trees, walkways along routes that once transported coal, and a curved cement pathway evoking a Japanese garden. If you take a bus or a taxi, you miss this inspirational introduction.

Museum director Annabelle Ténèze says that the walk from the train station to the museum through the park can be "the best experience of the entire visit. A grand march of twenty minutes—more if you stop to enjoy the landscape, less if you rush through in the rain—astonishing!" The museum sits on a raised horizontal slag heap, the site of what was once coal mine pit No. 9. To blend with the landscape of the north and its rainy skies, the architects built five low-lying structures in shades of gray and silver.

I first explored the site with Marie Lavandier, Ténèze's predecessor. For seven years, she was the public face of the Louvre-Lens. Lavandier and I stood together in the center of the entry space and looked out through the floor-to-ceiling windows that encircle the museum. The walls seem to disappear, creating unity with the landscape. A large maquette of the

mining site—with shafts, rail tracks, and the surrounding town—graces the main entry hall. Study it and you can feel the sweat and hard labor of the miners emanating from beneath your feet.

"We have a very special location because we are on top of a mine," Lavandier said. When the mines closed, unemployment in some areas reached 40 percent, she added. "This became a sinister territory. People were not used to going to museums. But they said, 'We have the right to art. Art is not something superfluous.' So we began to write a new history together."

The heart of the museum, the Galerie du Temps, holds the permanent collection. A slightly curving, 32,000-square-foot cavern of a space, it has aluminum walls and pale stone floors that incline downward. The slope follows the contour of the mine underneath. Spotlights enhance the long narrow openings in the roof that let in daylight.

Where the Louvre in Paris is cautious, the Louvre in Lens is daring. The art in this gallery, enhanced by rotating exhibitions, spans dozens of civilizations and styles, from 3500 BC to the mid-nineteenth century. The works are displayed not geographically, as is the case in the Paris Louvre, but in multidisciplinary arrangements, ever-changing, in loose chronological order.

From start to finish, the philosophy of this museum has been a departure for the Louvre. "A total revolution," said Lavandier. "It broke all the codes. No more departments, no more wings with names. Nothing straight, all curves, no white and black, all gray. Glass ceiling, diffuse light, reflective aluminum walls, a contemporary feel. You bounce around the gallery from masterpiece to masterpiece like a pinball in a cavern. Or maybe you feel like a dancer, as there is something choreographic about circling around the artworks. Or maybe like floating on a river of time."

During that early visit, I was confronted by a brutal reality: a series of fifteen panels, stretching more than fifty feet along a wall. They displayed a long black-and-white photograph of Afghanistan's Bamiyan Valley, where two enormous holes in the cliff remind the viewer of the two monumental sixth-century Buddhas that once stood there. The Taliban destroyed them in 2001.

Across an expanse of a pale gray concrete floor, the oldest artworks in

the museum faced the Bamiyan panorama. Artifacts from ancient Meso-
potamia marked the emergence of writing. A black stone statue of Gudea
greeted visitors entering into the timeline. The intention was to create "a
silent encounter" with the works from the Louvre, "taken from the past,
preserved for centuries," according to a museum text.

Then, during another visit, following the Russian invasion of
Ukraine in 2022, the museum had hung a large text supporting Ukraine,
along with instructions on how to donate to the Red Cross. Outside, the
museum flew the blue-and-yellow Ukrainian flag next to those of France
and the European Union.

Here is a museum with a conscience.

At one point a vitrine of glazed earthenware figurines not more than
a few inches high, from an ancient Egyptian tomb, sat close to larger-
than-life ancient Greek and Roman statues. From the Middle Ages there
were decorative arts from many worlds: a Neapolitan silver-and-crystal
reliquary in the shape of a forearm with relics of Saint Luke; a Syrian
chandelier in copper, silver, and gold; an Aztec terra-cotta sculpture of
an old man. The paintings came last. In the first ten years the museum
borrowed hundreds of works from the Louvre, among them paintings by
Raphael, Ingres, Rembrandt, and Vermeer.

The museum prides itself on always having guides to help the public.
On a day trip from Paris to Lens with fifteen members of the Société des
Amis du Louvre, our guide was Aurore Descamps-Ronsin, whose grand-
father had been a miner. Her hair, dyed several shades of red, was pinned
up with big fake flowers, complementing her fuchsia-colored pants. Her
enthusiasm would have been considered over-the-top in Paris, although
our group was charmed.

"We don't need a *Victory of Samothrace* here," she said as she showed
us a ten-inch ancient Greek terra-cotta statue in a glass case. "We have
one! She's a lot smaller, but ours has a head and arms." A close look
revealed that indeed, this is a miniature Nike.

As time dissolves, as geography collapses, and as dozens of works are
replaced each year, the gallery eludes definition, constantly creating new
connections and conversations. As you walk past the masterpieces, you
feel the relationships among them. "You can almost hear how they're
talking to each other!" said Descamps-Ronsin.

❖

WHEN I ASKED MARIE LAVANDIER about her own earliest memories of the Louvre, she said that she first learned about it from her father. When he and his brother were children, he told her they could scoop up coins from a well in the museum using a sieve they made with their mother's hairnet.

"For me, the Louvre through my father's stories was a place that opened the world, and opened it in a joyful, playful way, like a door to the past," she said. "For me, the Louvre was not about painting. All that I discovered later. It's funny, isn't it? It's funny to think that whatever background we belong to—because my father was from a simple background—we go to the Louvre." The belief that the museum belongs to everyone permeates the Louvre-Lens. "It's why I always say in our museum that the only phrase I forbid is 'In a museum you don't do that!'" she said.

"It's the Louvre without fear," I responded.

Ténèze had a different memory of her first visit to the Louvre. During a school trip when she was fourteen, she was overcome by the emotional power of Géricault's *The Raft of the Medusa*. "It was a shock," she said. "I cannot explain why, because when you're fourteen you don't understand what moves you. But I remember very well that it was a shock."

Ténèze has preserved the singularity of the Louvre-Lens—and has gone further in making visitors feel comfortable. In 2024, the museum renovated its spaces for the first time since it opened. The Louvre in Paris lent two hundred works from its permanent collection to replace most of the works that had been on display. The Louvre-Lens built a new gallery that took the form of a curving, moving, chronological "river of time" designed to connect the new works. Among the works shown for the first time were icons sent for their protection to France from Ukraine during its war with Russia. "It is a political gesture," said Ténèze. "The icons are in exile here."

The Louvre-Lens also created new meeting spaces for lectures and social activities for people of all ages and backgrounds to explore subjects as far-ranging as the place of women in art and the challenges of health

and education in everyday life."I want to amplify the sharing power of the Louvre-Lens and its cultural and societal mission," Ténèze said.

AS YOU SPEND TIME AT the museum, you realize it has become a magnet for the community. A free outdoor picnic area beckons. Visitors walk through the entryway, bringing their lunches with them. One day I saw a mother take a supermarket rotisserie chicken out of its paper bag and carve it for her three children.

The connection to the community is intentional. "We wondered how to reach an audience that could be distant, that thought that the museum was not made for them," said Loyrette. "It was the idea of taking by the hand those who were reluctant to come to the museum. This social dimension was important."

While the Paris Louvre is top-heavy with curators, administrators, and office support staff, almost a third of the Lens museum's staff of about two hundred are hired to do outreach.

"So many people have health problems, so we work in hospitals, we do art therapy, Pilates, jogging," explained a young guide. "We organize vegetable gardens in the park. We were the first to offer visitors the chance to do yoga at the museum, to come with their babies, to come dressed as superheroes or all in pink for an exhibition. We even go to shopping centers!" Seventy percent of the visitors come from Lens or nearby, a reverse of the Louvre in Paris, where about 70 percent of the visitors are tourists.

The Galerie du Temps feeds into the Pavillon de Verre (Glass Pavilion), a space that gives out onto the gardens, intended for temporary exhibitions, including the work of living artists. It is part of a landscape of artistry, with a formal garden that evokes Europe and Japan, clearings and walkways cut through biodiverse meadows and groves.

During one of my visits, the French artist Bernar Venet was showing *The Hypothesis of Gravity*, an installation of 110 steel beams that plays with disorder and gravity. He used a forklift to force the steel arches to collide into one another with a deafening noise and end up collapsing

on the ground a few feet away from spectators. He called the Louvre the ideal image of a "paradise where all the greatest artists in history meet forever . . . the image of a dream."

The Louvre-Lens dares to do exhibitions that are edgy—perhaps too edgy for the fortress-palace in Paris. *The Disasters of War*, for example, used 450 works to trace the evolution of war images from heroic representations of warriors and their battles in the eighteenth century to gritty scenes of tragedy and barbarity in the nineteenth and twentieth. *Love,* in 2019, explored love in seven forms: seduction, worship, passion, relationship, pleasures, romanticism, and freedom. *The Table of Power,* devoted to power dining, showed clips of famous dining scenes from French films; and four hundred objects over five thousand years, from ancient friezes showing offerings to the gods to the seating chart for Charles de Gaulle's state dinner for the Kennedys in 1961.

A major exhibit on how the Louvre influenced Picasso displayed postcards he collected from the museum. Laurence des Cars made her first visit to Lens as president of the Louvre to open the show. Waiting for the last train to Paris that night, I found myself on the platform with her. When we got to Paris, there were no taxis, and she offered me a lift home. She couldn't stop talking about Picasso. "If only that exhibit could have come to Paris," she said.

WHEN THE LOUVRE-LENS WAS OPENED, there were predictions that it would take Lens from poor to prosperous in ten years. Alas, the city has not become a tourist mecca. There is no promotion of the museum at the Louvre in Paris; there are no ambitious day tours by bus or train that start and end at the museum. Only a small sign on the A1 highway announces its approach.

Yet the museum has become part of Lens's definition of itself, a source of pride to rival the local soccer team. One year, when Daniel Percheron was pushing the impossible dream of a visit of the *Mona Lisa*, part of his campaign unfolded at the stadium. Across dozens of seats in the stands, fans unfurled a 4,300-square-foot piece of canvas featuring a giant T-shirt

decorated with the face of the *Mona Lisa* and the yellow-and-red colors of the team.

The cityscape of Lens, a place of about thirty thousand, is a hodge-podge, but one of its Art Deco jewels is the tourism office, located in the main town square in a building that was once a boutique selling fine porcelain. The office has preserved the original floors, shelving, staircases, windows, and mosaics. It doubles as a community center and sells secondhand china and glassware; crafts and jewelry made by local artisans; and tourist souvenirs like snow globes featuring two hills of coal.

In the surrounding area, the inescapable focus of tourism is World War I, but a more optimistic kind of tourism is taking hold. UNESCO designated the coal mine region a World Heritage Site in 2012. In 2022, the slag heaps came to life as a sustainable tourist attraction. From far away they look black, but get close and you see green. Enterprising ecologist-farmers are growing plants there. There are Chardonnay vines, and the wine they produce—although not much yet—is playfully called *charbonnay*. (*Charbon* is the French word for coal.) Rare birds perch to rest. Hikers, runners, and cyclists come as well, even skiers who are attracted to an artificial slope. The *terrils* have become a cultural center, with music, art therapy, and meditation classes.

At the Louvre-Lens, the consciousness of war and destruction mirrors the scars on the nearby landscape. But the museum remembers and transcends. The Buddhas of Bamiyan are destroyed; war continues, even in Europe. But in the Galerie du Temps, tragedy is a backdrop to great art and treasured artifacts. It is the stuff of dreams, carried from Paris to this place of hope.

Canadian National Vimy Memorial, near Lens. It is dedicated
to the Canadian Expeditionary Force members killed during
World War I who have no known grave. *Charlotte Force*

The Louvre Abu Dhabi, France's largest cultural project abroad, on Saadiyat Island in the United Arab Emirates. *Louvre Abu Dhabi*

CHAPTER 28

❖❖❖❖❖❖❖❖❖❖❖❖❖❖❖❖❖❖❖

When Money Is No Object

Art washes away from the soul the dust of everyday life.
—**Pablo Picasso,** quotation etched into a
window of the Louvre Abu Dhabi café

IF THE LOUVRE-LENS IS AN INVESTMENT IN REGIONAL RENEWAL, THE
Louvre Abu Dhabi is a creature of wealth.

Abu Dhabi is the capital of the United Arab Emirates (UAE), a federation of seven monarchies on the shore of the Persian Gulf. Awash in oil money, it has spent billions to develop Saadiyat Island, or Island of Happiness, as a ten-square-mile tourist destination. The Louvre Abu Dhabi is the centerpiece.

The museum is a fantasy far from the everyday, so new and adventurous that it expands the idea of what can come under the Louvre name. That fantasy is crystallized in the structure itself: a visual wonder of a dome, soaring wide and high over a cluster of bright white, flat-roofed boxes. And its location? It sits not in the centuries-old heart of a congested city but on an offshore platform balanced just above the water at high tide. It is pierced by small U-shaped coves open to the sea, where visitors can sit, rest, and reflect.

Its audacity penetrates its walls. The Louvre Abu Dhabi is what the Louvre in Paris cannot be: a blank canvas for exploring the concept of a museum freed from time and place.

The museum was conceived in 2007 by the UAE in partnership with France as a geopolitical project, using art as a weapon of power. The French saw it as a way to help fund France's museums and to promote soft power diplomacy. Abu Dhabi is paying more than $450 million for the lease of the Louvre brand for thirty years within a total of $1.1 billion for French expertise, guidance, and loans of artworks from the Louvre and other French public cultural institutions. The deal also included a strategic payback: the UAE ordered forty Airbus A380 aircraft and has bought billions of dollars' worth of armaments from France.

Opposition in France was swift and fierce.

The most cutting criticism came in an open letter in *Le Monde* titled "Museums are not for sale," coauthored by Françoise Cachin, the Musée d'Orsay's founding director, and two leading French art historians. They called the Louvre's project in Abu Dhabi "alarming" and accused the French government of "selling its soul" to foreigners.

Loyrette, as director of the Louvre at the time, also initially opposed the idea. The UAE presented France with a plan, complete with a Jean Nouvel design, before securing the Louvre's permission. "It was a bit shocking," Loyrette told a France Culture interviewer. "They were putting the cart before the horse. It's never very pleasant to be invited into a project after many things have already been decided."

Yet he eventually supported the partnership, because it would create a museum that would bring together works not only of the Louvre but also of more than a dozen other French museums as well. "It was to be a universal museum with an ensemble of artworks and ideas," he told me. Of course, he added, money was important. The UAE's financial arrangement, he said, "represented a fair fee for the use of the name."

But his close friendship with Cachin was broken. They never spoke after that. "There is a wound, certainly," he said.

Other critics of the deal pointed out that a Louvre in Abu Dhabi would boost the image of sophistication and cultural solidity the UAE had long desired, but that it could cheapen the Louvre's reputation as a temple of art without equal. The UAE was rapidly growing and modernizing, with ultra-expensive attractions in the nearby largest city of Dubai, including indoor ski slopes, the tallest building in the world, and

vending machines that dispense bars of gold. But human rights advocates criticized the absence of free and fair elections, political parties, an independent judiciary, and trade unions; and the criminalization of homosexuality and government criticism.

Others described the UAE as a soulless, rootless place, a network of highways and vertical glass-and-steel buildings that emerged from nothing and were built with the sweat of foreign laborers who are subject to abuse and exploitation.

Despite the critiques, the French state proceeded with the deal, and this new version of the Louvre came to be promoted as a museum freed from rules and traditions, open to exploring new ways to excite art lovers. In addition, in the years since its opening, the Louvre Abu Dhabi has exhibited some of the Louvre's finest paintings on loan—from Leonardo's *La Belle Ferronnière* and *Saint John the Baptist* to Titian's portrait of François I and Vermeer's *The Astronomer*. These loans are not second-rate works dusted off from storage. They are superstars. Unlike the Louvre-Lens, the Louvre Abu Dhabi is not a Louvre franchise. It borrows art through France Muséums, a private agency controlled by various cultural institutions.

The Louvre Abu Dhabi is also building a permanent collection of its own, aggressively buying works of art from prehistoric to contemporary times. By the time it opened in 2017, the museum had acquired more than six hundred works, including a Madonna and Child by Giovanni Bellini, Piet Mondrian's *Composition with Blue, Red, Yellow and Black*, a Rembrandt painting of Jesus, and a Gilbert Stuart portrait of a tight-lipped George Washington. In 2019 it bought more than 2,800 coins from Islam's medieval era from a private collector in Europe. Price seems to be no object, and purchases from the private market are often kept secret. The value of the museum's collection is impossible to assess.

Some museum specialists boast that seen through the layers of its architecture, "the history of the Louvre is the history of France." By contrast, the Louvre Abu Dhabi is not moored to any country's past and declares that it is free to tell its own version of history. It is a global mix-and-match, a chronological dialogue of world history through works of art displayed side by side. "So many people come here and they say, 'Oh,

it's not at all like the Louvre in Paris,'" said Latifa Al Azdi, the young press officer at the museum who served as my guide. "And we say, proudly, 'No, it is not!'"

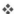

THE 92,000-SQUARE-FOOT MUSEUM COMPLEX IS made up of fifty-five small buildings, twenty-three of them museum galleries. All are liberated from the Cartesian logic of France. Galleries connect with one another by passageways of lanes, small squares, and dead ends. A glimpse of the water appears from time to time. The result is a celebration of the chaos and organic feel of an Arabian medina.

There is harmony among the elements—the architecture, the water, the light, the air, the sand, the wind. Sparrows, doves, and pigeons nest in the crevices and fill the outdoor space with sound and song, as if to pay homage. Small turtles that have lost their way swim into the museum's pools; gazelles run freely in the gardens. The street leading up to the museum, lined with palm trees, is named in honor of Jacques Chirac, who approved the deal.

The first, overwhelming impression for visitors is the dome, an architectural miracle of density and lightness. Its eight layers of stainless steel and aluminum weigh about 7,500 tons, about as heavy as the Eiffel Tower, but its filigree design makes it porous and open to the sky.

From the outside the roof seems to hover weightlessly in the air. On the inside it filters and scatters sunlight to create a shifting sculptural beauty of thousands of geometric spaces or "stars" repeated in different sizes and patterns.

Its designer, the Pritzker Prize–winning architect Jean Nouvel, was inspired by Abu Dhabi's palm tree oasis. He calls the ever-changing experience the "rain of light." Even on the most stifling days, the dome protects against the unforgiving Persian Gulf sun. As you stand underneath, you feel a cool breeze coming off the sea.

I watched as the dome created dapples of light that kissed the walls and floors. They also change shape, intensity, and color with the season and the time of day. Manuel Rabaté, the museum's director, told me how he once explained this "rain of light" to a blind man. "We walked and

when we came to a dapple of sunlight, we stopped," he said. "He felt the warmth of the sun on his face and said, 'Ah, now I know what you mean.' It was magic."

The museum itself is a spiral, not a grid. To retain the feel of purity in the design, the space is clutter-free. The air-conditioning system is hidden, the light fixtures and security cameras built to blend in. The signage—in English, Arabic, and French—is purposefully minimal. There is now a free printed map; and there are guides in English, French, and Arabic at the boutique, and a free downloadable app in seven languages. Still, as you move from room to room, you might find yourself in an open space that makes no sense. You're forced to wander and are almost encouraged to lose your way.

The vestibule introduces what it called the "concept of universality" with nine glass cases like giant crystals that hold works arranged not by geography or century but by theme: motherhood, death, religion, writing. For motherhood: a bronze statuette, dated 800–400 BC, of the Egyptian goddess Isis nursing the infant Horus; a fourteenth-century ivory Virgin Mary and baby Jesus from France; and a nineteenth-century mother and child from the Democratic Republic of Congo, carved in wood. In another case, funeral masks from ancient China, Peru, and ancient Phoenicia made of gold convey the belief that precious materials can bring immortality and preserve memories of the dead.

The next gallery deals with objects from millennia ago when people first gathered in villages: one is a nine-thousand-year-old statue from Jordan, with two odd-shaped heads and piercing eyes.

Two statues of kings stand in another large room. The larger one is Ramses II, exuding absolute power from the cube-shaped throne on which he sits, hands resting on thighs, wearing a majestic headdress than hangs down onto his shoulders. The other is Gudea, barefoot, clean-shaven, and wearing a modest wide-brimmed cap, his hands clasped in a sign of piety.

Cultures are brought together in other ways. A darkened room whose walls are lined in bronze features a Torah from Yemen dating from 1498 alongside a seventh-century Quran and a thirteenth-century Gothic Bible.

While the approach is meant to give value to works of art from

different periods and places and create links among them, the museum grounds the narrative in the local environment with displays of objects found in the UAE, like a ceramic vase from 5500 BC. Made in Mesopotamia but unearthed on Marawah Island, it underscores the robust trade passing through the Persian Gulf more than seven thousand years ago.

As noted, the Louvre in Paris is almost entirely restricted to artworks created before 1848; the Louvre Abu Dhabi owns art by Rodin, Manet, Caillebotte, Picasso, and Magritte. Japanese prints hang side by side with works by Gauguin. One room is devoted to Universal Expositions in Paris; another contains examples of Art Deco living and dining rooms from 1925.

In one space sits Jean Tinguely's 1960 sculpture *Orange Press*, made from functional objects like a citrus juicer and a pail. Near it is an installation called *Food for Thought*, by Maha Malluh, a contemporary Saudi-born female artist, of battered and blackened food pots that transform the preparation of traditional goat stew into a visual poem.

One temporary exhibit was a collection of boxes each with brightly dyed spices by the Italian sculptor Claudio Parmiggiani—the work was on loan from the Centre Pompidou. I tried to figure out its meaning. An Indian couple with a five-year-old daughter stood next to me.

"What do you smell?" I asked the child.

"I smell sand," she said. "Rainbow sand."

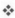

WHEN I VISITED THE LOUVRE Abu Dhabi in 2022, Souraya Noujaim, the director responsible for the collections, was the key to my understanding of the museum; a Beirut-born expert on medieval history and archaeology, she would become head of the Islamic art department at the Louvre in Paris in 2023.

Noujaim told me to stop and listen at a fountain from Syria that had recently been restored at a specialized mosaic atelier in Lyon. The water from the fountain comes slowly, and its sound is high-pitched and soft. "With these shapes and colors, it is like a puzzle," she said. "It takes you to infinity."

Another room was hung with a series of blue and white paintings by Cy Twombly; with them was a display of 2000 BC rock fragments of different sizes from Saudi Arabia that featured carved images and jagged edges. "The stones are in dialogue with Twombly," Noujaim said.

I asked her about criticism of the museum for its avoidance of sensitive subjects like slavery and colonization in its collection and exhibitions. She did not deny the gaps but said the museum has the advantage of flexibility in both its exhibitions and its permanent collection. "These obviously are topics we are studying," she said. "We are constantly adjusting the narrative. We want to open up, to evolve."

We then saw a European work of art that stood out because of its quality, subject, and date: *Portrait of an African Woman.* It was painted by an unknown artist in Florence in 1560, only a few decades after Leonardo painted the *Mona Lisa* there. Unlike *Mona Lisa*, this woman was Black.

I had already seen the portrait. A voice on the audio guide that had led me to her said, "How can we fail to be taken in by the gentle gaze of this woman, looking us straight in the eye, seemingly wanting us to be her witness?"

The painting had shaken me to the core. The woman's gaze was too direct for comfort. Her eyes were tired, rimmed with dark circles. Her lips were painted orange. She was holding a clock made by a master jeweler. "Who is she?" the audio guide went on. "We can work out her identity thanks to several clues. Her outfit is the fashion typical of Florence in the sixteenth century: luxurious jewelry, black pearls in her ears, a coral necklace, and a silver net in her hair. She probably worked as a servant or a lady's companion for a powerful family. Also if you take a close look on the right we see the sleeve of another dress and a lace veil. So this young woman was originally standing next to her mistress, who would have been the main protagonist of the painting. . . ." The woman in the painting was not its star but a prop, a servant whose presence was intended to train the spotlight on her white mistress. The rest of the commentary sought to soften the uncomfortable subject of Black people and slavery in Renaissance Europe.

"The status of African people in Europe was variable," the audio guide continued. "They might be slaves or living in freedom. In Florence

the child took on the status of the father, so the child of a female slave and Florentine citizen would also be born a free citizen."

For Noujaim, *Portrait of an African Woman* is a treasure. "It was a brilliant acquisition," she said. "She is fabulous, she is beautiful, she is our *Joconde*! We will give her a place of honor one day."

MY VISIT ALSO INCLUDED A rare excursion to the dome from above.

"It could have been a flat and boring roof," said Latifa Al Azdi, the museum guide. "Instead, you have thousands of angles. Just look at the layers and the shapes. It never gets old for me."

We climbed up till four layers of the dome were above us and four below. I could see how the overlapping of the layers created multi-shaped openings. The sun shone on the pieces of metal and created shadows. One metal beam was lit up in five shades of gray—one was almost black, another the color of cold slate, a third like gunmetal, a fourth a warm gray brown. The last one was the brightest of silver.

To our right was the Persian Gulf. And far below us was a rectangular patch of emerald green bordered by white stone or concrete, one of the pools of water at the museum's edge. Through a trapezoid-shaped opening I saw the pale turquoise of the sea and the even paler blue of the sky. Another opening revealed a sun-kissed construction site in shades of sand and taupe as it met the sea. It could have been an impressionist painting of the Normandy coast.

"The water below the museum belongs to us," Al Azdi said.

"What a lovely image," I said.

"No, it really belongs to us," she said. "We own the water space around the museum. It gives us security. No boats can come close to our shore."

A bird's nest was perched on one beam. The birds own this space, it seems. At one point the museum used predatory bird sounds to scare them away. It didn't work. The lean and hungry cats that prowl the museum's grounds do not scare them.

An all-is-well-with-the-world calm takes over up here.

"You have given me a moment of beauty and magic," I told the security guard as we said our goodbyes.

❖

THE LOUVRE ABU DHABI IS technically in the city, but it feels like a world apart. Until the 1970s, Saadiyat Island had no electricity or drinking water. Now it is taking shape as a world-class "cultural district." New York University has a campus here. There are hotels, condominiums, businesses, malls, parks, golf courses, marinas, and restaurants. The Louvre Abu Dhabi's upscale restaurant is an outpost of the original Fouquet's on the Champs-Élysées in Paris.

The multi-faith Abrahamic Family House, a place of worship with a mosque, a church, and a synagogue, opened in 2023. Frank Gehry's Abu Dhabi Guggenheim is scheduled to open in 2026. Norman Foster's Zayed National Museum, a natural history museum, a maritime museum, and a performing arts center are planned.

When the Louvre originally made its deal with Abu Dhabi, the criticism in France was long and loud. In 2022 the Louvre name was leased out again, this time to a real estate development company with plans to build four hundred luxury apartments on Saadiyat Island, called Louvre Abu Dhabi Residences. In its initial offering, the developer promised homeowners a close relationship with the museum, including "personalized art consultation and service." But that went too far for the museum, which required the developer to remove that phrase from its promotional material. "It was a misunderstanding," said Manuel Rabaté, without further explanation.

How much is the deal? I asked him. He refused to answer, except to say that the apartments would be "priced to reflect their exclusivity," and that the initiative was crucial for the "economic sustainability" of the museum. "We are branding one part of the island. And with the residences, there is an unparallel opportunity to live at the most inspiring cultural address in the world."

The museum's well-intentioned outreach to the community has been extensive and diverse. There are fee-based yoga and exercise classes under the dome and kayaking in the waters surrounding the museum. There are exhibits for the visually impaired. The museum sponsors events with universities like NYU and the Sorbonne.

There was an event that invited the staff—cleaners, security guards,

office boys (yes, they are called "boys"), servers in the café—to visit the collection. When the president of Nepal visited, she invited the museum's Nepalese workers to take a photo with her. But many of them have never visited the collections. In the UAE, immigrant workers outnumber citizens by about nine to one, and I did unofficial polls of many of the people I met. The two Syrians at the phone store had never been to the museum, nor had the two female bank tellers from the Philippines or the South African cashier at the supermarket.

I decided to ask every taxi driver I encountered whether he (they were all men) had ever entered the museum. I interviewed about thirty drivers. Most gave the same answer: they worked long hours, six and sometimes seven days a week, and lived with roommates in company-run dormitories that have a toilet and shower down the hall. They needed to sleep during their time off.

On the last day of my trip, my taxi driver was a forty-two-year-old Nigerian whom I will call Frederick. He told me that he had a wife and three children back home whom he had not seen for two years.

I asked him if he had ever been inside the museum.

"No, but I have always wondered what is inside. I was a photographer back home, and I would love to," he said. "It is my dream."

I asked him if he wanted to accompany me to visit the museum. "I'll pay you for your time, of course," I said.

"Today is my lucky day!" he replied.

He parked in the lot and picked up his camera. We walked toward the entrance when suddenly he froze. He had changed his mind; he explained that to leave his taxi unattended during his shift could jeopardize his job.

A wave of sadness washed over me. I knew that there was no use in arguing. I thanked him and paid him. He put his hand on his heart and walked away.

One of the guards inside the museum told me that the taxi companies can track their cars with a GPS system and would notice if one was stationary. He said it can take years for a foreign worker to get a work visa, but no time at all to lose it. I have no idea whether it was true. But fear is often not truth; it is what is imagined.

For the Louvre, the UAE is a complicated partner. The relationship was reinforced by the UAE's decision to reject sanctioning Russia for

its invasion of Ukraine in 2022. The country became a haven for super-wealthy Russians with links to Vladimir Putin, who are drawn by its mostly tax-free status and the promise of financial secrecy.

In the long run, will the Louvre's cultural power and reputation be enhanced or diluted by its partnership with this tiny, rich, less-than-free emirate far away in the Persian Gulf? Perhaps, by 2047, when the lease is up, the Louvre Abu Dhabi may have made itself into a cultural star in its own right.

It may no longer even need the Louvre or its name.

The museum's dome soars over a cluster of white, flat-roofed boxed
installations that sit on an offshore platform balanced just above the water.
© Department of Culture and Tourism Abu Dhabi, photo by Hufton+Crow

PART SIX

Be Mine

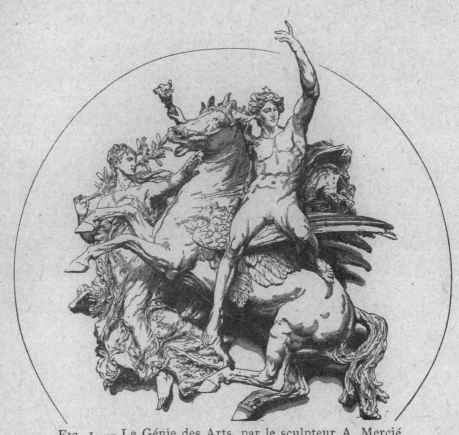

Fig. 1. — Le Génie des Arts, par le sculpteur A. Mercié.
(Façade du Louvre, à Paris.)

Engraving of *The Genius of Arts* by Antonin Mercié (1845–1916)
from a frieze on the facade of the Louvre facing the Seine

CHAPTER 29

✦✦✦✦✦✦✦✦✦✦✦✦✦✦✦✦✦✦✦✦

Creating an Identity

Free yourself! Get lost!
—Sébastien Allard

CAN THE LOUVRE CHANGE YOUR LIFE? JEAN-LUC MARTINEZ, THE MUSE-um's former director, says it can. His first experience there, as an eleven-year-old schoolboy, pulsed through him like a bolt of cultural lightning. He did not tell his parents, even though it shook him to the core.

Martinez comes from a family of immigrants who fled the poverty of Andalusia for Paris. His father was a postman, his mother a concierge. Their first apartment had no indoor toilet. Later they moved to a public housing project in the suburb of Rosny-sous-Bois. His parents hardly ever ventured into the heart of the city. One day a teacher took Martinez's class to the Louvre. At the base of the Daru staircase, he looked up at the Nike of Samothrace. "It was the first artwork I ever saw in my life," he recalled.

Martinez felt as if a storm were carrying his body upward: "Its monumentality, its staging atop the staircase, is one of the most beautiful scenes in all of the museums of the world. It was the first time that I left everything around me that was modern and entered the ancient world." At that moment, his career path was decided.

The Louvre has struck many visitors with that same lightning bolt of excitement, inspiring them to return again and again. Especially when you're in love. One day I found myself giving directions to two middle-aged tourists. We got talking, and it turned out that Carrie, who is English, and Giovanni, who is Italian, were on a whirlwind trip to Paris. Years before, he had spotted her in a café in the Sicilian seafront town where he lives and where she was vacationing with her children and parents. He knew he had to meet her. They were both divorced, raising school-age children, and one thing led to another. They've maintained a long-distance relationship ever since.

"So this is love?" I asked.

"*Sì*, yes," said Giovanni.

"Well, the Louvre is a good place to be with someone you love," I said.

Giovanni was on his way home to Sicily from a trip to Brazil. Carrie had come from England to meet him. They had twenty-four hours to spend together in Paris. It was Carrie's first visit to the museum. They had endured the circuslike atmosphere around the *Mona Lisa* before Giovanni showed her the four other Leonardos that hang nearby.

Giovanni wanted Carrie to experience that bolt of lightning, the powerful force that can trigger a sudden spiritual awakening. "I cry when I see the masterpieces of Leonardo," he told her. "I just want to kneel down in front of their beauty. When I see his paintings, I know that God really exists."

They kissed.

MY ENCOUNTERS IN THE LOUVRE convinced me that you can be whoever you want to be when you go there. I have observed several types of visitors, assuming several identities. All are valid; anyone can pick the one that fits best.

THE SPRINTER. This is the museum equivalent of the one-night stand. For this visitor, speed is everything: the Louvre is not an experience to be savored but rather an item on a best-of list to be checked off as quickly

as possible. Ian Fleming, the creator of James Bond, said he had "often advocated the provision of roller-skates at the door of museums and art galleries."

The American newspaper humor columnist Art Buchwald wrote about the race to visit the Louvre in fewer than six minutes, a subject he revisited over time. "As everyone knows there are only three things worth seeing in the Louvre museum—the *Venus de Milo*, the *Winged Victory* and the *Mona Lisa*—the rest of the stuff is all junk," he wrote in his last version, in 1990, visiting the Louvre with his son. "For years tourists have been trying to get through the Louvre as quickly as possible, see those three things, and then go out shopping again. Before World War II, the record for going through the Louvre was seven minutes and 30 seconds held by a man known as the Swedish Cannonball. After the war an Englishman, paced by his Welsh wife, did it in seven minutes flat—and pretty soon everyone started talking about a Six-Minute Louvre."

In Buchwald's original telling, in 1954, a fictional American student named Peter Stone flew through the Louvre and into a waiting taxi in 5 minutes and 56 seconds. But in his 1990 visit, Buchwald found a more difficult challenge: the long line outside the Pyramid entrance "made it impossible to get near the record," he wrote. "Look at us—we've been standing in line for an hour." And once they were in, the French did everything they could to confuse them. "They would point you in the direction of the *Mona Lisa*, and you'd wind up in the salle displaying 22 armless and headless Roman statues."

Fans of the French New Wave in cinema know the scene in Jean-Luc Godard's 1964 quirky heist film *Band of Outsiders*, when a trio of young friends run through the Louvre and break the fastest record of their day: 9 minutes and 45 seconds; they shave two seconds off the time.

One of the most joyful celebrations of the Louvre in film is a playful parody of that scene in *Faces Places*, a 2017 documentary by Agnès Varda, filmed while traveling with the photographer and artist JR. They make an odd couple: Varda, tiny, her hair in a two-toned copper-and-white bowl cut, aged eighty-seven; JR, tall, thin, hiding behind sunglasses, aged thirty-four. As JR pushes her in a wheelchair through the Grande Galerie at racing speed, Varda raises her arms and calls out the names of

the painters whose works she passes: "Bellini! Del Sarto! Ah, *c'est beau*! Lorenzo Costa! Ghirlandaio! Botticelli!" At one point JR jumps in the air; at another, he pushes the wheelchair, runs around a circular banquette, and sends Varda on her own. "Aye! Oui-e, Raphael!" she continues, pressing her hands as if praying before the Italian master. She ends with Arcimboldo.

Racing in the Louvre is banned, but some fans cannot resist.

THE MAXIMALIST. We can set fantastic goals for ourselves in life. Some people run marathons; others master French cuisine or Italian opera. A goal among a certain type of Parisian is to visit every room and see every work of art in the Louvre.

When the Ministry of Finance was located in the Richelieu wing, Alain Lecomte, a midlevel financial official, spent every Wednesday and Friday evening in the museum. He did four or five rooms at a time, and finished after three years. *Le Parisien* and French television interviewed him on his extraordinary feat.

"It became like the stories in *One Thousand and One Nights*," he said. "Stories without an end! I felt like I owned the Louvre."

Hélène Huret realized that she was bombarded by surprises whenever she attended events at the Louvre in her position as director of the foundation for Bernardaud porcelain. "I knew nothing," she said. "I said to myself, 'Shame on you. Beauty saves the world.' So I decided to go for ninety minutes every Friday evening." It took her a year to see everything.

"Usually people who visit the Louvre are lazy," she said. "They go to see what they already know from images or art history. I'd say to myself, 'Last week you did this, and this week you will do that.' Along the way I'd ask myself, 'What do you see? What moves you? What are the themes, the symbols?' It was a bit like conquering a battlefield."

Lecomte and Huret followed their own rules as they fell in love with the Louvre. A different kind of maximalist is driven by passion.

THE INSATIABLE LOVER. There was no more voracious, rapacious, obsessive, possessive lover of the Louvre than Pablo Picasso. Living in Paris

at one stage of his life, he walked to the Louvre every day, absorbing, digesting, remembering everything he saw within. Fellow painter Ardengo Soffici wrote that Picasso went "prowling like a hunting dog in search of fowl among the Egyptian and Phoenician antiquities, the sphinx, the basalt idols, the papyruses, and the sarcophagi painted in bright colors."

Picasso created his own versions of dozens of the Louvre's paintings. He was so enraptured by ancient Iberian art that he bought two carved stone heads that turned out to have been stolen from the museum; they later became models for the faces in his 1907 masterwork *Les Demoiselles d'Avignon*. Late in life he kept plaster copies of the Louvre's slave statues by Michelangelo in his studio in Antibes. During a personal crisis in the mid-1930s, when his mistress Marie-Thérèse became pregnant and he and his wife Olga separated, Picasso stopped painting for a short time. In a poem of despair, he wondered whether he'd ever have a work of art "worthy of entering the Louvre."

Did Picasso ever dream of the Louvre? Well, he once took pen-and-ink to a piece of brown cardboard with a white label glued to it that read, "The Louvre, Paris." He drew two nudes, their eyes closed, amid trees. He called it *The Dream*. So perhaps.

Marcel Proust was also obsessed, visiting the Grande Galerie and its adjoining rooms almost every day until asthma forced him to give up most museumgoing. The Louvre's paintings took him in spirit to faraway places. "Going to the Louvre to look at a Titian consoles us for not being able to go to Venice," he wrote. Once asked by a Parisian newspaper what he would do in the face of near-certain death, he answered that he would throw himself at the feet of a certain Miss X, take a trip to India, and visit the new galleries of the Louvre.

THE MINIMALIST. The Louvre is not one museum but nine, ever since the Byzantine and Eastern Christian art department was created in 2022. Each has a different history, collection, personality, and director. If you look at too many works of art, you'll forget them. So, how about just one?

In a speech at the Guggenheim Bilbao in 2001, the Italian medieval

scholar and novelist Umberto Eco urged his audience to master just one work of art during a museum visit. He confessed that he hated the "torrents" of uninformed tourists "who wanted to see everything [and] would see nothing." His ideal, he said, is a museum that "helps a visitor to understand and enjoy a single painting or a single statue, or even a single Cellini saltshaker." For him, "half an hour of intense contemplation satisfies the spirit. And then I leave."

You might even look at the same single painting again and again over time. Each time could be a different experience. As the British art historian T. J. Clark said, "A painting opens itself to repeated looking, and looks different and, you know, directs your attention and your feelings, in ways that open up day after day, week after week."

THE FAITHFUL PARTNER. For some of us, the gradual approach is the best way. I once asked Neil MacGregor how to fall in love with the Louvre. He pondered the question, then cautioned against expecting too much.

"Like proper love affairs, this is slow loving," he said. "Go several times, and choose a bit, and just that bit. And really be disciplined about it, accept that you're not going to see everything. You're going to fall in love with three bits of the Louvre, and it'll be slow. And then it will become passionate."

I later sent him an email asking which "three bits" first-time visitors to the Louvre should seek out.

"Any three bits will do," he wrote back.

"Any three bits will do? Good grief! Talk about playing hard to get!!!" I shot back.

"I mean it," he wrote. "Just spend the time and the love will come. Anywhere in the museum."

And that perhaps is the core of it: knowledge precedes true love.

THE ETERNAL EXPLORER. The most faithful Louvre lover I have ever known is Henri Loyrette. From 2001 to 2013, when he was director, he and his family lived in the museum's residential quarters on the top floor of the Flore wing. He sometimes treated special guests to a nighttime tour of the museum's empty halls and galleries.

Loyrette is elegant, charming, and erudite. It requires time and

extensive preparation to earn his respect. Our first personal encounter was brief. It came in 2004, when I was Paris bureau chief for the *New York Times* and he was hosting a formal, private lunch for American donors as they toured the artworks featured in Dan Brown's best-selling thriller *The Da Vinci Code.*

Caught between the desire to preserve decorum and the need to attract private money, Loyrette struggled to keep a cool distance from the *Da Vinci Code* theme tour. He said he had no intention of reading the book, even though the museum's bookstore was selling the French translation. He declined an invitation to accompany the Americans on their tour. But he also confessed that the Louvre needed to shed its reputation for "arrogance," and that the event offered "a way of entry" into the museum.

Over time, as I continued to write about the Louvre, Loyrette became a trusted guide. His attraction to the museum was not love at first sight. "I don't have a memory of the first time I visited, but rather a constant memory of its presence," he said. Seared into his consciousness are childhood encounters with nineteenth-century French masterpieces, portraits from ancient Rome, and ancient stone reliefs and funerary statues from Palmyra, in what is now Syria.

Even now, curiosity drives him. "Works of art call out to you," he said. "You start with something, and it pulls you to something else. I have known the Louvre for sixty years, but every time I go, I discover something new." Recently it was a delicious detail in Poussin's painting *Landscape with Diogenes.* The scene is familiar: the humble philosopher Diogenes is casting away his last remaining possession, a drinking cup, when he sees a man cupping his hands to drink water from a stream. Loyrette saw something else. "There were pebbles in the stream!" he said. "I never took the time to study this painting, and I saw pebbles in the stream for the first time."

He whipped out his iPhone and enlarged a photo to show me: small pebbles sparkling in the light at the edge of a stream. Then I, too, was entering the painting, feeling the warmth and tranquility of a summer day and the joy of his discovery.

Later I sent him a photo of shimmering leaves in Poussin's painting *L'Été* that reminded me of the stones in the stream. Touched by the

gesture, he wrote back, "This is a wonderful feeling, dear Elaine, and it brings joy to our lives. See you soon to continue our discussion."

THE PILGRIM. This is the classic Louvre-goer: hardworking, diligent, and determined to cover enough ground to justify the 22-euro admission fee. Louvre pilgrims map out a route and pay homage when they reach their destinations, checking off the best-of works one after the other. "When we go to a museum, it is as if we are going on a pilgrimage," said Vincent Rondot. "The best way is to prepare our visit. We define the objects that are to be found."

I met a dedicated pilgrim, Mitra, from San Francisco, in the museum gift shop one day. She had prepared a four-page color-coded to-do list for herself and her husband for their five-day visit to Paris. She had mapped out two "trails" from the Louvre website with rooms that were open that day. "I did my homework!" she declared.

Entire books have been written about how long it takes to do the "best of" the Louvre. Rick Steves, the American travel writer, sees the Louvre as a "magnificent challenge" for the tourist. "It's not supposed to be easy," he said in an interview. "It's supposed to be inspirational and overwhelming. And whenever we're dealing with the stress of not knowing when we can get in, and the mob scenes, and the congestion, and the body odor, and the horrible lines, and the lack of enough toilets, and the high prices at the cafés, I think, The Louvre is a triumph of the people! The commoners have gone wild! And it's a celebration of life!"

"So what's your parting advice?" I asked.

"Zoom in on the biggies and try to finish with enough energy to browse!" he said.

THE FLÂNEUR. "Give yourself the freedom to get lost," Sébastien Allard likes to say. How about forgetting the biggies and getting lost right from the start?

That's what the Nobel Prize–winning novelist Orhan Pamuk did in the spring of 2023 when he was lecturing in Paris and lived a ten-minute walk from the Louvre. He wandered the galleries for about twenty-seven hours in all. "I'm a museum lover, you might even say a museum maniac,"

he told the *Guardian*. He said that museums "make my romantic imagi-
nation work. And the Louvre is *the* museum. It's so big and so astounding
and I loved getting lost in it. One of my happiest encounters was with a
self-portrait by Albrecht Dürer that he painted in his early twenties. I was
all alone with it."

There is an art to getting lost in the Louvre. I discovered *flânerie*,
that urban pastime of liberation that comes with aimless strolling, when
I was a graduate student writing my doctoral dissertation (unfinished) on
Louis-Sébastien Mercier. He wandered on foot, recording whatever he
saw in haphazard fragments collected in his *Tableau de Paris*, published
from 1781 to 1789. An obsessive *flâneur*, he perfected his art on the streets,
but it also works in the Louvre.

Wandering through the galleries of ancient Iran and Mesopotamia,
I noticed a large window with an unobstructed view of the Pyramid, the
Eiffel Tower in the distance. I once met an American couple sitting on
the bench in front of it, holding hands. They come every year to Paris—
and to this spot—to celebrate their wedding anniversary. You won't find
their bench in any tourist guide.

The rewards can last until the final moment of your visit. I once got
lost trying to find my way out of the museum. I happened on an elevator
and took it down to the lowest level. Still searching for an exit, I turned
right and confronted a sixteenth-century wood statue of Mary Magda-
lene, clothed only by her hair before she was raised up to heaven by angels.
She is one of the most beautiful women in the Louvre.

THE RESPONSIBLE PARTY. What is it like to walk through the Louvre as
the person in charge of it all?

Laurence de Pérusse des Cars brought impeccable credentials as
director of the Louvre. She is an expert in nineteenth- and twentieth-
century art, with decades of museum experience. In a palace like the
Louvre, her noble blood helps. Her full surname, de Pérusse des Cars,
denotes an aristocratic line that dates back a thousand years. Her family
is so embedded in French history that during World War II the family's
Château de Sourches was one of the hiding places for the Louvre's trea-
sures, including Delacroix's *Liberty Leading the People*.

Her father, Jean, is a journalist and popular historian; her grandfather,

Guy, was the author of about sixty pulp novels that sold tens of millions of copies. Her step-grandmother, New York–born Marta Labarr and Guy des Cars's third wife, had been a minor film and stage actress who once coached Gina Lollobrigida in English. Labarr insisted on speaking to Laurence only in English, teaching her the flawless (almost) American-accented English she speaks today.

"What kind of a Louvre-goer are you?" I asked. "A *flâneur*? A minimalist homing in on one artwork? An eternal explorer who can never get enough?" She said that she no longer has the luxury of dreams when she walks through the Louvre. "I'm trying to run it, so it's a bit different now," she said. "Each visit I make in the galleries should be useful. There is generally a problem that must be solved, a decision that must be made. I have to think about all the technical details. How long does it take to go to this gallery? Is it tiring? Is there a toilet? Is there an elevator? If I can't walk, or if I am with young kids, what do I do? The graphic signage is awful, so where do I go?"

She must think ahead. "Things that were true five years ago are no longer true," she said. "And here I am at the head of a fantastic institution, but I have to somehow project into the future. Dealing with constraints— financial, technical, the reality of the building. There's no school for running this. There's no user's manual. There's no parachute."

Still, she wants the museum's visitors to explore as freely as any *flâneur*, to view art as passionately as any lover. "The Louvre is a very strong place," she said. "It projects this idea that it has always been there. It's just that I want more, I want it to enchant."

412. — LE RADEAU DE LA MÉDUSE (GÉRICAULT).
(Musée du Louvre.)

Engraving of Theodore Géricault's *The Raft of the Medusa*. The painting depicts the true story of a group of men clinging to life on a makeshift raft at sea after the wreck of their frigate *Medusa* in 1816. It is one of the "must see" artworks in the Louvre.

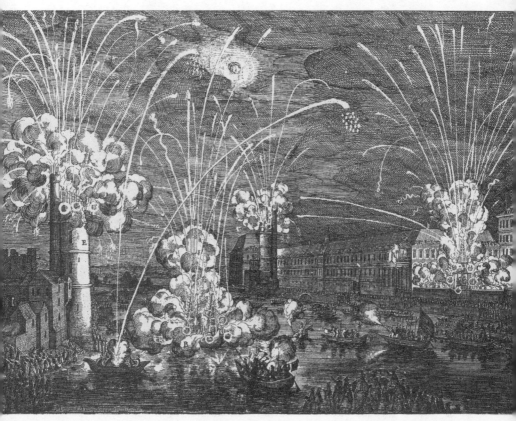
Engraving of fireworks on the Seine, in front of the Louvre's Grand Galerie.

✦✦✦✦✦✦✦✦✦✦✦✦✦✦✦✦✦✦✦

Blue in the Bushes

The art of seeing has to be learned.
—Marguerite Duras

My business is to paint what I see, not what I know is there.
—J. M. W. Turner

AS A LIFELONG JOURNALIST, I HAVE LEARNED HOW TO TALK TO ANY-
one about anything, from farmers and factory workers to presidents and
kings. But as a visitor to the Louvre, I also had to learn to communicate
with works of art. That meant seeing, really seeing.

I had an early introduction to this idea from my mother, who took
my siblings and me to our local art gallery in Buffalo and encouraged us
to sit and look at paintings by Géricault and Matisse and Monet. "Look
at ordinary things," she would tell us, pointing to the apples and knives of
a still life. "They tell stories."

Eventually, my mother turned my former childhood bedroom into a
studio and painted, not brilliantly, but well enough to be shown in local
exhibitions. She knew, too, that the most skillful artists knew how to
closely observe the world around them. At a eulogy at her funeral in 2005,
my younger daughter, Gabriela, called her "a talented artist who painted

what she saw." Then she told a story: "One time when we were painting together, she told me there was blue in the bushes. At the time, I had no idea what she was talking about. But then I learned that there is more to art than what you see at first glance, and in order to capture an image you must look at it hard and interpret it in various ways.

"This is how Grandma treated life."

The writer James Baldwin had a similar lesson in seeing: the iridescent hues of an oily puddle left a lasting impact on his creative vision. "I remember standing on a street corner with the black painter Beauford Delaney down in the Village, waiting for the light to change," he said. "And he pointed down and said, 'Look.' I looked and all I saw was water. And he said, 'Look again,' which I did, and I saw oil on the water and the city reflected in the puddle. It was a great revelation to me. I can't explain it. He taught me how to see, and how to trust what I saw. Painters have often taught writers how to see. And once you've had that experience, you see differently."

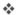

TRUE, THE LOUVRE CAN FEEL too vast, complicated, forbidding, disorganized. Yet its intimidating veneer is pierced every time you make an intimate connection with even one work of art. The Louvre may have put digital images of its entire collection of half a million works online, but it remains unapologetically analog. You can't just look at a reproduction to make that connection.

This is the *partage*—the sharing—that comes only with museumgoing, the sensual dialogue that sometimes comes when we get close enough to really see a glorious work of art, and when that work of art moves us.

When asked what the Louvre means to the world, Henri Loyrette likened it to "a mirror of human existence, passions and sentiments, a world in which we can all find something in ourselves, of our lives, thoughts, and deeds."

I think he was saying that we can come to the Louvre and see its treasures as a series of mirrors in which we see ourselves. Each of us responds to a work of art in different ways, depending on our own history and our own preconceptions. The Louvre was created as a "people's museum"

open to the citizens of the world. Everyone has the right to enter and to have an opinion.

The works of art within its walls showcase beauty for eternity. They have taken me around the world and have shown me how history was made, how kings ruled, how lives were lived, how wars were fought, how myths were told. Learning how to see in the Louvre applies to both up-close views of artworks and to the complexity of the building itself.

When I think of my Louvre, I think of the view from a window on a landing of I. M. Pei's long escalator in the Richelieu wing on certain summer afternoons, when the sun bores through the angled glass of the Pyramid and projects dapples of light onto the facade of the Denon wing.

And a surprise in the English and American galleries, when suddenly I spot a landscape by Turner painted in 1845, which squeaked in just before the Louvre's cutoff date for its collection.

And the wide, horseshoe-shaped double ramp built in the Lefuel courtyard by Napoleon III in the mid-nineteenth century, designed so that horses and carriages could enter his vaulted riding hall, where the tops of the columns are decorated with animals that evoke riding and hunting.

And the quiet room in the Flore wing where I can hold in my hands unframed original engravings and drawings and pastels and watercolors by the world's most famous artists.

And the colored brick friezes of bearded marching archers with bows on their backs from the ancient Persian city of Susa that are more beautiful than the friezes in Persepolis.

And the broad, long Daru staircase toward the Nike of Samothrace when there are only a few people around—in the five minutes just after the museum opens in the morning or late in the day just before it closes.

And *The Madonna of Chancellor Rolin*, by Jan van Eyck, painted on a plank of oak in about 1430 and restored to its original brilliance in 2024. Not the painting, which is breathtaking in its vibrant detail, of course, but its reverse side. Van Eyck painted it like a piece of porphyry marble in green, yellow, and black, but with a luminous density that makes it vibrate like a night sky and makes him seem as modern as if he were painting today.

And the pale white marble sculpture of the goddess Diana nude and reclining, her right arm wrapped around the neck of a stag, where the

American expatriate novelist Edith Wharton rendezvoused with Morton Fullerton, her cad of a lover.

And the out-of-the-way Spanish painting galleries where Zurbarán and Murillo and El Greco and Goya wait to be noticed and admired.

And the complex gaze of Ingres's *Grande Odalisque*, the image on the cover of this book. A concubine wearing a turban and a ruby and pearl adornment in her hair, she looks directly at us. Is she sad, defiant, aloof?

And the sweet smell of beeswax on wood floors polished like tabletops. I think about how curators in every department of the Louvre claim to have their own *Mona Lisa* masterpieces with mysteries as deep as her smile. Egyptian antiquities has *The Seated Scribe*; Islamic art has the *Princely Head*; Near Eastern antiquities has the *Code of Hammurabi* stele; Greek antiquities has the pure white marble head of a Cycladic idol that inspired artists from Picasso to Brancusi.

I think of a man who captivates me. He is a square-jawed, dark figure, late fifteenth-century, Sicilian, painted in oils as the *Portrait of a Man* by Antonello da Messina. My Sicilian is also known as *Il Condottiere*, a warlord or a mercenary soldier under contract. The painting was recently restored, its layers of yellow varnish removed and shades of black revealed. You now can see every single hair on his face. And dark circles under his eyes that stare through you with the hard look of the Sicilian south that some of my ancestors had. And the tone and texture of his luminous skin. And the deep dimple in his chin. And the scar above his upper lip that you want to touch; you want to ask him to tell the story behind it. Few visitors stop to look at him, so we're often alone.

Sébastien Allard once said that this painting suggests that Antonello da Messina was "as talented as Leonardo da Vinci." So I call my Sicilian *condottiere* the undiscovered *Mona Lisa*.

He does not have the delicate features of the Venetian north that you see in Titian's *Man with a Glove*, the portrait Dame Judi Dench would take with her to a desert island. Titian's young man is more refined than my *condottiere* and seems like a kinder companion. But my Sicilian was not always called *Il Condottiere*, and perhaps that meant he was not a mercenary. Perhaps his intense look is not one of quiet rage but of deep melancholy. If I had to choose, I'd choose him to keep me company.

These experiences have taken on even greater meaning whenever I

share them. I have found myself walking up to perfect strangers and start-ing conversations. Like the time in front of the Leonardos in the Grande Galerie when I overheard a family from Australia complain about how they were rushed past the *Mona Lisa*. The kids—ages ten, eight, and six—had been on the road with their parents touring Europe for a month and were fed up. I asked what they thought of the *Mona Lisa*.

"Boring," said Alexandra, the ten-year-old.

"Normal," said eight-year-old Ava.

"What if you could see her really up close?" I asked. The guards some-times allow children to cut in front of the public barrier, so I brought the family back into the *Mona Lisa* room. The guards let them through. The mother handed one of the guards her iPhone and he snapped the perfect "I Posed with the *Mona Lisa*" holiday card photo, as perfect as the one taken of Beyoncé and Jay-Z in their music video. The kids giggled and ran off; the parents were thrilled.

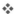

FINALLY, THERE IS THE COUR CARRÉE, the perfectly proportioned court-yard at the east end of the Louvre. To enter it is to enter a moment in time.

The Cour Carrée took on different functions, shapes, and identities throughout its history: space for a royal tennis court; stately homes and gardens; universal exhibitions; lodging and studios for artists; workshops for tradesmen; retail stores for shopkeepers; hidden corners for activities like prostitution and debauchery. Corpses rotted here following the Saint Bartholomew's Day Massacre, which pitted Catholics against Protestants in 1572. In the aftermath of World War II, the Cour Carrée served as a makeshift detention center for captured German soldiers. During the de Gaulle era, André Malraux rescued it from darkness when he ordered its facade scrubbed clean.

In recent years, it has been used as an open-air theater and as a film set. LVMH has built runways here for its ready-to-wear shows. Dozens of cavaliers on horses trotted over its cobblestones for the 2023 film ver-sion of *The Three Musketeers*. Performers from Madame Arthur, the old-est drag cabaret in Paris, sang, danced, and glittered on a stage built for a summer film festival.

LE PALAIS DU LOUVRE.

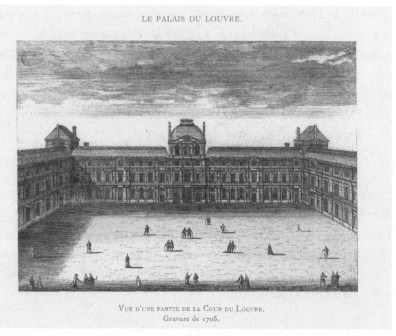

VUE D'UNE PARTIE DE LA COUR DU LOUVRE.
Gravure de 1705.

Engraving of the Cour Carrée, the perfectly proportioned courtyard on the eastern end of the Louvre. Standing on the original stones of the Louvre from its days as a medieval fortress, the courtyard was later renovated by Napoleon Bonaparte.

As night falls, the courtyard becomes the most peaceful place in Paris. A visit has to be carefully planned—just before the gates are about to close. I like to sit on one of the cool stone benches for several minutes so that my eyes can adjust to the darkness. I let them wander over the architectural excesses, like the façade of the Pavillon de l'Horloge, which includes an allegory of history, Moses with the ten commandments, the Egyptian goddess Isis, an Inca emperor, and a king of Rome.

I can peek through the archways on each of its four sides to see the Pyramid to the west all lit up, the church of Saint-Germain l'Auxerrois to the east, the rue de Rivoli to the north, and the Institut de France to the south. The only light comes from beyond the walls, and the few lighted offices of the Louvre and perhaps from the moon. If I am lucky, a cellist or a violinist will be playing under the west arch, where the acoustics are just about perfect.

I don't hear the noise from the streets. I am conscious of my solitude. I look around. I see beauty. I fall in love.

Acknowledgments

I started thinking about the Louvre in the early days of the pandemic when the museum, like most of Paris, was closed. Confined at home by decree except for brief outings to essential destinations like the pharmacy, I sought refuge in my bookshelves. I found a 1913 two-volume set on the paintings of the Louvre that I had once bought from a bookseller along the Seine.

The books were a technical triumph. Each painting was photographed not in black and white, as was the practice at the time, but in radiant color, and printed on high-quality glossy paper glued to heavy stock inserts.

The Louvre was woefully under-visited back then, and the books were intended to attract French readers who knew little about art. "To possess the museum at home, to carry it in your hand, at any hour, at any moment, what a happy stroke of luck!" the book exclaimed.

I plunged in. The pages were speckled with brown mold and smelled faintly of ripe vanilla. But the paintings looked glorious. I was seduced. These books were a century-old version of how to fall in love with the Louvre.

I knew that countless numbers of books and millions of words already had been written about the Louvre: scholarly histories, travel guides, artists' biographies, photo-studded coffee-table books. And I knew that the number of visitors to the Louvre had exploded in recent years. But I had long been struck by how often people described visits to the Louvre as an

obligation rather than a joy. So I decided to approach the museum not as an art expert but as the journalist I have always been. This project would be an adventure of discovery and, hopefully, a means of helping others to enjoy the richness of what the Louvre has to offer.

I had the good fortune to be published twice before by W. W. Norton & Company. Jill Bialosky, my editor and an accomplished author of poetry, fiction, and nonfiction, coincidentally also had the museum in mind. "I'm thinking about the Louvre," she said to me one day. "A fun idea. A very sexy idea." She and the team at Norton—including Meredith McGinnis in marketing, Ingsu Liu in art, and Lauren Abbate and Susan Sanfrey in production, worked together to make the book a success. Laura Mucha, Jill Bialosky's assistant, resolved dozens of issues with patience, determination, and good cheer. Gabby Nugent, in publicity, passionately promoted my love of the Louvre. Janet Byrne, a rigorous copyeditor, cared deeply about my project.

My literary agent, Andrew Wylie, and his deputy, Jeff Posternak, once again were active and faithful partners as they have been for previous books over more than twenty-five years.

I survive the rigors of book writing thanks to my friends. Paul Golob, a master editor with an impressive memory, brought the pursuit of excellence and compassion to our weekly phone conversations. Barbara Ireland, a former *New York Times* editor with a sharp pencil and a quick mind, joined me in Paris and helped me with ideas for shaping and polishing the manuscript as she has done for other books. Joyce Seltzer, a brilliant former senior editor at Harvard University Press and a close friend since graduate school, pushed me to stay positive and think big. Stephen Heyman stepped in urgently at the last minute to help.

Professor Elisabeth Ladenson of Columbia University was both an intellectual guide and a cheerleader, blending her deep knowledge of French literature with a cutting sense of humor. Professor David Bell of Princeton University generously read the manuscript and provided valuable feedback, despite the rigors of his own scholarly research and writing.

Then there was Henri Loyrette, the former director of the Louvre, who became a trusted guide. He taught me not to be afraid of the Louvre, but also to be humble within its walls. He spent hours with me, sharing his wisdom and experiences.

I am blessed to have had the advice and support of other friends and colleagues: Xavier Salomon, Bruno Racine, Gérard Araud, Jean-Claude Ribaut, Christophe Leribault, Jeffries Blackerby, Donna Smith Vinter, Nancy Hunt, Meredith Miller, Stacy Schiff, Jason Farago, Vanessa Friedman, Lauren Collins, Devorah Lauter, Frédéric Martel, Sophie Stuber, Graham Bowley, Corinne Hershkovitch, Venita Datta, Claire Bommelaer, Julia Husson, Guy Savoy, Elizabeth Stribling, Bertrand and Marie-Christine Vannier.

Gary Zuercher generously shared some of his evocative black-and-white photographs of Paris at night, collected in his 2015 book, *The Glow of Paris*. My friend Dee Dee Debartlo helped the Norton team spread the word and organize events, as she has done as a publicist for previous books.

Early on, the Louvre administration was cautious. A "minder" was assigned to arrange and monitor every encounter with museum officials, curators, and employees. Eventually, museum officials loosened up and supported my project, even though they were unaccustomed to dealing with an American journalist with a never-take no-for-an-answer style.

I owe a special thanks to Louvre director Laurence des Cars and the members of her team, including Kim Pham, Matthias Grolier, Luc Bouniol-Laffont, Barthélemy Glama, and Donatien Grau. Des Cars understands and likes the United States so well I sometimes joke that she speaks English better than I do. She told me in an interview on the day she was appointed that she wanted to "throw open the doors and the windows" of the Louvre; she did that for me as well.

Before her arrival, the Louvre press team, then led by Sophie Grange, arranged interviews with Louvre officials, from senior curators to window washers. I appreciate the dedication of her team, which included Nadia Refsi (now at the Musee d'Orsay), Joëlle Cinq-Fraix, Céline Dauvergne, Marion Benaiteau, Coralie James, and Jeanne Scanvic.

Sébastien Allard, the brilliant director of the department of paintings, spent hours with me, walking me through the galleries as he discussed all sorts of subjects—from the choice of color for museum walls to the precision of restorations. I also had the good fortune to interview other Louvre department heads, including Jannic Durand, Cécile Giroire, Sophie Jugie, Yannick Lintz, Vincent Rondot, Xavier Salmon, and Ariane Thomas; they were eager to tour their collections with me.

I owe a special thanks to other Louvre officials. Valerie Coudin, the editor of the Louvre's Grande Galerie magazine, and one of the most knowledgeable people at the Louvre about its history and collections, was kind and patient with my incessant questions. Ludovic Laugier, the curator of ancient Greek collections, led me on adventures of joy with the *Winged Victory of Samothrace* and the *Venus de Milo*. Captain Fabien Hequet, the former head of the Sapeurs Pompiers unit in charge of protecting the Louvre from floods, fires, and terrorists, and Captain Jean-Pierre Huault, who replaced him, took me deep into basement corridors and up to the rooftops.

Other current and former Louvre curators, administrators, and staff who helped me include François Bridey, Philippe Carreau, Charlotte Chastel-Rousseau, Matthieu Decraene, Dominique de Font Reaulx, Anne de Wallens, Denis Fousse, Aline François, Isabelle Glais, Aude Gobet, Emmanuelle Héran, Guillaume Kientz, Françoise Mardrus, Jean-Luc Martinez, Néguine Mathieux, Emmanuelle Polack, Vivien Richard, Hannah-Marie Seidl, Didier Selles, and Daniel Soulié.

On the fringes of the Louvre, Sophie Prieto welcomed me to La Chalcographie du Louvre, where I watched Marius Tessier create engravings. Sophie Lefèvre organized a day-long tour of the C2RMF, the independent institute which conducts scientific studies and restorations of artworks. Claire Pacheco, chief of AGLAE+, the only particle accelerator in the world dedicated exclusively to artistic investigations, explained how the system works.

Doors were opened for me at the Louvre-Lens Museum by director Marie Lavandier and Annabel Ténèze, her successor. In Abu Dhabi, I was welcomed at the Louvre Abu Dhabi by director Manuel Rabaté, Souraya Noujaim, and Latifa Al-Azdi, and hosted by Carol Brandt of New York University Abu Dhabi.

Other thanks go to photographer Ferrante Ferranti; contemporary artists Jean-Michel Othoniel and Pedro Cabrita Reis; art historian Anne Lafont; tour guide Sylvie Cuni; Neil MacGregor, former director of the British Museum; Ian Wardropper, director of the Frick Collection; Monique Wells, cofounder of Entrée to Black Paris; Louis-Antoine Prat, former president, and Sébastien Fumaroli, deputy director, of the Société des Amis du Louvre.

I love working with young people, who bring joy to the workplace.

Charlotte Force, a gifted researcher, photographer, and artist, shared her knowledge of French history and love of adventure, working side by side with me for a year. Martin Muller followed, bringing keen analytical skills and a passion for the pursuit of excellence. Joining the team at various stages were Elsa Dupuy d'Angeac, Lucy Norton, Isabelle Book, Alice McCrum, Lillabeth Brodersen, Ekaterina Tsavalyuk, Josie Smart, Katia Kermaol, Marian Picard, Oliver Riskin-Kuntz, Miranda Christ, Christina Rim, Anne Gorayeb, Elita Farahdel, Tatiana Mezitis, Briana Anthony, and Sébastien Kraft.

I run a sort of informal journalistic boot camp, filling these young people with my stories and life lessons as we work. They revolve in and out of my apartment-office, some for a few days, some for a year or so. Some of them have been sent by Princeton and Wellesley as summer interns, and I am grateful for the support of these two universities over the years.

As always, I thank my family for pushing me to write this book, a project that has taken much longer than those that came before.

My older daughter, Alessandra, a special education teacher who is used to dealing with eight-year-olds, kept me both calm and laughing; my younger daughter, Gabriela, was my visual inspiration once again, snapping photographs and my author photo for yet another book.

Most important was my husband, Andrew Plump. He flew into action when my life was upended by a health crisis and saw me through the aftermath. Pencil in hand, he read and edited the text with lawyerly logic and precision as he has always done. And now it is time for us to celebrate with new adventures in the Louvre.

Location is everything, and when Nike was given her own space atop the Daru staircase, she mesmerized onlookers. She has been copied, imitated, reinterpreted with arms and a head, and made famous around the world. In the 1957 film *Funny Face*, Audrey Hepburn runs down the Daru Staircase, extends her arms and lifts a long, sheer chiffon scarf over her head in imitation of the statue's wingspan. *Getty Images*

Appendix A: Parting Strategies

So the Louvre is huge—very, very huge. Its collection is really, really big.
—**Marielle Vignat,** leading an English-
language tour of the Louvre one day

Over years of trial and error, I have developed personal strategies to make a Louvre visit more enjoyable, for both first-timers and old hands.

A trip to the Louvre is the museum version of a blood sport. You need to be ready for the fight.

It can take forever to get in. In the summer of 2013, shortly after he was named director, Jean-Luc Martinez posed as an ordinary tourist and stood in line at the Pyramid entrance. It took him more than three hours to enter. It's not nearly that bad today, but still not good enough.

I once asked Guillaume Kientz, director of the Hispanic Society Museum & Library in New York and a former Louvre curator, what he would tell New Yorkers en route to Paris who are anxious at the prospect of crowds at the Louvre. "I say it's like taking a plane on the eve of Thanksgiving," he said. "You're stuck in LaGuardia with half of the city and it's horrible. But the day after Thanksgiving, you think about how you ate turkey with your family and friends and you had the greatest time. Often you will forget about the hard time you had to get into the Louvre, because it has this magic of being a great museum that can make a bad experience feel good."

You can avoid the Pyramid by trying the special-entry entrances, but they also get clogged. You can book your tickets early and line up at least fifteen minutes before the museum opens, but that tactic can backfire if too many tour guides do the same thing. Sometimes going at lunchtime or at the end of the day works better. Joining an organized group visit or

hiring a private guide can help avoid the lines. Even with the Louvre's decision in 2023 to slash the number of entry tickets by 30 percent, there may be a wait, and it could be a long one, whatever your strategy.

Come relaxed, not stressed from a ride in an overcrowded Métro or a taxi that has been trapped in central Paris gridlock. And don't count on eating when you get inside. The food stations are crowded, and the food is mediocre. It's best to arrive at the Louvre straight from a café.

My favorite spot is Le Nemours, the restaurant and café, a three-minute walk from the museum on the place Colette. Old-style waiters here wear the classic uniform: a white shirt, black vest, bow tie, and pants, and a long white apron tied in front. They like to be seduced, verbally, with a *"Bonjour, et comment allez-vous?"* before they seat you at a round black café table on a rattan chair, patterned in teal blue and white.

When I am alone, I try to grab the table abutting a column near the entrance. In front of me is the Palais Royal Métro entrance, with its double canopy of colored glass beads, designed by Jean-Michel Othoniel. To the right are the limestone columns of the Comédie-Française, the theater that still performs the plays of Molière.

You never know when a famous actor and screenwriter like Guillaume Gallienne might walk by. (He comes here often.) This is also a hangout for *fonctionnaires* from the Conseil d'État next door, the Ministry of Culture down the street, and—*bien sûr*—shoppers about to attack the tony boutiques on the rue Saint-Honoré. Parisians at the table next to you might just be sipping champagne for no other reason than this is Paris.

Toward the end of the film *Conversations with My Gardener*, a famous Parisian painter shares a drink here with his gardener before taking him to visit the Louvre for the first time. In *The Tourist*, Angelina Jolie, playing a British spy, sits alone at Le Nemours while French police keep a lookout nearby. And in the film *Clair de Femme*, Yves Montand and Romy Schneider meet accidentally and then sit together in a Paris café. A bit later, he's in her bed. The scene wasn't filmed in Le Nemours, but it's that kind of place.

No one at Le Nemours would mind if you ordered just one *chocolat chaud* and sat there for five hours. But hot chocolate is not your goal. So fortify yourself with a traditional, correctly toasted croque monsieur and head to the Louvre.

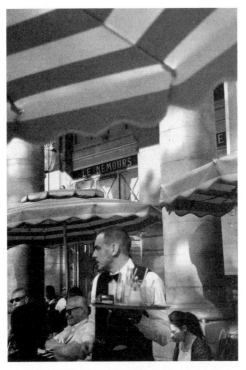

Le Nemours, on the place Colette, near the Louvre. Sit at an outdoor table; in front of you is the Palais Royal Métro entrance, with its double canopy of huge colored glass beads, designed by Jean-Michel Othoniel. *Gabriela Sciolino Plump*

Once inside, you head down escalators into an open space of chaos and noise with the feel of an airport terminal. You hear the crowd before you see it. The signs warning visitors to look out for pickpockets are unnerving but necessary. If it's a sunny day, it gets hot; sunlight bounces off the pale stone floors and blinds you. Your visit hasn't even started, but you already feel disoriented.

Even though the museum is wheelchair accessible (it works; I've tried it), there is a shortage of elevators, directional signage, and places to sit. The deficiency continues right up until your departure. You may have a hard time finding the signs with the image of the Pyramid that point to the *sortie*—the exit. Those signs lead you into the plaza under the Pyramid, and if you're not careful, you'll end up trapped among the dozens of boutiques in the private underground Carrousel shopping mall.

❖

MOST OF THE EXPLANATORY LABELS near each work of art are brief and only in French. The official fold-out map, showing locations of the exhibits, seems designed to confuse.

The Nintendo 3DS audio tour looks promising at first, with a choice of audio files for slightly more than 100 artworks. The problem comes with the technology. The touch screen is so sensitive that you can get lost on the interactive map. "People complain that it's too complicated and that the volume doesn't work," said one agent. "The worst part is that we haven't been trained to help, so when they come to us we're lost ourselves."

But don't let the Louvre's imperfect welcome discourage you. You're here to see great art. You've paid admission to get in, and the temptation is to want to get your money's worth. Ninety minutes to two hours is what most people can manage in one go. If you try to stay longer without a break, your feet will hurt, your back pain will get worse, and you forget much of what you saw. Travel light, with a small backpack or the smallest handbag possible; leave the guidebook, the sketchbook, and the water bottle home. Wear sturdy shoes. *Condé Nast Traveler* recommends Dansko XP clogs in the Louvre, but on the slippery stone and marble stairs, I would stick with hiking boots or your most structured running shoes. To minimize distractions, avoid Mondays. It's the worst day to go, because the Musée d'Orsay is closed, increasing demand at the Louvre. Wednesday is the worst afternoon, because French children have no school, freeing throngs of families for museumgoing.

The Louvre also closes certain rooms every day (cleaning, renovations, lack of security staff) and announces the closures on its website. If you are determined to see certain artworks, reading up in advance offers some help. There are thousands of guidebooks. My favorite is an oversized, 107-page softcover official guide with excellent color images, *Masterpieces of the Louvre*. It comes in several languages and is only 8 euros.

As much as I prefer wandering, I can give a basic Louvre pilgrims' tour—the biggies and more—in two hours. I take guests up the escalator to the Sully wing through the vestibule whose walls are decorated with four friezes, and then into a long tunnel to see the vestiges of a centuries-old wall.

Then we mount a staircase on the right, and then another, still to our right, and enter the Renaissance Louvre in a room with the four

Cariatides and ancient Roman statues. Through the windows, we view the Pyramid on the right and the Cour Carrée on the left and continue straight to the *Venus de Milo*, in the room next door.

We take a breath here. Then comes a right turn through the juncture of the Greek, Roman, and Etruscan collections, with a quick look at the baroque ceiling, and up the stairs to the *Victory of Samothrace*. We have now reached the Denon wing and find ourselves at the museum's busiest crossroad. First, we revel in the beauty of the goddess of victory. Then we proceed to the left into the razzle-dazzle gold-gilt Apollo Gallery with the crown jewels. After we've been blinded by France's royal heritage—or what's left of it—we U-turn and return to Nike.

This time we take a right, pausing as we encounter Botticelli's *Venus*. (There are quiet places to sit near the windows that look out to the floor below.) Then through the Salon Carré, with its thirteenth-to-fifteenth-century Italian paintings, and more famous and later Italian paintings in the Grande Galerie, which is not a gallery but a long corridor. We don't miss the four Leonardos! Walking the length of the Grande Galerie, we then follow the crowd to a room that leads to the Salle des États to see *Mona Lisa*. I tell my guests *not* to waste twenty minutes waiting in line unless they are determined to take a selfie with her, but to look at her from the side. Then I insist we take in the other great paintings in the room, starting with Veronese's *The Wedding Feast at Cana*, 150 times bigger than the *Mona Lisa*. And we don't leave without spending time with Titian's *Man with a Glove*. On the other side of the partition where the *Mona Lisa* hangs are three other Titians. Hardly anyone looks at them, but we do!

When we leave the Salle des États through the *Mona Lisa* gift shop, we turn to the Red Room filled with the best of neoclassical art, from David's *The Coronation of Napoleon* to Ingres's *Grande Odalisque*, one of the most beautiful women in the Louvre. Then we go back to the other gallery next to the Salon Denon, to see what romanticism did best in Géricault's *The Raft of the Medusa* and Delacroix's *Liberty Leading the People* and *Women of Algiers in Their Apartment*. After this we'll find ourselves at the Escalier Mollien, which we walk down to witness how Michelangelo captured in marble the beauty of his two *Slaves*. *Et voilà*, we've seen some of the best the Louvre has to offer.

If, after this tour, my guests have the energy to go on, we go back to

the Pyramid's entrance hall and up another set of escalators to the Richelieu wing. It is never crowded and makes a pretty terrific tour on its own. We start with the two skylit courtyards, the Puget and the Marly, with their marble sculptures. Then up the stairs of the Cour Puget into ancient Mesopotamia and Persia, to the Cour Khorsabad and the *Code of Hammurabi* stele, followed by the glazed friezes from Susa.

We cap the visit with a glass of champagne or perhaps a *Mona Lisa* mocktail of grapefruit juice, celery syrup, lime, and soda water on the Café Marly terrace overlooking the Pyramid and the Cour Napoléon.

Now for my dirty little secret about how to conquer the Louvre stress-free. Join the Société des Amis du Louvre online or in person and receive the magical card that gives you instant free access anytime the museum is open. It is the best cultural deal in Paris.

While entry is free for many, in January 2024 the Louvre raised the price of a ticket from 17 to 22 euros. If you plan to visit multiple times over the course of a year, splurge and become a friend of the Louvre. For the price of dinner with wine at a reputable bistro, you can buy an 80-euro annual membership (120 for two). You can apply in advance online, with a photo; the card will be mailed to you. Or apply in person at the Amis du Louvre office inside the Louvre. Membership includes a quarterly magazine (in French) and a picture-ID card that lets you skip the line. You just wave the card in a special entrance in the Cour Richelieu as if you are a VIP. You get in for free whenever you want and stay for as long as you want. Beware: the Amis du Louvre is not connected to the American Friends of the Louvre, a U.S.-based fundraising organization whose cheapest annual membership is $1,000 for two.

Launch an *opération séduction* on the staff. "If you're a normal person, you might feel aggressive and frustrated," said Kientz. "Instead, be extremely nice to all the employees—say *bonjour* to all the security guards. They could use appreciation from the visitors, because they are the ones no one looks at except to complain. If you treat a French person with kindness, all the doors will open for you, because the French are not used to that."

When it all feels overwhelming, head to a quiet place: the lower floor of Islamic Arts, perhaps, or the rooms with the Poussin paintings, or a marble bench in the Marly sculpture courtyard. Just say to yourself over and over, "I am in Paris. I am in the Louvre."

Appendix B: A Selection of Artists and Works

Following is a list of most of the artworks mentioned in the text and their location in the museum. Artworks are listed in the order in which they appear for the first time in the text, with the artist's last name first (or "Anonymous"). A long dash signifies successive works by the same artist. Formal titles of the works are used here; in the text, titles are sometimes shortened or works are described rather than named.

INTRODUCTION: FALLING FOR THE LOUVRE
Leonardo da Vinci, *Portrait of Lisa Gherardini, Wife of Francesco del Giocondo*, known as *Mona Lisa*, also *La Joconde*, 1503–1519. Room 711 (Salle des États), Denon wing, pp. 3, 4, 10, 11, 23, 28, 29–41, 42, 43, 44, 48–51, 52, 53, 61, 62, 64, 65, 66, 73, 86, 90, 94, 101–3, 111, 112, 114, 123, 141, 155, 164, 183, 188, 200, 218, 221, 225, 247, 255, 256, 257, 264, 266–67, 276, 281–82, 291, 300, 301, 314, 315, 327, 328.
Titian, *Man with a Glove*, 1500–1525. Room 711, Denon wing, pp. 3, 33, 42, 49–50, 314, 327.
Tintoretto, *Self-Portrait*, c. 1588. Room 711, Denon wing, p. 3.
Anonymous, *Winged Victory of Samothrace*, also known as Nike, 200–175 BC. Daru staircase, Denon wing, pp. 4, 8, 9, 10, 52, 54, 62, 64, 75, 112, 114, 123, 223, 257, 258, 278, 299, 313, 320, 327.

CHAPTER 1: BEAUTY AND THE FEATHER
Anonymous, *Venus de Milo*, 150–125 BC. Room 345, Sully wing, pp. 11, 52, 53–59, 120, 123, 188, 195, 201, 257, 259, 264, 301, 320, 327.

CHAPTER 2: THE PEOPLE'S PALACE
Anonymous, *Gabrielle d'Estrées and Her Sister*, c. 1594. Room 824, Richelieu wing, pp. 20, 242–43.
Veronese, Paolo, *The Wedding Feast at Cana*, 1500–1600. Room 711, Denon wing, pp. 26, 33, 112, 146, 153, 159, 214, 327.

CHAPTER 4: THE PAINTINGS MAGICIAN
Vermeer, Johannes, *The Lacemaker*, 1669–1670. Room 837, Richelieu wing, pp. 44–45, 173.
———. *The Astronomer*, 1668. Room 837, Richelieu wing, pp. 44, 287.
Rembrandt, *Bathsheba at Her Bath*, 1654. Room 844, Richelieu wing, pp. 45–46, 173.
Pisanello, *Portrait of a Princess*, 1425–1450. Room 709, Denon wing, p. 47.
David, Jacques-Louis, *Portrait of Juliette Récamier, née Bernard*, 1800. Room 702, Denon wing, pp. 47–48.

CHAPTER 5: A GODDESS WITH NO ARMS

Anonymous, *Aphrodite of Knidos*, AD 100–200. Room 344, Sully wing, p. 57.

Anonymous, *Pallas of Velletri*, AD 1–100. Room 344, Sully wing, p. 57.

Delacroix, Eugène, *Liberty Leading the People*, 1830. Room 700, Denon wing, pp. 58, 92, 99, 307, 327.

CHAPTER 6: A TOUR GUIDE NAMED BEYONCÉ

David, Jacques-Louis, *The Coronation of Napoleon*, 1806–1807. Room 702, Denon wing, pp. 64, 264, 327.

Géricault, Théodore, *The Raft of the Medusa*, 1818–1819. Room 700, Denon wing, pp. 64, 217, 218, 279, 309, 327.

Benoist, Marie-Guillemine, *Portrait of a Black Woman*, also known as *Portrait of Madeleine*, 1800. Room 935, Sully wing, pp. 64, 216–17.

Anonymous, *The Great Sphinx of Tanis*, 2620–1866 BC. Room 338, Sully wing, pp. 66, 209.

CHAPTER 7: THE CENTER OF THE UNIVERSE

Anonymous, *Diana of Versailles*, AD 125–150. Room 348, Sully wing, p. 72.

Pigalle, Jean-Baptiste, *Mercury Tying His Sandals*, 1753. Room 105, Richelieu wing, p. 75.

Vries, Adriaen de, *Mercury Abducting Psyche*, 1593. Room 403, Denon wing, p. 75.

Anonymous, *Diana Reclining on a Stag*, also *Diana of Anet* and *Fountain of Diana*, 1540–1560. Room 214, Richelieu wing, pp. 75, 207, 313–14.

CHAPTER 8: THE OPEN-AIR MUSEUM

Penone, Giuseppe, *The Vowel Tree*, 1999–2000. Tuileries Garden, pp. 84–85.

Bourgeois, Louise, *The Welcoming Hands*, 1996. Tuileries Garden, p. 85.

Leonardo da Vinci, *The Virgin and Child with Saint Anne*, 1503–1519. Room 710, Denon wing, pp. 86, 276.

Michelangelo, *Rebellious Slave*, 1513–1515. Room 403, Denon wing, pp. 86, 240, 264, 327.

CHAPTER 9: A STRANGE CONSTRUCTION

Anonymous, *The Seated Scribe*, 2620–2500 BC. Room 635, Sully wing, pp. 95, 209, 265, 314

CHAPTER 10: LE LOUVRE *LA NUIT*

Leonardo da Vinci, *The Virgin of the Rocks*, 1483–1494. Room 710, Denon wing, pp. 107, 240, 251.

David, Jacques-Louis, *The Oath of the Horatii*, 1784. Room 702, Denon wing, p. 107.

Anonymous, *Black Stone Sculpture of Sobekhotep IV*, 1786–1650 BC. Room 636, Sully wing, p. 108.

Anonymous, male mummy; cartonnage set, 332–330 BC. Room 322, Sully wing, p. 108.

CHAPTER 11: IS THE LOUVRE BURNING?

Robert, Hubert, *Imaginary View of the Grande Galerie of the Louvre in Ruins*, 1796. Room 932, Sully wing, p. 115.

Jacob-Desmalter, François-Honoré-Georges, et al., throne of Napoleon I, 1804. Room 552, Richelieu wing, p. 120.

Maréchal, Charles-Raphaël, *Glory and Truth Crowning the Works of Genius*; *Allegory with Napoleon III and the Empress Eugénie*. Room 544, Richelieu wing, p. 121.

Le Moiturier, Antoine, *Tomb of Philippe Pot*, 1475–1500. Room 210, Richelieu wing, pp. 122–23.

CHAPTER 12: UP CLOSE

Maillol, Aristide, *Nuit*, 1909. Jardin du Carrousel, p. 129.

Cabanel, Alexandre, *Triumph of Flora*, 1873. Ceiling of the Consultation Room for prints and drawings, Flore wing, pp. 130, 134.

Leonardo da Vinci, *Portrait of Isabella d'Este*, 1499–1500. Consultation Room for prints and drawings, Flore wing, p. 131.

Delacroix, Eugène, *A Courtyard in Tangier*, date unknown. Consultation Room for prints and drawings, Flore wing, p. 131.

———. *Justinian Drafting His Laws*, 1826. Consultation Room for prints and drawings, Flore wing, p. 132.

———. *Faust and Wagner*, c. 1827. Consultation Room for prints and drawings, Flore wing, p. 132.

———. *Six Nude Women*, c. 1820–1830. Consultation Room for prints and drawings, Flore wing, p. 132.

Cabanel, Alexandre, *Study of Triumph of Flora*, 1869–1873. Consultation Room for prints and drawings, Flore wing, p. 134.

CHAPTER 13: WHATEVER HAPPENED TO THE CROWN JEWELS?

Delacroix, Eugène, *Apollo Slays the Python*, 1850–1851. Room 705, Denon wing, p. 138.

Duflos, Augustin, Laurent Rondé, and Claude Rondé, personal crown of Louis XV, 1722. Room 705, Denon wing, pp. 139, 140.

Cope, Joseph, Regent diamond, 1704–1706. Room 705, Denon wing, p. 140.

Jacquemin, Alexis, and Jacques Guay, Côte de Bretagne spinel, date unknown. Room 705, Denon wing, p. 140.

Anonymous, pink Hortensia diamond, date unknown. Room 705, Denon wing, p. 140.

Bapst, Paul-Alfred, reliquary brooch, 1855. Room 705, Denon wing, p. 140.

Kramer, François, diamond bow brooch for the Empress Eugénie, 1855. Room 705, Denon wing, p. 143.

Lemonnier, Alexandre-Gabriel, diadem belonging to the Empress Eugénie, 1853. Room 705, Denon wing, p. 143.

Bapst, Christophe-Frédéric, and Jacques-Évrard Bapst, diadem belonging to the Duchess of Angoulême, 1819–1820. Room 705, Denon wing, p. 143.

Bapst, Christophe-Frédéric, and Paul-Nicolas Menière, pair of ruby bracelets for the Duchess of Angoulême, 1816. Room 705, Denon wing, p. 143.

CHAPTER 14: "LA BRIOCHE EST BRÛLÉE!"

Anonymous, *Code of Hammurabi* stele, 1792–1750 BC. Room 227, Richelieu wing, pp. 147–49, 264, 269, 314, 328.

Anonymous, kitchen mold, 1782–1759 BC. Room 227, Richelieu wing, p. 147.

Anonymous, stele of Nefertiabet, 2590–2533 BC. Room 635, Sully wing, p. 149.

Anonymous, banquet preparations mosaic, 180–190. Room 660, Sully Wing, p. 149.

Anonymous, round cup in blood jasper, 1600–1650. Room 705, Denon wing, p. 150.

Anonymous, spoon and fork of rock crystal and gilded silver mounted with rubies, 1530–1580. Room 527, Richelieu wing, p. 150.

Charpenat, Jean-Pierre, François Joubert, Jean-Charles Lethien, and Jean-Philippe Palma, Marie Antoinette's travel kit, 1788. Room 627, Sully wing, p. 150.

Anonymous, platter with vegetal design and inscription, 1585–1615. Room 185, Denon wing, p. 150.

Anonymous, pitcher with epigraphic design, 700–900. Room 185, Denon wing, p. 150.

Chardin, Jean-Baptiste-Siméon, *Basket of Strawberries*, 1761. Location TBD, p. 152.

Snyders, Frans, *Fish Merchants and Their Stall*, 1600–1625. Lefuel staircase, second floor, Richelieu wing, p. 152.

Delacroix, Eugène, *Women of Algiers in Their Apartment*, 1834. Room 700, Denon wing, pp. 153, 215, 327.

Chardin, Jean-Baptiste-Siméon, *The Brioche*, 1763. Room 928, Sully wing, pp. 154–55, 157.

Delacroix, Eugène, *Still Life with Lobster*, 1826–1827. Room 950, Sully wing, p. 156.

Chardin, Jean-Baptiste-Siméon, *The Ray*, 1728. Room 919, Sully wing, p. 156.

CHAPTER 15: THE ARTIST'S MENAGERIE

Titian, *The Madonna of the Rabbit*, 1500–1600. Room 711, Denon wing, p. 161.

Massys, Jan, *David and Bathsheba*, 1562. Room 811, Richelieu wing, p. 161.

Rubens, Peter Paul, *The Coronation of the Queen at the Abbey of Saint-Denis, May 13, 1610*, 1600–1625. Room 801 (Galerie Médicis), Richelieu wing, p. 161.

La Hyre, Laurent de, *The Dead Adonis Mourned by His Dog*, 1628–1630. Room 828, Richelieu wing, p. 161.

Anonymous, dog pendant, 3800–3100 BC. Room 232, Richelieu wing, p. 161.

Rouillard, Pierre Louis, bronze statue of dog and pups, c. 1849. Lefuel courtyard, p. 162.

Le Brun, Charles, *Infant Jesus Sleeping*, known as *Silence*, 1655. Room 911, Sully wing, p. 163.

De Vos, Paul. *Earthly Paradise*, c. 1650. Room 800, Richelieu wing, p. 163.

Boilly, Louis Léopold, *Portrait of Gabrielle Arnault as a Child*, 1803. Room 938, Sully wing, p. 163.

Géricault, Théodore, *The Dead Cat*, 1800–1900. Room 941, Sully wing, p. 163.

Anonymous, caracal perfume burner, 1100–1200. Room 185, Denon wing, p. 163.

Anonymous, *The Cat Goddess Bastet*, 664–610 BC. Room 643, Sully wing, p. 163.

Anonymous, cat mummy, 664–332 BC. Room 322, Sully wing, p. 163.

CHAPTER 16: HIDDEN CORNERS

Degas, Edgar, *Leaving the Bath*, 1880. Room 903, Sully wing, pp. 167–68, 169.

Anonymous, *The Beheading of Saint Catherine of Alexandria*, 1475–1500. Room 903, Sully wing, p. 168.

Lindon, Alfred, *Still Life*, 1900–1950. Room 903, Sully wing, p. 168.

Baschet, Marcel, *Portrait of Victor Lyon*, 1901–1931. Room 903, Sully wing, p. 168.

Anonymous, Yup'ik fish mask sculpture from Alaska, early twentieth century. Sessions Pavilion, Denon wing, p. 169.

Anonymous, Hawaiian sculpture, figure of the god Kuka'ilimoku, eighteenth century. Sessions Pavilion, Denon wing, p. 169.

Anonymous, sculpture of a couple having sex from the island of Makira, seventeenth century. Sessions Pavilion, Denon wing, p. 169.

Anonymous, Nok sculpture, 500 BC–AD 500. Sessions Pavilion, Denon wing, p. 169.

Anonymous, Easter Island sculpture, 1000–1400. Sessions Pavilion, Denon wing, p. 169.

Anonymous, giant elephant tusk from fifteenth- to sixteenth-century Sierra Leone, Sessions Pavilion, Denon wing, p. 171.

Gilded frames, sixteenth century. Room 904, Sully wing, pp. 171–72.

CHAPTER 17: THE ORPHANS OF WORLD WAR II

Vigée Le Brun, Élisabeth Louise, *Portrait of a Young Girl*, 1777–1825. Room 805, Richelieu wing, p. 175.

Delacroix, Eugène, *The Farrier*, 1853. Room 804, Richelieu wing, p. 175.

Fabritius, Barent, *Man Reading*, 1644. Room 805, Richelieu wing, p. 178.

Van Velsen, Jacob, *The Fortune Teller*, 1631. Room 804 or 805 (currently on loan), p. 178.

School of Nicola Bertuzzi, *Feast of Balthasar*, 1750–1775. Room 805, Richelieu wing, p. 178.

Pajou, Jacques-Augustin, *Mesdemoiselles Duval*, 1814. Room 804, Richelieu wing, p. 178.

Knupfer, Nicolaus, *Apparition of Saint Cecilia to a Couple*, 1655. Room 805, Richelieu wing, p. 178.

Géricault, Théodore, *Head of a Lioness*, c. 1819. Room 941, Sully wing, pp. 174, 179.

Boucher, François, *The Forest*, 1740. Room 927, Sully wing, p. 179.

Chardin, Jean-Baptiste-Siméon, *Copper Pot, Skimmer, Jug, and Slice of Salmon*, 1750–1760. Room 928, Sully wing, p. 179.

Boucher, François, *Woman and Children*, 1700–1800. Room 804, Richelieu wing, p. 179.

Cranach, Lucas, the Elder, *Saint Peter*, 1500–1550. Room 809, Richelieu wing, p. 180.

———. *Saint Paul*, 1500–1550. Room 809, Richelieu wing, p. 180.

Gérard, Marguerite, *The Bad News*, 1804. On loan, p. 180.

Van Schooten, Floris, *Still Life with Ham*, 1626. Room 831, Richelieu wing, p. 183.

Binoit, Peter, *Dish, Fruits and Glass on a Table*, 1600–1625. Room 831, Richelieu wing, p. 183.

CHAPTER 18: YOU BELONG TO ME

Painter of Suessela, Italy, Milo amphora, 410–400 BC. Room 347, Denon wing, p. 187.

Phidias, Panathenaic frieze, 445–438 BC. Room 347, Denon wing, pp. 186, 187, 190.

Anonymous, *Centaur Abducting a Woman* metope from the Parthenon, 447–440 BC. Room 347, Denon wing, pp. 188, 190.

Phidias, Parthenon fragment of beardless cavalier, 445–438 BC. Room 347, Denon wing, p. 188.

———. Parthenon fragment of woman evoking Iris, 442–432 BC. Room 347, Denon wing, p. 188.

Fauvel, Louis-François-Sébastien, plaster cast of processional frieze, Room 347, Denon wing, p. 190.

Anonymous ("Berlin painter"), amphora, 500–490 BC. Room 652, Sully wing, p. 191.

Ixion painter, krater of suitors, c. 330 BC. Room 659, Sully wing, p. 191.

Anonymous, marbles from the Temple of Zeus at Olympia, 470–450 BC. Room 407, Denon wing, pp. 191, 192.

Anonymous, *Las Incantadas*, 150–230 AD. Not on display, p. 191.

CHAPTER 19: WHERE ARE THE WOMEN?

Fragonard, Jean-Honoré, *The Bolt*, 1777–1778. Room 929, Sully wing, pp. 194, 196–98.

Boucher, François, *The Rape of Europa*, 1747. Room 927, Sully wing, p. 198.

Marqueste, Laurent Honoré, *The Centaur Nessus Abducting Deianira*, 1892. Tuileries Garden, p. 198.

Rubens, Peter Paul, *Henry IV Receives the Portrait of Marie de Médicis and Is Disarmed by Love*, 1600–1625. Room 801 (Galerie Médicis), Richelieu wing, p. 199.

——. *The Instruction of the Queen*, 1600–1625. Room 801 (Galerie Médicis), Richelieu wing, p. 200.

——. *The Queen's Arrival to Lyon*, 1600–1625. Room 801 (Galerie Médicis), Richelieu wing, p. 200.

——. *The Birth of Dauphin (Louis XIII) at Fontainebleau, September 27, 1601*, 1600–1625. Room 801 (Galerie Médicis), Richelieu wing, p. 200.

——. *The Capture of Juliers*, 1600–1625. Room 801 (Galerie Médicis), Richelieu wing, p. 200.

Hals, Frans, *The Bohemian Girl*, c. 1626. Room 846, Richelieu wing, p. 200.

Boucher, François, *The Brunette Odalisque*, 1745. Room 921, Sully wing, p. 201.

Vallayer-Coster, Anne, *Still-Life with Tuft of Marine Plants, Shells and Corals*, 1769. Room 933, Sully wing, p. 204.

Leyster, Judith, *Carousing Couple*, 1630. Room 846, Richelieu wing, p. 204.

Bertaux, Hélène, *The Navigation*, 1825–1909. Marsan Pavilion, p. 205.

——. *The Legislation*, 1825–1909. Marsan Pavilion, p. 205.

Collot, Marie-Anne, *Bust of an Unidentified Man*, 1765. Room 221, Richelieu wing, p. 205.

Fauveau, Félicie de, *Saint Reparata*, 1855. Room 226, Richelieu wing, p. 205.

Anonymous, Greek amphora featuring Hercules fighting Amazons, 530–520 BC. Room 659, Sully wing, p. 206.

Anonymous, Roman mosaic featuring Amazon warrior, 350–400. Room 186, Denon wing, p. 206.

Deruet, Claude, *The Departure of the Amazons*, 1600–1700. On loan, p. 206.

Anonymous, Mesopotamian figurine, 247 BC–224. Room 230, Richelieu wing, p. 206.

CHAPTER 20: PHARAOHS, KINGS, SLAVES, SERVANTS

Anonymous, *Taharqa and Hemen*, 690–664 BC. Room 643, Sully wing, pp. 210, 212.

Anonymous, soapstone statuette of Queen Tiye and Amenhotep III, 1390–1352 BC. Room 637, Sully wing, p. 212.

Skythés, aryballos, 520–510 BC. Room 652, Sully wing, pp. 208, 213.

Anonymous, alabaster vase featuring an Ethiopian warrior, 480–470 BC. Room 652, Sully wing, p. 213.

Anonymous, two powdered sugar shakers in the figures of men, 1725–1727. Room 605, Sully Wing, p. 213.

Apt, Ulrich, the Elder, *The Adoration of the Magi*, 1500–1525. On loan, pp. 213–14.

Rubens, Peter Paul, *The Adoration of the Magi*, 1617–1618. On loan, p. 214.

Lagrenée, Louis-Jean-François, *Death of the Wife of Darius*, 1785. Room 934, Sully wing, p. 214.

Carpaccio, Vittore, *The Sermon of Saint Stephen*, 1500–1525. Room 710, Denon wing, p. 214.

Gellée, Claude (aka Claude Lorrain), *Ulysses Returning Chryseis to Her Father*, c. 1644. Room 826, Richelieu wing, pp. 214–15.

Ingres, Jean-Auguste-Dominique, *The Turkish Bath*, 1862. Room 940, Sully wing, p. 215.

Caron, Antoine, *Sibylle of Tibur*, 1575–1580. Room 823, Richelieu wing, pp. 215–16.

Le Nain, Louis, and Antoine Le Nain, *La Tabagie*, 1643. Room 912, Sully wing, p. 216.

Lethière, Guillaume, *The Death of Virginie*, 1828. Room 701, Denon wing, p. 218.

——. *Brutus Condemning His Sons to Death*, 1811. Room 701, Denon wing, p. 218.

CHAPTER 21: AN ISLAM OF ENLIGHTENMENT
Anonymous, Iznik tile mosaic from Piyale Pasha mosque, c. 1570–1573. Room 186, Denon wing, pp. 223–24.
Anonymous, Mamluk Porch, 1400–1500. Room 186, Denon wing, p. 224.
Anonymous, *Princely Head*, 1185–1215. Room 185, Denon wing, pp. 220, 225, 314.
Anonymous, Carved ivory cylindrical box of al-Mughira, 968. Room 185, Denon wing, p. 225.
Anonymous, rock crystal pitcher from Saint-Denis treasure, 985–1100. Room 185, Denon wing, p. 225.
Zayn, Muhammad ibn al-, *Baptistery of Saint Louis*, 1325–1340. Room 186, Denon wing, pp. 227–28.

CHAPTER 22: PERSIA COMES TO PARIS
Anonymous, statue of Narundi, 2120–2100 BC. Room 231, Richelieu wing, p. 232.
Anonymous, winged ibex vase handle, 539–333 BC. Room 307, Richelieu wing, pp. 230, 234.
Anonymous, limestone column with kneeling bulls, 522–486 BC. Room 307, Sully wing, p. 234.
Anonymous, Susa frieze featuring archers; Susa frieze featuring lions; Susa frieze featuring griffins; Susa panel featuring winged bulls, 522–486 BC. Room 307, Sully wing, pp. 234, 313.

CHAPTER 23: THE QUEER UNIVERSE
Anonymous, Susa hermaphrodite, 333–324 BC. Room 310, Sully wing, pp. 237–38.
Anonymous, Sumeria hermaphrodite, 305–225 BC. Room 310, Sully wing, pp. 236, 237–38.
Anonymous, *Sleeping Hermaphrodite*, AD 100–150. Room 348, Sully wing, pp. 237, 238, 242.
Briseis painter, man and young boy on Athenian vase, 480 BC. Room 653, Sully wing, p. 239.
Anonymous, *Antinous Mondragone*, 130–138. Room 405, Denon wing, pp. 239, 251.
Cades, Giuseppe, *Achilles Playing the Lyre with Patrocles in His Tent, Surprised by Ulysses and Nestor*, 1700–1800. Room 718, Denon wing, p. 239.
Anonymous, *The God Amon and Ramses II Kissing*, 1279–1213 BC. Room 324, Sully wing, p. 239.
Qasim, Muhammad, *Portrait of Shah Abbas I and His Page*, 1627. Not on display, p. 239.
Leonardo da Vinci, *Saint John the Baptist*, 1508–1519. Room 710, Denon wing, pp. 240, 287.
Michelangelo, *Dying Slave*, 1513–1515. Room 403, Denon wing, pp. 240, 262, 264, 327.
Puget, Pierre, *Milon of Crotone*, 1672–1682. Room 105, Richelieu wing, p. 241.
Bouchardon, Edmé, *Sleeping Faun*, 1726–1730. Room 105, Richelieu wing, p. 241.
Mantegna, Andrea, *Saint Sebastian*, 1475–1500. Room 710, Denon wing, p. 242.
Perugino, Pietro, *Saint Sebastian*, 1475–1500. Room 710, Denon wing, p. 242.
Girodet de Roucy-Trioson, Anne-Louis, *The Sleep of Endymion*, 1791. Room 702, Denon wing, p. 242.
David, Jacques-Louis, *Leonidas at Thermopylae*, 1814. Room 702, Denon wing, p. 242.

CHAPTER 24: CELEBRATING THE CONTEMPORARY
Othoniel, Jean-Michel, *The Rose of the Louvre*, 2019. Room 105, Richelieu wing, pp. 244, 246–47, 251.
Braque, Georges, *The Birds*, 1953. Room 662, Sully wing, p. 248.

Twombly, Cy, *The Ceiling*, 2010. Room 663, Sully wing, p. 249.

Kiefer, Anselm, *Athanor*, 2007. North Palier staircase, Sully wing, p. 249.

Rubens, Peter Paul, *The Queen's Wedding Ceremonies*, 1600–1625. Room 801 (Galerie Médicis), Richelieu wing, pp. 250–51.

Dürer, Albrecht, *Portrait of the Artist Holding a Thistle*, 1493. Room 101, Richelieu wing, p. 251.

Van Utrecht Claesz, Jacob, *Portrait of a Young Woman from Lübeck Holding a Carnation*, c. 1525. Room 809, Richelieu wing, p. 251.

Master of the view of Saint Gudule, *Pastoral Instruction*, 1400–1500. Room 818, Richelieu wing, p. 251.

Memling, Hans, *The Rest During the Flight into Egypt*, 1562. Room 818, Richelieu wing, p. 251.

Greuze, Jean-Baptiste, *The Broken Pitcher*, 1771–1772. Room 932, Sully wing, p. 251.

CHAPTER 25: EXIT THROUGH THE GIFT SHOP

Arcimboldo, Giuseppe, *Autumn*, 1573. Room 712, Denon wing, p. 257.

CHAPTER 26: TUESDAYS AT THE LOUVRE

Houdon, Jean-Antoine, *Benjamin Franklin (1706–1790), Scholar and Minister*, 1778. Room 222, Richelieu wing, p. 270.

CHAPTER 28: WHEN MONEY IS NO OBJECT

Leonardo da Vinci, *La Belle Ferronnière*, 1490–1497. Room 710, Denon wing, p. 287.

Titian, *François I (1494–1547), King of France, Profile*, 1538. Room 711, Denon wing, p. 287.

CHAPTER 29: CREATING AN IDENTITY

Poussin, Nicolas, *Landscape with Diogenes*, 1654–1658. Room 825, Richelieu wing, p. 305.

————. *L'Été*, 1660–1664. Room 825, Richelieu wing, p. 305.

Erhart, Gregor, *Saint Mary Magdalene*, 1515–1520. Room 169, Denon wing, p. 307.

CHAPTER 30: BLUE IN THE BUSHES

Turner, Joseph Mallord William, *Landscape with a River and a Bay in the Distance*, c. 1845. Room 713, Denon wing, p. 313.

Van Eyck, Jan, *The Madonna of Chancellor Rolin*, c. 1430. Room 600, Sully wing, p. 313.

Ingres, Jean-Auguste-Dominque, *Odalisque*, also *La Grande Odalisque*, 1814. Room 702, Denon wing, pp. 314, 327.

Anonymous, head of Cycladic idol, c. 2600–2400 BC. Room 170, Denon wing, p. 314.

Antonello da Messina, *Portrait of a Man*, also *Il Condottiere*, 1475. Room 710, Denon wing, p. 314.

Moitte, Jean-Guillaume, *Law, Numa, Manco Cápac, Moses and a pharaoh*, 1806–1807. Cour Carrée, Sully wing, p. 316.

APPENDIX A: PARTING STRATEGIES

Botticelli, Sandro, *Venus and the Three Graces Presenting Gifts to a Young Woman*, 1475–1500. Room 706, Denon wing, p. 327.

Chronology

1190: The medieval king Philippe Auguste, who reigned for forty-three years, orders the construction of a garrisoned fortress and a wall encircling Paris before setting off on a crusade. The vestiges of the base of the fortress's tower have been restored for all to see in the basement of the Louvre.

1202: The fortress is completed. It will come to be called the Louvre; the precise origin of the name is unknown.

1364–1380 and after: During the reign of Charles V, who sometimes lived at the Louvre, it is transformed into a comfortable royal residence, with a grand garden and the country's first royal library of manuscripts.

1400s: The kings of France abandon the Louvre as their preferred royal residence in favor of the châteaux of the Loire Valley.

1516: The Renaissance king François I persuades Leonardo da Vinci to live and work in France. Among the works Leonardo brings with him is the *Mona Lisa*.

1527–1528: François I demolishes the grand tower of Philippe Auguste's medieval fortress and begins work on the Louvre of the Renaissance, which he makes his residence.

1549: Henri II, François I's son, continues his father's work, deciding to change the Louvre's architectural design and beginning the construction of new wings. His Louvre is a prime example of French Renaissance architecture with grand decorative sculptures and reliefs.

1564: Catherine de Médicis, Henri II's widow, begins building the Tuileries Palace and Garden for herself, next to the Louvre and just outside the city walls.

1572: The Saint Bartholomew's Day Massacre, the Roman Catholic slaughter of Protestants in which both Catherine de Médicis and her son Charles IX are complicit, unfolds. It is one of the bloodiest episodes in French history. The Louvre is the backdrop for the violence; Protestants in and near the Louvre are killed, bodies piled up in the Cour Carrée.

1595: Henri IV, having ended the civil war in France, begins a radical, visionary political project called the Grand Design, which will include construction of the painting corridor eventually known as the Grande Galerie to connect the Louvre to the Tuileries.

1608: The Grande Galerie is completed. Over a quarter mile in length, it is the longest building in Paris. More than two dozen lodgings and studios for artists and craftsmen are constructed underneath it the following year.

1610: Henry IV is assassinated by François Ravaillac, a Catholic fanatic, while riding in his carriage; the king dies before his body arrives at his home in the Louvre.

1624: Louis XIII, the son of Henry IV and his second wife, Marie de Médicis, begins new building work in the Louvre that is stymied by political and financial problems.

1641: Nicolas Poussin, the French baroque painter, begins work on the decor of the Grande Galerie.

1643: Louis XIV succeeds his father, Louis XIII, at the age of five. He rules for seventy-two years, until his death in 1715.

1648: The Royal Academy of Painting and Sculpture is founded by Louis XIV.

1652: Louis XIV makes the Louvre his principal residence and for two decades is its passionate developer, raising the facades of the Cour Carrée and completing the Tuileries Palace.

1658: Molière's plays are first performed in the Louvre.

1660: The last remnants of the medieval Louvre of Philippe Auguste are destroyed.

1659–1666: André Le Nôtre, landscape architect and the royal gardener, designs and completes the Tuileries Garden with neat and structured paths, ponds, lawns, flower beds, and rows of trees.

1661–1663: Louis XIV orders the construction and decoration of the Apollo Gallery under the direction of Charles Le Brun.

1667: Work begins on the Colonnade, a portico of columns on the ground floor of the eastern facade of the Louvre facing the city of Paris.

1667: Louis XIV moves into the lavish apartments of the Tuileries Palace for four years.

1667: The first Salon, a state-run public exhibition of the Royal Academy of Painting and Sculpture, is held in the Grande Galerie. These exhibitions will continue until 1848.

1672: The Académie française is allowed to meet in the Louvre.

1682: Louis XIV, who comes to dislike both Paris and the Louvre, loses interest in his projects and leaves for a new palace he builds at Versailles. He leaves behind some of the artwork of the royal collection in the Louvre; they will form the basis for the future museum.

1692: The Royal Academy of Painting and Sculpture is installed in the Louvre.

1715: With the death of Louis XIV, the Regent Philippe d'Orléans and the young Louis XV take up residence in the Tuileries Palace, which continues to be a seat of government until the king moves to Versailles in 1722.

1774–1789: Charles-Claude Flahaut de la Billarderie, the comte d'Angiviller and director general of the king's buildings, conceives and develops an idea to create a national "museum" at the Louvre.

1789: The French Revolution begins. Louis XVI is compelled to share power with the National Assembly. In October, Parisian crowds force him and his wife, Marie Antoinette, to leave Versailles and take up residence in the Tuileries Palace. From then on, the revolutionary government moves a large number of artworks into the Louvre, acquired through the nationalization of church property, the confiscation of artworks owned by the nobility who flee France, and military campaigns in the Netherlands and Italy.

1791: The revolutionary French government captures Louis XVI and Marie Antoinette as they attempt to flee the country.

1792: After ruling for eight centuries, the French monarchy falls. A National Convention is elected and meets in the Salle du Manège in the Tuileries Palace. Louis XVI and Marie Antoinette are arrested. The guillotine is installed on the place du Carrousel in front of the Tuileries Palace and later relocated to the place de la Concorde (then known as place de la Révolution). The next year, both the king and queen are executed.

1793: The revolutionary government establishes the Musée Central des Arts, housed in the Grande Galerie of the Louvre and open to the public. It opens on August 10 for one day, as part of a celebration of the first anniversary of the end of the monarchy. Three months later, the Louvre opens permanently.

1794: Orchestrated by the National Convention's Committee of Public Safety, instability and violence pervade the country during the Reign of Terror. In July, the Terror comes to an end when the leading figure on

the committee, Maximilien Robespierre, is expelled from the National Convention and executed.

1798: War booty—paintings and antiquities—from the military campaigns of an ambitious young general named Napoleon Bonaparte flows into the museum. His forces seize thousands of works, including, from a Venice monastery, Paolo Veronese's *The Wedding Feast at Cana*. The works are inventoried and studied for eventual public display.

1799: Napoleon Bonaparte carries out a coup d'état, moving into the Tuileries Palace three months later. He declares his desire to end the Revolution and ushers in an increasingly authoritarian regime marked by costly military expeditions.

1800: The Consulate, France's government from 1799 to 1804, forces merchants and shopkeepers out of the area around the Louvre.

1801: Napoleon expels artists living and working in the Louvre's Cour Carrée.

1803: Napoleon changes the Louvre's name to Musée Napoléon.

1804: Napoleon crowns himself emperor.

1806–1808: Napoleon builds the Carrousel's small triumphal arch in red, pink, and white marble in the Tuileries Garden to honor his military victories.

1810: After Napoleon divorces Josephine, he marries Marie-Louise of Austria in splendor in the Salon Carré at the Louvre.

1810–1814: The north gallery along the rue de Rivoli is constructed.

1814: Napoleon Bonaparte is exiled to the island of Elba. In 1815, he stages a brief comeback before his final defeat at Waterloo. Under the Restoration, France returns most of the art treasures he plundered to the Allies.

1816: The French ship the *Medusa* runs aground, inspiring Théodore Géricault to create the painting *The Raft of the Medusa* in 1819.

1819: The building of galleries and wings continues, importantly the completion of the Cour Carrée.

1820: The *Venus de Milo* is discovered on the Aegean island of Melos; it arrives in Paris the following year.

1827: An Egyptian museum is created.

1827: The Musée de la Marine opens, showcasing scale models of ships as well as the wealth and technical know-how of the French navy. In 1919, the French state decides to detach it from the Louvre.

1830: The unpopularity of the Bourbon monarch Charles X propels anti-governmental demonstrations, leading to the July Revolution and Louis-Philippe's ascension to power. Rioters pillage the Tuileries Palace during the conflict. Eugène Delacroix's celebrated *Liberty Leading the People* depicts this revolution.

1838: Louis-Philippe's Spanish museum opens.

1847: The Assyrian and Algerian museums open. In the late nineteenth century, the Assyrian museum becomes the Louvre's department of Near Eastern antiquities. The Algerian museum, however, closes its doors just before the turn of the century, narrowing the focus of the Louvre. Other small museums within the Louvre will subsequently close as the museum transforms and moves away from the idea of being an "encyclopedic" institution.

1848: A revolution overthrows Louis-Philippe, who seeks exile in England, taking his private collection of great Spanish paintings with him.

1850: The Mexican and ethnographic museums are created in the Louvre. As the museum refocuses and narrows its scope in the late nineteenth and

early twentieth century, both of these collections depart to other institutions, such as the Trocadéro ethnographic museum and the Museum of National Antiquities, now the National Archaeology Museum.

1851–1852: Napoleon III, Napoleon Bonaparte's nephew, becomes emperor in 1852 following a coup the previous year.

1852–1857: Napoleon III undertakes the construction of the new Louvre. He completes the Richelieu wing and reorganizes the Denon wing, giving the Louvre its current shape. Along with Louis XIV, he will be considered the Louvre's most ambitious builder.

1863: *Winged Victory of Samothrace* is discovered in Greece; it arrives at the Louvre the following year. During a 2013–14 restoration of the statue, a large feather is discovered and added, changing the shape of the left wing.

1866: Some of the ruins of Philippe Auguste's medieval Louvre in the Cour Carrée are uncovered.

1870: The Prussians defeat Napoleon III in battle, imprison him, and eventually exile him to England. Autocratic rule ends as the anti-monarchical Third Republic takes power in France.

1871: Rebels burn down the Tuileries Palace during the Paris Commune uprising. The library of the Louvre is destroyed.

1871: The Ministry of Finance is installed in the Richelieu wing of the Louvre.

1882: The ruins of the Tuileries Palace are demolished.

1883: The École du Louvre is created inside the Louvre.

1887: The Third Republic holds a public auction of most of the crown jewels in the Louvre. More than 77,000 stones are sold.

1901: A French archaeologist discovers the *Code of Hammurabi* stele at Susa, in Iran. Dating from 1750 BC, it lays out the Babylonian system of laws. In 1902, it is brought to France.

1905: The Musée des Arts Décoratifs moves into the Rohan wing of the Louvre on the rue de Rivoli.

1911: Vincenzo Peruggia, an Italian worker, steals the *Mona Lisa* from the Louvre. The theft makes news around the world, helping to transform the painting into a global icon. Eventually Peruggia takes it to an art dealer, hoping for a reward. Instead, he is arrested. The *Mona Lisa* is returned to the Louvre twenty-eight months later.

1914: World War I is declared; part of the Louvre's collection is evacuated.

1928: The Louvre installs an elaborate electric lighting system for the first time, allowing it to remain open until six o'clock in the evening.

1939: Most of the museum's collections are evacuated to the provinces at the outbreak of World War II before the French surrender and the German occupation of Paris.

1940: Adolf Hitler tours Paris for a day but does not enter the Louvre.

1945: At the end of World War II, the artworks of the Louvre return, and the museum reopens.

1945: The Louvre's Asian collections move to the Musée Guimet in the Sixteenth Arrondissement.

1947: The Louvre moves its post-1848 collections, including its impressionist paintings, to the Jeu de Paume, then an annex of the Louvre close by in the Tuileries Garden.

1953: Georges Braque's painting of two amorphous giant black birds is

installed on the ceiling of a royal apartment in recognition of the importance of contemporary art in the Louvre.

1961: The Flore Pavilion becomes part of the Louvre.

1963: The *Mona Lisa* travels to Washington and New York after First Lady Jacqueline Kennedy talks French president Charles de Gaulle into lending it.

1965: The French television series *Belphégor*, based on the 1927 novel *Belphégor*, by Arthur Bernède, mesmerizes France with its chilling story of a killer ghost in the Louvre.

1968: French culture minister André Malraux decorates the Louvre-Rivoli Métro station with copies of Louvre statues. Malraux also approves the installation of eighteen sculptures by Aristide Maillol in the Carrousel Garden.

1981: President François Mitterrand announces a project to build the Grand Louvre.

1984–1986: The excavation of the Cour Carrée uncovers traces of Philippe Auguste's medieval fortress; the excavation of the Cour Napoléon leads to the discovery of a seventeenth-century wall built by Louis Le Vau.

1986: The Musée d'Orsay, built in the former Gare d'Orsay, a Beaux-Arts railway station on the Left Bank, is inaugurated. In a painful loss, the Louvre's post-1848 collections, including its impressionist paintings, move there from the Jeu de Paume annex.

1988: AGLAE, the world's only particle accelerator devoted exclusively to artistic investigations, is installed under the Louvre, fifty feet belowground.

1989: I. M. Pei's Pyramid, a vision of modernity, opens. The Ministry

of Finance is ejected from the Louvre and moves to Bercy, in the Twelfth Arrondissement.

1989: The Louvre's prints and drawings department is inaugurated. It resides in a wing of the Flore Pavilion.

1990: Archaeological excavation is carried out in the Carrousel zone. Walls and fortifications built under Charles V are uncovered, as well as remnants of the original fortress.

1993: A second phase of the Grand Louvre project is completed, creating underground space below the place du Carrousel to accommodate parking and multipurpose exhibition halls. The Carrousel du Louvre, a shopping mall, opens.

1998: The new premises of the École du Louvre in the Flore wing are inaugurated.

1998: The Center for Research and Restoration of the Museums of France (C2RMF) is created. Its mission is to conserve and promote French cultural artifacts, including works from the Louvre and other museums. The C2RMF is housed in the Flore Pavilion.

2000: President Jacques Chirac inaugurates the galleries of African, Asian, Oceanic, and American art in the Sessions Pavilion with a selection of works from the future Musée du Quai Branly, which will be officially inaugurated in 2006. In 2024, Laurence des Cars decides to transform the Sessions Pavilion.

2004: The small Musée National Eugène Delacroix on the place de Furstenberg is incorporated into the Louvre.

2004: President Jacques Chirac decides to create a small satellite museum in Lens, in northern France. It will be free of walled-off spaces and geographical constraints, a laboratory for what art museums might become.

2005: The Tuileries Garden becomes part of the Louvre administration.

2006: The blockbuster film based on *The Da Vinci Code*, Dan Brown's runaway best-selling thriller, is released and grosses $760 million worldwide; attendance at the museum increases.

2012: The Islamic art department opens in a new structure built into the enclosed Visconti courtyard.

2012: The Louvre-Lens Museum opens.

2017: After defeating far-right candidate Marine Le Pen in the French presidential campaign, President-elect Emmanuel Macron delivers his victory speech in front of the Louvre Pyramid.

2017: The Louvre Abu Dhabi museum, France's largest cultural project abroad, opens in the United Arab Emirates. Opposition in France to the project was fierce; critics accused the Louvre of selling its soul to foreigners.

2018: Beyoncé and Jay-Z make a six-minute, five-second music video in the museum; attendance soars. Suddenly, the Louvre sheds its reputation as the world's largest repository of musty old art and becomes cool.

2019: A fire breaks out in the Cathedral of Notre-Dame in Paris. Its wood spire and much of the roof are destroyed.

2019: A state-of-the-art conservation center opens in Liévin near the Louvre's satellite museum in Lens. The center was built to store more than a quarter of a million artworks.

2020–2021: The global pandemic forces the Louvre to close twice over the course of several months. During that time, the museum undertakes cleaning and renovation projects.

2021: Laurence des Cars becomes the first female director of the Louvre.

2023: The Louvre buys Jean-Baptiste-Siméon Chardin's *Basket of Strawberries* for over $1.7 million, after blocking its sale to the Kimball Art Museum in Fort Worth, Texas. The Louvre now has forty-two Chardins in its collection.

2024: Laurence des Cars conceives a plan for an ambitious Louvre building project: a new entrance through the Colonnade that would connect to an underground area carved out under the Cour Carrée. If the project is approved and money raised, it will create a separate room for the *Mona Lisa* and space for temporary exhibitions. The cost: about 500 million euros.

Selected Bibliography

In the absence of footnotes or endnotes, the principal sources used in writing this book are listed here. If a source has been omitted inadvertently, it will be added in a subsequent edition. For the sake of clarity and style, in some cases I have translated passages into English myself and cited the original French texts. I hope I have done them justice. In other cases, I have relied upon, and cited, existing English translations of French texts.

For a deeper understanding of the Louvre, I recommend the scholarly three-volume, nearly two-million-word-long *Histoire du Louvre*, edited by Geneviève Bresc-Bautier and Guillaume Fonkenell, and the down-to-earth *Le Louvre pour les nuls* (The Louvre for Dummies), by Daniel Soulié. In English, there is the masterful history of the museum: *The Louvre: The Many Lives of the World's Most Famous Museum*, by James Gardner.

BOOKS

Alcouffe, Daniel, Marc Bascou, Michèle Bimbenet-Privat, et al. *Les Diamants de la couronne et joyaux des souverains*. Paris: Faton, 2023.

Allard, Sébastien. *Le Louvre à l'époque romantique – Les décors du palais (1815–1835)*. Lyon: Fage Éditions, 2006.

Baudelaire, Charles. *Les Fleurs du mal*. Paris: Auguste Poulet-Malassis, 1868.

Becq, Juliette, D' de Kabal, Marc Étienne, et al. *Toni Morrison: Invitée au Louvre – Titre 22*. Edited by Christian Bourgois. Paris: Christian Bourgois Éditeur, 2006.

Bernède, Arthur. *Belphegor: Chantecoq and the Phantom of the Louvre*. Translated by Chris Amies. Middletown, DE: Libretto, 2019.

Bindman, David. *The Image of the Black in Western Art, Volumes I–V*. London: Belknap, 2012.

Bologne, Jean Claude, and Elisa de Halleux. *Love in the Louvre*. Paris: Flammarion, 2008.

Bottéro, Jean. *The Oldest Cuisine in the World: Cooking in Mesopotamia*. Translated by Teresa Lavender Fagan. Chicago: University of Chicago Press, 2004.

Bresc-Bautier, Geneviève. *The Louvre, a Tale of a Palace*. Paris: Somogy Art Publishers, 2008.

———. *Jardins du Carrousel et des Tuileries*. Paris: Réunion des Musées Nationaux, 1996.

Bresc-Bautier, Geneviève, and Guillaume Fonkenell. *Histoire du Louvre*. Paris: Fayard, 2016.

Bringley, Patrick. *All the Beauty in the World: A Museum Guard's Adventures in Life, Loss and Art*. New York: Simon & Schuster, 2023.

Brocvielle, Vincent. *Why Is It Famous? The Incredible Journey of the Louvre's Icons*. Paris: Réunion des Musées Nationaux, 2019.

Chanel, Gerri. *Saving Mona Lisa: The Battle to Protect the Louvre and Its Treasures During World War II*. New York: Heliopa Press, 2014.

Charnier, Jean-François, ed. *Louvre Abu Dhabi: The Complete Guide*. Paris: Éditions Skira Paris, 2018.

Child, Julia, and Alex Prud'homme. *My Life in Paris*. New York: Knopf, 2006.

Childs, Adrienne L., and Susan Houghton Libby. *The Black Figure in the European Imaginary*. London: GILES, 2017.

Clark, Kenneth. *The Nude: A Study in Ideal Form*. New York: Doubleday Anchor Books, 1956.

Corey, Laura D., Paula Deitz, Guillaume Fonkenell, Bruce Guenther, Sarah Kennel, and Richard H. Putney. *The Art of the Louvre's Tuileries Garden*. New Haven, CT: Yale University Press, 2013.

Curtis, Gregory. *Disarmed: The Story of the Venus de Milo*. New York: Knopf, 2003.

Dayot, M. Armand, ed. *Le Musée du Louvre: Les grands musées du monde illustrés en couleurs*. Volumes 1–2. Paris: Pierre Lafitte, 1913.

De Baecque, Bruno, and Joëlle Jolivet. *Les plus belles fesses du Louvre*. Paris: Éditions Séguier, 2013.

De Botton, Alain. *How Proust Can Change Your Life*. New York: Vintage International, 1997.

De Botton, Alain, and John Armstrong. *Art as Therapy*. London: Phaidon Press Limited, 2013.

De Font-Réaulx, Dominique. *Le Louvre. Le Guide*. Paris: Réunion des Musées Nationaux; Louvre Éditions, 2023.

DeJean, Joan. *How Paris Became Paris: The Invention of the Modern City*. New York: Bloomsbury, 2014.

Delieuvin, Vincent, and Olivier Tallec. *What's So Special About Mona Lisa?* Arles: Actes Sud, 2017.

Descure, Virginie, and Christophe Casazza. *Ciné Paris: 20 balades sur des lieux de tournages mythiques*. Paris: Éditions Hors Collection, 2003.

Deutsch, Lorànt, with Emmanuel Haymann. *Metronome: L'histoire de France au rythme du métro parisien*. Neuilly-sur-Seine: Michel Lafon, 2009.

Duncan, Carol. *Civilizing Rituals: Inside Public Art Museums*. London and New York: Routledge, 1995.

Fernandez, Dominique. *A Hidden Love: Art and Homosexuality*. Munich: Prestel, 2002.

Fonkenell, Guillaume, Hubert Naudeix, and Marlène Faure. *Building the Louvre: A Richly Illustrated History*. Arles: Éditions Honoré Clair, 2018.

Galard, Jean, with Nicole Picot. *Promenades au Louvre: En compagnie d'écrivains, d'artistes et de critiques d'art*. Paris: Robert Laffont, 2010.

Gardner, James. *The Louvre: The Many Lives of the World's Most Famous Museum*. New York: Atlantic Monthly Press, 2020.

Gautier, Théophile. *Le Musée du Louvre*. Presented and annotated by Marie-Hélène Girard. Paris: Citadelles & Mazenod, 2011.

Glama, Barathélemy. *Objective Louvre: Art History for All the Family*. Paris: Actes Sud and Musée du Louvre, 2015.

Glantz, Margo, et al. *Musée Du Louvre, Chaussures Peintes/Painted Shoes/Calzados Pintados/ Gemalte Schuhe.* Ed. Baden bei Wien: Lammerhuber, 2011.

Goetz, Adrien. *100 chefs-d'œuvre du Louvre racontent une histoire du monde.* Paris: Beaux-Arts Éditions, 2015.

Goetz, Adrien, and Claudette Joannis. *Jewels in the Louvre.* Paris: Musée du Louvre Éditions, 2008.

Gopnik, Adam, ed. *Americans in Paris: A Literary Anthology.* New York: Library of America, 2004.

Grau, Donatien, ed. *Under Discussion: The Encyclopedic Museum.* Los Angeles: Getty Research Institute, 2021.

Green, Julien. *Paris.* Translated by J. A. Underwood. London: Marion Boyars, 2001.

Hale, Sheila. *Titian: His Life.* New York: HarperCollins, 2012.

Hamiaux, Marianne, Ludovic Laugier, and Jean-Luc Martinez. *The Winged Victory of Samothrace: Rediscovering a Masterpiece.* Paris: Musée du Louvre, 2015.

Hautecœur, Louis. *Histoire du Louvre: Le chateau, le palais, le musée: des origins à nos jours, 1200–1940.* 2nd ed. Paris: L'illustration, 1940.

Hazan, Éric. *The Invention of Paris: A History in Footsteps.* Translated by David Fernbach. London: Verso, 2010.

Héran, Emmanuelle. *The Tuileries Gardens Yesterday and Today: A Walker's Guide.* Paris: Somogy Éditions d'art; Paris: Musée du Louvre, 2016.

Hessel, Katy. *The Story of Art Without Men.* New York: W. W. Norton, 2023.

Higonnet, Anne. *Liberty Equality Fashion: The Women Who Styled the French Revolution.* New York: W. W. Norton, 2024.

Higonnet, Patrice. *Paris: Capital of the World.* Translated by Arthur Goldhammer. Cambridge, MA: Belknap Press of Harvard University Press, 2002.

Horne, Alistair. *The Seven Ages of Paris: Portrait of a City.* London: Knopf, 2002.

Houghteling, Sara. *Pictures at an Exhibition.* New York: Vintage Books, 2009.

Hoving, Thomas. *Making the Mummies Dance: Inside the Metropolitan Museum of Art.* New York: Simon & Schuster, 1993.

Huntsman, Penny. *Thinking About Art: A Thematic Guide to Art History.* New York: Wiley-Blackwell, 2015.

Hussey, Andrew. *Paris: The Secret History.* New York: Viking, 2006.

Isaacson, Walter. *Leonardo da Vinci.* New York: Simon & Schuster, 2017.

James, Henry. *Autobiography.* Edited by Frederick W. Dupee. Princeton, NJ: Princeton Legacy Library, 1983.

Jones, Colin. *Paris: The Biography of a City.* New York: Penguin Books, 2006.

Joseph-Jeanneney, Brigitte. *Nocturne au Louvre.* Paris: Cohen & Cohen, 2017.

Katz, Jonathan, Isabel Hufschmidt, and Änne Söll, eds. *On Curating Issue 37: Queer Curating.* California: CreateSpace, 2018.

Kennedy, Élizabeth, and Olivier Meslay. *American Artists and the Louvre.* Chicago: Terra Foundation for American Art, 2006.

Kerper, Barrie. *Paris: The Collected Traveler.* New York: Three Rivers Press, 2000.

Kolfin, Elmer, and Esther Schreuder, eds. *Black Is Beautiful: Rubens to Dumas.* Zwolle: Waanders, 2008.

Konigsburg, E. L. *From the Mixed-Up Files of Mrs. Basil E. Frankweiler.* New York: Atheneum Books, 1967.

Lafont, Anne. *Une Africaine au Louvre en 1800: La place du modèle.* Paris: Institut National d'Histoire de l'Art, 2019.

Lafont, Anne, Mechthild Fend, and Melissa Hyde, eds. *Plumes et pinceaux: Discours de femmes sur l'art en Europe (1750–1850)*. Dijon: Institut National d'Histoire de l'Art, 2012.

Laneyrie-Dagen, Nadeije. *Détails vus au Louvre*. Paris: Éditions de La Martinière and Musée du Louvre, 2009.

Lesné, Claude, Anne Roquebert, and Direction des Musées. *Catalogue des peintures MNR*. Paris: Réunion des Musées Nationaux, 2004.

Levenstein, Harvey. *We'll Always Have Paris: American Tourists in France Since 1930*. Chicago: University of Chicago Press, 2004.

Lis, Michel, and Béatrice Vingtrinier. *Flowers in the Louvre*. Paris: Flammarion and Musée du Louvre Éditions, 2009.

Littlewood, Ian. *Paris: A Literary Companion*. New York: Perennial Library, 1988.

Loyrette, Henri. *Louvre Abu Dhabi: Naissance d'un musée*. Milan: Skira, 2012.

MacGregor, Neil. *A History of the World in 100 Objects*. London: Penguin Books, 2013.

Makariou, Sophie, Marie Fradet, and Frédéric Viaux. *Les arts de l'Islam au musée du Louvre: Album de l'exposition*. Paris: Hazan, 2012.

Malgouyres, Philippe, and Jean-Luc Martinez. *Venus d'ailleurs: Matériaux et objets voyageurs*. Paris: Louvre, 2021.

Mardrus, Françoise. *La Pyramide du Louvre*. Madrid: Ediciones El Viso; Paris: Musée du Louvre, 2019.

Matsumoto, Taiyo. *Cats of the Louvre*. San Francisco: VIZ Media, LLC, 2019.

Maurus, Véronique, and Jean-Christophe Ballot. *La vie secrète du Louvre*. Bruxelles: Renaissance du Livre, 2006.

McAuley, James. *The House of Fragile Things: Jewish Art Collectors and the Fall of France*. New Haven, CT: Yale University Press, 2021.

McClellan, Andrew. *Inventing the Louvre: Art, Politics, and the Origins of the Modern Museum in Eighteenth-Century Paris*. Berkeley: University of California Press, 1999.

McCullough, David. *The Greater Journey: Americans in Paris*. New York: Simon & Schuster, 2011.

Morel, Bernard. *Les joyaux de la Couronne de France: Les objets du sacré des rois et des reines suivis de l'histoire des joyaux de la Couronne de François Ier à nos jours*. Antwerp: Fonds Mercator; Paris: Albin Michel, 1988.

Morvan, Frédéric. *Objective Louvre: Surprises for the Entire Family*. Paris: Actes Sud and Musée de Louvre, 2011.

Nayeri, Farah. *Takedown: Art and Power in the Digital Age*. New York: Astra House, 2022.

Nochlin, Linda. *Representing Women*. London: Thames & Hudson, 1999.

Nourissier, Francois, and Elisabeth Foucart-Walter. *Dogs in the Louvre*. Paris: Flammarion, 2008.

Nouvel, Jean. *Louvre Abu Dhabi: Story of an Architectural Project*. Paris: Skira, 2019.

Nowinski, Judith. *Baron Dominique Vivant Denon (1747–1825): Hedonist and Scholar in a Period of Transition*. Rutherford, NJ: Fairleigh Dickinson University Press, 1970.

O'Reilly, James, Larry Habegger, and Sean O'Reilly, eds. *Travelers' Tales Paris*. San Francisco: Travelers' Tales, 2002.

Obrist, Hans Ulrich. *Les Conversations du Louvre*. Paris: Éditions du Seuil and Musée du Louvre, 2023.

Othoniel, Jean-Michel. *The Secret Language of Flowers: Notes on the Hidden Meanings of the Louvre's Flowers*. Paris: Actes Sud and Musée du Louvre, 2019.

Paul, Elliot. *Hugger-Mugger in the Louvre*. New York: Random House, 1940.

Pei, I. M., Émile Biasini, and Jean Lacouture. *L'Invention du Grand Louvre*. Paris: Éditions Odile Jacob, 2001.

Perrot, Jean. *Le palais de Darius à Suse: Une résidence royale sur la route de Persépolis à Babylone*. Paris: PUPS, 2011.

Pinard, Yves, and Paul Bocuse. *Food in the Louvre*. Milan: Skira, 2009.

Pochon, Caroline, and Allan Rothschild. *La face cachée des fesses*. Paris: Democratic Books/Arte Éditions, 2009.

Poselle, Laurence, ed. *Les Noces de Cana de Véronèse: Une œuvre et sa restauration*. Paris: Réunion des Musées Nationaux, 1992.

Powell, Jessica. *Literary Paris: A Guide*. New York: Little Bookroom, 2006.

Rosenberg, Pierre. *Chardin: 1699–1779*. Cleveland: Cleveland Museum of Art, 1979.

Rossiter, Heather. *Sweet Boy Dear Wife: Jane Dieulafoy in Persia 1881–1886*. Cambridge, MA: Wakefield Press, 2015.

Russell, John. *Paris*. London: B. T. Batsford, 1975.

Salmon, Dimitri, dir. *Les Louvre de Pablo Picasso*. Paris: Lienart Musée du Louvre, Musée du Louvre-Lens, Musée national Picasso, 2021.

Salomon, Xavier F., et al. *Cocktails with a Curator: The Frick Collection*. New York: Rizzoli Electa, 2022.

Saltzman, Cynthia. *Plunder: Napoleon's Theft of Veronese's Feast*. New York: Farrar, Straus and Giroux, 2021.

Sassoon, Donald. *Mona Lisa: The History of the World's Most Famous Painting*. New York: HarperCollins, 2001.

Schama, Simon. *The Power of Art*. London: Vintage Digital, 2023.

Schneider, Pierre. *Les dialogues du Louvre*. Paris: A. Biro, 1991.

Schubert, Karsten. *The Curator's Egg: The Evolution of the Museum Concept from the French Revolution to the Present Day*. 3rd ed. London: Ridinghouse, 2009.

Singaravélou, Pierre. *Fantômes du Louvre: Les musées disparus du XIXe siècle*. Paris: Hazan and Musée du Louvre, 2023.

Smith, Charles Saumarez. *The Art Museum in Modern Times*. London: Thames & Hudson, 2021.

Sofio, Séverine. *Artistes femmes: La parenthèse enchantée, XVIIIe–XIXe siècles*. Paris: CNRS Éditions, 2016.

Sollers, Philippe. *Le Cavalier du Louvre: Vivant Denon (1747–1825)*. Librairie Plon, 1995.

Solomon-Godeau, Abigail. *Male Trouble: A Crisis in Representation*. London: Thames & Hudson, 1999.

———. *Mistaken Identities*. Santa Barbara: University of California Press, 1993.

Soulié, Daniel. *Le Louvre pour les nuls*. Paris: First, 2010.

———. *Louvre: Secret et insolite*. Paris: Parigramme, 2011.

Szántó, András. *The Future of the Museum: 28 Dialogues*. Berlin: Hatje Cantz, 2020.

Thomas, Ariane. *La Mésopotamie au Louvre: De Sumer à Babylone*. Paris: Somogy éditions d'art, 2016.

Torres, Pascal. *Les Secrets du Louvre*. Paris: Vuibert, 2013.

Trombetta, Pierre-John. *Sous la pyramide du Louvre, vingt siècles retrouvés*. Paris: Le Rocher, 1987.

Vitoux, Frédéric, and Élisabeth Foucart-Walter. *Cats in the Louvre*. Paris: Flammarion, 2007.

White, Edmund. *The Flâneur: A Stroll Through the Paradoxes of Paris.* New York: Bloomsbury, 2001.

Zelba. *Le Grand Incident.* Paris: Futuropolis Gallisol Éditions, 2023.

JOURNALS, ARTICLES, AND PODCASTS

Bohringer, Romane, host. Les Enquêtes du Louvre. Musée du Louvre, 2021–2022. https://www.louvre.fr/louvreplus/les-enquetes-du-louvre/les-enquetes-du-louvre-saison-1

Datta, Venita. "L'as-tu vue la Joconde?" *Faits divers et vies déviantes,* ed. Marie-Ève Thérenty. (Paris: CNRS Éditions, 2022), pp. 224–231.

Foucher Zarmanian, Charlotte. "Le Louvre des femmes. Sur quelques présupposés à l'égard des femmes dans les musées en France au XIXe siècle." *Romantisme* 173, no. 3 (2016): 56–67. https://doi.org/10.3917/rom.173.0056

Grande Galerie: Le Journal du Louvre. Musée du Louvre. Issues 1–64, 2008–Present.

Grout, James. "The Parthenon Marbles in the Louvre." *Encyclopædia Romana.* University of Chicago, June 17, 2024.

Hanson, Kate H. "The Language of the Banquet: Reconsidering Paolo Veronese's Wedding at Cana." *Invisible Culture,* 2010. https://doi.org/10.47761/494a02f6.b216e7ad

Harris, Gareth. "Louvre Acquires Chardin's Strawberries Painting Thanks to 10,000 Individual Donors." *The Art Newspaper,* March 8, 2024. https://www.theartnewspaper.com/2024/03/06/louvre-acquires-chardins-strawberries-painting-thanks-to-10000-individual-donors

Higonnet, Anne. "Through a Louvre Window." *Journal18,* Issue 2 *Louvre Local* (Fall 2016). https://www.journal18.org/1057. DOI: 10.30610/2.2016.7

Jones, Ryan Christopher. "The Pilgrimage to Guadalupe: Sacred Renewal in Mexico City." *Revista,* January 28, 2021. https://revista.drclas.harvard.edu/the-pilgrimage-to-guadalupe-sacred-renewal-in-mexico-city/

Le Parisien: La saga du Louvre: De la forteresse au plus grand musée du monde. Beaux Arts Éditions and *Le Parisien.* Issue 19, 2022.

Lichfield, John. "The Moving of the Mona Lisa." *The Independent,* April 1, 2005. https://www.independent.co.uk/news/world/europe/the-moving-of-the-mona-lisa-530771.html

Lorquin, Bernard, and Olivier Lorquin. "Aristide Maillol." FranceArchives, 2011. https://francearchives.gouv.fr/fr/pages_histoire/39415

"Salons et expositions artistiques. 1, Le Salon officiel et ses héritiers (SAF et SNBA), expositions d'Ancien Régime et salons de province." Bibliothèque nationale de France, February 20, 2024. https://bnf.libguides.com/salon_officiel

Stammers, Tom. "Facets of French Heritage: Selling the Crown Jewels in the Early Third Republic." *Journal of Modern History* 90, no. 1 (March 2018): 76–115. https://doi.org/10.1086/695884

"Symbolique Impériale." Napoleon.org, August 2018. https://www.napoleon.org/histoire-des-2-empires/symbolique-imperiale/

Talbot, Margaret. "The Myth of Whiteness in Classical Sculpture." *The New Yorker,* October 8, 2018. https://www.newyorker.com/magazine/2018/10/29/the-myth-of-whiteness-in-classical-sculpture

Whiteley, Mary. "Le Louvre de Charles V: dispositions et fonctions d'une résidence

royale." *Revue de l'Art*, 1992. https://www.persee.fr/doc/rvart_0035-1326_1992 _num_97_1_348001

VIDEOS/DVDS/TELEVISION SERIES

24h avec . . . Léonard de Vinci: La Jocondomania. Musée du Louvre. YouTube, August 9, 2019. https://www.youtube.com/watch?v=xsg8XCtW4z8

APESHIT. The Carters. YouTube, June 16, 2018. https://www.youtube.com/watch?v =kbMqWXnpXcA

JR au Louvre et le secret de la Grande Pyramide. Musée au Louvre. Facebook, July 4, 2019. https://www.facebook.com/museedulouvre/videos/476833873075426/

Man Throws Cake at Mona Lisa Painting at Louvre Museum in Paris. *USA Today*. You-Tube, May 30, 2022. https://www.youtube.com/watch?v=wZuDXgF4lp8

Mona Lisa Smile ft. Nicole Scherzinger. will.i.am. YouTube, April 14, 2016. https://www.youtube.com/watch?v=0041WCg4ypU

FILMS

3 Days to Kill. Directed by McG. EuropaCorp, Wonderland Sound and Vision, 2014.

Au Louvre avec Miquel Barceló. Directed by Valéria Sarmiento. Institut national de l'audiovisuel, 2004.

Bande à part. Directed by Jean-Luc Godard. Columbia Pictures, 1964.

Belphegor, or the Phantom of the Louvre. Four-part series. Directed by Claude Barma. ORTF, 1965.

Belphegor, Phantom of the Louvre. Directed by Jean-Paul Solomé. Bac Films, 2001.

Edge of Tomorrow. Directed by Doug Liman. Village Roadshow Pictures, RatPac-Dune Entertainment, 3 Arts Entertainment, Viz Productions, and TC Productions, 2014.

Francofonia. Directed by Alexander Sokurov. Idéale Audience, 2015.

French Kiss. Directed by Lawrence Kasdan. Polygram Filmed Entertainment, Prufrock Pictures, 20th Century Fox, and Working Title Films, 1995.

Funny Face. Directed by Stanley Donen. Paramount Pictures, 1957.

Is Paris Burning? Directed by René Clément. Marianne Productions and Transcontinen-tal Films, 1966.

It Must Be Heaven. Directed by Elia Suleiman. Rectangle Productions, Nazira Films, Pal-las Film, Possibles Média, and Zeyno Film, 2019.

La Joconde: Histoire d'une obsession. Directed by Henri Gruel. Argos Film, Como Films, and Son et Lumière, 1958.

Le capital. Directed by Costa-Gavras. KG Productions, The Bureau, 2012.

Monte Carlo. Directed by Thomas Bezucha. Fox 2000 Pictures, New Regency Produc-tions, DiNovi Pictures, Dune Entertainment, Dune Entertainment III, and Blos-som Films, 2011.

The Age of Innocence. Directed by Martin Scorsese. Columbia Pictures and Cappa Productions, 1993.

The Da Vinci Code. Directed by Ron Howard. Columbia Pictures, Imagine Entertain-ment, and Skylark Productions, 2006.

The Dreamers. Directed by Bernardo Bertolucci. Recorded Picture Company, Fiction, and Peninsula Film, 2003.

The Extraordinary Adventures of Adèle Blanc-Sec. Directed by Luc Besson. EuropaCorp, Apipoulaï, and TF1 Films Production, 2010.

The Rape of Europa. Directed by Richard Berge, Bonni Cohen, and Nicole Newnham. Actual Films, 2006.

Une nuit—Le Louvre avec Lambert Wilson. Directed by Valérie Amarou and Jean-Pierre Devillers. Black Dynamite Production and Troisième Œil Productions, with the participation of France Télévisions, 2017.

Une visite au Louvre. Directed by Jean-Marie Straub and Danièle Huillet. Straub-Huillet Films, 2004.

Index

Page numbers in *italics* refer to illustrations.